PHOTOGRAPHY: A FACET OF MODERNISM

PHOTOGRAPHY:

A FACET OF MODERNISM

PHOTOGRAPHS FROM THE
SAN FRANCISCO MUSEUM OF MODERN ART

VAN DEREN COKE WITH
DIANA C. DU PONT

HUDSON HILLS PRESS, NEW YORK
IN ASSOCIATION WITH THE SAN FRANCISCO MUSEUM OF MODERN ART

First Edition

© 1986 by the San Francisco Museum of Modern Art

Published in the United States by Hudson Hills Press, Inc., Suite 1308, 230 Fifth Avenue, New York, NY 10001-7704.

Distributed in the United States, its territories and possessions, Mexico, and Central and South America by Rizzoli International Publications, Inc.

Distributed in Canada by Irwin Publishing Inc.

Distributed in the United Kingdom, Eire, Europe, Israel, and the Middle East by Phaidon Press Limited.

Distributed in Japan by Yohan (Western Publications Distribution Agency).

Editor and Publisher: Paul Anbinder

Manuscript editor: Irene Gordon

Index: Karla J. Knight

Designer: Betty Binns Graphics/Martin Lubin and David Skolkin

Composition: A & S Graphics, Inc.

Manufactured in Japan by Toppan Printing Company

Library of Congress Cataloguing-in-Publication Data

San Francisco Museum of Modern Art.
Photography, a facet of modernism.

Bibliography: p.
Includes index.
1. Photography, Artistic—Exhibitions. 2. Art and photography—Exhibitions. 3. San Francisco Museum of Modern Art—Photograph collections—Exhibitions.
I. Coke, Van Deren, 1921– . II. du Pont, Diana C., 1953– . III. Title.
TR650.S26 1986 779'.09'04074019461 86-15261
ISBN 0-933920-74-1 (alk. paper)

Cover illustration: Paul Strand, *Chair Abstract, Twin Lakes, Connecticut*, 1916, palladium print

Contents

Copyrights and Permissions for Plates and Text Illustrations

Acknowledgments

Two years in the making, *Photography: A Facet of Modernism* has benefited greatly from the generous support, encouragement, and expertise of numerous individuals and institutions. We wish here to acknowledge the people and institutions who helped make this publication possible.

To those who participated directly in the project, we extend our warmest thanks. We are especially grateful to writer/photographer John Bloom for coauthoring the artists' biographies. We also express our sincere appreciation to Karin Victoria, who served as Curatorial Assistant for this project and contributed in many ways during the final phases of preparing the publication while processing rights and reproductions and carrying out research on the artists' portraits and text illustrations. Our grateful thanks are due Sara Leith, Research Assistant, for her important contributions during the early stages of the project, especially her thorough job of locating many of the artists' portraits.

We are indebted to Anne Munroe, former Exhibitions and Publications Coordinator, for the grace with which she saw this book through the publication process. Eugenie Candau, Librarian, was instrumental in facilitating our research by means of the fine photography library she has formed and the generosity with which she and her staff, particularly Karen Brungardt, located myriad sources for us. We also acknowledge the invaluable aid of Carol Rosset, Registrar/Permanent Collection; Pamela Pack, Associate Registrar; and Anita Gross, Rights and Reproductions Coordinator.

We extend a special thank you to photographer Ben Blackwell, who was responsible for all the copy photography for this book and brought high professional standards to each phase of the project.

Throughout the course of preparing this book, we benefited from the enthusiastic support of interns and volunteers. Among them, we single out for special thanks Sarah Spencer and Marilyn Hyde.

We extend our sincere appreciation to the artists or their families for their enthusiastic cooperation and willing response to our many queries. Equally generous were the many museum curators, scholars, dealers, collectors, and independent professionals the world over, who graciously answered our questions and provided valuable information. We note in particular: Stuart Alexander, Paris; Paula Baxter, Research Librarian, and Richard L. Tooke, Supervisor, Rights and Reproductions, The Museum of Modern Art, New York; Carol Bickler, Stanford University Libraries, Department of Special Collections; Philip Brookman, San Diego, California; Peter C. Bunnell, Curator, The Minor White Archive, Princeton University; Nicholas Callaway, Callaway Editions, Inc., New York; Herschel B. Chipp, Professor Emeritus, University of California, Berkeley; Guillemette Delaporte, Musée des Arts Décoratifs, Paris; Elaine Dines-Cox, Curator of Selected Exhibitions, Laguna Art Museum, Laguna Beach, California; James L. Enyeart, Director, Center for Creative Photography, University of Arizona, Tucson; David Fahey, Los Angeles; Ann Gilbert, Librarian, and Jane Hellesoe-Hennon, Library Assistant, Art History/Classics, Doe Library, University of California, Berkeley; Nancy Goldman, Librarian, Pacific Film Archive, University Art Museum, University of California, Berkeley; Sarah Greenough, National Gallery of Art, Washington, D.C.; Cindy Herron, San Rafael, California; Julie Hochstrasser, Fairfax, California; William Innes Homer, H. Rodney Sharp Professor of Art History, University of Delaware, Newark; Graham Howe, Pasadena, California; Joseph Ishikawa, Director, Kresge Art Museum, Michigan State University, East Lansing; Lisa Karplus, Registration Assistant, and Barbara Lee Williams, Assistant Curator, M. H. de Young Memorial Museum, San Francisco; Robert Knodt, Museum Folkwang, Essen, Germany; Giovanni Lista, Paris; Suzanne E. Pastor, Rudolf Kicken Galerie, Cologne, Germany; John Rewald, Professor Emeritus, The Graduate School and University Center, City University of New York; John Rohrbach, Director, Paul Strand Archive and Library, Millerton, New York; Robert Shapazian, Fresno, California; Becky Simmons, Librarian, International Museum of Photography at George Eastman House, Rochester, New York; Mary Stevenson, The Detroit Institute of Arts; Kristine Stiles, Washington, D.C.; Roberta K. Tarbell, Assistant Professor of Art History, Rutgers University, Camden, New Jersey; David Travis, Curator of Photography, The Art Institute of Chicago; Anne Tucker, Curator of Photography, The Museum of Fine Arts, Houston; David Warrington, Head of Reference and Readers' Services, The University Libraries, Indiana University, Bloomington; Maynard P. White, Queenstown, Maryland; and Jürgen Wilde, Galerie Wilde, Zülpich-Mülheim, West Germany.

We also take this opportunity to thank Paul Anbinder, Editor and Publisher, Hudson Hills Press, for his keen interest in our project and extend our appreciation to Irene Gordon, Manuscript Editor, whose in-depth knowledge of publishing procedures, the history of art, and rules of the English language were invaluable.

Finally, we express our profound gratitude to the National Endowment for the Arts and the Andrew W. Mellon Foundation for their generous contributions to our effort.

Van Deren Coke
Director, Department of Photography

Diana C. du Pont
Assistant Curator for *Photography: A Facet of Modernism*

Preface

Selected from across the century and from image makers from Los Angeles to Moscow, the sixty-six pictures included here could be likened to a film of quick cuts that focuses on sixty-six facets of modern photography. When seen in each other's company, they define the qualities that are common to this century's creative production in the medium. Many of the works also exemplify the special aims that underlie the collecting of photographs for the San Francisco Museum of Modern Art: that is, they are linked to the mainstreams of modern art.

This presentation consists of three main sections: an introduction; sixty-six full-page reproductions, each accompanied by an essay that discusses the work; and artists' biographies, which include a portrait of each photographer represented. The introductory essay explores some of the important connections between photography and the major art movements of this century. The individual essays serve as invisible "docents" anticipating queries, indicating aspects of the pictures one might not notice initially, or supplying information gathered from research.

Three criteria determined the selection of photographs shown here. First, they entered the collection of the San Francisco Museum of Modern Art after 1979. Second, while many are by major masters, the pictures selected are not usually well known and in some cases are reproduced here for the first time. Third, as already mentioned, they have close connections with the development of modern art. One picture by each photographer does not convey a true sense of the range and quality of the work of these artists, nor of the material recently acquired for the collection. Viewed as a group, however, they indicate the major directions taken by creative photography in the twentieth century. The power of these pictures can be sensed without recourse to the intimate history that lies behind them. Nevertheless, the knowledge provided in the essay that accompanies each work offers a fuller understanding of the ideas conveyed by the photographer and how they pertain to the concerns of the time.

For the sake of convenience, the pictures have been arranged according to four primary aesthetic concerns: formalism, which grew out of Cubism and Constructivism; dream imagery, which owes much to Surrealism; Expressionism, which speaks of emotions over everything else; and the pluralistic directions taken by many artists in the last twenty years, such as Body Art, sequential art, Conceptual Art, and art and language. The divisions

are not airtight, for many of these pictures have attributes that would allow them to be included in a number of "categories." The sensibilities incorporated in a single photograph can often be multifaceted, even contradictory. The coexistence of different tendencies in a single work asserts that modern photography, like modern art, is not a closed system. Yet, it has seemed best to categorize the pictures so as to ease the path between perception of what was in front of the camera and recognition of what the photographer meant to convey by using a nominal subject.

The photographs presented here insist that one think about their implications, for they are telling signifiers of our internal as well as external lives. The works of the 1920s demonstrate great respect for the dignity of geometry, symbol of the prevailing optimistic view of the role of technology in modern society. The pictures from the 1930s in Europe and somewhat later in America express the anxieties of the century in the haunting images one experiences in the world of dreams. The expressive, poetic realm of feeling has, on the other hand, been a subject for many of the photographs concerned with offering psychological insights about our times. These pictures affect our emotions with an intensity that sobers our thoughts. The more recent photographs demonstrate that formalism, Surrealism, and Expressionism have given way to a vigorous pluralism. By the late sixties, the major art movements had begun to split in many directions, due to the loss of faith in the viability of the then dominant Minimal Art. The art dealer's role in shaping aesthetic directions was brought into question, which impelled artists to produce work—site art, Performance Art, Conceptual Art—that was difficult to treat as a commodity. This reconsideration of a "fundamental truth" in the dissemination of modern art also led photography into new avenues of exploration.

The selection of photographs here does not pretend to offer a history of creative photography for the period covered, nor even a sketch. Instead, it presents the multiplicity of concerns and techniques that have shaped the course of photography as a vital art form during our own century.

Van Deren Coke
Director, Department of Photography

Introduction

With the advantage of historical perspective, it is now apparent that modern photography began in the years 1915–20 with the work of four American artists: Paul Strand (plate 1), Strand's close friends Charles Sheeler (figure 1) and Morton Schamberg (figure 2), and Man Ray (figures 9 and 10, and plate 20). Certainly Alfred Stieglitz—and to a limited extent Paul B. Haviland in New York (figure 4) and Christian Schad in Germany (figure 5)—contributed to the new ideas that separated pictorial photography from modern photography. Yet it should be recalled that Stieglitz, after a very strong early start with such works as *The Steerage* (1907), *Old and New New York* (figure 3), and *Outward Bound, The Mauretania* (1910), began to direct his attention to his Photo-Secession Gallery ("291") and devote himself to exhibiting and propagandizing avant-garde painting rather than his own photography. Similarly, Schad, who created unique cameraless photograms in Germany in 1918 with pieces of printed paper collaged to form graphic designs, soon turned to printmaking—for which his photograms were meant as studies—and painting, the medium to which he then devoted his major energies. When focusing on ideas in modern photography,

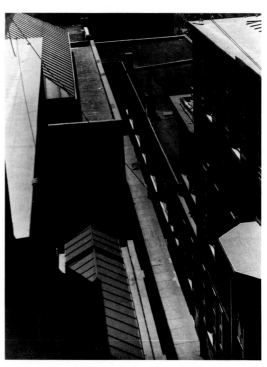

Figure 2 Morton Schamberg. Untitled, 1917. Gelatin silver print.

Alvin Langdon Coburn must not be over-looked either, but after his now well-known *Octopus* picture, made with symbolic intentions from high above New York's Central Park in 1912, he did no further truly modern work until 1917, when he created Vortographs (figure 6), so named because their abstract geometric patterning was related to the faceted work of the English Vorticist painters, who had been inspired by Cubism. After 1918 Coburn essentially dropped out of serious photography.

It was, then, primarily Strand in America and Man Ray, first in America and later in France in the early 1920s, who in sustained campaigns linked the medium of photography to the concepts of modern art. This book appropriately begins with Strand, for among the photographers referred to above, he was the earliest to incorporate modern concepts of form into his work. He followed this approach until 1924, by which time his ideas had been assimilated into the mainstream of modern photography.

In 1915 Europe was at war. America had not yet entered the conflict, and among those who sought these shores as a haven were a number of avant-garde artists from Paris who settled temporarily in New York City. For photography, the most important of

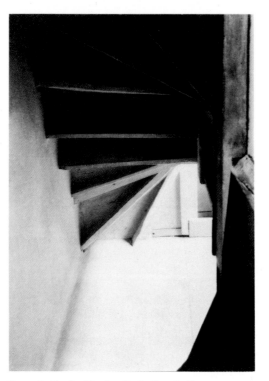

Figure 1 Charles Sheeler. *Bucks County House, Interior Detail,* 1917. Gelatin silver print.

Figure 3 Alfred Stieglitz. *Old and New New York,*
1910. Photogravure.

Figure 4 Paul B. Haviland. *Passing Steamer,* ca. 1912.
Photogravure.

Figure 5 Christian Schad. Untitled, 1918.
Printing-out paper (Schadograph).

Figure 6 Alvin Langdon Coburn. *Vortograph #8,*
1917/1950s. Gelatin silver print (Vortograph).

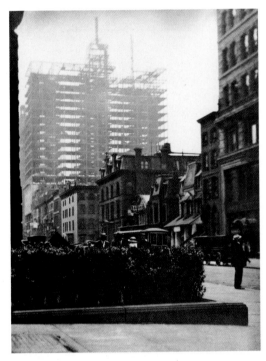

Figure 3

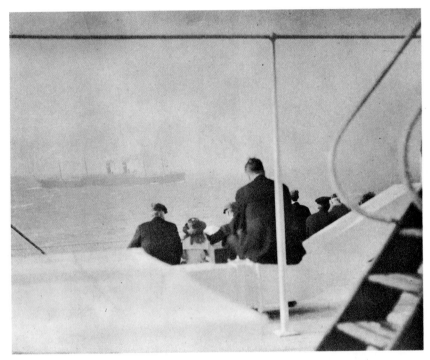

Figure 4

Figure 5

Figure 6

these were Marcel Duchamp and Francis Picabia. Both were well known to Alfred Stieglitz, and his gallery at 291 Fifth Avenue became the meeting place where they exchanged ideas with American artists and critics. The most significant photographer who became alert to their ideas was Strand, Stieglitz's major protégé at the time. Up through 1916 Strand had frequently made rather soft-focus pictures that recall Stieglitz's early images of the city. However, he also took shots from above which stressed the geometry of the streets or backyards below, as well as close-ups of people, among them a

Figure 7 Paul Strand. *Man, Five Points Square, New York,* 1916. Platinum print.

man in a derby hat and an elderly man despondently staring off into space (figure 7). While the urban views were composed to create an ordered picture space, and the photographs of people were charged with emotion, they were still rather soft in outline and offered no significant formal breakthrough.

During 1916, however, some of Strand's photographs suddenly became sharper and more concentratedly geometric. By photographing forms close up he abstracted from a whole motif significant details that were always recognizable in their abbreviated state, but which were clearly not intended as documents of his subjects. Strand's process of

abstracting to arrive at precisely rendered geometric forms led to a new and separate kind of image which, helped by the distance of intervening decades, we now see as decidedly modern compared to anything done up to that date in Europe or America. Strand's newfound style brought to fruition the idea of pure, or straight, photography that Stieglitz had predicted in his important work of the first decade.

Picabia, and to a lesser extent Duchamp, played pivotal roles in the emergence of Strand's new style. The paintings, drawings, and sculptures of machine parts by Picabia (figure 8) and Duchamp, as well as the similar work of Schamberg, were truly the catalysts for the ideas behind Strand's revolutionary photographs of 1916. Not to be overlooked when searching for Strand's models, however, were the paintings of the American Cubist Max Weber. Weber, who had studied in Paris from 1905 to 1909 and had attended Matisse's painting classes, was an intimate member of the Stieglitz circle and well known to Strand. Both in his teaching and through his articles published in *Camera Work* and elsewhere, Weber expounded his views on Cubism as a style in tune with the modern age. His exhortations were certainly in Strand's mind, consciously or unconsciously, when he began using his new emphatic, crisp geometric style of representation.

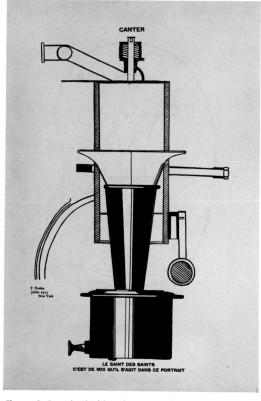

Figure 8 Francis Picabia. *The Saint of Saints,* 1915.

Picabia and Duchamp exerted added influence on American art as the initiators of New York Dada, a movement quite independent of Zurich or Berlin Dada. Whereas in Switzerland and Germany the Dadaists were carrying on a guerilla war against all established systems, Picabia and Duchamp were nihilistic in artistic, not political terms. Their new friend Man Ray seemed to grasp more quickly than any other artist what these two exiles were doing. Through his wife Adon (Donna) Lacroix he had, by 1915, become involved with radical concepts of poetry and was a natural convert to the cause of humor for the serious purpose of challenging accepted views about art and life, a major aim of New York Dada. His paintings and drawings of the 1917–19 period reflect his venturesome mind and wry wit. Beginning in 1917, he explored new mechanical methods of image making, a combination of spray painting and stencils emerging as the most successful of his attempts. Because of their "photographic" look, pictures made in this way took on a prophetic quality. By 1920, under the influence of Duchamp and New York Dada, Man Ray, who had first used photography as a recording tool as early as 1915, perfected his camera techniques for artistic purposes. This resulted in such striking photographs as *L'Inquiétude* (figure 9), an enigmatic image of smoke, and *La Femme* (figure 10), a close-up view of an eggbeater. Soon after these Dada photographs were made Man Ray realized that America was not the place for an artist of his radical inclinations; in the summer of 1921 he went to Paris, where Duchamp introduced him to the Dadaists.

In Paris, Man Ray found it difficult to sell his canvases and turned to his camera as a means of livelihood, specializing in portraits of artists and fashion photography. He also began to see more clearly how photographs could be made to yield results that pleased him aesthetically at the same time that they provided a sense of adventure. During his second year in Paris he discovered by accident—a circumstance especially dear to the hearts of Dadaists—a process that made it possible to make enigmatic photographs without the use of a camera. He found he was able to create images in his safelighted darkroom by placing ordinary objects on photosensitive paper; after momentarily turning on a white light, the parts of the paper exposed to the rays turned black when placed in the developer, while the parts covered by the objects yielded vestiges of the forms that had lain on the paper.

These cameraless images, or Rayographs as he called them a few years later, were

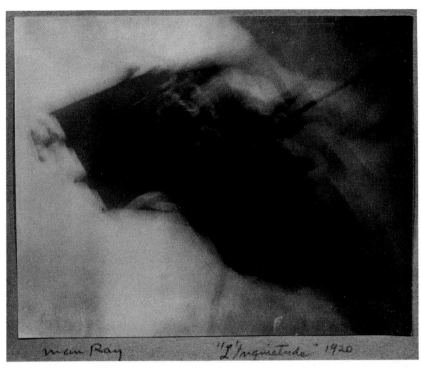

Figure 9 Man Ray. *L'Inquiétude* (Disquiet), 1920. Gelatin silver print.

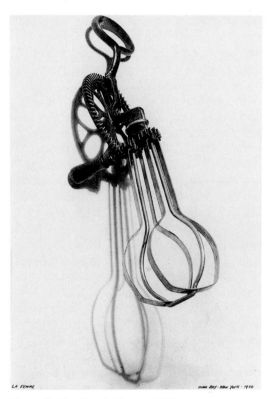

Figure 10 Man Ray. *La Femme*, 1920. Gelatin silver print.

unpredictable photographs that caught the spirit of mystery courted by Picabia and Duchamp. They were thought-provoking images for they conveyed a sense of ambiguous space and the enigma of time. Real objects were the source of the forms created, but what came to life in the developing tray was only vaguely related to everyday reality. Rather, what resulted appeared to have been conjured up by a sorcerer. Dadaists saw this

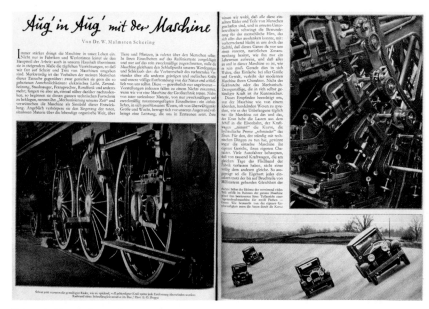

Figure 11 Pages from *Die Koralle,* September 1929. Left: photograph by E. O. Hoppé; right: photographer(s) unknown.

[1] Kertész's series on fortune-tellers (plate 23), for example, was commissioned by the French periodical *Vu* in 1930; but, as was not uncommmon with Kertész, some photographs in the series had already appeared a year earlier in Germany in the *Berliner Illustrirte Zeitung*; see David Travis, "André Kertész and Photojournalism," in *André Kertész: Of Paris and New York*, published on the occasion of a major retrospective exhibition (Chicago: Art Institute of Chicago/New York: Metropolitan Museum of Art, 1985), p. 48. In 1930 the *Münchner Illustrierte Presse* published Kertész's photographs of student life in Paris, which *Vu* then published two years later; see Sandra Phillips, "André Kertész: The Years in Paris," in ibid., p. 44.

kind of dislocation as an affirmation that the ordinary can have incantatory powers.

Interested in new ways of perceiving the world, the Dadaists, and later the Surrealists, were enthusiastic about Rayographs, for their transformation of the familiar provided access to phenomena hitherto unknown. They were equally enthusiastic about X-ray photographs—commonplace today, but rare in the 1920s—because of their ability to extend beyond the visible. However, while Man Ray's Rayographs became known through their appearance in avant-garde publications and an album entitled *Les Champs délicieux* published in 1922, original prints were not sold in any quantity. It was his fashion work and portrait photography that provided Man Ray with a modest, dependable income.

World War I changed modes of life in many ways. In the war's aftermath crowns toppled, new countries emerged, old empires shrank. Vienna and Budapest, the twin capitals of the old Austro-Hungarian Empire, became the centers of quite small countries after 1919. For photographers and artists from such countries this meant fewer opportunities in the lands in which they were born and raised. Many, among them László Moholy-Nagy (plate 21), Gyorgy Kepes (plate 16), and Martin Munkacsi (plate 14)—all Hungarians— went to Berlin; others emigrated to Paris.

André Kertész (plate 23)—who had already produced a respectable body of work in Budapest—was one of those who chose Paris. The Paris he came to in 1925 was alive with new ideas in the arts. Kertész was one of the earliest photographers to take his hand-held camera out into the streets, boulevards, and bohemian districts of fortune tellers and artists, as well as the parks and bistros along

the Seine. A petit bourgeois himself, he approached the art of photography in a con-servative way as far as subject matter was concerned, but being aware of the modern movements that were reshaping the look of painting, he photographed these subjects from new viewpoints. The compositions of his photographs, which revealed that frag-ments could be as faithful as whole scenes in conveying the tempo and passions of the city, made a distinct break with the past. Never judgmental, always humanistic and fresh in outlook, his pictures appeared in dozens of magazines and newspapers in France, England, and Germany.[1]

Kertész, as was soon true of other photog-raphers working as he did, made his living in these years not from the sale of prints to collectors or museums, but from fees paid by newspapers and magazines for the right to reproduce his work. By the end of the 1920s, publications with photographic illustrations flourished in France and, especially, Germany. They were made possible by the advances in photoreproduction techniques that developed after World War I, when new high-speed printing presses were perfected. The photo-graphs taken for these weekly or monthly journals and progressive dailies were as different from routine newspaper photos as creative advertising photographs were from standard pictures made to illustrate sales catalogues. Shot from new viewpoints or by means of high-speed shutters and new wide-angle and telephoto lenses, these photo-graphs pictured personalities in the news, reported cultural and sports events, docu-mented innovations in architecture and man-ufacturing, and comprised essays on travel, both domestic and foreign.

In Germany, the birthplace of photo-journalism and the greatest market for innovative photographs, all the major cities supported such illustrated publications. Some of these, such as the *Berliner Illustrirte Zeitung*, had been established before the war, but during the postwar years evolved into special vehicles for the publication of all manner of striking photographs. Others, such as the *Münchner Illustrierte Presse*, *Die Dame*, *Die Koralle* (figures 11 and 12), *Uhu*, and even the literary journal *Der Querschnitt*, first appeared in the 1920s and both stimulated and satisfied the demands of a sophisticated middle class eager for readily digestible information complemented by exciting photographs.

From the liberal direction of the Weimar Republic—nurtured by the success of the Russian Revolution and the repercussions of that upheaval in Germany—there emerged a

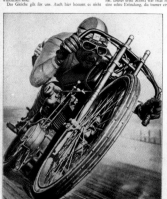

view that the arts could play a leading part in creating a new society. Advertising and documentary photography benefited from the new social climate, for it was considered to be a truthful source of information, in contrast to the aggrandizing drawn or painted magazine illustrations used in the pre-1920s period. Photographers who took assignments from editors and advertising agencies became very knowledgeable and worldly in the post-World War I era. To align themselves with the avant-garde and acquaint editors and art directors with what they could do, the best of the modernists saw to it that their pictures were reproduced in high-quality trade magazines, such as *Art and Industry*, a British monthly. Even more outstanding was the German journal *Gebrauchsgraphik* (Commercial Art). Photography was taken seriously by the editors of such magazines; the finest paper and the latest reproduction processes were used, and photographs with artistic value were regarded as effective sales tools or as journalistically informative.

Unlike the case today, the photographers of the 1920s, and well into the thirties, had a great deal of freedom in determining the most effective way of presenting a personality or a product. Individual creativity was not circumscribed by a proliferation of editors, art directors, and assorted experts dictating the form and content of the photographs made for magazines. During these years some of the most innovative photographers were active in the fields of journalism and advertising. One of the most outstanding and highly paid of the photojournalists working in Germany was Martin Munkacsi (figure 12 and plate 14). Hans Finsler's composition of a tube of toothpaste and a toothbrush (plate 15) was a commissioned advertisement, as was Edmund Kesting's photograph of his wife at the steering wheel of a Horch automobile (plate 11). Although rarely shown in art galleries, such photographs were not considered to be of second rank in the world of art. In fact, the opposite was true. When Jan Tschichold, innovative German graphic designer, typographer, and teacher at a master printing school in Munich, discussed the relation of photography and typography in his book on modern typography,[2] he lauded, among others, the work of Ralph Steiner (plate 2) and Paul Outerbridge (plate 3), two photographers highly regarded by the American fine arts community whose work is clearly linked to aspects of modern art. In Germany, many of the photographers who reached the highest levels in the commercial arena were attuned to modern art, for they had been trained at the Bauhaus in Weimar, the Folkwang School in Essen, or the Arts and Crafts School at Halle, where emphasis in each case was placed on graphic design that incorporated photographs.

While photographs influenced by Surrealism were in some demand for publication in fashion magazines during the thirties, formal, geometric photographs were more popular with editors, for such pictures were considered to be evidence of the new advances in technology as manifested in giant ocean liners, fast automobiles, and airplanes. The "look" of these photographs owed much to the early Futurist, Cubist, and Constructivist investigations of space and time. While these movements were known firsthand by Jaromír Funke (plate 7) and Alexander Rodchenko (plate 12), for example, there were photographers who absorbed their visual characteristics through their plebeian offspring—the more familiar imagery of the style now classified as Art Deco. Introduced to the world in Paris in 1925 at *L'Exposition Internationale des Arts Décoratifs et Industriels Modernes*, this style was exactly what the term implied, a mode of decoration that could be applied to myriad manufactured products. As a manifestation of change, it symbolized the victory of simple, repeated geometric shapes in post—World War I design and manufacturing over the complex, undulating lines of Art Nouveau, which had dominated the late nineteenth and early twentieth centuries. Rectilinear rather than curvilinear, Art Deco was a style that could be readily incorporated into objects made of wood, plastic, concrete, or glass. While elaborate Art Nouveau decoration was, indeed, made with machines, the results in most cases were intended to seem handmade, so as to indicate costliness. Art Deco, on the

Figure 12 Pages from *Die Koralle,* September 1929. Left: photographer unknown; right: photographs by Martin Munkacsi.

[2] Jan Tschichold, *Die neue Typographie: Ein Handbuch für zeitgemäss Schaffende* (Berlin: Bildungsverband der deutschen Buchdrucker, 1928).

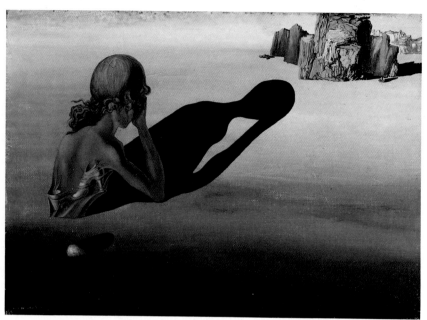

Figure 13 Salvador Dali. *Remorse (Sphinx Embedded in the Sand),* 1931. Oil on canvas.

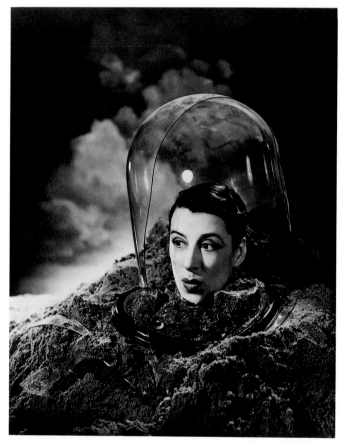

Figure 14 Angus McBean. *Bea Lillie,* ca. 1937. Gelatin silver print.

other hand, was intended to suit the requirements and look of mass production. It was fundamentally a geometric design system that could be executed with a T-square, triangle, and compass—tools of modern designers who acknowledged the machine. The photographers who adopted the geometric style of Art Deco did so in a variety of ways. František Drtikol, for instance, applied the language of Art Deco to his series of female nudes of the 1920's (plate 9). He posed his models in constructed settings of abstract shapes that alternated between graceful, serpentine form and rigid, geometric patterning. Many striking advertising photographs were made in the spirit of Art Deco, for it was well understood that this fashionable, up-to-date style appealed to a sophisticated, monied clientele that wished to be associated with the avant-garde. Outerbridge, while fully aware of Cubism through his association with Max Weber, realized the effectiveness of Art Deco in reaching a middle- and upper-middle-class market. In such pictures as his image of a crankshaft superimposed on the silhouette of a grand touring car (plate 3), he directed his commercial photography to fashion- and speed-conscious men and women of means.

About the time Constructivism evolved into Art Deco in the late 1920s, photographers discovered Surrealism. As a result, some gradually turned away from the repetitive geometric shapes and linear elements and began to stage illusions. In 1924 the poet André Breton had published his Manifesto of Surrealism, in which he set forth the tenets of a philosophy that soon gave rise to one of the three major avant-garde movements that flourished between the wars. In many ways Surrealism was an extension of the European Dadaists' antiwar and anti-establishment stances that abated when the war ended in 1918. With peace, they had found, the incoherence and hate they had fostered no longer attracted attention. The protest and bitter nonsense of their work gave way to the evocation of dreams and mysteries. After 1922 most Dada-nihilists gradually evolved into Surrealists.

By the 1930s the dream theories of Sigmund Freud and Carl Jung were fashionable topics of conversation in Europe. Dreams were said to hold up a mirror to our repressed emotions and fantasies, and the interpretation of dreams became increasingly popular. As interest rose, photographers contrived more and more images that evoked the generally accepted look of the world of dreams. Throughout the thirties, reflections of the

dream state in both advertising and fashion photography became a standard means by which popular magazines demonstrated their association with what was modern. Salvador Dali's paintings, with their simulated paranoia, were some of the earliest Surrealist works to be emulated by photographers. The capricious eroticism and dazzling technical skill of Dali's meticulous dreamscapes (figure 13) intrigued the up-to-date crowd and truly lighted up the bizarre firmament of Surrealism. Perhaps his work became so immediately popular because it was closely attuned to communal obsessive fears and dreams; as a consequence, the work of Dali—his name itself—became synonymous with Surrealism. Instead of presenting pages from an intimate journal, a type of literary outpouring that characterized much of Surrealism, Dali produced pictures that evoked a disquieting sense of the forgotten and the familiar by his ambiguous spatial relationships and startling connections among disparate objects.

In leading European artistic and literary circles Surrealism was taken up as a fresh and important means of expression. In 1933 Albert Skira and E. Tériade founded *Minotaure*, which quickly became an influential Surrealist periodical. This deluxe review, which frequently reproduced photographs, was responsible for acquainting the sophisticated European public with the aims of Surrealism. Surrealist objects, Surrealist photographs (figures 15 and 16), Surrealist painting, poetry, and theater provided the shock that some people found necessary during some of the desperate years between the wars.

Surrealism appealed especially to those editors and such photographers as Philippe Halsman (plate 35) who associated with the world of fashion and the avant-garde. The stagelike illusion of space, particularly in Dali's painting, can be superficially re-created in a photographic studio: his forms are palpable, his people, however distorted, can be replicated by special mirrors, and his strange light can be achieved by the use of klieg spot lamps. Angus McBean's portrait of Bea Lillie (figure 14), one of a series of photographs McBean took of theater and film actresses for the British magazine *The Sketch* beginning in 1937, is a good example of Dali's influence on commercial and illustrative photography. Staged entirely in the studio, the image brings together the comedienne and an array of props to create a strange sense of the bizarre. Her head under a vitrine, Bea Lillie is situated in a desolate landscape buried to her neck in sand.

André Kertész's series of fortune-tellers (plate 23) also exemplifies the influence of

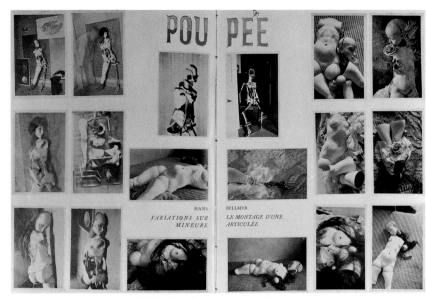

Figure 15 Pages from *Minotaure,* No. 6, 1935. Photographs by Hans Bellmer.

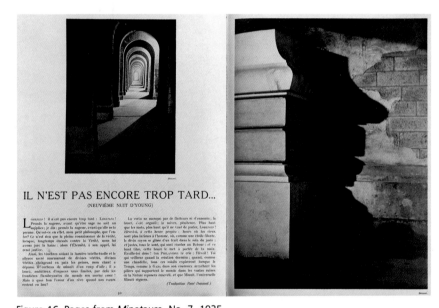

Figure 16 Pages from *Minotaure,* No. 7, 1935. Photographs by Brassaï.

Surrealism on photographers. Probing the unknown, whether the past or future, has been the role of soothsayers for thousands of years. History does not tell when the gazing globe was first used for this purpose, but it has long served fortune-tellers as a means of predicting future events and interpreting dreams. Due to the use of a wide-angle lens, Kertész's Dali-like photograph of this age-old practice possesses a surreal magic. Our curiosity is stimulated by the exaggeration of forms created in this way, such as the enlarged hands of the fortune-teller in contrast to the small, receding forms in the reflecting globe.

Neither wide-angle lenses nor subjects inherently rich in mystery were necessary in order to create surreal images. The German photographer Herbert List, working in Greece during the 1930s, demonstrates this in his photograph *Santorin* (plate 27). He achieved his surreal purposes most effectively by the quizzical juxtaposition of a fish in a clear bowl resting on a windowsill high above the Mediterranean Sea. The accentuated relationship between the imprisoned fish, a living "gold" curiosity, and the open sea causes us to shudder and imprints on our mind a haunting and far-reaching metaphor on mental and physical captivity. Erwin Blumenfeld, on the other hand (plate 30), achieved surreal effects by using a darkroom technique whereby parts of a negative are made positive by momentarily exposing them to white light during development. A negative created in this way and printed normally exerts a hypnotic fascination, for it brings together a part negative-part positive image, setting up psychological tensions and emotional currents consonant with the dream experience.

Subjects that have little in common in their original state can, when rearranged in cut and pasted collages, have an entirely new and united purpose. This transformative process is at the center of Georges Hugnet's Surreal photocollages.[3] One of Hugnet's most enigmatic and erotic collages, *Initiation préliminaire aux arcanes de la forêt* (plate 29), illustrates the range of expressive means used by Surrealists to direct the mind into new channels. Humor and masochism are blended with parody and ambiguity, all major devices of Surrealism.

World War II provided so many actual disjunctive experiences that the dreams and fantasies conjured up by artists and poets became inconsequential. The most significant example of the influence of Surrealism on an American photographer, however, came about because of this world conflict. Max Ernst, like many avant-garde artists, sought refuge in America during the war. Among the strange red rocks of Sedona in central Arizona he found the kind of natural environment that evoked anthropomorphic forms in his mind. In Arizona he met Frederick Sommer, a sophisticated photographer knowledgeable about Surrealism and already deeply involved with mysticism. It was Ernst who substantiated and broadened Sommer's appreciation of the role of the subconscious in the creation of art. For *Chicken Entrails* (plate 32) Sommer made a needle-sharp contact print from an eight-by-ten-inch negative, thereby achieving an extremely disquieting image resulting from the impact of an unsavory subject rendered with pristine clarity. If addressed by a mind open to stimulating experiences, photographs such as Sommer's can connect us with a mysterious and shadowy world that we tend to keep under wraps. Such photographs provide an exhilarating experience, for they free our imagination in a society in which all kinds of agencies circumscribe exploration into the unknown.

While the photography of Kertész and Sommer is now widely known, work by other photographers equally successful in evoking the dream state has had little exposure until recently. Val Telberg's challenging imagery (plate 40) is a case in point. His multifaceted photographs were shown internationally in the 1950s, then virtually forgotten by art and photography critics. We can now appreciate his multinegative prints—like overlapping video freeze-frames of the inner workings of a person's mind—as powerful reflections of the state of the world's psyche.

By the 1960s Surrealism had lost most of its appeal for American painters, but it continued—even to this day—to fascinate a small number of photographers. Two of the more interesting of these are Jerry N. Uelsmann and Joel-Peter Witkin. Uelsmann uses a number of enlargers to project different images in turn onto a single sheet of paper. His work is somewhat like free verse, in which concrete imagery is combined while retaining the individual identity of the assembled parts. The detailed results are not so much disturbing and supernatural as disorienting. An early experimental work created by multiple exposure, *Fleeing Man* (plate 38) foreshadows the complicated multiple-negative imagery of Uelsmann's mature style. In Witkin's photographs the blending of fact and fiction is vivid and provocative. He opens our eyes to the joys of the flesh—more for the purpose of broadening our imagination and involving us in forbidden worlds than for the sake of erotic titillation. Witkin's dreamlike tableaux (plate 41) are a marvel of pretense and contrivance, but they provide an emotional

[3] By means of complicated assemblages of images or the layering of multiple negatives modern artists found that they were able to create new and startling relationships. The term "photomontage" was first used by the German Dadaists in the early 1920s to describe their invention of an art form in which multiple photographic images were combined with type and other graphic elements. By the late 1920s, when commercial as well as creative photographers were actively involved with the process, the term had received varying definitions, and to this day there is little agreement among both artists and historians on the definition of the word. Franz Roh (plate 10), among others, has defined photomontage as the "cutting, pasting and mounting" of photographs; see "Mechanism and Expression: The Essence and Value of Photography," in *Photo-Eye. 76 Photos of the Period*, ed. Franz Roh and Jan Tschichold (New York: Arno Press, 1973), p. 17; reprint of *Foto-auge. 76 Fotos der Zeit*, ed. Franz Roh and Jan Tschichold (Stuttgart: Fritz Wedekind, 1929). Pierre Boucher (plate 31) has defined it more broadly to include not only collage and the photographing of collaged

entry into the mysteries of lust and death. His images are metaphors for midnight sexual longings and terrors that he makes compelling by an uncommon talent for creating believable pictorial fantasies. His work is both surreal and expressionistic.

In addition to those who made photographs of geometric structure and pattern to communicate a positive vision of the modern world, or created dreams and fantasies to make the pleasures and terrors of man's inner world more tangible, there are those who have pointed their finger at society's ills in general and unfortunate individuals in particular. These photographers take seriously their role of making us aware of all kinds of strife, from the interior fire of the young to the stifled hopes of the elderly.

The category of expressionism in art is very broad. Georges Rouault's paintings of prostitutes and religious figures deal with widely divergent subjects, yet both are treated in a highly charged manner. In Germany, pre—World War I artists such as Ernst Ludwig Kirchner and Karl Schmidt-Rottluff depicted the new sense of freedom that was emerging in bohemian circles. In France between the wars, Chaim Soutine, in many ways an inheritor of Vincent van Gogh's mantle, used bright color and turbulent layers of paint, as the great Dutch master had, to signal his emotions. By means of flowing contours and tormented faces, the Norwegian Edvard Munch, perhaps the greatest expressionist of the late nineteenth and early twentieth century, conveyed society's underlying fears and anxieties. During the last five years a marked renewal of expressionistic figurative painting has developed, some of it related in form and color to the work done in Germany before and after World War I.

Throughout the century, modern photographers, like modern painters, have been involved with imagery that evokes strong emotions or records heightened feelings. Evolving physical, emotional, or psychological reactions to people or events have always been a powerful direction in photography. The most expressionistic image in this book is that of Arnulf Rainer's ink-slashed face, *Bündel im Gesicht* (plate 52). The tragedies between the two World Wars, and the mutilating injuries in World War II to soldiers and civilians alike, which have continued in more recent conflicts, are a sobering demonstration of man's relentless inhumanity to man. Rainer's self-portraits are a crystallization of the fears and bestiality that exist today in torture chambers and racial wars. Reflecting a searing angst, Rainer brutally marks his own features

as an act of atonement for the world's pain and suffering. Also expressive of a deep feeling of angst is the work of Bernhard Johannes Blume, whose photographic sequences present a world of chaos and hysteria. While deeply personal in nature, the sequences also operate on broad social and philosophical levels. The blurred vision, the spinning pitcher falling in space, and the crazed grimacing of Blume himself (plate 64) create a disturbing sense of confusion that alludes to the instability of society. Throughout the text component of the sequence, Blume reflects on the nature of human existence, on the idea that an individual is both body and mind, form and spirit.

When we turn back to the period between the great wars, we see a different and subtler kind of expressionism. The German photographer Umbo, here represented by a very striking head of the actress Rut Landshoff (plate 43), conveys the brashness of Berlin's daring theatrical productions and cabaret entertainments of the 1920s and pre-Hitler 1930s. Stark white and deep black serve here as effectively as the acidic colors of the Neue Sachlichkeit painters to express the fragile, brittle façade of the newly rich Germans during the Weimar Republic years.

Expressionism is based in part on the feelings that are revealed in unguarded, as well as guarded, moments. Suffering, both physical and mental, when seen in photographs seems to fascinate us, perhaps because of the catharsis they provide, the feeling that there "but for the grace of God go I." Why else have photographs of murder, mayhem, and tragedy been so popular as subjects for publication and exhibition? That the misfortunes of the downtrodden and marginal members of society can best be communicated by photographs is demonstrated by Larry Clark's searing group of photographs known as the *Tulsa* series (plate 51). Like his subjects, Clark was estranged from society when he made these pictures of the drug scene in Tulsa, ultra-candid images that joltingly reveal the world of addiction.

Robert Frank also thought of himself as an outsider and used anger to fuel his work. Frank punctures our sense of security by conveying in his pictures a feeling of cynicism and bitterness about life. His photographs of the common man and commonplace events in America of the 1950s (plate 47) suggest that all was not well in this land of opportunity. Using quite different techniques but in a similar spirit, Judith Golden has created symbolic self-portraits that refer to frustrations she has suffered or to a lack of personal fulfillment (plate 53). Her background as a

works, but also the superimposition of two or more negatives in the printing process, a technique dating back to the "combination printing" of the nineteenth century; letter to Diana du Pont, January 1985. During the late 1920s and 1930s, the term "photomontage" might signify (1) works that were actual collages; (2) works that were seamless photographic prints created by photographing these collages; or (3) works resulting from multiple printing. More recently, photomontage, as used by Jerry N. Uelsmann (plate 38), for example, has been associated primarily with superimposition. Some photohistorians have restricted its application to the photograph of a photocollage; see, for example, Nancy Hall-Duncan, *Photographic Surrealism*, exhibition catalogue (Cleveland: New Gallery of Contemporary Art, 1979), p. 13, n. 14. Artists have on the whole used the term broadly, giving greater emphasis to the transformative powers of combining multiple photographic images than to the specific physical characteristic of the result.

In this book, credence has been given to how either the artist or, failing any such indication, historical sources have identified the work.

painter is reflected in her combination of photography, drawing, and painting by which she relives dreams that are related to the hopes and visions common to us all. A poignant sense of dispiritedness is especially moving in Roy DeCarava's picture of a black man emerging from a subway station (plate 46), an image made to change public consciousness. In this work, DeCarava epitomized the blacks' struggle in America against relegation to the bitter edges of society. Due to the emotional hold they have on our imagination, such pictures take us inside ourselves. Whether instilling a state of meditation, owing to their talismatic qualities, or stimulating emotions through social issues and dramatic situations, they convey a powerful sense of immediacy.

The work of Alfred Ehrhardt and Paul Caponigro, for example, reveals that deeply felt emotions can also be expressed by photographs of subjects other than people. Ehrhardt's beachscape of miles of sand flats, in which he has turned the horizon over forty-five degrees to create a psychological tension (plate 48), evokes a sense of loneliness and loss of equilibrium that is both actual and symbolic. Caponigro exploits our strong empathetic response to the death of any living thing in his image of the torn and jagged wound that appeared around the stump of a recently felled tree (plate 49). We read this photograph not only as a wrenching cry of nature, but also as a symbol of the photographer's tormented state of mind when he made this compelling picture early in his career.

When a medium has established a canon of technique and subject matter that is acceptable to a wide audience, there are two courses open to the next generation. Either it can feed upon the past and hope to perfect fixed traditions, at the cost of stagnation, or it can reflect newly emerging ideas and risk revolutionary solutions, thereby fulfilling the destiny of modern art. Whatever the force of pictures made in the latter spirit, it cannot be new subject matter alone that announces a fresh direction, nor merely new techniques. The key factor is a new attitude. It is this willingness to pursue new ways of thinking and new means of image-making that characterizes photography of the 1970s and 1980s. No longer considered the norm, the Purist aesthetic in the tradition of Alfred Stieglitz, Edward Weston (plate 4), and Ansel Adams was squarely challenged by a multitude of innovative directions inspired by vital interchanges between photography and the other arts. The multifaceted

dimensions of photography paralleled the general trend of pluralism in the arts. No longer bound by the notion of "truth to materials," photographers were free to explore new ways of making photographs, which resulted in rich and varied expressions.

During the 1970s and 1980s in Canada, Germany, Australia, and particularly America, the university teaching system fostered a vigorous dialogue between photography and the other arts. Creative photographers, such as Thomas F. Barrow (plate 62), were appointed to faculty positions in university art departments. Economically secure, they could, alongside their teaching, explore new avenues of artistic development in company with painters and printmakers. Contributing to the fertile environment were video, film, and performance-art classes, which began to be offered in many university art departments. As was the case with still photography, the products of these mediums were, in the university context, largely divorced from the compromises of commercial considerations.

These photographer-teachers taught photography as part of mainstream art, emphasizing shared ideas between the medium and the other arts. Students of photography also took courses in drawing, painting, printmaking, and art history, which introduced them to a depth of historical awareness that had been largely lacking in earlier instruction in photography. Faculty members teaching the traditional mediums were accustomed to talking and thinking in terms of art historical references and expected their students to be acquainted with the general history of Western art. Professors of photography thought in similar terms, which awakened an interest on the part of students in the history of photography as a source of ideas.

The freedom that faculty members enjoyed to explore new paths was absorbed by their students, and their venturesomeness became infectious. Ideas germinated in one class were extended in new directions and transplanted into varying mediums in other classes. In the work of Robbert Flick (plate 65), Greg MacGregor (plate 66), and Sandra Semchuk (plate 57)—all of whom did concentrated graduate work in photography—we see, for instance, where Conceptual Art, Performance Art, and film are related to work in still photography.

Both within and outside the university context, the art world of the 1970s began to treat photographs of conceptual pieces or earth works as objects on a par with other avant-garde art. Photographs by such artists as Bruce Nauman (figure 17), Dennis Oppenheim, Vito Acconci, or Richard Long

(figure 18) made in the service of a concept or to record an event or mammoth structure in a remote landscape often turned out to be interesting in and of themselves.

Photographers and artists who used photography for documentation recognized the potential in photography for conceptual statement and soon began making their own idea-oriented photographs. Robert Cumming was one of the first artists to pursue this direction. Originally a sculptor, Cumming initially used photography to document his three-dimensional work, but eventually found these documents more intriguing than his sculpture. This led to a concentration on still photography throughout the 1970s. As seen in the work *Spray-Snow Christmas* (plate 59), ironic humor with an intellectual edge is at the heart of Cumming's imagery. His dry wit is achieved, in part, by his clever use of titles, which, like those of Paul Klee, set in motion our responses to the ideas he is expressing in his work.

In the 1970s, encouraged by Robert Rauschenberg and Andy Warhol in America and by European painters who used photography, such as the Austrian Arnulf Rainer (plate 52), more and more photographers broke out of restrictions imposed by the orthodox aesthetic that adhered to a pure combination of optics and chemistry. Making

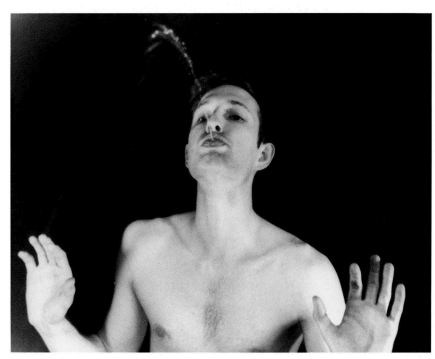

Figure 17 Bruce Nauman. *Self-Portrait as a Fountain*, 1966–67. Type-C print.

marks on a print's surface became a major trend among photographers. In part, marking grew out of an increased awareness of photography's power to hold its own, however small the image, against the sensual appeal of pigment and the beautifully drawn line. In an anxiety-ridden world, the pure uninterrupted surface of a photograph was seen by many as too impersonal a means for expressing their ideas and emotions. There was a need to emphasize certain elements of the picture while playing down others. For photographers working in this vein, a feeling of involvement with the art-making process beyond the instrument of the eye became of utmost importance. A leader among the "markers" is Rick Dingus (plate 61), whose silvery strokes exuberantly animate the surface of his black-and-white landscapes. His scribbled, graffitiesque marks are evidence of his active physical participation in the art process, as opposed to his submission to the passive role of the camera.

Another major direction in recent years has been the "fabricated-to-be-photographed" movement, a trend incipiently formulated as much as a decade ago but now appearing full-blown and in striking colors. An early practitioner of creating set-ups to be photographed, Les Krims is currently making large color prints which continue this practice (plate 58) while retaining his interest in humor and social comment. The psychological edge to his work stems from his unexpected combinations of quite ordinary things. These

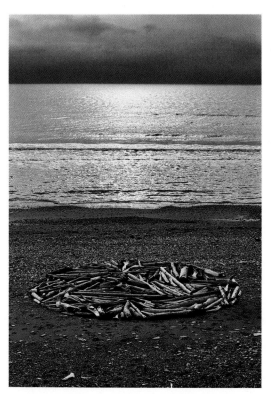

Figure 18 Richard Long. *A Circle in Alaska*. Bering Strait Driftwood on the Arctic Circle, 1977. Gelatin silver print.

bizarre juxtapositions have symbolic implications that are very up-to-date. While Krims's earlier fabricated scenarios provoked raucous laughter, his recent work—in which the humor is laced with tension—causes one to halt and ponder what his visually packed images might mean in our overly materialistic world. Krims's photographs are like theater, which entertains to capture the attention of the audience, then gradually opens it up to the realization that what it is seeing is a fantasy that carries a message. Krims strikes a chord deep in our psyche in his search for new meaning in today's absurdities.

Dissatisfied with the effects achieved by a single image, many photographers have turned in recent years to serial imagery. Taking cues from Conceptual Art and film, these image makers see the whole as greater than its individual parts. Each element reinforces the other to create an integrated progression that is not necessarily narrative. Robbert Flick and Michel Szulc Krzyzanowski are two artists who use this device for entirely different ends. Flick (plate 65) relies upon the repetitious patterning of uniform shapes to comment upon man-made systems and their effect upon society. Packed with detailed information about specific geographic regions, Flick's complex grid structures point up the most simple, unassuming factors of daily life that literally shape our environment and, hence, our thinking. More introspective, on the other hand, Krzyzanowski is like a ballet dancer, interested in exploring himself through theme and variation. While his sequences challenge our visual perception (plate 63), they more importantly dramatize the artist's veneration of nature. Using his own body, his performance in the landscape is like a spiritual meditation in which he is united with the earth.

Rather than dealing with his own psyche, as does Krzyzanowski, Greg MacGregor deals with our collective psyche under the threat of imminent annihilation. *Backyard Sales Demonstration* (plate 66), on the surface a humorous series offering seven step-by-step directions on how to blow oneself up, alludes essentially to the question of mankind's self-destruction by nuclear war. Critical of the extremes to which our faith in science and technology has led us, MacGregor spoofs the analytical presentation of scientific data and our reliance upon it. Like the best comedy, MacGregor's humor allows him to communicate about difficult issues, in this instance, perhaps, the most complex issue of our time.

This book is based on the premise that in 1916 modern photography was launched on an artistic course that was clearly related, both in form and content, to the series of tradition-shattering movements that punctuate the development of modernism. Indeed, some of this century's most important photographs were made by artists at the forefront of the avant-garde. Rodchenko, Man Ray, Moholy-Nagy (plates 12, 20, 21) during the 1920s and 1930s in Europe and Roszak (plate 17) later in America were leaders of Constructivism and Surrealism. To these trained painters and sculptors, photography was simply another means by which to express their ideas; their work with the camera was shaped by the same issues that guided their explorations in other mediums. The modernist ideas that Steiner and Outerbridge (plates 2 and 3) learned at the Clarence H. White School of Photography, or that Arndt and Ehrhardt (plates 13 and 48) absorbed at the Bauhaus, or Cartier-Bresson (platle 24) acquired at the studio of Cubist painter André Lhote clearly influenced their photography as well. While trained strictly as photographers, Strand, Weston, and Cunningham (plates 1, 4, 5), for instance, interacted with avant-garde painters, writers, and sculptors, thus placing themselves and their work at the center of modernism.

During the 1920s and 1930s avant-garde photography provided a culturally relevant ingredient in consolidating the language of modernism. By reproduction in specialized as well as general periodicals, innovative photographs served as a conduit for the dissemination of new concepts about space, time, the unconscious, and social injustice. As a consequence, first a few, then many, people absorbed, almost subliminally, the visual characteristics of the advanced movements in art.

At midcentury the idea of pure, or straight, photography that Stieglitz had predicted by 1910 and Strand had crystallized by 1916 continued in the work of such photographers as Paul Caponigro and Minor White (plates 49 and 50). Both adhered to modernist preoccupations with the language of photography—sharp focus, full tonal range, and abstract details—and both based their visual philosophy on the early aims of modern art. In the tradition of Stieglitz, each absorbed the idea of the "equivalent," a notion that the camera's recording of objective reality could express subjective feeling. This non-documentary symbolic approach evolved from Stieglitz's attempt to reconcile abstraction and photography, a critical problem influenced by the paintings and writings of Vasily Kan-

4 At the historic Armory Show held in New York in 1913 Stieglitz had purchased Kandinsky's semi-abstract painting of 1912 *Improvisation No. 27* (now Metropolitan Museum of Art, New York, The Alfred Stieglitz Collection). Of German descent, Stieglitz had also read in the original German Kandinsky's *Über das Geistige in der Kunst* published in 1912 (published in English as *The Art of Spiritual Harmony* [London: Constable, 1914]).

dinsky and addressed by Stieglitz in his cloud studies of the 1920s.[4]

In recent decades, somewhat more than a century after its invention, photography has become a powerful force within our culture. As a primary means of disseminating information about the world, photographs now pervade the social landscape. In the 1960s the leaders of the Pop Art movement, Robert Rauschenberg and Andy Warhol, clearly understood that photography was fast becoming the ubiquitous medium of the age. Unhindered by a sense of hierarchy in the arts, they freely drew upon advertising photographs, snapshots, and news photos to create telling images symbolic of a technological society obsessed with consumerism. The example of Rauschenberg and Warhol was of key importance for younger American and European artists. In the late sixties, seventies, and eighties more and more painters, sculptors, and designers turned to photography, creating a special combination of the eye and the lens to form a new kind of visual expression. Brimming with ideas, they were fascinated by the speed with which they could produce an image with the camera as opposed to the time-consuming hand. The ability to realize concepts quickly and embark upon new investigations was seductive and opened the door to new artistic uses of photography.

People trained as artists have approached photography very differently from those educated exclusively as photographers. The latter are in the main oriented to see the world through the instrument they use and to master the chemical/optical techniques of making negatives and prints. The schooled painters and sculptors bring to photography a sense of philosophic inquiry that is part and parcel of their education in the traditional arts. Inspired by their backgrounds in drawing, painting, sculpture, or design, these artists are not inhibited by straight photography's notion of purity of process. Rather, they possess a flexible, open-minded attitude that gives them the freedom to combine photographic images with the materials and techniques of different mediums. They exploit the fact that photographs in combination with other processes can evoke deep, psychological concerns that speak to some of the major issues of our time. The emergence of Performance Art and Conceptual Art has encouraged this type of interplay because of its insistence on blurring the distinctions between mediums. Similarly, the teaching of photography alongside drawing, painting, sculpture, printmaking, and performance in the university context in the United States, Germany, Canada, and Australia has favored such interaction.

The resulting cross-pollination of ideas and techniques has brought about both an expansion upon and divergence from the straight photograph that dominated photography into the post—World War II era. Witkin, Rainer, Golden, Dingus, and Barrow (plates 41, 52, 53, 61, 62) have each transformed the unadulterated, sharp-focus black-and-white print through adding pencil, paint, bleach, or toner to the print surface. Barrow and Witkin often deliberately scratch their negatives. Cumming, Krzyzanowski, Blume, and Flick (plates 59, 63—65), on the other hand, have chosen to expand the limitations of the straight-print tradition by introducing ideas derived from Conceptual Art, Performance Art, and Body Art. As the possibilities for straightforward photography seem to have become exhausted, it has been the photographers who know about the history of art, not simply the history of photography, who have shaped important directions for the future.

The examination of modern photography as artistic expression, from the emergence of straight photography to the multidimensional works of today, reveals its important connections to the vast reservoir of ideas at the heart of art and literature of the twentieth century. Over half the artists represented in this book were trained as painters, sculptors, or designers, and have brought to photography a broad sensibility based on the concept that art is a form of visual philosophy. The character of much of the photography collected by the San Francisco Museum of Modern Art over the last seven years has been shaped by this view. The curators who have formed this collection and many of the artists included in it consider photography as just another way of making a mark.

Van Deren Coke
Director
Department of Photography

Formalism

Paul Strand

American, 1890–1976

Chair Abstract, Twin Lakes, Connecticut

1916
palladium print
13 x 9 11/16"
(33.0 x 24.6 cm)
Purchase
84.15

[1] In an interview in the *New York Tribune*, October 1915; quoted in William A. Camfield, *Francis Picabia: His Art, Life and Times* (Princeton: Princeton University Press, 1979), p. 77.

Between 1915 and 1916 Paul Strand was of two minds. He was drawn to picturesque people on the streets of New York—a blind woman, a man carrying advertising boards— but also to the inherent geometry of the city. It was during a stay in Connecticut in the summer of 1916 that he carried his experiments with geometry toward abstraction. This radical change in Strand's photography

Figure 19 Paul Strand. *Abstraction, Porch Shadows, Twin Lakes, Connecticut,* 1916/1976. Gelatin silver print.

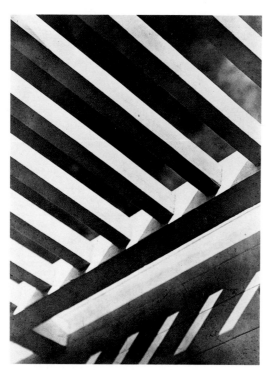

Figure 20 Paul Strand. *Shadows, Twin Lakes, Connecticut,* 1916. Platinum print.

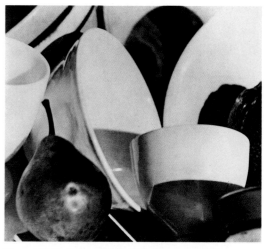

Figure 21 Paul Strand. *Still Life, Pear and Bowls, Twin Lakes, Connecticut,* 1916. Platinum print.

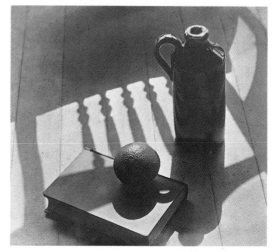

Figure 22 Paul Strand. *Bottle, Book and Orange, Twin Lakes, Connecticut,* 1916. Platinum-palladium print.

was influenced by the Cubist drawings of Pablo Picasso and the Dadaist machine images of Francis Picabia. Together Picabia and Marcel Duchamp awakened American artists to the clean, spare, formal beauty of the machine. Picabia, on his arrival in America in 1915, observed, "It flashed on me that the genius of the modern world is in machinery, and that through machinery art ought to find a most vivid expression."[1] Although the Americans did not embrace the attitude of irreverence or the anti-art ideas characteristic of these progenitors of New York Dada, they were deeply influenced by their choice of subject and treatment of form.

Strand's close friends Charles Sheeler and Morton Schamberg were also sources of inspiration for his transition to sharply focused close-ups of intrinsically geometric subjects. Both were photographer/painters whose smooth, crisp pictures of architectural and machine subjects during the teens were precursors of Precisionism, the movement in modernist American painting of the 1920s in

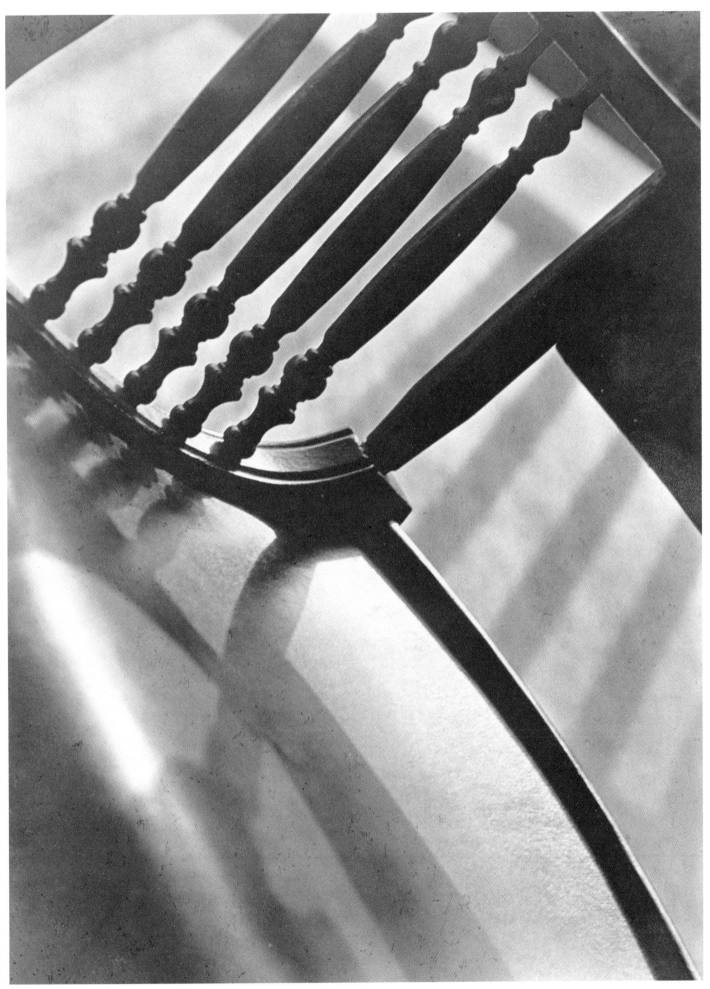

Plate 1

which the country's flourishing architectural and industrial landscape was rendered with precisely defined forms and meticulous surfaces. During the summer of 1916, Strand made a dramatic turn to domestic objects as vehicles for the exploration of abstraction. Bowls, chairs, cups and saucers, porch railings and their shadows were tightly framed and viewed up close, divorced from their familiar context to emphasize formal relationships. *Chair Abstract, Twin Lakes, Connecticut*, one of these innovative works of 1916, is a close-up view of the back and seat of a chair. In this prosaic object, Strand found geometric shapes that bear a generic relationship to Cubism and machine parts. By tilting his camera over forty-five degrees and bringing it close in to the subject, he emphasizes the structural quality of this motif, creating a semi-abstract picture that has little to do with the subject in front of his camera, but much to do with shallow space, angular forms, and the dynamism of the diagonal. He evokes a sense of movement by the way in which the back of the chair tilts to the right and the seat slopes downward. With the pictorial tension created by contrasting these diagonal directions, Strand dramatically challenges our familiar horizontal-vertical relationship to the world.

Ralph Steiner

American, 1899–1986

Untitled

1921–22
from the unique, handmade
book *The Beater and the Pan*,
1921–22
gelatin silver print
4 5/8 x 3 7/16"
(11.8 x 8.8 cm)
Purchase
83.109.8

Untitled

1921–22
from the unique, handmade
book *The Beater and the Pan*,
1921–22
gelatin silver print
4 3/4 x 3 11/16"
(12.1 x 9.4 cm)
Purchase
83.109.5

[1] Steiner later said of this training that the notion of imposing a design was not "photographic," and that the truth to the medium lay in finding and isolating composition within the world as it is: "Of course the organization of lines and spaces in a photograph has importance, but what we were taught was an approach to design which was suited to the painting of the time rather than to photography. We were taught rigid rules and formulae for what was 'good' and what was 'bad' composition. Besides being absurd, such an approach is impractical. First, a photographer cannot move a tree in a landscape to satisfy a painterly demand. . . . The photographer has to accept the world's arrangements as they come." Ralph Steiner, *A Point of View* (Middletown, Conn.: Wesleyan University Press, 1978), p. 5.

[2] Letter to Van Deren Coke, August 6, 1983.

[3] Ibid.

[4] Arthur Wesley Dow, *Composition: A Series of Exercises Selected from a System of Art Education* (New York: Baker and Taylor, 1900), p. 18.

While Paul Strand's approach to abstraction developed from his association with Alfred Stieglitz's circle, through which he was exposed to Cubism and New York Dada, Ralph Steiner's sense of abstraction developed from his experiences as a student at the Clarence H. White School of Photography in New York during 1921–22. There, the influence of Arthur Wesley Dow—the innovative teacher of design theory at Teachers College of Columbia University and a friend of Clarence White—was strongly felt, as was that of Max Weber, the American Cubist painter who helped establish the school and taught there continuously from 1914 to 1918, after which he lectured on an intermittent but frequent basis. Despite the influence of Weber and his espousal of Cubist ideas, Steiner gravitated toward the aesthetic of Dow. Clarence White hired an instructor from Teachers College thoroughly trained in Dow's theories to teach students the fundamentals of design, and the assigned problems were based on the principles of Japanese art from which Dow had derived many of his ideas.[1]

For his final project at the White School, Steiner created a series of eight photographs bound as a unique, handmade book titled *The Beater and the Pan*. As in Strand's work of the summer of 1916 (see cat. no. 1), simple domestic objects, in this case an eggbeater and pie pan, serve as vehicles with which to explore visual design verging on abstraction. "At the White School," Steiner has commented, "it was design/design/design— charcoal on Japanese paper until the designs leaked into our dreams."[2] One of the two examples from *The Beater and the Pan* illustrated here takes advantage of the way in which a camera lens can flatten and abstract form when the subject is shot from above and close up. The eggbeater's blades are situated in the top of the frame and lighted from above to throw dramatic shadows across the bottom portion. Cast shadows are the sole subject of the other example, which does not picture the actual objects. Again, as in Japanese art, Steiner creates an exaggerated flatness by filling the entire pictorial field with form. Of the resulting insectlike shadows, Steiner has written, "It could be that I thought some of the shapes a bit ominous—like hobgoblins."[3]

Steiner's emphasis on the interplay between light and dark stems from Dow's ideas influenced by Eastern art. Integral to Dow's book *Composition*, first published in 1899, is the principle of *notan* which is based on the artistic arrangement of darks and lights as a means of achieving abstract harmonies. "The placing together of masses of dark and light, synthetically related," he wrote, "conveys to the eye an impression of beauty entirely independent of meaning."[4] With his photographs for *The Beater and the Pan*, Steiner ventured further than any other vanguard American photographer of the time in the use of Oriental concepts of abstraction.

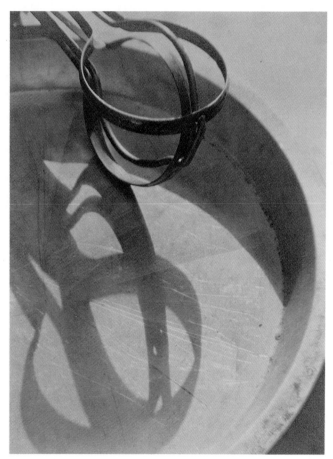

Plate 2a

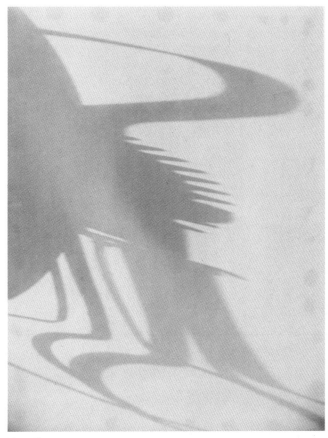

Plate 2b

Paul Outerbridge

American, 1896–1958

Crankshaft Silhouetted against Car

1923
platinum print
1 7/16 x 4 1/16"
(3.7 x 10.3 cm)
Purchase
82.336

One of Ralph Steiner's classmates at the Clarence H. White School of Photography in New York (see plate 2) was Paul Outerbridge. There he, too, was influenced by the teachings of Arthur Wesley Dow, but most particularly by those of Max Weber. Initially involved with painting and theater design, Outerbridge turned to photography as a new and independent technology that had not been explored as a medium of art. "To appreciate photography," Outerbridge stated, "one must dissociate it from other forms of art expression. Instead of holding a preconceived idea of art, founded on paintings, it must be considered as a distinct medium of expression—a medium capable of doing certain things which can be accomplished no other way."[1] During the twenties, Outerbridge concentrated on still-life compositions of familiar objects; some are abstract designs in the manner of Dow, while others are more Cubist in their creation of sophisticated spatial illusion. This fresh and assured ability to make the commonplace seem uncommon accounts for the immediate success Outerbridge achieved in commercial photography following his studies at the White School.

Crankshaft Silhouetted against Car, an outstanding photograph from this early period, presumed to have been commissioned by the Marmon Car Company, features a crankshaft superimposed over the profile silhouette of a grand touring car. The picture has an emblematic quality that is both eye-stopping and evocative of the high-level production expertise needed to make such a motorcar. The work also addresses the new, challenging space-time concepts as found in such Cubist paintings as those by Fernand Léger, which could well have been the source of Outerbridge's basic idea. The car itself is a symbol of movement and power, which Outerbridge emphasizes by overlapping it with a crankshaft, an essential element in propelling the automobile. This image demonstrates the great interest in space and time as subjects expressive of the new machine age.

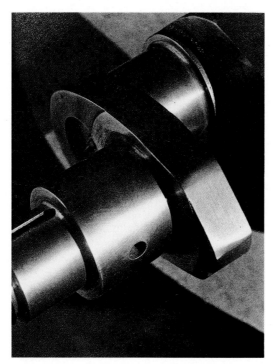

Figure 23 Paul Outerbridge. *Marmon Crankshaft,* 1923. Platinum print.

[1] Quoted in *Paul Outerbridge: A Singular Aesthetic. Photographs and Drawings 1921–1941: A Catalogue Raisonné,* ed. Elaine Dines in collaboration with Graham Howe (Laguna Beach, Calif.: Laguna Beach Museum of Art, 1981, p. 21).

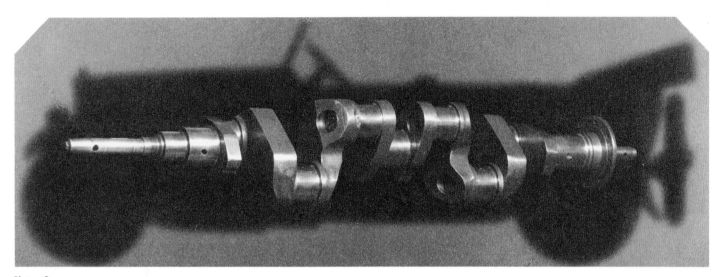

Plate 3

Edward Weston

American, 1886–1958

Pirámide del Sol
(Pyramid of the Sun)

1923
gelatin silver print
7 9/16 x 9 1/2"
(19.2 x 24.2 cm)
Gift of Brett Weston
84.253

In 1923 Edward Weston went to Mexico, which became for him what Paris continued to be for many American artists in the 1920s—a supportive climate in which to work out ideas. In Mexico, Weston found much to photograph in the new, more form-conscious style he had just begun to evolve. He responded enthusiastically to the ever-present evidence of a truly grand, centuries-old civilization. He was fascinated by the pre-Columbian master builders of the stone game courts, temples, and majestic, squat pyramids and by the native craftsmanship seen on all sides, in the churches of the Spanish period and in colorful folk-art objects. Weston came to love all this during his three-year stay.

Weston made one of his most impressive photographs, *Pirámide del Sol*, during his first few months in Mexico. In this image, the illuminated blades of grass and the darkened trees in the foreground give scale to the weighty stone pre-Columbian pyramid. The arrow-shaped silhouette magnifies the massiveness of the pyramid, evoking for the viewer the magical power of this special place. Even today, after more than a half century of intensive study, much remains to be learned of the people who built this shrine. Weston's photograph is far from being a document; it is an act of true poetic intelligence. It is as if he had heard voices emanating from the clefts in the stones at the summit, speaking of their god, the sun, in terms that were exhilarating, but also imbued with thoughts of deep, dark shadows and the concept of memento mori, the acknowledged condition of life in the Eden that is Mexico.

Figure 24 Edward Weston. *Mexican Toys,* 1925.
Platinum print.

Plate 4

Imogen Cunningham

American, 1883–1976

Agave Design I

ca. 1929/ca. 1974–76
gelatin silver print
13 5/8 x 10 5/8"
(34.6 x 27.0 cm)
Clinton Walker Fund Purchase
84.14

Imogen Cunningham was so pithy a character in her mature years—her eighties and even early nineties—and so beloved by her students and friends that her innovative photography of the 1920s has often been overlooked in favor of her later work. In her early career, however, she was every bit the equal of such male contemporaries as Paul Strand and Edward Weston when it came to absorbing the lessons of European modernism. Her crisp photographs of plants from this period are as sharply focused and geometric as the wheels and cogs of Strand's 1922–23 pictures of his precision-made Akeley movie camera, or Weston's 1923 image of Mexico's *Pirámide del Sol* (plate 4). Her inherently sensuous subjects—large, graceful flowers, elegant, tapered leaves, and rounded cacti—were transformed into formal compositions by her emphasis on close-up views, geomet-

ric detail, and the tendency of shadows to appear as opaque silhouettes in photographs.

In *Agave Design I* of circa 1929, Cunningham speaks to the beauty of pure geometry in nature. The sharp, slender agave leaves, hard and uniform as if created by a machine, recall stacked bayonet blades. Their thrusting biological form implies nature's energy, as Strand's mechanical subjects suggest man-generated energy. Cunningham's tightly framed and precisely rendered images of plant forms were so admired by Edward Weston that he included a selection of them in *Film und Foto*, the famous international exhibition held in 1929 in Stuttgart, which brought together the most avant-garde photography and film of the time.

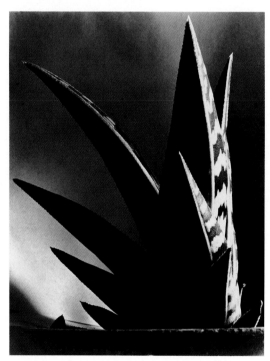

Figure 25 Imogen Cunningham. *Aloe,* 1925/1984. Gelatin silver print.

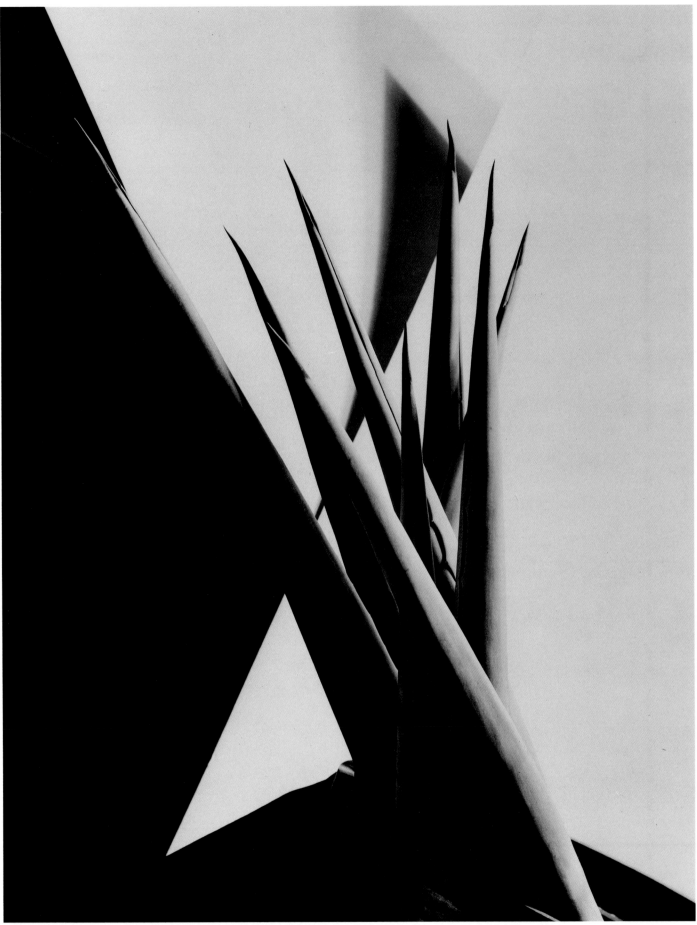

Plate 5

Robert Petschow

German, 1888–1945

Untitled

ca. 1930
gelatin silver print
11 1/16 x 14 7/8″
(28.1 x 37.8 cm)
Purchase
82.9

Views by German photographers of their native countryside are totally different from landscape photographs by such American photographers as Ansel Adams and Edward Weston (plate 4). This is due to differences in philosophies, types of terrain, and atmospheric conditions—the clear, brilliant light of the American West, for example, compared to the moisture-laden skies of Germany.

Robert Petschow was one of a few extremely imaginative landscape photographers in Germany during the 1920s and 1930s who used fresh concepts, as well as current technology, to record the world from new and different viewpoints. With a sensitive eye for abstract design, Petschow photographed his fatherland from a hot-air balloon. From high above fields, rivers, and mountains, he saw the topographic character of the land as a vast relief map accented by roads and canals. To create this untitled image, Petschow shot directly down and restricted his view to a single subject, the Rhine River in winter dotted with chunks of ice. He investigated the tendency of the camera's eye to flatten out the world that human eyes see as three-dimensional, and, as a result, space and scale in his work become ambiguous and fascinating at the same time. We cannot tell whether we are looking at a river or a microphotograph of a vein through which blood flows.

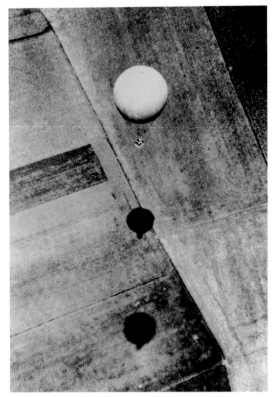

Figure 26 Robert Petschow. *Balloon with Shadows,* 1926. Gelatin silver print.

Plate 6

Jaromír Funke

Czechoslovakian, 1896–1945

Untitled

ca. 1927
gelatin silver print
11 1/2 x 9 1/4"
(29.2 x 23.5 cm)
Purchase
79.250

Long a prosperous city of the Austro-Hungarian Empire, Prague rose to new heights as an art center after 1919, when Czechoslovakia gained her independence. The city is readily connected to Paris, Berlin, and Moscow by rail, and its artists and photographers were quick to absorb the influences of Cubism, Constructivism, and Surrealism. Photographers and painters in Prague readily involved themselves with the pictorial problems and philosophical implications raised by these modern movements.

Jaromír Funke was the most accomplished photographer to emerge in Prague in the 1920s and 1930s. Influenced by Cubism and Constructivism, he devised numerous ways in which light could serve as a faceting agent in photography. This untitled photograph of circa 1927 is one of a series of still-life compositions in which square and rectangular pieces of paper and glass, and domestic ob-

jects such as bottles and wire whisks were carefully arranged and dramatically lit to create solid, planar forms out of both the shadows and the brightly illuminated areas. In this instance, the actual still life is not seen, but merely its cast shadow, which emphasizes a feeling of flatness and abstraction. Funke's use of overlapping and transparent geometric forms stems from Constructivism. His translucent geometric shapes and dark-light contrasts create a staccato rhythm similar to that found in the Constructivist canvases of László Moholy-Nagy and Vasily Kandinsky. Yet this is not a cold, calculated picture. Funke's sense of light as warm and soft evokes a satisfying feeling of structured poetry.

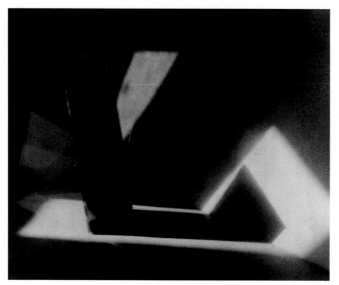

Figure 27 Jaromír Funke. Untitled, ca. 1927.
Gelatin silver print.

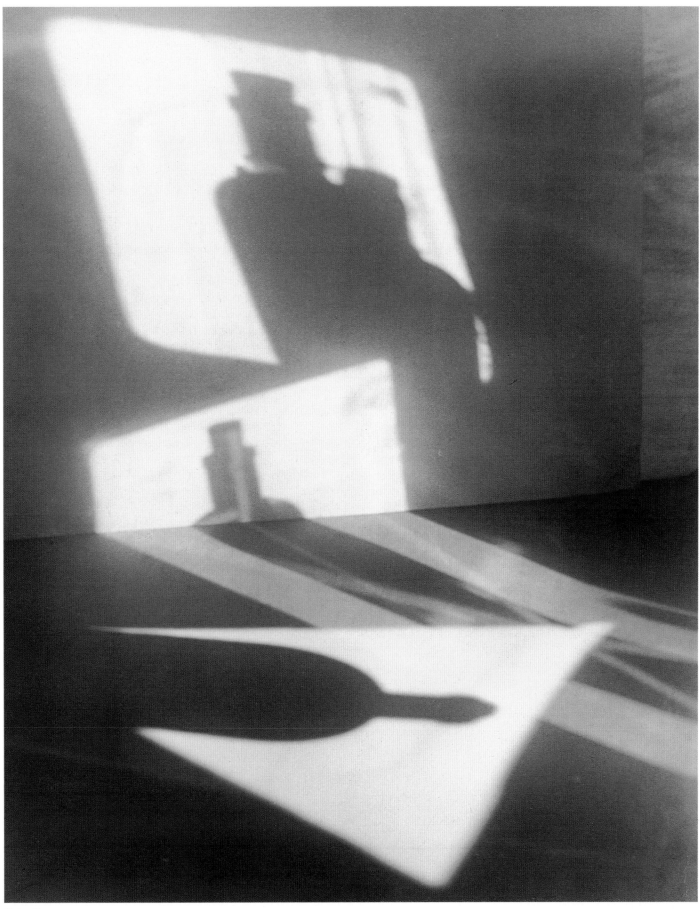

Plate 7

Francis Joseph Bruguière

American, 1879–1945

Untitled

ca. 1932
gelatin silver print
11 x 13 15/16"
(28.0 x 35.4 cm)
Purchase
82.58

Alvin Langdon Coburn in London and Francis Joseph Bruguière in New York, and subsequently London, carried the concept of abstraction in photography farther than anyone else working in the first quarter of the century. Both photographers based their abstractions on pure light—the essence of photography—as the principal agent of form and expression. Yet Coburn's Vortographs, as his abstractions were called, were isolated experiments, in contrast to Bruguière's cut-paper abstractions, which were the result of a sustained effort throughout the 1920s and early 1930s.

Bruguière first began to experiment with light in New York during the 1920s while working as a commercial photographer for *Vogue*, *Harper's Bazaar*, *Vanity Fair*, and the Theatre Guild. He was influenced by both his own painting of the period and his work for the Theatre Guild, which gave him an appreciation for light as a vehicle for emotional expression. His abstract canvases of the early 1920s share the pictorial concerns of Synchromism to the extent that light in the form of geometric slivers is the primary subject, as it is in the prismatic paintings of pioneer Synchromists Morgan Russell and Stanton Macdonald-Wright. An important turning point for Bruguière was a series of commissioned photographs he made in 1921 of projected, colored light compositions created by Thomas Wilfred's "color organ," an early attempt in America to create by means of color a visual experience that was equivalent to the rhythms in music. These documents stand as the earliest examples of his interest in photographing pure light. In 1923, Bruguière then began what he referred to as his "designs in abstract forms of light."[1] Throughout the 1920s he photographed shaped or cut-paper designs that were dramatically illuminated to create a complex interplay of abstract patterns of light and shadow that emphasize form and movement.

In 1928 Bruguière moved to London, and by the early 1930s he introduced subtle figurative elements into his cut-paper abstractions, which are best seen in the photographs included in the 1931 book *Few Are Chosen*.[2] The untitled cut-paper abstraction of circa 1932 shown here is similar to those works in that its central motif is a small mask.[3] However, the arcing, curvilinear shapes formed by the slashed paper illustrate the complex degree to which Bruguière continued to pursue abstract patterning. The rhythmic counterpoint created by the contrasting areas of light and dark lends the work both a sculptural and a kinetic quality. Its rich tonal variations are the result of the innovative technique of freely moving the light source across the paper construction while keeping the lens continuously open.[4] With this method Bruguière created multiple, overlapping shadows cast from varying directions. While an interest in composition, form, and tone are inherent to this light abstraction, it is also concerned with poetic evocation. Like Alfred Stieglitz's "equivalents" or Vasily Kandinsky's "compositions," Bruguière's photographs are visualizations of states of feeling. In his notes, Bruguière wrote: "Curious thing happens in intelligently taken photographs / really gives you what you see / what you take, the reflection of your own vision / that quality of mind should be cultivated / the thing you see inwardly, emotion / desire to express feeling, thought, mental reaction."[5]

[1] Quoted in James Enyeart, *Bruguière: His Photographs and His Life* (New York: Alfred A. Knopf, 1977), p. 16.

[2] Oswell Blakeston and Francis Bruguière, *Few Are Chosen: Studies in the Theatrical Lighting of Life's Theatre* (London: E. Partridge, 1931).

[3] This comparison was made by James Enyeart in conversation with Diana du Pont, November 20, 1984.

[4] This method was identified by James Enyeart in conversation with Van Deren Coke, December 1, 1984.

[5] Enyeart, op. cit., p. 23.

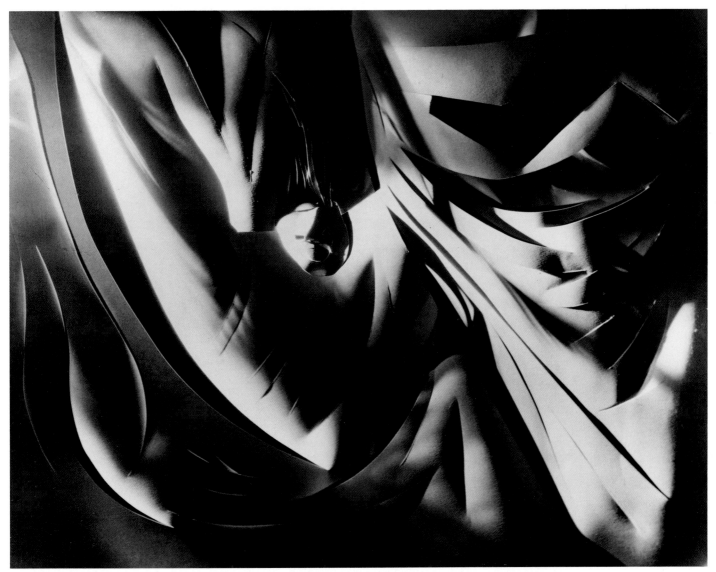

Plate 8

František Drtikol

Czechoslovakian, 1883–1961

Untitled

ca. 1927
gelatin silver print
10 7/8 x 8 13/16"
(27.7 x 22.4 cm)
Purchase
83.164

Along with Jaromír Funke (plate 7), František Drtikol was one of the earliest Czech photographers to embrace the avant-garde influences of Cubism, Constructivism, and their offshoot, Art Deco. After having been trained from 1901 to 1903 at the Lehr- und Versuchanstalt für Photographie (Teaching and Research Institute for Photography) in Munich, Drtikol worked as an assistant in various portrait studios in Germany, Switzerland, and Bohemia (Czechoslovakia). In 1910 he established his own studio in Prague. From 1918 until 1935, when he gave up photography for painting and Oriental philosophy, Drtikol concentrated on photographing the female nude in both his studio and the open air. Although the nude was his central motif, he used a variety of modernistic props and wall decorations as settings or backdrops. These foils to the female form lend his pictures an Art Deco look, for they frequently incorporate angular shapes and repeated undulating outlines. In addition to being striking designs, his photographs evoke some of the mystery of sensuous flesh and at the same time glamorize the nude in a theatrical sense.

This untitled photograph of circa 1927 exemplifies his use of dramatic lighting to transform the figure into a semiabstract shape. The light and shadows and the way in which the fabric falls from the upraised arm create an angular unified form that links this photograph to modern figurative sculpture such as that of Alexander Archipenko.

Figure 28 František Drtikol. *Studie,* 1929.
Gelatin silver print.

44

Plate 9

45

Franz Roh

German, 1890–1965

Nackt im Auto/
Fleisch und Metall
(Naked in Car/
Flesh and Metal)

ca. 1927–28
gelatin silver print
6 5/16 x 8 9/16"
(16.1 x 21.8 cm)
Fund of the 80's Purchase
84.155

Franz Roh first became interested in art when he studied literature and art history at the universities of Leipzig, Berlin, Basel, and Munich. In 1918 he became an assistant to the great art historian Heinrich Wölfflin and wrote a dissertation on seventeenth-century Dutch painting. Still photography and films were his next fields of investigation. He wrote extensively about each medium as an art historian and critic, and he became a photographer himself with a special interest in the negative print and other experimental techniques that introduced ambiguity into straightforward photography. In his essay for the book *Foto-auge* (*Photo-Eye*) of 1929, which he edited with the innovative graphic artist Jan Tschichold, Roh became a spokesman for these vanguard approaches: "our book does not only mean to say 'the world is beautiful,'" he wrote, "but also: the world is exciting, cruel and weird. therefore pictures were included that might shock aesthetes who stand aloof. — there are five kinds of applied photography: the reality-photo, the photogram, photomontage, photo with etching or painting, and photoes [sic] in connection with typography."[1]

Important among the new approaches advocated by Roh was the use of unusual perspectives, as seen in his photograph *Nackt im Auto* of circa 1927–28 and a variation of this image made as a negative print. "formerly pictures were taken only in horizontal view-line," Roh observed. "the audacious sight from above and below, which new technical achievement has brought about by sudden change of level (lift, aeroplane, &c.), has not been utilized sufficiently for pictorial purposes so far. new photoes [sic] show this up and down of appearance. . . . the significance lies in opening astronomic perspectives so to say: vertical in this greater sense really is radial position corresponding to an imaginary centre of the earth."[2] In *Nackt im Auto*, Roh transformed a "reality-photo" into something provocative and unfamiliar not only by shooting from above, but by relying on the principle of dislocation as well. While carefully constructed from a formal standpoint, the work possesses an element of incongruity or irrationality as in a dream, for only after close study are we aware that the model is nude, so active and so precisely placed are the patterns of light and dark throughout the picture. This combination of formalism and ambiguity was innovative. László Moholy-Nagy (plate 21) was the only other photographer who made such an early connection between Surrealism and Constructivism.

Figure 29 Franz Roh. Untitled, ca. 1927–28.
Gelatin silver print (negative image).

[1] Franz Roh, "Mechanism and Expression: The Essence and Value of Photography," in *Photo-Eye. 76 Photos of the Period*, ed. Franz Roh and Jan Tschichold (New York: Arno Press, 1973), p. 16; reprint of *Foto-auge. 76 Fotos der Zeit*, ed Franz Roh and Jan Tschichold (Stuttgart: Fritz Wedekind, 1929). The absence of capital letters accords with the published text.
[2] Ibid., p. 17.

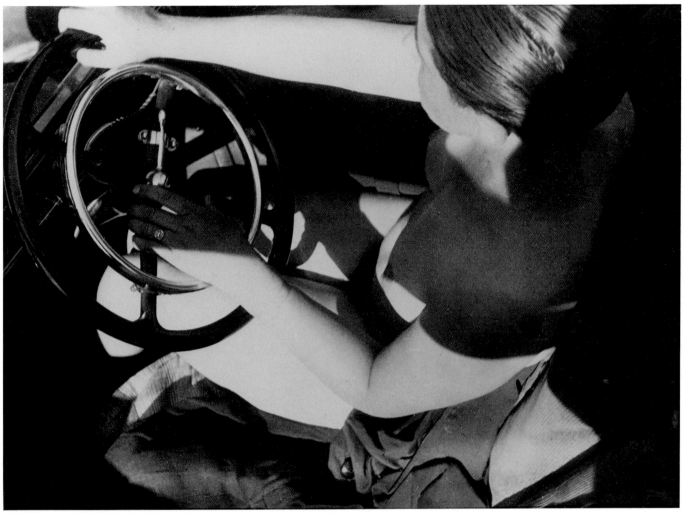

Plate 10

Edmund Kesting

German, 1892–1970

Am Hause
(By the House)

1930
gelatin silver print
11 1/4 x 15 1/4"
(28.6 x 38.8 cm)
Mrs. Ferdinand C. Smith
Fund Purchase
78.170

During the 1920s Edmund Kesting was at the very center of the avant-garde in Germany. Initially trained as a painter, he turned to collage and photography, developing a high level of expressionism coupled with a familiarity with Cubism and Surrealism.

One of Kesting's finest pictures of the period is this advertising photograph of the German Horch. Taken in 1930, the photograph is a closely cropped view of Kesting's wife at the wheel of this luxury sports car. By situating the Horch in the German countryside with a farmhouse in the distance, Kesting speaks of the freedom and mobility the leisure class enjoyed with this automobile. The way in which he uses the frames of the car's windshield and window to fragment the view, creating different and separate pictures within one, recalls the faceting of forms of early Cubist paintings by Pablo Picasso and Georges Braque. One vignette presents a profile view of Mrs. Kesting's face; another, a sharply defined portion of the steering wheel and one of the clamps that anchors the convertible top; and a third, the driver's hand on the wheel and a reflection of trees in a side window. Though made over fifty years ago, this Horch advertisement is a strikingly contemporary picture in terms of both its concept and its form. The division of space into geometric fragments and the use of reflections that flatten the picture plane are qualities that reverberate today in many of Lee Friedlander's well-known street photographs (plate 18).

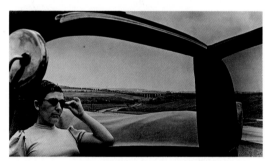

Figure 30 Edmund Kesting. *Kennwort: Kulturerbe* (Code Word: Cultural Heritage), 1933. Gelatin silver print.

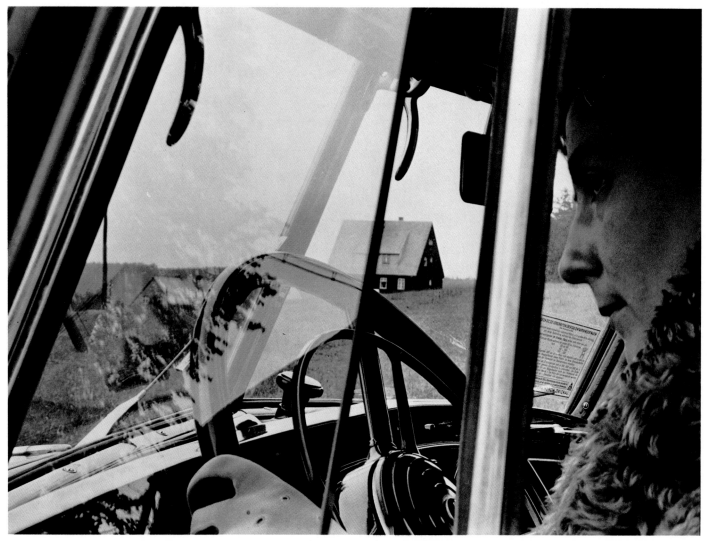

Plate 11

Alexander Rodchenko

Russian, 1891–1956

Untitled

1930s
gelatin silver print
8 11/16 x 11 1/2"
(22.1 x 29.2 cm)
Purchase
84.60

Alexander Rodchenko was Russia's innovative modern photographer. Initially a student of painting, Rodchenko attended the Kazan Art School from 1910 to 1914, when he moved to Moscow to enroll in the Stroganov Institute. At this time the Moscow art world was in a state of ferment. Cubism, Futurism, and Cubo-Futurism, a unique Russian synthesis of the two movements, were all being explored by the avant-garde. Meanwhile, vigorous experimentation by the Suprematist Kasimir Malevich and the proto-Constructivist Vladimir Tatlin revealed the possibilities of pure abstraction.

Rodchenko, who became one of the leading Russian Constructivists, enthusiastically responded to the freedom that abstraction gave artists who wished to move away from objective illustration of the world. The geometry of Constructivism met his spiritual and philosophical needs for nonrepresentational art. Wholeheartedly in favor of the Russian Revolution, he saw this new form of art as another means of reshaping society. During the 1920s he renounced painting to concentrate on graphic design, which entailed making political posters for the new regime. Around 1923, influenced by the works of fellow artists El Lissitzky and László Moholy-Nagy (plate 21), which combined photographs with geometric forms, Rodchenko began to make photomontages with found images. He believed that the use of recognizable elements in the form of photographs was an effective means of conveying information.

About 1924 this experience led Rodchenko to start making his own photographs. The pictures were generally of people or commonplace scenes, but shot from unexpected viewpoints, creating images that challenged convention. More and more he began to see the world through a viewfinder, that is, he saw as a camera sees. In this untitled work of the 1930s, for example, Rodchenko accentuates how the camera's eye flattens space by shooting from above. The female figure is dramatically foreshortened while her cast shadow is elongated, becoming the focal point of the photograph. This new sense of space is coupled with a new sense of dynamism created by the rhythmic contrast of light and dark and the forceful diagonal composition. By using diagonal compositions and unusual vantage points, Rodchenko's photographs were not intended merely to convey information, but to function as avenues for psychological responses to a new era. "In photography there is the old point of view," Rodchenko wrote in 1928, "the angle of vision of a man who stands on the ground and looks straight ahead or, as I call it, makes 'bellybutton' shots. . . . I fight this point of view, and will fight it, along with my colleagues in the new photography. The most interesting angle shots today are those 'down from above' and 'up from below,' and their diagonals."[1]

[1] Quoted in Beaumont Newhall, *The History of Photography, From 1839 to the Present*, rev. and enl. ed. (New York: Museum of Modern Art, 1982), p. 201.

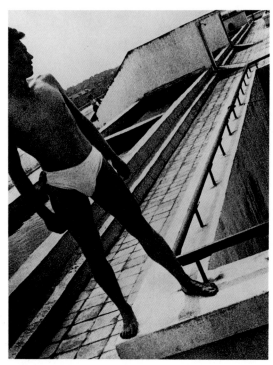

Figure 31 Alexander Rodchenko. *Lefortovo—studentské městečko* (Lefortovo—Student Village), 1930. Gelatin silver print.

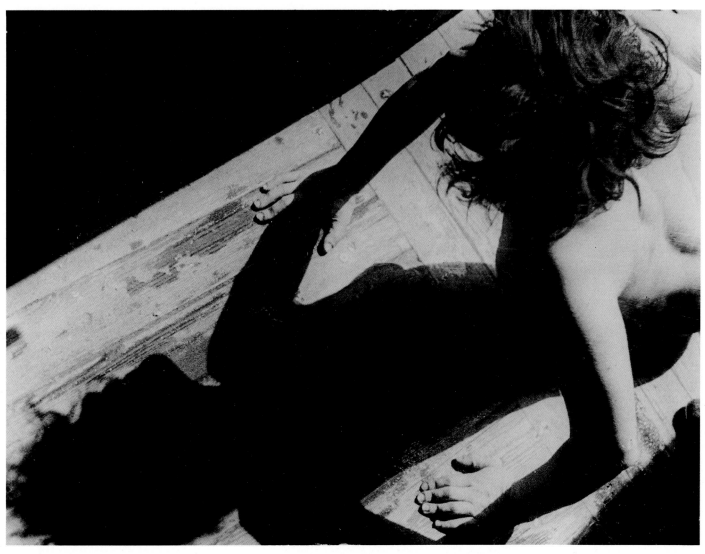

Plate 12

Gertrud Arndt

German, born Silesia, 1903

Untitled

1930
gelatin silver print
8 15/16 x 6 3/8"
(22.7 x 16.2 cm)
Purchase
81.101

While a student of painting and weaving at the Bauhaus from 1923 to 1927 Gertrud Arndt came under the influence of László Moholy-Nagy (plate 21) and what became known as "new vision" photography. Moholy-Nagy did not teach photography per se, but his photographs were exhibited on the walls of the Bauhaus and reproduced in books, such as his influential *Malerei, Fotografie, Film* first published in 1925. Arndt understood that Moholy-Nagy's revolutionary way of shooting up and down was a new means of enlivening pictures of routine events.

In this untitled work of 1930, Arndt shot from below when she photographed fellow Bauhaus students who were applying paint to an exterior wall of a building in order to study the effect of weathering on pigments.

By using a worm's-eye perspective, she transformed this casual event into a dramatic composition in which the students on ladders act as accents in a semiabstract arrangement. The picture conveys information while it also invokes the new dimensions of space Arndt absorbed as a student at the Bauhaus. The diagonal lines, which imply a sense of movement, challenge the horizontal-vertical structure of nature that was the traditional underpinning of artistic composition in Western art.

Figure 32 Gertrud Arndt. Untitled, 1930.
Gelatin silver print.

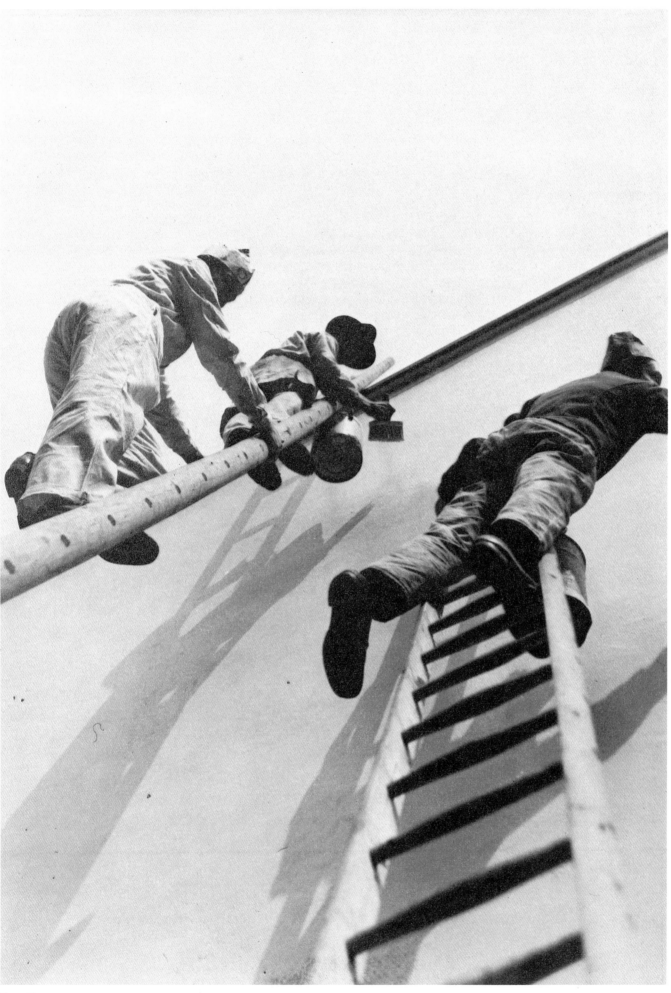

Plate 13

Martin Munkacsi

American, born Hungary, 1896–1963

Children at Kissingen, Germany
(A Field Full of Children, Kissingen, Germany)

1929
gelatin silver print
11 9/16 x 9 1/4"
(29.4 x 23.5 cm)
Purchase
81.47

In Germany in the late 1920s and early 1930s a seasoned photojournalist was, in most cases, given a general assignment and left to carry it out in his own way. Under these autonomous working conditions, the Hungarian-born photographer Martin Munkacsi developed a distinctive, personal approach to photojournalism. He began his career as a photojournalist in Budapest, where he initially worked as a sports photographer. Hoping to expand his horizons, he moved to Berlin in 1927. There he went to work for Ullstein Press and contributed to such publications as the *Berliner Illustrirte Zeitung, Die Dame, Die Koralle*, and *Uhu*. His association with the Ullstein Press coincided with the birth of Germany's modernist movement in photography, called the "new vision." Not surprisingly, Munkacsi soon embraced the dramatic camera angles, strong diagonals, and bold, repeated patterns characteristic of "new vision" photography. His innovative pictures were a result of an instinct for spontaneity and for fresh, radical viewpoints that gave zest to current events of the day. He achieved a sense of energy and motion by the use of stop-action, made possible by new and improved lenses capable of shutter speeds of up to 1/1000 of a second.

In 1929 Kurt Koroff, an editor at the Ullstein Press, assigned Munkacsi to do a series on Germany's largest kindergarten, located at Marienruhe bei Bad-Kissingen. One of the most eye-catching pictures in the series, which was published in the *Berliner Illustrirte Zeitung* with an article by Munkacsi, is this image titled *Children at Kissingen, Germany*. The photograph depicts a veritable sea of children lying and sprawling on a stretch of grass, looking upward with a seeming awareness of the photographer. The children are positioned close together, filling the frame in an even, allover composition. As flat forms against a flat ground, the children lose their individuality and become elements in an abstract design. The fluctuating tonal values in clothing from one child to the next and the varying leg positions create a rhythmic, animated surface pattern. By shooting from almost directly overhead, Munkacsi accentuated the two-dimensional quality; he denied the traditional horizon and obscured any perception of depth between the suspended telephone wires and the children below.

With a sense of modern pessimism in the face of a society that lauded conformity and increasingly hindered freedom of choice, Munkacsi said of this picture: "Its contents are most dramatic. It depicts the hopeless fate of human beings: their similarity to the fate of herrings, pressed into a barrel, or pressed in a city, minus air, with no horizon—freedom on paper only, and not in fact—with duties made by themselves, or imposed by leaders, to hold them in a certain spot in a certain manner. I like it because it saddens me, again and again, whenever I look at it."[1]

[1] G. Herbert Taylor, ed., *My Best Photograph and Why* (New York: Dodge Publishing Co., 1937), p. 62.

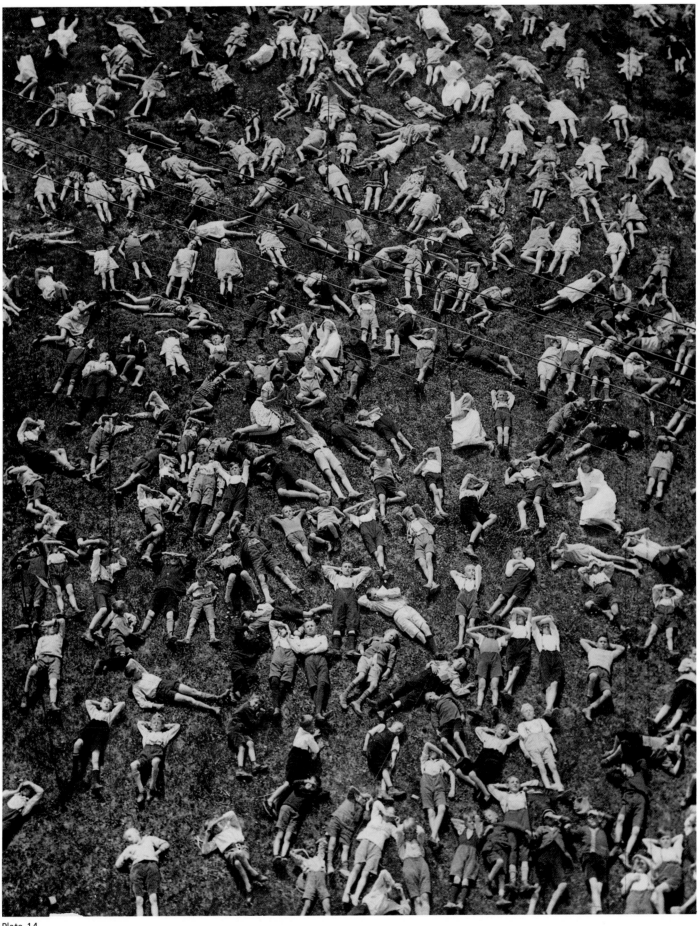

Plate 14

Hans Finsler

Swiss, 1891–1972

Untitled

ca. 1930
gelatin silver print
8 1/2 x 6"
(21.6 x 15.3 cm)
Purchase
81.141

The earliest photographic images in which letters appear as graphic elements were made in 1918 by the German artist Christian Schad. By 1930 striking photographs were being made regularly with words or lettering as an integral part of advertisements. The bold pictures of Swiss-born Hans Finsler were among the strongest of these commercial photographs.

Finsler had been trained as an architect and art historian before becoming a successful commercial photographer and influential teacher in Germany during the 1920s. His study of architecture gave him a solid foundation in form and design, which was applied to whatever subjects he photographed. Finsler's most important work reveals his fascination with the object and his full understanding of "new vision" photography. Crisp details, strong designs, and close-ups of manufactured products arranged with great attention to geometric repetition of forms were almost always characteristic of his work. The modern look of these photographs attracted the attention of innovative companies wishing to publish striking catalogues of their products and adventurous advertising agencies serving imaginative clients seeking new and captivating means of marketing.

Finsler's photograph of circa 1930 of a tube of toothpaste and a toothbrush demonstrates how a background in fine art can be effective in product presentation. By introducing the tube as an isolated form on a darkened mirror, Finsler suggests an antiseptic setting and transforms this humble object into a grand symbol of modern hygiene. This presentation subliminally reinforces the name of the toothpaste—Sarizol—which sounds like a gush of clean, pure water. The sheer sharpness of the image and the opposing diagonals of tube and brush convey a feeling of dynamism and modernity, effects very much in keeping with the aims of the manufacturer of Sarizol toothpaste.

Removed from its commercial context, this photograph is as much an object of aesthetic delight as is Mies van der Rohe's classic Barcelona Chair of 1929. Like Mies's chair, Finsler's composition resolves itself into a new and exciting combination of forms that extends beyond the primary, material purpose that instigated the initial creation.

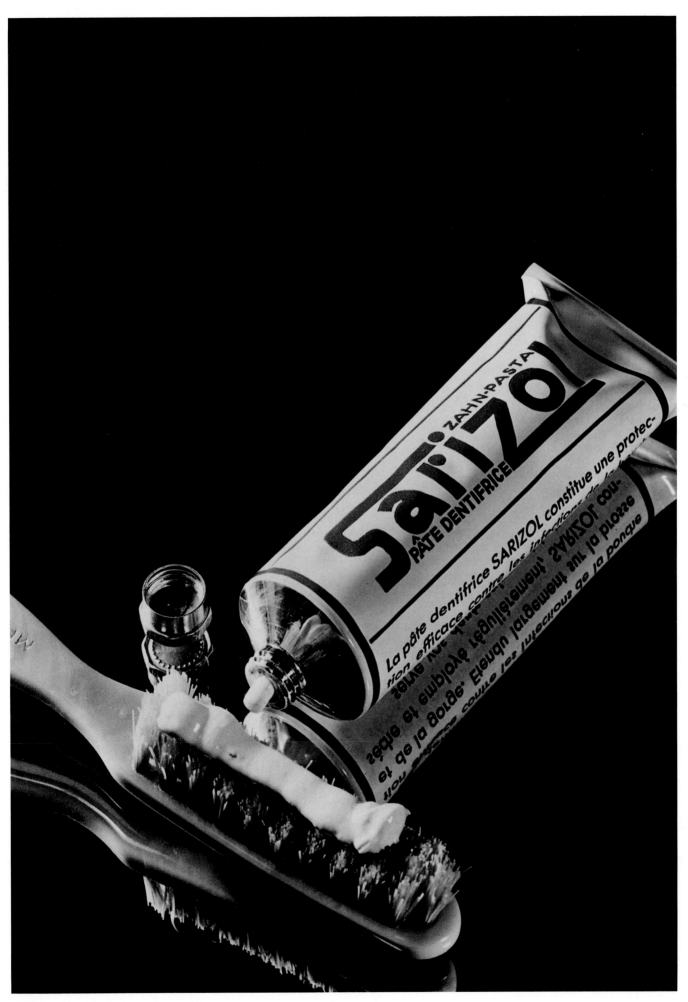

Plate 15

Gyorgy Kepes

American, born Hungary, 1906

Untitled

1939
gelatin silver print
(combined straight
photograph and photogram)
19 3/8 x 15 7/16"
(49.2 x 39.2 cm)
Purchase
82.24

Gyorgy Kepes maintains that he is not a photographer, but rather an artist "committed to working with light"[1] in whatever medium. As with his close friend László Moholy-Nagy (plate 21), for Kepes, photography has been only one means among many—painting, film, stage and architectural design—by which he has persistently explored the poetry of light. While Kepes adopted the same basic artistic concerns of Moholy-Nagy, with whom he first worked in Berlin during the early 1930s, he translated the latter's formal, intellectual Constructivism into a more romantic, lyrical mode. Although he shared Moholy-Nagy's belief in art as a means of transforming society, instead of following his attempt to create a new order by means of a universal form-language composed of geometric shapes, Kepes—who describes himself as "a seeker not a stater"[2]—used this language to reveal nature and its universal laws.

Like Moholy-Nagy, Kepes turned to photography as a means of uniting art and the wonders of modern technology, and to this end both men experimented with cameraless photographic techniques. Kepes brought this pioneering spirit with him when he arrived in Chicago in 1937 to teach at the New Bauhaus (later the Institute of Design) then being founded by Moholy-Nagy. This untitled work, made during Kepes's early years in Chicago, combines straightforward and cameraless photography. The negative of an out-of-focus night scene featuring artificial lights was projected from an enlarger onto a sheet of photographic paper on which translucent Plexiglas rods were placed, which in turn created negative images. The black lines are a result of the way in which the Plexiglas rods concentrate or focus light.

The practice of combining imagery from different sources has been an established procedure in photography for well over a century. Due to the wet collodion negative's oversensitivity to blue light, landscape photographers of the 1850s and 1860s were forced to make a second negative for clouds. From the 1850s into the 1870s, genre photographers Oscar G. Rejlander and Henry Peach Robinson made complex combinations of multiple negatives to create elaborate allegories. Surrealist photographers of the 1920s and 1930s employed the technique to suggest alternative realities. Kepes turned to this method to create a metaphor for the underlying structure of nature. He was fascinated by the "beautiful hidden rhythm of the world"[3] as revealed to him by science's micro- and macrophotography. Through his work, he sought "to read nature, to learn about nature, and to create patterns which reveal nature."[4]

In this work, Kepes has said, his aim was "to juxtapose a staccato, fragmented light space with some more structured rhythmic pattern of geometric shapes. This juxtaposition or opposition of the free undisciplined and the geometrical disciplined is a persisting motive in my work."[5] Here the theme of polarity as a fundamental relationship in nature is emphasized by Kepes's contrast of a structured composition of clearly defined perpendicular lines in the foreground with an amorphous field of indistinct shapes in the background. He once said, "A sheer negative doesn't say anything. Only the interplay of the negative and the potential positive creates the quality that I hope I sometimes catch."[6]

[1] Telephone interview with Diana du Pont, October 24, 1984.

[2] Ibid.

[3] Robert C. Morgan, "Sermon for Tranquility: An Interview with Gyorgy Kepes," *Afterimage*, vol. 10, no. 6 (January 1983), p. 8.

[4] Telephone interview with Diana du Pont, October 24, 1984.

[5] Letter to Van Deren Coke, October 16, 1984.

[6] Morgan, op. cit., p. 7.

Plate 16

Theodore Roszak

American, born Prussia, 1907–1981

Untitled

between 1937 and 1941
gelatin silver print
(photogram)
9 15/16 x 8"
(25.3 x 20.3 cm)
Purchase
84.61

From 1937 to 1941 Theodore Roszak made hundreds of photograms while producing his smoothly finished, geometric, machine-inspired sculptures. The forms and composition of these photograms clearly share affinities with his sculptural work of these years.[1] Initially trained as a painter, Roszak began to make sculpture in 1932, shortly after returning to America from an extended period of study in Europe, where he had been introduced to Constructivism and to the works and writings of László Moholy-Nagy in particular (plate 21). Although he did not visit the Bauhaus, he learned about its ideology in 1930 from Moholy-Nagy's book *The New Vision: From Material to Architecture* (originally published in Munich in 1929 as *Von Material zu Architektur*).[2] Roszak was unique among his American contemporaries of the 1930s in his understanding and application of Constructivist concepts, as seen in his wood and plastic sculptures which emphasize the geometry of pure form.

It was at the height of his work in this idiom that Roszak turned to the photogram. At the time, he was teaching design and composition at the Design Laboratory, an experimental school in New York City, funded by the WPA, which had been founded under the guidance of Moholy-Nagy and with the intention of advancing Bauhaus principles in America. Drawing upon instructional exercises outlined in *The New Vision*, Roszak incorporated the photogram into his teaching assignments and began to make photograms himself. He fully understood that for Moholy-Nagy the photogram was an important means by which to explore the Constructivist principles of light, transparency, and motion.[3]

Although never publicly shown during his lifetime, Roszak's photograms are some of the most authoritative images of their kind ever to have been made. All similar in sensibility, they rely on an interplay of fundamental geometric shapes suspended in indeterminate space and demonstrate the same purely intellectual and formal concerns of Moholy-Nagy's work. The forms also show the influence of the Art Deco stage designer Norman Bel Geddes, with whom Roszak collaborated in the 1930s. In this untitled photogram, circles, rectangles, and intersecting lines exemplify Roszaks's machine aesthetic. Their placement and interrelationship suggest a kinetic feeling that, in addition to Constructivist ideas, may be related to Roszak's long-standing interest in aviation and the possibilities of cosmic exploration. While rooted in Constructivism, Roszak's photograms may also be seen as a celebration of America as a land of industrial progress, with sophisticated manufacturing skills then being put to the test by aircraft and armament orders from the warring countries of Europe.

[1] None of Roszak's photograms is dated and few are signed, but it appears, based on their similarity to certain constructions of that period, that they were executed from 1937 to 1941; see "Theodore Roszak (1907–1981): Photograms of the 1930s," *Zabriskie Gallery Newsletter* (Fall/Winter 1985).

[2] Joan M. Marter, "Theodore Roszak's Early Constructions: The Machine as Creator of Fantastic and Ideal Forms," *Arts Magazine*, vol. 54, no. 3 (November 1979), p. 113, n. 5.

[3] Roszak and Moholy-Nagy met in the late 1930s, when Roszak was an instructor at the Design Laboratory and Moholy-Nagy was the director of the New Bauhaus (later the Institute of Design) in Chicago. Correspondence dating from May to September 1945 indicates that Roszak sought Moholy-Nagy's opinion of his photograms; see *Zabriskie Gallery Newsletter*, op. cit.

Plate 17

Lee Friedlander

American, born 1934

Akron

1980
gelatin silver print
7 9/16 x 11 1/4"
(19.2 x 28.6 cm)
The Helen Crocker Russell
and William H.
and Ethel W. Crocker
Family Funds Purchase
83.68

Lee Friedlander's wide-eyed vision of the 1960s spawned a cult of spontaneity among photographers. Visual not social consciousness was raised by his pictures. His photographs are documentary, but with the sole aim of recording how a person can see ordinary surroundings afresh, as if he were in a foreign land. Friedlander shows us the familiar and the unfamiliar as though they were under a magnifying glass, detached in space and scale from the lived-in environment. The appeal of his city scenes lies in the psychological balance he creates out of seeming chaos by means of linear, geometric composition. His is a tightrope act. The internal dynamics of these cityscapes are as intellectually challenging as slightly off-key harmonic notes in music. There is also a sense of strangeness to it all. Friedlander can take any part of the city and create a sense of enigma and tension, for space is often condensed and slightly askew.

Spatial enigma and tension are key elements in this photograph taken in Akron, Ohio, as one of a series of commissioned photographs of the urban and industrial landscape of Ohio and Pennsylvania made in 1980 and later published as a book.[1] The picture is divided in half horizontally. The lower portion depicts a walkway, not quite in the center, while the upper portion illustrates the cityscape in the distance. On one hand, the wide-angle view and the planar quality of the simple shapes composing the walkway make the bottom part appear as a flat, abstract composition. On the other, the lines of the planes converge toward the horizon, creating a contradictory feeling of recession. Beyond the issue of pictorial tension between flatness and depth, Friedlander also quietly comments on the contemporary American cityscape in his contrast of the elaborate nineteenth-century building on the left and its neighbor, the spare, utilitarian twentieth-century structure on the right.

[1] Lee Friedlander, *Factory Valleys: Ohio & Pennsylvania* (New York: Callaway Editions, 1982).

Plate 18

Lewis Baltz

American, born 1945

Industrial Structure during Painting, Irvine

1974
from the portfolio
The New Industrial Parks near Irvine, California, 1974, 15/21
gelatin silver print
6 1/16 x 9"
(15.4 x 22.9 cm)
Gift of Carol Campbell Wenaas
80.472.3

Lewis Baltz has the eye of a poolroom professional: he takes shots that count. His game is not pool, but the criticism of real estate development, or, in broader terms, of a society that creates modular "designed" buildings—whether for commerce or residence—that dominate in form and arrangement the lives of those who work and live in them. His case-study style elicits admiration for its thoroughness and objectivity; he uses the lens with an almost scientific detachment to reveal the true nature of man's actions.

Baltz's first great success was a body of work documenting the office and light-industry spaces in Southern California, *The New Industrial Parks near Irvine, California* series of 1974. Although these photographs attempt to present a neutral attitude, they do not refrain from conveying his distrust of the future. They are an ironic and, at times, bitter elegy to the spirit of Eden that symbolized the West before developers began their depredation. Images of the insides and outsides of buildings and detail after subtle detail allude to the annihilation of an environment overwhelmed by the compulsive construction of streets, office complexes, and warehouses. Part of this series, *Industrial Structure during Painting, Irvine*, depicts a simple building facade. Its minimalist structure, composed of rigidly geometric components, such as squares and rectangles, calls attention to the sterility of these industrial parks. The two-foot-high shrubs struggle to survive, showing the incompatibility of living things with these man-made environments.

Baltz's scrupulous accounting and his detailed evidence make clear that the principles of art can be brought to bear on problems that are social in nature. His inner sense of equilibrium and his ability to choose the moment that isolates elements for full consideration arrest our attention and allow his message to sink in.

Plate 19

Surrealism

Man Ray

American, 1890–1976

Untitled

1922
gelatin silver print
(Rayograph)
11 15/16 x 9 3/8"
(30.4 x 23.8 cm)
Purchase
82.151

Dada and Surrealism, in their broadest definition the children of Freudian psychology, have had a profound influence on twentieth-century photography. Yet, only a few photographers were directly involved with both movements. Among these, Man Ray is the most important. As a young painter in New York and nearby Ridgefield, New Jersey, he associated with progressive writers and poets, and anarchists. He experimented with avant-garde forms of poetry and became a political radical. During World War I, he was a member of New York Dada, a group led by Marcel Duchamp and Francis Picabia, two Parisian artists who, in 1915, found the neutrality of America a more congenial atmosphere for their artistic endeavors. Initially, in 1915, Man Ray took up photography to document his own paintings, but he soon began experimenting with the medium, drawing upon the machine motifs of both Duchamp and Picabia.

In 1921 Man Ray went to Paris, carrying with him many of the ideas he had absorbed from these two artists, who had by then returned to Europe. There Man Ray's playful wit gained him immediate acceptance, first among the Dadaists and later the Surrealists. Man Ray's most Dadaist pictures made in Paris were the result of an accident. As he later wrote, while working in his darkroom at the Hôtel des Ecoles and waiting for some of his commissioned fashion photographs to develop, he "mechanically placed a small glass funnel, the graduate and the thermometer in the tray on the wetted paper. I turned on the light; before my eyes an image began to

form, not quite a simple silhouette of the objects as in a straight photograph, but distorted and refracted by the glass more or less in contact with the paper and standing out against a black background, the part directly exposed to the light."[1] These cameraless images, named "Rayographs" by Man Ray, captured the spirit of Dada in their unexpected and enigmatic imagery, their white "shadows" and partially revealed objects. The apparent automatism of the process and the use of commonplace objects also appealed to the Dada sensibility, which applauded chance and believed in the pictorial validity of prosaic materials. Man Ray created his Rayographs by "taking," as he said, "whatever objects came to hand; my hotel-room key, a handkerchief, some pencils, a brush, a candle, a piece of twine."[2]

In this untitled Rayograph the central image of the dangling door key lends the work an evocative, autobiographical quality. Man Ray has also included his hand, a frequent symbol of creativity in his work and in the photograms of László Moholy-Nagy. To underscore this idea of creativity, he depicts an egg form in the upper left. As in his other Rayographs, he has unified diverse elements and expanded the range of significance of simple things; he "transforms the everyday object into something mysterious."[3]

[1] Quoted in Arturo Schwarz, *Man Ray: The Rigour of Imagination* (New York: Rizzoli, 1977), p. 236.

[2] Ibid.

[3] Caption for one of Man Ray's Rayographs published in László Moholy-Nagy, *Painting, Photography, Film* (London: Lund Humphries, 1969), p. 77; translation of Ladislaus [László] Moholy-Nagy, *Malerei, Fotografie, Film*, 2d ed. rev., Bauhausbücher, 8 (Munich: A. Langen, 1927).

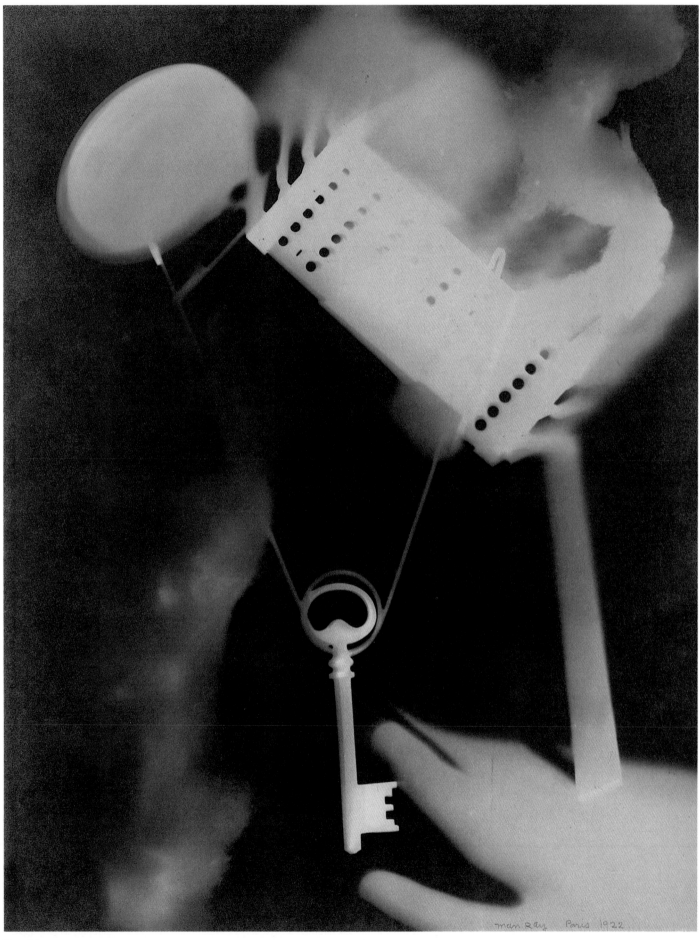

Plate 20

László Moholy-Nagy

American, born Hungary,
1895–1946

**Puppen
(In der Mittagssonne;
Puppen im Sonnenbad)**

(Dolls [In the Midday Sun;
Dolls Taking a Sunbath])

1926
gelatin silver print
9 11/16 x 7 7/8"
(24.6 x 20.0 cm)
Purchase
82.26

The eighth volume in the Bauhaus series of books, *Malerei, Fotografie, Film* was written by László Moholy-Nagy and first published in 1925. The discussion of photography there is based on the premise that the photograph has the potential to reveal what the human eye cannot see. According to Moholy-Nagy, the camera is able "to *make visible* existences which cannot be perceived or taken in by our optical instrument, the eye; *i.e., the photographic camera can either complete or supplement our optical instrument, the eye.*"[1] In addition to examining the use of extreme close-ups and unusual vantage points in straight photography, he also discussed and included examples of such innovative techniques as negative prints, multiple exposure, and photomontages. Despite this comprehensive statement on photography, specific classes in the medium were not taught at the Bauhaus until 1929. Experiments using photography, however, were often carried out in the foundation course taught by Moholy-Nagy, who was a master professor at the Bauhaus from 1923 to 1928. Students were aware of Moholy-Nagy's own revolutionary photographs not only from books and articles, but also from exhibitions held at the Bauhaus.

Puppen (*Dolls*) was included in the second edition of *Malerei, Fotografie, Film*, published in 1927. The image is one of several employing a fence and its shadow as a backdrop which were taken in Ascona in 1926 while Moholy-Nagy and his wife, Lucia, were on vacation with fellow Bauhaus master Oskar Schlemmer and his family. In each variation the subject—either Schlemmer, his two children, or dolls (perhaps the toys of the Schlemmer children)—is reclining and is viewed from above. Within this group of photographs, *Ascona*, the work most similar to *Dolls*, is more tightly framed and presents one doll instead of two. By shooting from above and at an angle and by using dramatic contrasts of light and dark patterns, Moholy-Nagy made these conventional photographs into something novel.

Dolls came at a time when reverberations of Surrealism were reaching Germany from Paris. Indeed, in *Malerei, Fotografie, Film*, Moholy-Nagy wrote the following caption for *Dolls*: "The organisation of the light and shade, the criss-crossing of the shadows removes the toy into the realm of the fantastic."[2] When Moholy-Nagy was experimenting with the space, design, and placement of elements in the camera's viewfinder, he may have realized that there were other factors at work in this picture, factors related to the work of the Surrealists with which he was becoming familiar. The toy dolls appear to be more than nominal subjects within an unusual composition emphasizing flat patterning and a new experience of space. They are an early instance of a provocative motif that became an important part of Surrealist iconography during the 1930s. Always an explorer, it seems that Moholy-Nagy may have taken this picture with formal concerns in mind, but then sensed that it was connected to the "realm of the fantastic."

[1] László Moholy-Nagy, *Painting, Photography, Film* (London: Lund Humphries, 1969), p. 28; translation of Ladislaus [László] Moholy-Nagy, *Malerei, Fotografie, Film*, 2d ed. rev., Bauhausbücher, 8 (Munich: A. Langen, 1927).
[2] Ibid., caption of photograph reproduced on p. 92.

Figure 33 László Moholy-Nagy. Untitled (Portrait of Oskar Schlemmer), 1926. Gelatin silver print.

Figure 34 László Moholy-Nagy. *The Schlemmer Children*, 1926. Gelatin silver print.

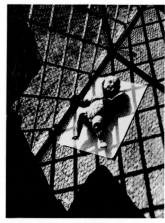

Figure 35 László Moholy-Nagy. *Ascona*, 1926. Gelatin silver print.

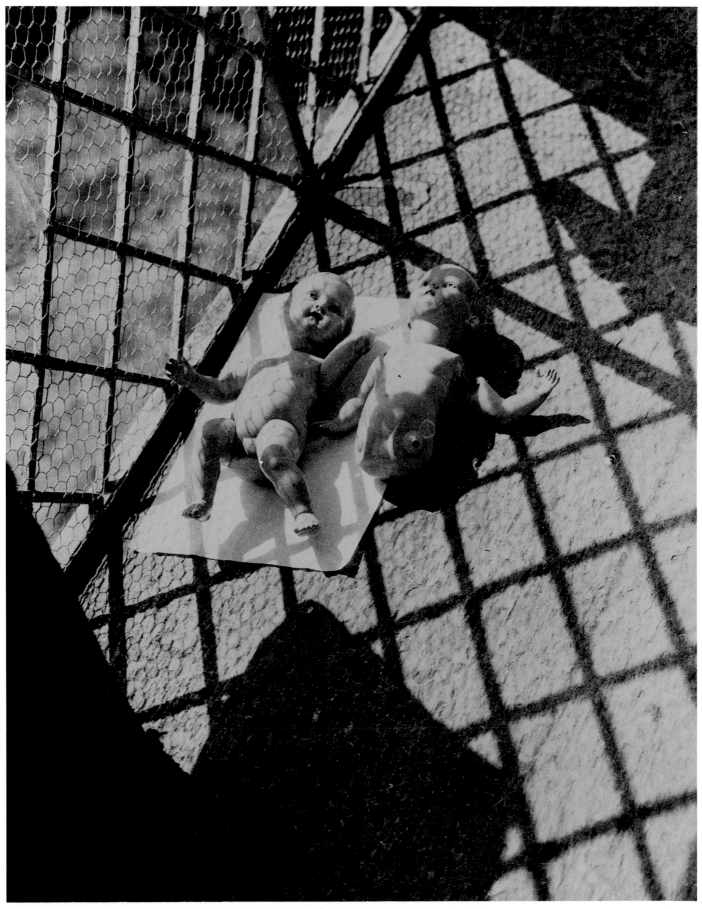

Plate 21

Roger Parry

French, 1905–1977

Untitled

1929
from the deluxe edition book
Banalité, Paris, 1930
gelatin silver print with toner
8 9/16 x 6 9/16"
(21.8 x 16.7 cm)
Gift of Robert Shapazian
82.543

A graduate of the Ecole des Beaux-Arts, Roger Parry was a young painter in Paris when, in 1928, he met the photographer Maurice Tabard. Parry became Tabard's studio assistant and learned photography from him. In the spirit of his mentor, Parry soon began making experimental photographs on his own—double exposures, photograms, and photomontages. By around 1930 his images were being published in such well-known publications of the era as *Photographie*, *Vu*, and *Voilà*, confirming his growing stature as an imaginative Surrealist artist.

While Parry achieved a surreal mood through such innovative techniques as multiple exposures, he captured this feeling with straight photography as well. In this untitled image of an abandoned interior,[1] for example, clues to the meaning may be found in the inverted, late-nineteenth-century portrait of a man and woman that rests on the floor, a rolled-up floor covering, a tangled piece of rope, and a pile of dust and debris. They suggest a human presence that once was. Yet, glowing light from the hallway penetrates this deserted room, casting eerie shadows, and the door is ajar, creating an air of ominous anticipation. Parry touches upon one of the most powerful and unsettling dream experiences, the unavoidable moving through space to a potentially dangerous situation. In tune with the romantic quality of much of Surrealism, he has masterfully succeeded in effecting a mood of anxiety that invokes subconscious fears.

Figure 36 Roger Parry. Untitled, 1929, from the deluxe edition book *Banalité*, Paris, 1930. Gelatin silver print with toner.

[1] This photograph is one of sixteen original prints from a deluxe edition of *Banalité*, a book of Surrealist prose and poetry by Léon-Paul Fargue, published in Paris in 1930 by Editions de la Nouvelle Revue Française. The original version of *Banalité*, published in 1928, was not illustrated. Intrigued by this collection of Surrealist writings, Parry wanted to publish an illustrated version and, thus, in 1929, made sixteen photographs specifically for this purpose. He was assisted by the artist and actor Fabian Loris, who was evidently responsible for making the cutouts that Parry used in his photograms included in this new edition.

Special thanks are owed both Robert Shapazian and Nicholas Callaway for generously sharing their knowledge about the life and work of Roger Parry.

Plate 22

André Kertész

*American, born Hungary,
1894–1985*

Untitled

1929
gelatin silver print
6 1/8 x 7 5/8"
(15.6 x 19.4 cm)
Purchase
79.261

André Kertész had an acute power of observation and an active imagination that matched his complex personality. In the late 1920s he quickly grasped how Surrealism could be applied to photography. His rarely seen pictures of fortune-tellers possess a psychological depth that exemplifies this.

In 1930, a time of uncertainty in France when long-held beliefs were questioned and a new fascination with mystery, superstition, and religious mysticism was on the rise, *Vu* magazine commissioned Kertész to photograph fortune-tellers for a story entitled "Chez les marchands d'avenir" by Jean Portail.[1] Kertész had already turned to the subject, for the untitled image reproduced here was first published in the *Berliner Illustrirte Zeitung* in 1929 and then included, among other photographs, in *Vu* in 1930, where it was featured on the first page of the story, cropped to show no more than the round crystal ball. The work addresses the idea of the subconscious as the source of psychic knowledge. As a means of seeing the past

and predicting the future with heightened significance, the crystal ball differs from the conventional mirror, for its curved surface distorts the mirrored image, transforming it into a fantastic, compact world. The reflected image creates a sense of wonder and wisdom; one imagines the wonder of the person whose fortune is being told and the wisdom of the far-seeing visionary who quietly reads her tarot cards.

This photograph extends Kertész's early interest in the distortion of the human form as seen in his 1917 photograph *Underwater Swimmer*. But more importantly it presages his well-known nude distortions of the early 1930s. This concern with distortion by means of reflecting glass balls or mirrored surfaces was featured by László Moholy-Nagy in his book *Malerie, Fotografie, Film*, first published in 1925 and reissued in 1927.[2] By the late 1920s, Kertész in France, Albert Renger-Patzsch, Walter Funkat, and Georg Muche in Germany, and Alexander Rodchenko in Russia were experimenting with this idea.

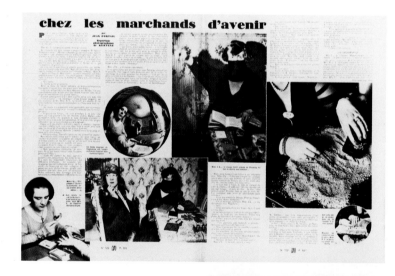

Figure 37 André Kertész. Pages from *Vu* magazine, September 3, 1930.

Figure 38 André Kertész. Back cover of *Vu* magazine, September 3, 1930.

Figure 39 Georg Muche. Untitled, ca. 1925. Gelatin silver print.

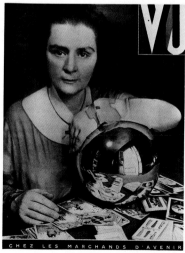

[1] David Travis, "Kertész and His Contemporaries in Germany and France," in *André Kertész: Of Paris and New York*, exhibition catalogue (Chicago: Art Institute of Chicago/New York: Thames & Hudson, 1985), p. 48.

[2] Published in English as *Painting, Photography, Film* (London: Lund Humphries, 1969); translation of Ladislaus [László] Moholy-Nagy, *Malerei, Fotografie, Film*, 2d ed. rev., Bauhausbücher, 8 (Munich: A. Langen, 1927).

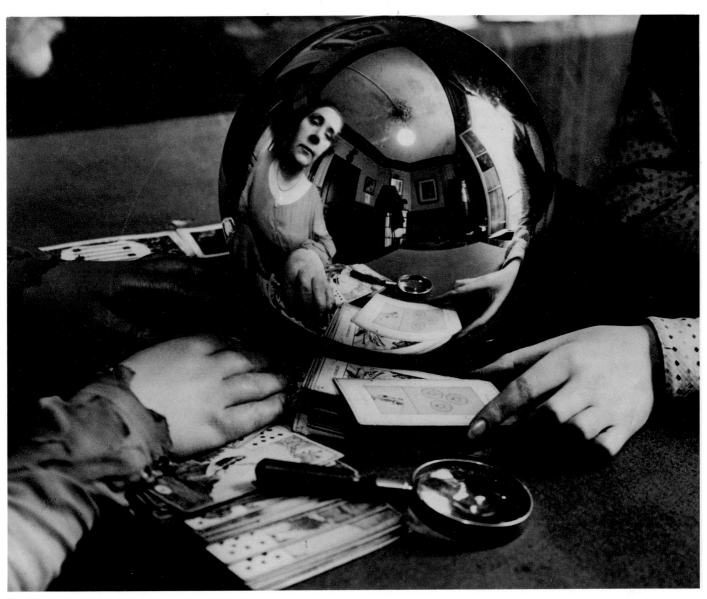

Plate 23

Henri Cartier-Bresson

French, born 1908

Roman Amphitheater, Valencia, Spain

1933/ca. 1979
gelatin silver print
9 1/2 x 14 5/16"
(24.2 x 36.4 cm)
Gift of Mr. and Mrs.
Frank Spadarella
82.163

Henri Cartier-Bresson is a neutral observer with no obvious feelings of discontent about society. As his eye quickly pans along a peopled street or a city's open spaces, form *becomes* content. The arrangement of parts in his photographs takes on a spirit and meaning in itself, as might be expected from a student of André Lhote, the premier teacher of the canons of Cubism in Paris in the 1920s.

In his first important body of work, much of it done in Spain in the early 1930s, concern with composition is clearly evident, as is a more-than-casual awareness of Surrealism. This is not surprising, for Cartier-Bresson knew well the poet and novelist Louis Aragon, one of the leading figures in the Surrealist movement, and was acquainted with other members of the Surrealist circle in Paris. From today's vantage point, there is justification for the opinion that in the early 1930s Cartier-Bresson was the best and most mature of the Surrealist photographers, although his work does not appear in any of the Surrealist periodicals. To achieve his effects, he did not resort to experimental techniques, such as the multiple printing of negatives, solarization, photograms, or negative prints in order to convey a dreamlike state. Indeed, there is nothing inherently surreal about Cartier-Bresson's pictures of the time; he merely saw the commonplace with keen eyes that were attentive to enigmatic details and ambiguous spaces.

Roman Amphitheater, Valencia, Spain of 1933 exemplifies the magic confluence of form and mystery within one image. The light reflected from the eyeglasses of the attendant who looks through the rectangular opening and the turn of the boy's out-of-focus body standing in the background create a provocative image. Certainly, one would not initially think of this scene as dreamlike, with Freudian implications, yet it somehow elicits a chilling sensation. Due to the uneasy relationship of the two people in their respective spaces defined by the painted, broken circle that evokes a curious impending violence, we slip into an altered psychology bordering on the dream.

This picture reminds one of the discontinuity of photocollage, a popular means among the Surrealists of the 1930s for suggesting the never-never land of half-record, half-hallucination. In such images, which are beyond rational analysis, there is also a haunting quality in the strange scale relationships. In this work, and in similar pictures of the same period, it is the small things that are peculiar and imbue the pictures with an unsettling feeling.

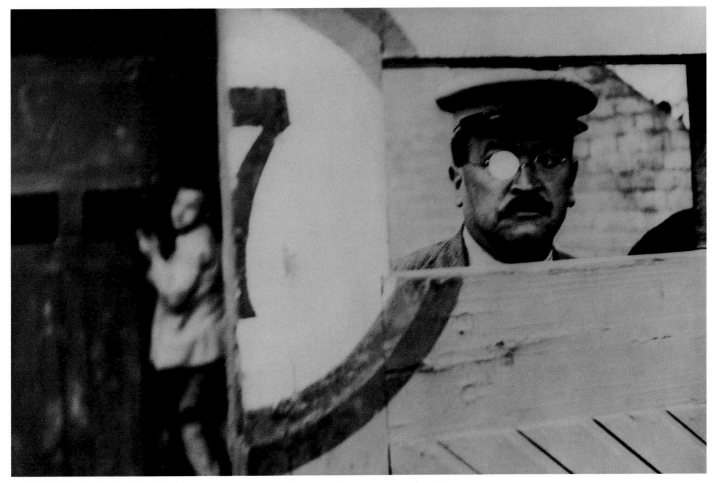

Plate 24

Studio Ringl & Pit
(Grete Stern and Ellen Rosenberg Auerbach)

Argentine, born Germany, 1904;
American, born Germany, 1906

Pétrole Hahn

1931
gelatin silver print
9 3/8 x 11 1/8"
(23.8 x 28.3 cm)
Purchase
83.35

In the heady days of Berlin's pre-eminence as a city of new ideas, innovative commercial photographers were given an opportunity to express their imagination in the service of clients eager to create ties with the vogue for modern Surrealist photography. In Berlin in the 1920s, there were a number of women photographers operating portrait studios, such as Elli Marcus and Lotte Jacobi. There were also some women photographers doing advertising work, a rarity in Paris, London, or New York. Among the best of this new breed were the young partners, Grete Stern and Ellen Rosenberg (later Auerbach), who, in 1930, founded Studio Ringl & Pit. Named after the respective childhood nicknames of these two young women, Studio Ringl & Pit worked with a great variety of clients, from cigarette manufacturers to distributors of petroleum products, creating original solutions to the problem of product identity.

With great imagination, these two photographers made this 1931 advertising photograph for the hair lotion, Pétrole Hahn, which catches the eye and conveys the interest of the time in Surrealism. The image depicts an attractive woman holding up a bottle labeled "Pétrole Hahn," implying that her beauty is derived from the use of this product. Upon close examination, we realize that although she is a mannequin, her hand is real, a circumstance that forces the potential buyer to look again, a major aim of an advertisement. This Surrealist juxtaposition of real and unreal is a clever and powerful way to imprint the sales message while also being a fresh aesthetic approach.

Figure 40 Studio Ringl & Pit. *Komol,* ca. 1931.
Gelatin silver print.

Plate 25

Hans Bellmer

German, born Silesia,
1902–1975

Maschinengewehr
im Zustand der Gnade/
La Mitrailleuse
en état de grâce
(The Machine Gun
in a State of Grace)

1937
gelatin silver print with oil
and watercolor
25 1/2 x 25 1/2"
(64.8 x 64.8 cm)
Gift of Foto Forum
84.123

Hans Bellmer went against the grain of conventional society, first as a draftsman-sculptor, then as a photographer. As part of his rebellion he aligned himself with the Neue Sachlichkeit (New Objectivity) artists George Grosz and Otto Dix, two of the most provocative painters working in Berlin in the early 1920s. Like Grosz, Bellmer used sex to symbolize the decay of German society after World War I.

In the early 1930s, this concern led to Bellmer's making his first puppet doll, fabricated from a wood-and-metal skeleton and wooden shell layered with flax fiber and plaster of Paris. His fascination with children's toys was encouraged by his friendship with the Berlin dollmaker Lotte Pritzel and his love of Max Reinhardt's elaborate production of Offenbach's opera *Tales of Hoffmann*, which features an automated doll. Bellmer's doll-object could assume numerous positions, from normal to bizarre, all of which he photographed.

Figure 41 Hans Bellmer. *Maschinengewehr im Zustand der Gnade (Machine Gun in a State of Grace)*, 1937. Gelatin silver print with gouache.

In 1934 he published these images himself, and in 1935 they were reproduced in the winter issue of the Surrealist journal *Minotaure*. That same year, Bellmer constructed a second, more flexible doll with a central ball joint, which he also photographed extensively.

Bellmer's photographs are not mere recordings of dolls. They are jarring, mordant images that exude an eccentric sexuality that is often heightened by the mechanical-human references. The most mechanized human presence Bellmer created and used as a photographic model was one he named "The Machine Gun in a State of Grace." The wood-and-metal frame of this doll-object is fully exposed, with the face and breasts developed. The unexpected combination of elements creates a strange dreamlike feeling, a mood accentuated in the photograph by the tawny oil paint Bellmer added to create an environment of indefinite place and scale. The pink wash on the doll's lips and nipples heightens the sense of surreality. The other known photograph of this object in this particular configuration[1] is embellished with watercolor, making the Museum's work unique with its background painted in oil. This hand-worked picture is an early example of the extension of creative photography into the traditions of painting.

[1] *Photographien/Hans Bellmer*, with text by Alain Sayag (Munich: Schirmer-Mosel, 1983), cat. no. 169. For other photographs in the series which present the doll-object in different configurations against varying backgrounds, see ibid., cat. nos. 87 and 170.

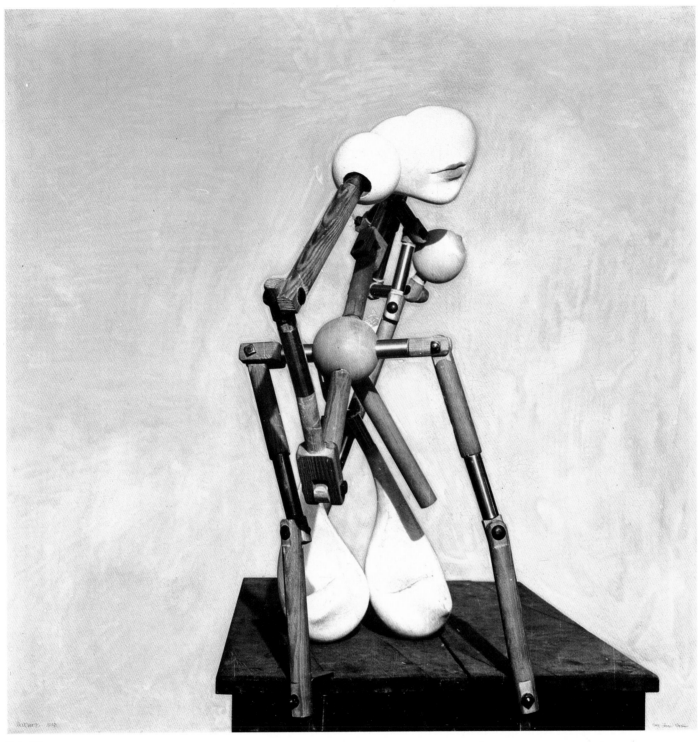

Plate 26

Herbert List

German, 1903–1975

Santorin

1937
gelatin silver print
11 1/2 x 9 1/2"
(29.2 x 24.2 cm)
Purchase
82.323

Herbert List is another German photographer who paid tribute to Surrealism. He became aware of the movement through literature while a student in Heidelberg during the early 1920s. After finishing school he had a successful career in his family's coffee business, but left the concern in 1936 to become a photographer. Unlike most innovative German photography done between the wars, List's pictures are lyrical.

Santorin, for example, his 1937 photograph of a goldfish in a bowl, is rich in connotation and implies much more than a first glance reveals. It can be viewed either as related to the infinite spaces in Salvador Dali's or Yves Tanguy's Surrealist paintings, or as a pleasant vista in the Greek islands. The clarity of the image produces an intense physicality that is disquieting and mysterious, recalling the irrational but convincing juxtapositions in the early paintings of Giorgio de Chirico. By contrasting the restricted space of the bowl with the limitless space of the sea, List creates a metaphor for all living things that are artificially restrained. In poetic terms, the goldfish represents a captive pet or a beautiful bauble kept in confinement to amuse its owner, or to decorate or animate man's spaces.

Of *Santorin*, List has commented: "A goldfish bowl placed on a balustrade against the background of the shining sea can make an attractive still life, provided the composition is well balanced. However, there is another dimension to this photograph. The fish in its confining bowl placed against the open sea symbolizes the human spirit. Because of its earthliness this spirit cannot entirely liberate itself from material things. It can merely sense the magnificence of the world beyond, but—being confined within a body—the spirit cannot become immersed in that other world."[1] Like other artists of his generation—Paul Klee, Jean (Hans) Arp, Vasily Kandinsky—List sought to find through art an inner essence and a sense of spirituality.

[1] Quoted in Günter Metken, *Herbert List: Photographs 1930–1970*, introduction by Stephen Spender (New York: Rizzoli, 1981), p. 18.

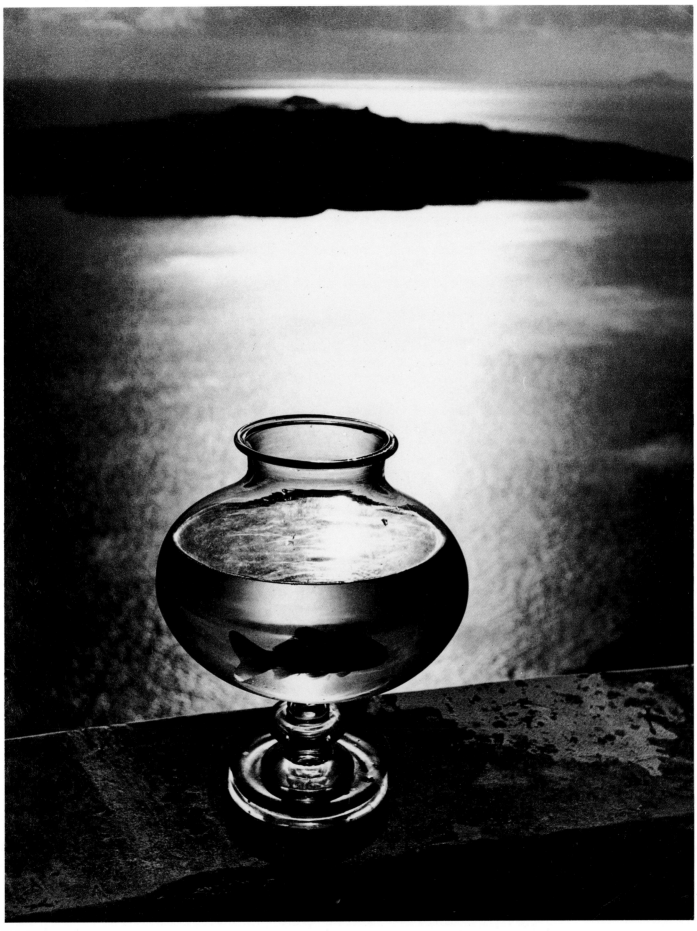

Plate 27

Dora Maar

French, born 1907

Untitled

1935
photomontage
8 5/8 x 10 1/16"
(21.9 x 26.9 cm)
Fund of the 80's Purchase
84.150

[1] In his design for the cover for the first issue of *Minotaure*, Picasso featured the minotaur. During his close association with the Surrealists, from the late 1920s through the 1930s, he continued to pursue the legend of Theseus. Raoul Ubac (plate 33), who, with Man Ray (plate 20), was a frequent contributor to *Minotaure*, referred to the mythical Amazons in his series of photographs known as *The Battle of Penthesilea* (ca. 1939). Mythological references also appear in the work of Max Ernst and Salvador Dali, who were closely associated with *Minotaure*.

[2] Pierre Cabanne, *Le Siècle de Picasso* (Paris: Denoël, 1975), p. 488.

[3] Maar herself has referred to the work as oneiric: "Titre et sujet 'Onirique' mais j'aime mieux sans titre"; letter to Diana du Pont, April 2, 1985.

[4] The motif of the upside-down head here calls to mind the inverted head of the dead child that appeared two years later in Picasso's *Guernica*, a work that was documented from inception to completion by Maar's photography. Picasso had treated the theme of the mother and dead child over the years, particularly in the early 1930s in a series of paintings and drawings entitled *Les Sauvetages* (*The Rescuings*). No proof exists, but the question arises as to whether Maar's photomontage acted as a catalyst for the re-emergence of the theme, with a new intensity of expression, in *Guernica*. Another provocative comparison is the image of the woman and dead child in Sergei Eisenstein's film *Potemkin*, first shown in Paris in 1926. However, Maar has stated that she was not familiar with the film; letter to Diana du Pont, op. cit. Nonetheless, the appearance of the inverted head in Eisenstein's film, as well as in Picasso's painting, demonstrates an iconography of violence that may provide some clue to the role this device plays in Maar's work.

[5] Letter to Diana du Pont, op. cit.

For artists dedicated to exploring man's unconscious motivations, as the Surrealists were, the psychoanalytic interpretation of myths, as well as of dreams, seemed a rich resource. They understood that even though myth operates in the realm of the supernatural, one of its enduring characteristics has been its concern with human nature.

The most explicit manifestation of Surrealism's response to the power of myth was *Minotaure*, the Surrealist journal published in Paris from 1933 to 1939, which proclaimed its interest by its very title and by its masthead, which listed among its concerns "ethnography and mythology." It is not surprising, then, that the body of Surrealist work in which mythological themes frequently appear is that of artists directly associated with *Minotaure*.[1]

Dora Maar, described as "beautiful . . . always proud and enigmatic," with "a face like a Madonna without a smile" and "an impulsive character capable of sudden rage and thoughtless violence,"[2] was at the very center of the *Minotaure* circle, through her friendship with such leading Surrealist writers and artists as Michel Leiris, Paul Eluard, Man Ray (plate 20), and André Breton. Although not a prolific artist, Maar's images number among the most provocative in Surrealism.

In this unique, untitled photomontage of 1935, Maar's interest in myth is revealed—not as a narrative form expressive of archetypal symbolism, but as a poetic form capable of evoking the oneiric.[3] Her photomontage does not portray a dramatic moment from a familiar mythological tale; rather, it creates a fantastic vision that is mysterious, elusive, and inexplicable. A desolate, forgotten corner in a classical building, moist and dank from years of neglect, is the eerie setting for a startling encounter between the present and the mythic past. Two contemporary male figures in the foreground, one standing and holding the other upside down over his shoulder, engage the viewer's immediate attention, while in the background, Athena quietly observes. What is happening is ambiguous, for there is no simple description here; all is evocation. Are we witnessing a rescue? or an abduction?[4] The atmosphere is laden with mystery, and a pervasive silence stills the scene. Maar has said, "The calm of the figures is Surrealist,"[5] yet an ominous feeling pervades the atmosphere, like the disquieting expectation that fills the empty, melancholy piazzas of de Chirico's early paintings.

Maar's personalization of myth, her use of it as a means of creating something rare and esoteric epitomizes the Surrealist vision. In isolating a mythic figure and juxtaposing it with contemporary experience, Maar subverts the collective understanding of myth and introduces a new extraordinary reality, a private realm of fantasy, in which the Surrealists sought liberation and deeper understanding.

Figure 42 Pablo Picasso. Detail of *Guernica,* 1937. Oil on canvas.

Figure 43 Mother carrying her dead son, from Sergei Eisenstein's film *Battleship Potemkin*, 1925.

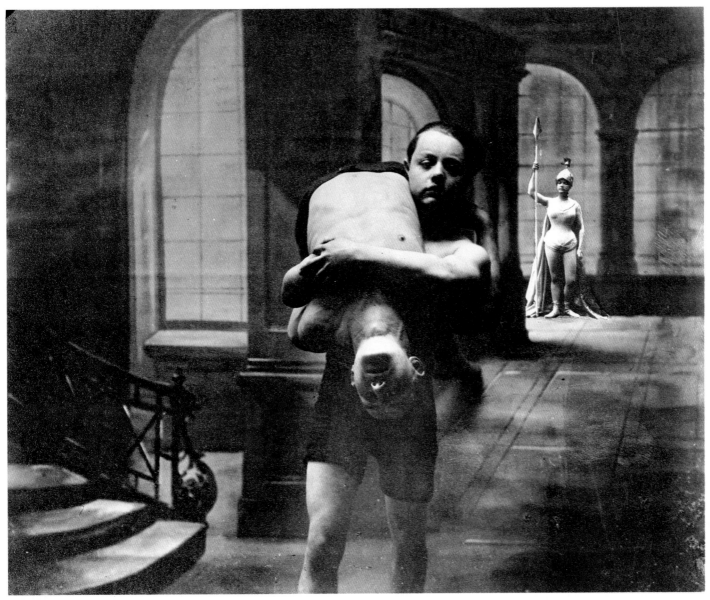

Plate 28

Georges Hugnet

French, 1906–1974

Initiation préliminaire aux arcanes de la forêt
(Preliminary Initiation into the Secrets of the Forest)

1936
photocollage
7 3/4 x 10 1/8"
(19.7 x 25.7 cm)
Purchased through a gift of Dr. and Mrs. Allan Roos
81.187

In 1920, at the age of fourteen, the budding poet Georges Hugnet became acquainted with Jean Cocteau, Pablo Picasso, Marcel Duchamp, Max Ernst, and other avant-garde artists whose work prefigured Surrealism. Encouraged by them, he wrote imaginative verse and eventually became an art critic, as well as a maker and publisher of hand-crafted books. From 1928 to 1934, books of his poetry issued in limited editions were illustrated by such prominent artists as Eugene Berman, Stanley William Hayter, Joan Miró, and Salvador Dali.

Given the kind of people he knew and the avant-garde art he was exposed to, especially Surrealism beginning in the late 1920s/early 1930s, it is not surprising that in 1934 he began to create wonderfully strange collages. He took snippets of photographs, combined them with elements from advertisements and other printed sources, and ultimately added handwritten text.

During Hugnet's association with the Surrealists, sexual themes were predominant, as seen in this 1936 photocollage entitled *Initiation préliminaire aux arcanes de la forêt*.[1] Hugnet evokes a sense of narrative, but where and when the episode is taking place is a mystery, for the setting is without clues as to time or location. In this netherworld, this subterranean tunnel laden with a network of industrial pipes, sex and violence are implied by partially nude females at the mercy of robed and hooded figures. As bizarre and unexpected as the scenario is the bright yellow flower that emerges in the center. For Hugnet and other Surrealists, such as Dali and Hans Bellmer (plate 26), the theme of sexual violence and perversion touched the depths of the human subconscious.

[1] It is interesting to note that the Surrealist Max Ernst wrote a short, poetic piece on the forest and its magic called "Les Mystères de la forêt," which was published in *Minotaure*, no. 5 (December 1934), p. 6.

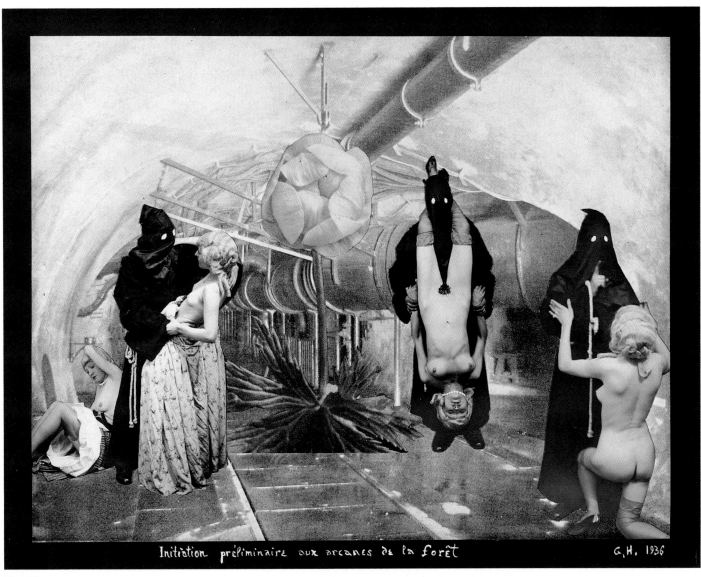

Initiation préliminaire aux arcanes de la forêt G.H. 1936

Plate 29

Erwin Blumenfeld

American, born Germany, 1897–1969

Cecil Beaton

ca. 1937
gelatin silver print
(solarized)
12 3/4 x 9 7/16"
(32.4 x 24.0 cm)
Purchase
83.26

Erwin Blumenfeld became one of the most adept practitioners of the part negative—part positive process of solarization. As a professional fashion photographer, first in Paris in the late 1930s and then in New York in the 1940s and 1950s, he was always alert to new photographic techniques that would draw attention to his pictures. Having been an apprentice dress designer in Berlin from 1914 to 1916, Blumenfeld knew how to lend an aura of newness to fashion design by relating it to modern art. In his later photographic work, he understood how the experimental part positive—part negative process, for example, could, by association, make a gown appear as "art" and therefore more desirable to the sophisticated readers of such magazines as *Votre Beauté*, *Vogue*, and *Harper's Bazaar.*

While the human figure, nude or clothed, challenged Blumenfeld's skill in using the solarization process, his best theme for this manipulation was portraiture, as seen in this striking picture of Cecil Beaton taken around 1937. Perhaps to emphasize the dual personality of Beaton, who was both a society portraitist and a friend of many on the fringe of the Surrealist circle in London, Blumenfeld presents a part negative—part positive image. While this manner of representation has Surrealist overtones, it also seems to refer to the simultaneous front-side views of Pablo Picasso's paintings. Ultimately, however, it is difficult to know the extent to which Blumenfeld intended to convey a concept of duality. It may be that he merely wanted to identify Beaton with the London avant-garde by treating his likeness in this unusual fashion. Whatever the case, Blumenfeld's results are intriguing, but also psychologically disturbing.

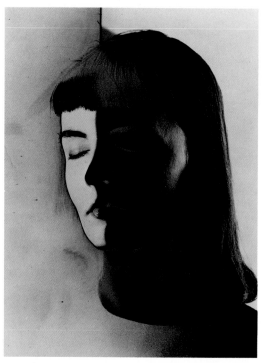

Figure 44 Erwin Blumenfeld. Untitled, ca. 1940.
Gelatin silver print (solarized).

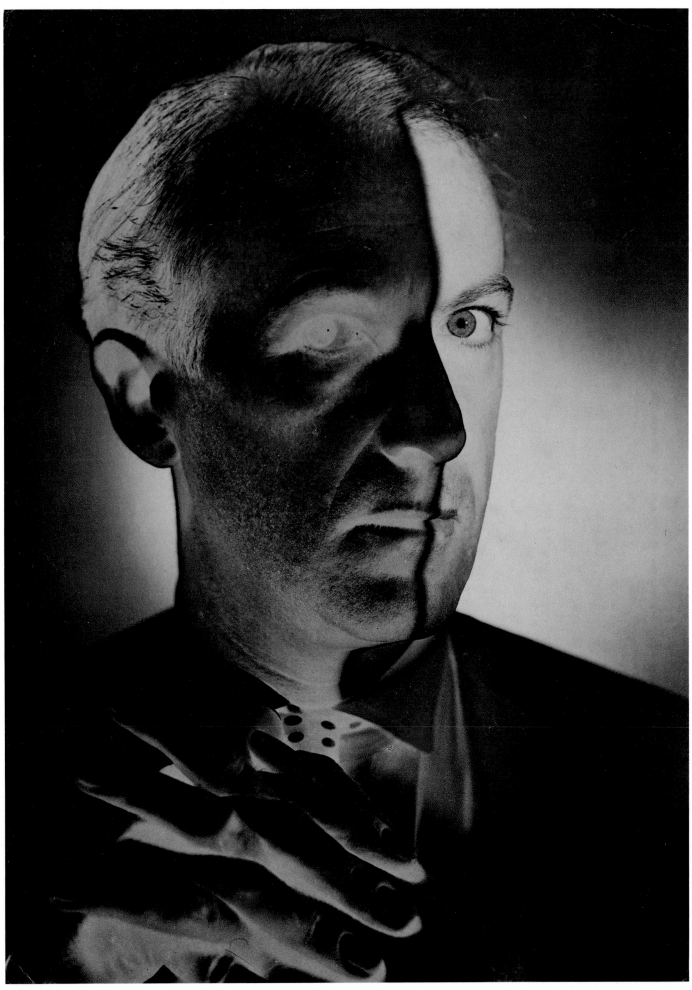

Plate 30

Pierre Boucher

French, born 1908

Ondine

1938
photomontage
11 1/2 x 9"
(29.2 x 22.9 cm)
Gift of Mrs. Virginia M. Zabriskie
83.262

[1] Boucher's work illustrated *Truquages en photographie* [Tricks in Photography] (Paris: Édition Mana, 1938), a book that describes how to do photograms, bas-reliefs, photomontages, distortions, solarization, infrared.

[2] The thirteenth-century German fable of the beautiful water spirit Ondine and the knight who died when he forsook her love for that of a human received its definitive form in the fairy tale published in 1811 by Friedrich Heinrich Karl de La Motte Fouqué (1777–1843). The story became one of the fundamental literary products of the Romantic movement, and throughout the nineteenth century it inspired a variety of literary and musical works. Among these was the 1816 opera, with libretto by La Motte Fouqué, composed by the writer and musician Ernst Theodor Amadeus Hoffmann (1776–1822), whose own stories would become the basis for Offenbach's *Tales of Hoffmann*. The supernatural tale of love and death appealed to the Surrealist imagination and attracted, among others, the French playwright Jean Giraudoux (1882–1944) and the American artist Joseph Cornell (1903–1972).

[3] Letter to Diana du Pont, January 19, 1985.

[4] Ibid.

The work of Pierre Boucher provides an important example of the vigorous and stimulating interchange between experimental and commercial photography that took place in Paris in the 1930s. Like several of his talented countrymen, Boucher bridged revolutionary aesthetic concerns with the demands of the marketplace. His early training was in the applied arts. From 1922 to 1925 he studied at the Ecole des Arts Appliqués in Paris; in 1926 he apprenticed with the printer Draeger; in 1927 he designed publicity material for the Au Printemps department store.

It was while serving in the air force in Morocco, from 1928 to 1930, that Boucher gained a knowledge of the craft of photography. Returning to Paris in 1931, he applied his skills in both graphic design and photography to the areas of publishing, publicity, and advertising, through which he became acquainted with some of the most progressive and creative photographers of the era, Maurice Tabard and René Zuber, for example. Like these adventurous practitioners, Boucher became interested in all the experimental photographic techniques—solarization, bas-relief, photograms, superimpositions, distortions, and photomontage.[1] Of these varied approaches photomontage became his special domain.

In the spirit of the Dadaists and Surrealists, Boucher turned to photomontage as a provocative means of subverting reality, of juxtaposing incongruous figures or objects to transform the ordinary into the extraordinary. In an intriguing paradox, he and other artists of the period viewed photography—reality's truest mirror—as the ideal medium with which to dismember reality. Unlike the incisive political statements of the Berlin Dadaists, or the nightmarish visions of the Surrealists (see plate 29), Boucher's photomontages are closer to bizarre daydreams. Mysterious waters dappled with warm, inviting sunlight or cool glowing moonlight and

inhabited by the female form have often been the subject of Boucher's most ethereal photomontages. In *Ondine* of 1938, for example, the immortal sea nymph[2] for whom the work is titled magically levitates above crystalline water. Her fanciful ears, pleasing smile, and gentle eyes bathed in radiant sunshine evoke a peaceful, tantalizing reverie.

The construction of *Ondine* illustrates Boucher's concept of photomontage as a synthesis of different techniques and approaches. "For me," Boucher has written, "photomontage contains all the forms of montage possible."[3] Here the background is the result of sandwiching two different negatives of water, while Ondine's face and ears are collage elements cut out from other photographs. Originally made for exhibition, *Ondine* piqued the imagination of the Printel advertising agency, which asked Boucher to adapt it for an advertisement for Radio-France, the country's national broadcasting station. The ease with which this work could meet this challenge is evident in Boucher's words: "The sound waves are represented by the undulations of the water, the song of the mermaid and the shells suggest mellifluous and sonorous sound."[4]

At the time, Radio-France was interested in commissioning a series of photomontages for the lobby of their building, but the advent of World War II halted the project. After the war, Boucher's interest in the ideas engendered by this unrealized proposal led to his creation of a mural some twenty-six feet long for a Parisian record producer. This work, in which the motifs of *Ondine* are incorporated within an inventive mélange of drawing, collage, negative sandwiching, and photograms, demonstrates that Boucher continued to explore the fruitful relationship between the avant-garde and the applied arts that informed his work of the 1930s.

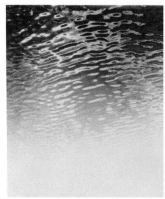 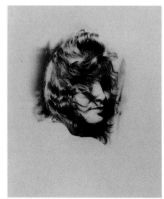 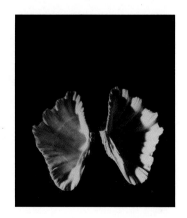

Figures 45–47 Pierre Boucher. Photographs used to create the photomontage *Ondine*, 1938.

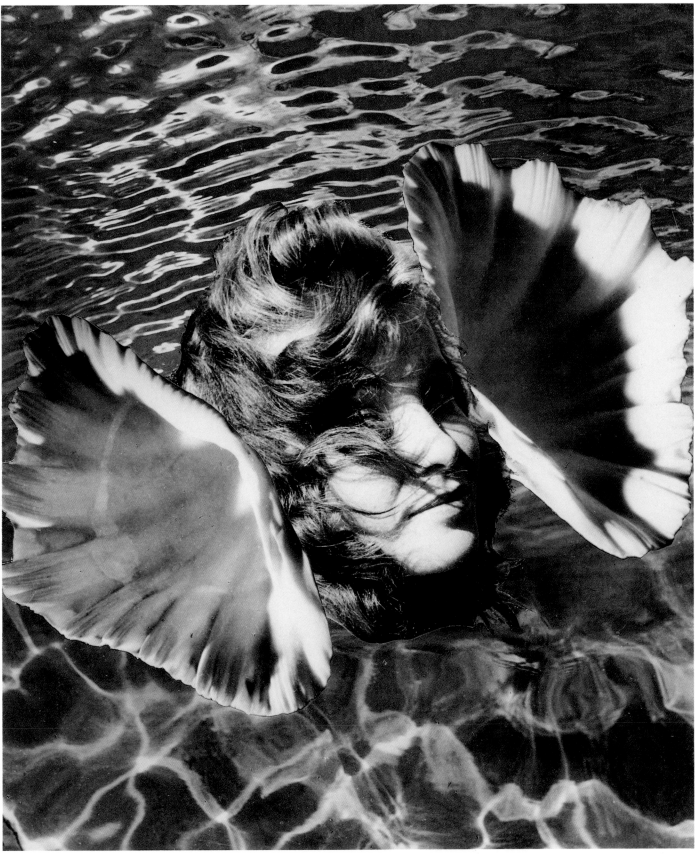

Plate 31

Frederick Sommer

American, born Italy, 1905

Chicken Entrails

1939
gelatin silver print
9 1/2 x 7 5/8"
(24.2 x 19.4 cm)
Gift of Brett Weston
83.410

Frederick Sommer has long felt that religion in the twentieth century requires different and more powerful images to rekindle the sense of mystery that stirred people in the past. By means of photography, he believes, reality can be made poetic and thus engender a fresh symbolism of greater intensity than the familiar metaphors expressed in traditional painting. In virtual exile in a small mountain town in Arizona where the climate was good for Sommer's ailing health, he created new poetic realities by assembling "found objects" for the camera, as seen in his early still lifes of the heads and entrails of chickens. To him, the camera's eye had a special way of expressing the hidden mysteries in these disturbing compositions. "I know that photography has a way of handling some things well and I make more of these available then [*sic*] I could find in nature. If I could find them in nature, I would photograph them. I make them because through photography I have a knowledge of things that can't be found."[1]

It was in 1939 that Sommer began his series of photographs of chicken heads and entrails. While watching butchers disembowel chickens, he recognized in the discarded body parts a new subject capable of tremendous visual and emotional power. He proceeded to make a number of images in which these various chicken parts were arranged so as to create disquieting figurative allusions.

One of the most effective works from this series is *Chicken Entrails* of 1939. The glistening animal juices and the scattered remnants of flesh suggest that an act of violent sacrifice has just occurred. Killing a chicken and examining its entrails was an old means of divination in South America and Africa. To complicate the picture's meaning, a membrane is pulled over the chicken's head to form what appears to be a hood or cowl like those worn by Catholic monks.

Born in Italy but raised in Brazil, Sommer would likely have gained an awareness of the rituals of the pervasive Catholic church, as well as the occult traditions of the native Indians and the legacy of the black African slaves. This may explain, in part, what he had in mind when he took these visceral pictures. Ultimately, the work's complete symbolism is not discernible, for Sommer prefers to suggest rather than reveal his intentions. As in a dream, the essence of this photograph lies deep within us. It has been sublimated by the veneer of culture and exists only in our subconscious.

[1] Quoted in Constance W. Glenn and Jane K. Bledsoe, eds., *Frederick Sommer at Seventy-Five: A Retrospective*, exhibition catalogue (Long Beach, Calif.: Art Museum and Galleries, California State University, Long Beach, 1980), pp. 13, 16.

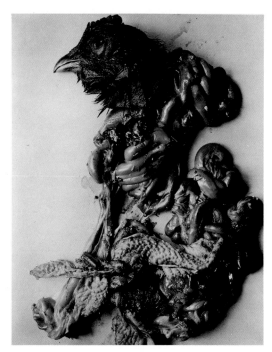

Figure 48 Frederick Sommer. *Chicken Entrails 1st Series #3*, 1938. Gelatin silver print.

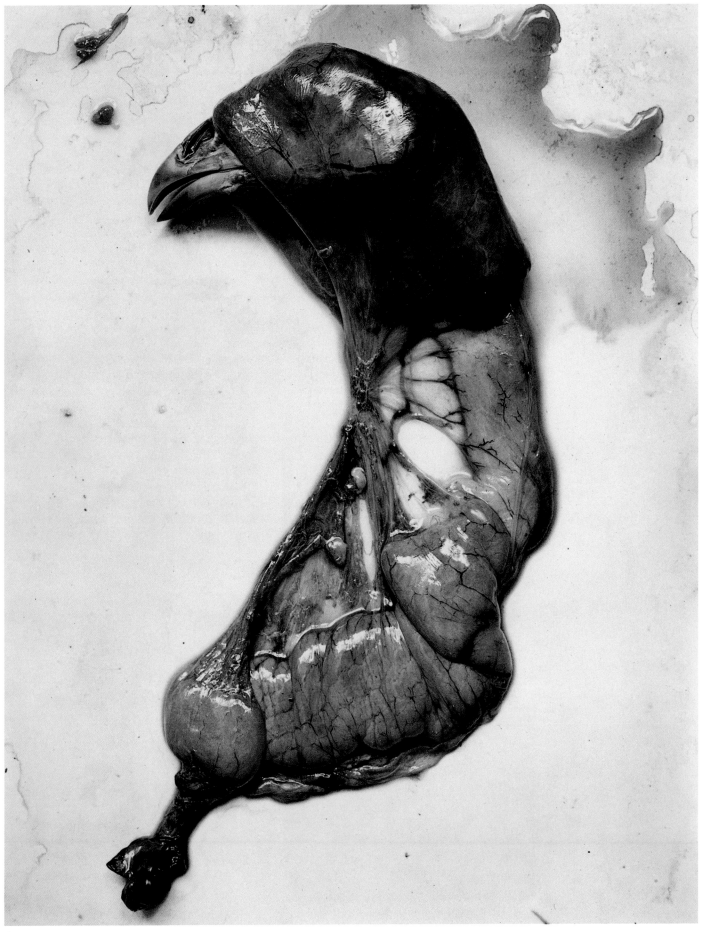

Plate 32

Raoul Ubac

Belgian, 1910–1985

Maquette pour un mur
(Maquette for a Wall)

1938–39
from the series
Le Combat des Penthésilées
(Battle of the Amazons)
gelatin silver print (bas-relief)
6 3/4 x 9 1/2"
(17.2 x 24.2 cm)
Purchase
82.327

The contribution to Surrealism by Belgian artists has often been overlooked. René Magritte is well known, but there were also other Belgian Surrealists of first rank, among them Pol Bury, E. L. T. Mesens, and Raoul Ubac. Of these artists, Ubac became an accomplished photographer. Ubac's interest in photography began in Paris during the early 1930s under the influence of Man Ray. His first photographs date to 1933, when he visited the island of Hvar, off the coast of Yugoslavia, where he became fascinated with the natural groupings of stone in the landscape and tried to capture them in snapshots. In Paris his countryman Magritte paved the way for his acceptance in the Surrealist circle and saw to it that Ubac's work was included in key exhibitions of Surrealism in Belgium. In the late 1930s Ubac, although less influenced by the French Surrealists than Magritte, successfully explored the surreal nature of bas-relief figure pieces created by the imaginative use of photomontage, solarization, and various photographic printing techniques, all of which divorced the original subject from a readily recognized context.

Figure 49 Raoul Ubac. Untitled, 1938–39, from the series *Le Combat des Penthésilées (Battle of the Amazons)*. Gelatin silver print (bas-relief).

For *Maquette pour un mur* of 1938–39, from the series *Le Combat des Penthésilées*, Ubac photographed a single figure in various poses. From the resulting pictures, he made a collage composition which he then photographed and solarized to produce part negative, part positive passages. Next, it appears, he photographed this image twice, and from the resulting negatives created two positive transparencies, which he sandwiched—slightly off register—to create the final work: a bas-relief print made on high-contrast paper in which the figures seem to protrude three-dimensionally as in low-relief sculpture. By joining two positive transparencies, instead of a negative and a positive transparency as in conventional bas-relief printing, Ubac replaced the dark contour lines with broad areas of gray that meld the abstracted composition.[1]

Ubac's series title derives from Greek mythology. Penthesilea, daughter of Otrera and Ares, god of war, was queen of the Amazons. She was mortally wounded by Achilles when she came to the aid of the Trojans after the death of Hector, but her Greek conquerors were so impressed by her valor and beauty that she became legendary. This warring history provides a telling background for *Maquette pour un mur*, which seems like the aftermath of destruction. Human fragments—parts of backs, arms, and legs—appear to drift in a thick, turbid, gray liquid, evoking the kind of ambiguity associated with Surrealism.

[1] For additional information on Ubac's photographic processes, see Rosalind Krauss, Jane Livingston, and Dawn Ades, *L'Amour fou: Photography and Surrealism,* exhibition catalogue (Washington, D.C.: Corcoran Gallery of Art/New York: Abbeville Press, 1985), pp. 70 and 236.

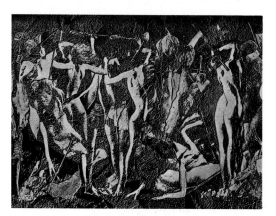

Figure 50 Raoul Ubac. *Le Mur sans fin* (The Infinite Wall), 1938–39. Gelatin silver print (bas-relief).

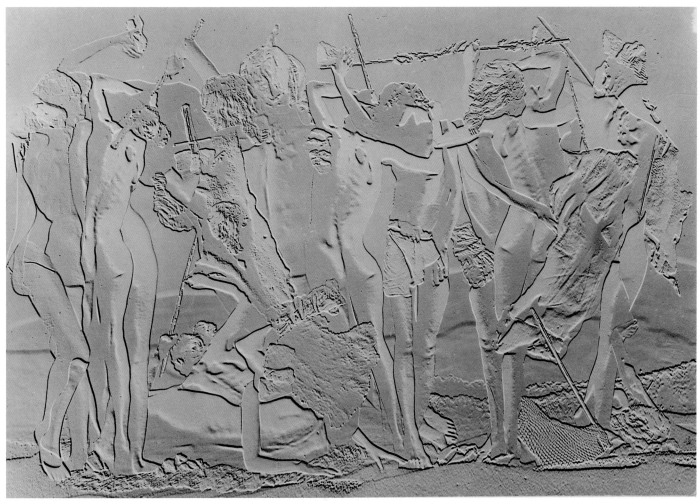

Plate 33

Konrad Cramer

American, born Germany, 1888–1963

Untitled

ca. 1946
gelatin silver print
(negative image)
9 5/8 x 7 13/16"
(24.5 x 19.9 cm)
Purchase
83.167

In the crucial years 1912–13, when the idea of abstraction in painting was being explored in key European art centers, Konrad Cramer provided a direct link between the progressive Blaue Reiter (Blue Rider) group in Germany and the American avant-garde. After establishing a studio in Karlsruhe, where he had studied painting at the Academy of Fine Arts, Cramer made frequent trips to Munich. There, as early as 1910, he became acquainted with the work of Vasily Kandinsky, Franz Marc, and their followers. In 1911 he came to the United States and passed on to a number of artists what he had learned in the movement toward abstraction taking place in Munich. He soon became a friend of Alfred Stieglitz, who photographed him in 1914. In the 1920s Cramer received considerable recognition for his semiabstract paintings executed in the 1913–18 period.

During the late 1930s and early 1940s, Cramer taught photography at Bard College in New York State. As his technical skills developed, he began to write articles for photography publications. From these experiences, and his acquaintance with Stieglitz, grew an interest in using the camera to create pictures of an artistic value equal to that of his paintings.

One of the processes Cramer used to give his photographs a more abstract character was the negative print. Negative prints present images that are familiar, but are not synonymous with reality. Therein lies their secret hold on us. We must study such pictures at length to get our bearings, for they are crossover images that turn day into night. They are unusually graphic, which accounts for Cramer's interest in them, given that he was initially trained as a painter and involved in abstraction from his youth.

This untitled negative print of about 1946 features a classical head and a round-bellied vessel among other studio still-life props. The work expresses a feeling of melancholy that the artist was experiencing at this time, brought about by his belief that his current work was not receiving the kind of attention it deserved. That such a picture can assume psychological dimensions is due to the potential of negative prints to yield content, but not the content of a living moment. They are like shadows, a step removed from but inevitably linked to reality.

Figure 51 Konrad Cramer. Untitled, ca. 1938.
Gelatin silver print (solarized).

Plate 34

Philippe Halsman

American, born Latvia, 1906–1979

Popcorn Nude

1949
gelatin silver print
13 13/16 x 10 7/8"
(35.1 x 27.7 cm)
Clinton Walker Fund Purchase
83.7

"For me photography can be dead serious or great fun," Philippe Halsman observed. "Trying to capture the elusive truth with a camera is often frustrating toil; trying to create an image that does not exist, except in one's imagination, is often an elating game. I particularly enjoy this game when I play it with the surrealist painter Salvador Dali."[1] Halsman first met Dali in 1941, and the two began a friendship and collaboration that lasted four decades. Dali's love of spectacle combined with Halsman's humorous nature resulted in a series of inventive and wildly amusing surrealist pictures more in the spirit of the Marx Brothers than of André Breton or Max Ernst. Some of the most captivating of these photographs are those of Dali jumping in midair.

The idea of photographing Dali in midair was inspired by the painter's composition *Leda Atomica*, which Halsman saw in an exhibition in 1948. Halsman was intrigued by the fact that everything in the work appeared to be suspended. He asked Dali why he called it *Leda Atomica*, and Dali responded, "Because in an atom everything is in suspension—the electrons, the protons, the mesons, neutrons and other junk . . . and since I live in an atomic era I have to paint everything suspended in space."[2] Consequently, Halsman made one of his most famous pictures of Dali. Named *Dali Atomicus*, it shows the painter, three cats, a chair, an easel, a painting, and a spurting stream of water all frozen in midair by stop-action photography. In a tongue-in-cheek homage to Dali, the painting represented within the photograph is Dali's *Leda Atomica*.

Less well known but equally bizarre, and humorous, is Halsman's picture of Dali called *Popcorn Nude*, of 1949. In this photograph, the painter appears to be kicking a female nude up into the air, where she is surrounded by myriad phallic symbols in the form of *baguettes* and bread rolls. In this way Halsman captures Dali's sublimated fear of sex, a recurring theme in the painter's work. The fantastic scenario, Dali's odd facial expression, and the sense that an explosion has been brought to a magical standstill are all qualities that parallel in spirit some of the Spanish artist's most famous Surrealist paintings.

Dali was just one of many world-famous celebrities whom Halsman photographed in midair. Marilyn Monroe, J. Robert Oppenheimer, Grace Kelly, and Richard Nixon, among others, jumped before his camera. In having his subjects perform this unusual exercise, Halsman hoped to capture aspects of their inner personalities normally suppressed in traditional portraiture. He believed this was possible because "the leaping man has little time to compose his face."[3] "In order to be a portrait," wrote Halsman, "the photograph must capture the essence of its subject. Herein lies the main objective of portraiture and also its main difficulty. The photographer probes for the innermost. The lens sees only the surface."[4]

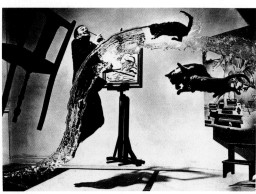

Figure 52 Philippe Halsman. *Dali Atomicus,* 1948/1981. Gelatin silver print.

[1] Philippe Halsman, *Sight and Insight* (New York: Doubleday, 1972), p. 173.
[2] Quoted ibid., p. 177.
[3] Quoted in Owen Edwards, "Halsman: A Tribute," *Portfolio*, vol. 1, no. 4 (October/November 1979), p. 42.
[4] Halsman, op. cit., p. 7

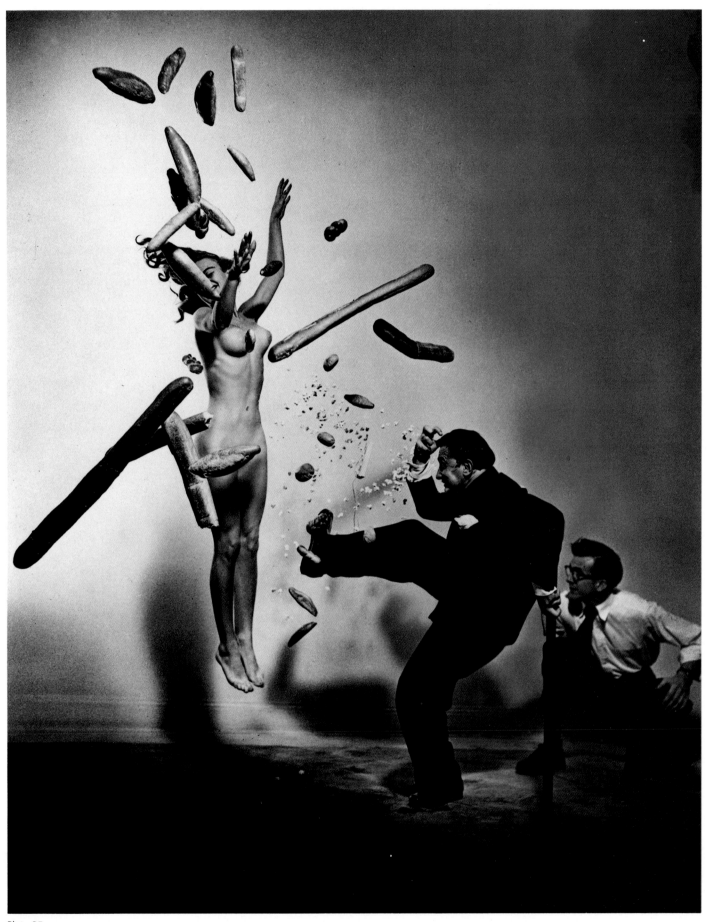

Plate 35

Aaron Siskind

American, born 1903

Untitled (#63)

1956
from the series
*Pleasures and
Terrors of Levitation*
gelatin silver print
10 7/8 x 9 1/2"
(27.7 x 24.2 cm)
Anonymous gift
83.212

While Aaron Siskind's detailed pictures of dripped paint, peeling walls, and graffiti—symbols of the fragmentation of life in our time—have been justly celebrated, his photographs of boys jumping and diving into Lake Michigan are less well known but of equal importance. Collectively titled *Pleasures and Terrors of Levitation*, this series, begun in 1953, demonstrates Siskind's sensitivity as a photographer who can present an ordinary event so that it is seen afresh. Each summer millions of pictures are taken of youngsters diving into pools, ponds, lakes, or oceans, but few evoke the thrill, or fear, of moving through space to the culminating splash in the water as do Siskind's photographs. In his pictures, the boys assume strange postures: some are poised show-offs who look like comical ballet dancers, while others have their arms and legs akimbo, as in this untitled work of 1956. Here, as in other works in the series, Siskind is beginning to explore the aesthetic possibilities of white space as the subject is silhouetted against the sky. With no reference to scale or context, he has captured the boy's innocent amazement in his brief flight through the air.

Works in the *Pleasures and Terrors of Levitation* series touch us directly, as if we ourselves were floating in space, moaning in ecstasy, or shrieking in fright. They sum up as few photographs do the terrifying sense of tumbling into an abyss that occurs in dreams. Breathing is halted, not from fear for the safety of these youngsters throwing themselves into the air with such abandon, but from that innate and deep-seated fear of falling.

Figure 53 Aaron Siskind. Untitled, 1961.
Gelatin silver print.

Figure 54 Aaron Siskind. Untitled (#37), 1953.
Gelatin silver print.

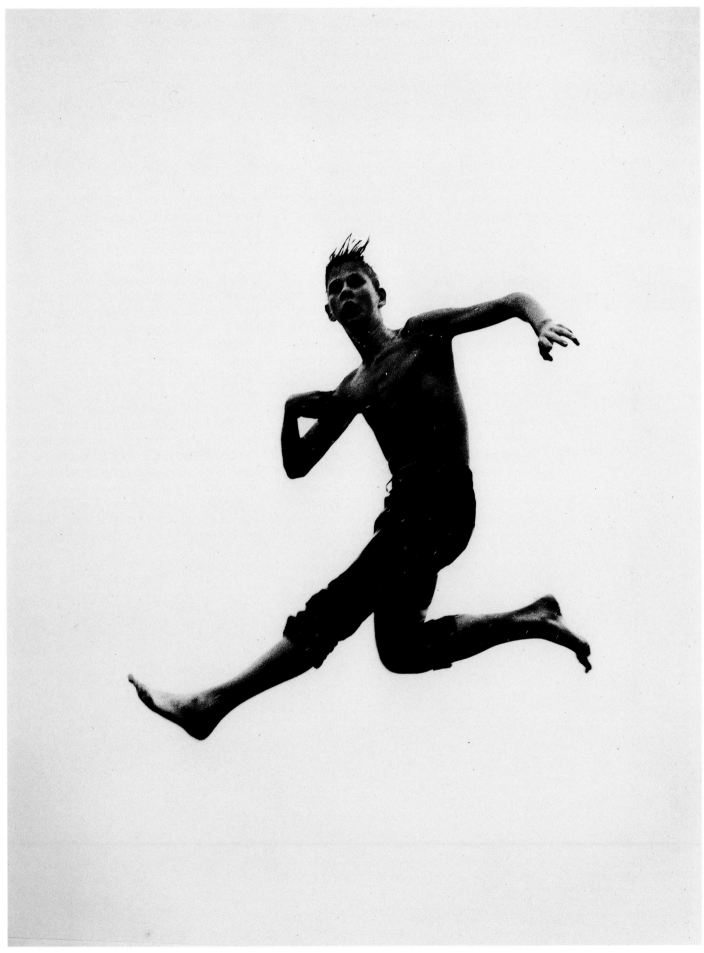

Plate 36

Ralph Eugene Meatyard

American, 1925–1972

Untitled

ca. 1959
gelatin silver print
7 x 5 5/8"
(17.8 x 14.3 cm)
Anonymous gift
83.365

Although an interest in photojournalism, as exemplified by the work of Henri Cartier-Bresson (plate 24) and W. Eugene Smith, overshadowed the interest in metaphoric imagery after World War II, there were still a few poetic photographers who probed the disconnected vision of dreams. One of the most imaginative of these was an amateur living in the ante-bellum community of Lexington, Kentucky. Ralph Eugene Meatyard invented a world in which people—usually his friends or members of his family—and objects were recorded on film in strange, eerie settings of abandoned houses, dark forests, or cemeteries. With the hard eye of the camera, he captured episodes of dislocation that are far more unsettling than the spooky games of Halloween. As this author once wrote, "He draws the curtain back on scenes that recall the pageantry of a class play we were left out of in the first grade, late night movies seen when we are only half awake, or moments of stark reality we thought had been dismissed from our minds."[1]

Meatyard's photographs are so effective because he created visionary scenarios out of the world around him by selecting unusual but recognizable settings against which his subjects acted out the exraordinary. His magic consisted in subverting the realism of the camera's eye. Meatyard used no contrivances, such as collage or the multiple printing of negatives, so that the viewer would have absolute confidence in what he saw, even if it were as implausible as a dream.

In this untitled photograph of circa 1959, the grotesque mask on the face of the young boy in short pants grips our imagination. The mask is a powerfully disturbing symbol that recurs throughout Meatyard's work. In his notebook he had written Friedrich Nietzsche's statement that "every profound spirit needs a mask." Christopher Meatyard, the photographer's son, has explained, "Part of the use of masks was to disguise these figures. . . . It was a way of abstracting what would usually be more identifiable, making it more universal."[2] In this work, the mask denies the boy's individuality and speaks to the multiple personalities one assumes in society. Unsettling here is the evocation of innocence harboring the baser nature of man. Indeed, the most remarkable and compelling aspect of this photograph is the tension Meatyard creates between youth and innocence and maturity and monstrousness. Standing on the threshold of an ominous, blackened doorway, the masked child suggests the fragile balance between darkness and light. The decayed, weathered building and the dead weed that crosses the boy's path are sobering reminders of the passage of time and inevitable death.

In a general, inexplicable way, this image is a forceful metaphor for the profound anxieties of our day. Ultimately, however, its specific symbolism is not easy to decode, for it came from a source deep in the photographer's psyche which he himself never quite understood. It is this sense of mystery and enigma in Meatyard's photographs that is at the very heart of their emotional intensity.

[1] Van Deren Coke, *Ralph Eugene Meatyard*, Portfolio Three (Louisville, Ky.: Center for Photographic Studies, 1974), Introduction.

[2] In a conversation published in the *Newsletter* issued by the Center for Photographic Studies, Louisville, Ky., circa 1974.

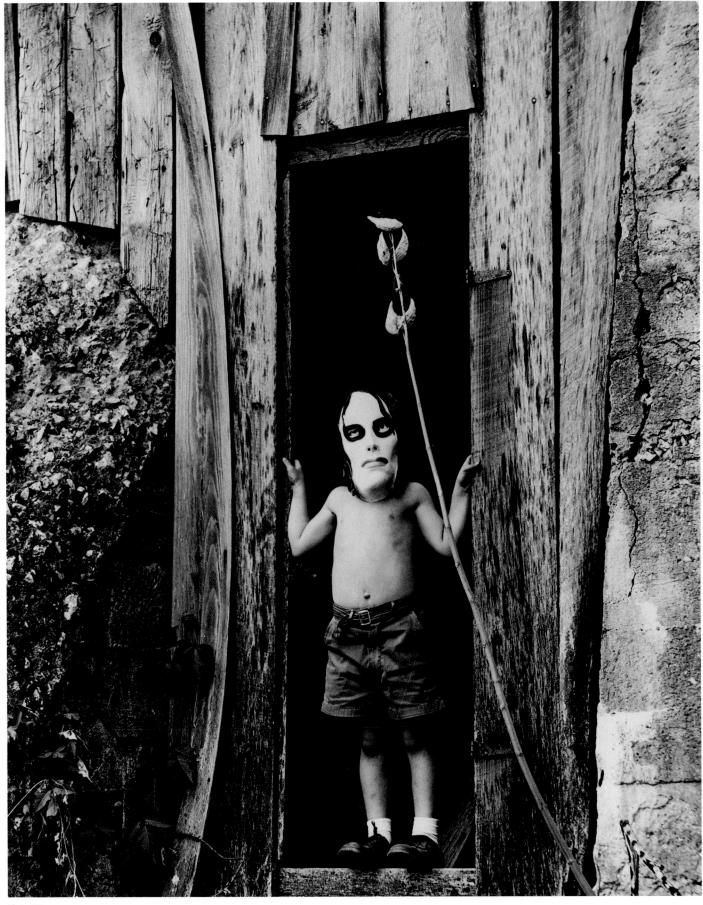

Plate 37

Jerry N. Uelsmann

American, born 1934

Fleeing Man

1961
gelatin silver print
7 5/16" x 8 15/16"
(18.6 x 22.7 cm)
Anonymous gift
80.333

[1] James L. Enyeart, *Jerry N. Uelsmann. Twenty-five Years: A Retrospective* (Boston: A New York Graphic Society Book published by Little, Brown, 1982), p. 19.

[2] Quoted ibid., p. 42.

[3] Quoted ibid., p. 37.

[4] Uelsmann dealt with the theme of freedom in two other works of the same year, both entitled *Restricted Man*. In one image, a man is seen peering out from behind a small window; in the other, a face is confined behind a sheet of metal with cutouts only for the eyes. See ibid., figs. 14 and 23.

[5] The hand as a symbol has a history in twentieth-century photography. It was an important motif in the work of such vanguard American and European photographers of the 1920s and 1930s as Man Ray and László Moholy-Nagy, who saw it as a metaphor for creativity. In Uelsmann's work the hand is a recurring motif, which in one sense is symbolic of the artist getting in touch with his authentic self; telephone conversation with Diana du Pont, January 5, 1985.

[6] Ibid.

[7] The issue of mechanized man concerned Uelsmann as early as the late 1950s. *Mechanical Man #1* of 1959, for example, features a man's face superimposed on a motorcycle engine; see *Jerry N. Uelsmann: Silver Meditations*, introduction by Peter C. Bunnell (Dobbs Ferry, N.Y.: Morgan & Morgan, 1975), n.p.

[8] Enyeart, op. cit., p. 28.

Jerry N. Uelsmann is a master at combining multiple negatives to create elaborate composite photographs that are visual equivalents to our inner realities—our dreams, fantasies, and emotions. His unexpected juxtapositions of forms and motifs put us within grasp of Alice's world on the other side of the looking glass. His precise, seamless blending of surprising visions entices and beguiles us into believing the unbelievable. Whether with humor or seriousness, his pictures are intangible, open-ended evocations that extend beyond a level of verbalization. In this, it has been observed, Uelsmann is "affirming the mystery of art and life."[1] Indeed, the idea of questioning is at the very heart of his aesthetic philosophy: "It is important that we maintain a continual open dialogue with our materials and process; that we are constantly questioning and in turn being questioned. In terms of my own development, I have found the recognition of questions more provocative than the provision of answers."[2]

Fleeing Man of 1961, one of Uelsmann's early works, exemplifies the formative stages of an experimental technique and personal symbolic approach that came to fruition in the multiple imagery of his mature style. Rather than finding a subject in nature and taking its picture, he directed a scenario specifically for the camera. Further, the dual image of hand and mechanical toy is the result of his investigation of multiple exposure. This technique and the orchestrated subjects form a metaphoric statement that is part of a series of the early 1960s in which Uelsmann explored what he called "the predicament of Man." As he stated in 1962 in his first mani-

Figure 55 Jerry N. Uelsmann. *Free but Securely Held,* 1965. Gelatin silver print.

festo, called "Random Thoughts on Photography": "I am very much concerned with the way man is prevented from being certain things by conditions that exist outside of himself . . . over which he has no control, yet their effect is immediate and real. Man prevented by economic conditions, by social tradition, by education, by his physical being. . . . I am attempting to create an intensive awareness of the existence of these restrictions."[3]

In *Fleeing Man* Uelsmann addresses the "predicament" of man's freedom.[4] The work features a large, threatening hand[5] seen both closing in and opening up on a small plastic figure who seeks escape, suggesting the opposing forces of freedom and restraint. At the time, this concern was of special importance to Uelsmann; newly appointed to his first teaching position in photography, he was faced with balancing artistic freedom and institutional structure.[6] This reading of the picture is both guided and reinforced by the suggestive, literary title he assigned the work, a practice he commonly indulged in during this early period.

That Uelsmann's image of man is represented by a mechanized figure is at first an enigma that tantalizes the viewer, perhaps even a paradox in light of our cultural vantage point, which reveals a society enmeshed in advanced computer technology at the service of robotics.[7] Yet, Uelsmann's choice of a mechanical figure pays homage to the Surrealist penchant for the doll as symbol. He was thoroughly familiar with the motif, for it appeared in the Surrealist-influenced work of Ruth Bernhard and, particularly, Ralph Hattersley, who along with Minor White (plate 50) was one of his undergraduate teachers at the Rochester Institute of Technology. Furthermore, Uelsmann selected a generalized, archetypal portrayal of man so as to subvert the power of photography to seduce the viewer into identifying a given subject rather than probing its meaning.

By 1963 Uelsmann had developed his multiple-image technique to a high level of proficiency, and with this came decidedly more complex photographs. The direct, simplified nature of *Fleeing Man* is made clear when it is compared with the picture *Free but Securely Held* of 1965. Here the fleeing man is but one element among several that comprise this mysterious allegory, indicating two important things: one, that Uelsmann frequently reuses motifs, to the extent that they have been compared to Jungian archetypes; and two, Uelsmann's basic aesthetic philosophy relies on a fusing of reality and fantasy ultimately to create a new reality that is greater than either of its parts.[8]

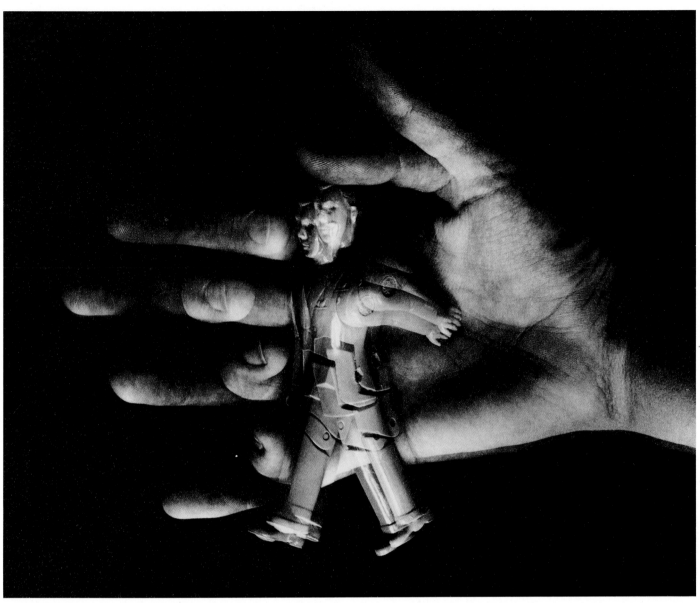

Plate 38

Lucas Samaras

American, born Greece, 1936

Photo-Transformation 9/19/73

1973
Polaroid SX-70 print
3 x 3"
(7.6 x 7.6 cm)
William L. Gerstle Collection
William L. Gerstle Fund Purchase
80.405

The notion of transformation, the act of changing, growing, and metamorphosing, has been a pervasive concern throughout the work of Lucas Samaras. In New York in the early 1960s, Samaras was closely aligned with Happenings and the emerging Pop Art scene and its concern with the common object. Following the legacy of American Surrealist artist Joseph Cornell, Samaras made his reputation with a series of boxes whose simple, familiar forms were transformed into bursting vessels of the unexpected—pins, razors, glass, scissors, wires, costume jewelry, sequins, glitter, and brilliantly colored yarn. Other everyday objects—a tennis racket, shoes, and chairs—fascinated Samaras by their rich potential for metamorphosis. With them he could exploit that fragile balance between the familiar and the fantastic. By 1969 he had recognized the most fecund object with which to explore transformation: himself. That year he wrote, directed, and acted in a film entitled *Self*, and from that point forward, he has been his primary subject and photography his primary medium.

Samaras's myriad aesthetic interests—the self-portrait, theater, performance art, body art, and painting—coalesced in his extensive series *Autopolaroids* made between 1969 and 1971. The Polaroid camera provided Samaras with a "handy" means by which to realize his long-held desire to explore his body photographically.[1] It gave him complete autonomy: he could work alone instead of with a photographer, and he did not have to learn any complicated techniques, since Polaroid

photography is a one-step process that does not require a darkroom. In discussing the *Autopolaroids*, Samaras has stated, "The speed with which a result is obtained without outside help and the complete privacy afforded me an opportunity of doing something impossible with regular photography. I could tune up or tone down emotion. I could move a little to the left or shift this or that and be my own critic, my own exciter, my own director, my own audience."[2] In the *Autopolaroids* Samaras was the actor, and his studio and brownstone apartment the stage for self-exploration. He is seen standing, sitting, lying, playacting, hugging himself, masturbating, and making love to himself. He transformed himself by means of double and multiple exposures, blurs, colored lighting, and role-playing, and by altering the surface of the finished prints by manipulating the emulsion layer and depositing ink in dots and lines.

This transformation of self as well as of photography was further explored in Samaras's succeeding series, the *Photo-Transformations*. In this group of pictures, made with the then-new Polaroid SX-70 camera, Samaras continued to focus on himself and his isolated world. In *Photo-Transformation 9/19/73*, for example, Samaras is seen performing for the camera. Sitting on a chair—a recurring motif throughout his work—in the kitchen off his studio, Samaras expands his torso and thrusts his arm upward as he holds a radiant strobe light. The image is aglow with colored light; here, light is the transformative device, rather than the manipulation of the emulsion layer after exposure. Samaras's body is bathed in "lollipop" green, red, and yellow light, "cheap . . . five and ten" colors, as Samaras has said.[3] The bilateral structure of the image is particularly striking. One side invites you into Samaras's private theater while the other, in its abstract, planar form, keeps you out. To create this barrier, Samaras positioned the camera in front of a kitchen wall whose flatness he accentuated by broad areas of colored light.

In comparison with the *Photo-Transformations* in which the emulsion layer has been pushed and pulled to form terrifying, grotesque visions, *Photo-Transformation 9/19/73* and others like it, which rely primarily on light as the agent of change, are more ethereal and dreamlike. There is more self-conscious control and less raw hostility. Ultimately, however, all the images in the series work together as an exercise in theme and variation on the self.[4]

[1] Lucas Samaras, "Autopolaroid," in *Samaras Album: Autointerview, Autobiography, Autopolaroid* (New York: Whitney Museum of American Art and Pace Editions, 1971), p. 16.
[2] Ibid.
[3] Quoted in "Barbara Rose Interviews Lucas Samaras," *Samaras: Reconstructions*, exhibition catalogue (New York: Pace Gallery, 1978), unpaginated.
[4] The idea of theme and variation as consistent with Samaras's concept of transformation is commented upon in John Bloom, "Transformative Visions: Photography and Mark-Making in the Work of Lucas Samaras and Lynton Wells" (Master of Fine Arts diss., University of New Mexico, 1981), p. 18.

Figure 56 Lucas Samaras. *Photo-Transformation 11/22/73*, 1973. Polaroid SX-70 print.

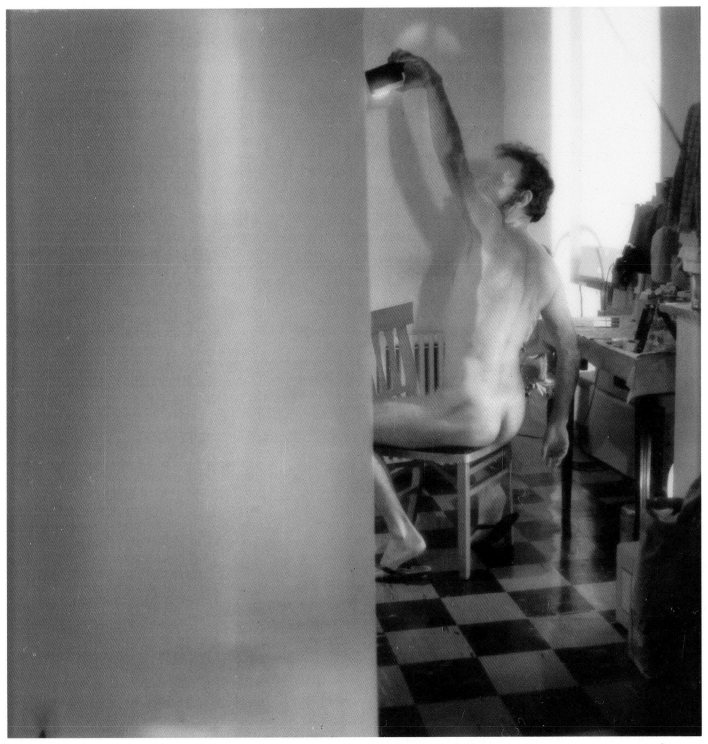

Plate 39

Val Telberg

American, born Russia, 1910

Greeting

1979
gelatin silver print
15 7/16 x 19 7/16"
(39.2 x 49.4 cm)
Gift of the artist
83.138

[1] "Art and the Subconscious: The Multi-Negative Photography of Vladimir Telberg-von-Teleheim," *American Artist,* vol. 13, no. 1 (January 1949), p. 60.

[2] In that Telberg's imagery is psychologically motivated, it can be related to the Surrealism of the 1920s and 1930s. However, Telberg never adopted the Surrealist method of automatism. While his working method naturally incorporated spontaneity and intuition, it was not philosophically based on an aesthetic of chance; Telberg in telephone conversation with Diana du Pont, January 9, 1985. An entry in his diary on August 13, 1948, more fully explains the conscious element in his approach to making photomontages: "Methods of working: (1) Derive design, subject etc. from unrelated, unplanned negatives. (2) Plan the finished product completely in advance"; quoted in letter from Telberg to Van Deren Coke, May 15, 1982.

[3] An important development for Telberg was his addition of a second enlarger to the process. This allowed him to compound the complexity of his imagery by superimposing a whole new set of images over the already exposed and half-developed paper from the first enlarger. This often results in a partial solarization of the photograph, which, in combination with other techniques, such as bleaching, dodging, and burning in, helps to explain his richly textured prints.

[4] "Composite Photography by Val Telberg," *American Artist,* vol. 18, no. 2 (February 1954), p. 47.

[5] Telephone conversation with Diana du Pont, January 9, 1985.

[6] Quoted in Linda Pierzecki, "Val Telberg: On Creativity," interview, *Hamptons Newspaper/Magazine,* June 10, 1982.

"What interests me most is not what one can see, but what goes on unseen in one's mind," Val Telberg commented in 1949.[1] Indeed, through his photography Telberg has sought to give visual form to his thoughts, feelings, memories, dreams, and fantasies. His pictures capture the essence of stream-of-consciousness in their endless flow of seemingly unrelated imagery. Their almost hallucinatory compositions abound with fragmented images of reality arranged to suggest evocative relationships and subtle variations in mood and effect.

Since the late 1940s, Telberg has approached the complex layerings of the mind through an innovative use of photomontage, a technique of combining multiple negatives to make one print. Telberg's move toward multiple imagery was influenced primarily by experimental filmmaking to which he was exposed while a student of painting at the Art Students League in New York in the early 1940s. He was particularly impressed by the use of dissolves, jump-cuts, and the general Surrealist sensibility of films by Maya Deren and Francis Lee. A loner at heart, however, Telberg did not turn to the collaborative endeavor of filmmaking as a career, but instead became a pioneer in adapting filmic effects to still photography through photomontage.

In the late 1940s and the 1950s, when photojournalism was on the rise and the tradition of straight photography maintained its influence, Telberg's approach was a controversial challenge. Rather than adhering to the dominant concept of "previsualization," which stated that one's artistic ability lay in seeing the finished print on the ground glass before releasing the camera's shutter, Telberg retreated to the darkroom where he gave his imagination full rein to distort, manipulate, and even destroy parts of his negatives in the process of forming his dreamlike compositions.[2] With a vast store of negatives at his disposal, he arranged and rearranged pieces of exposed film on a light table, creating puzzle pictures that were then sandwiched between glass and placed in the enlarger.[3]

Greeting of 1979 is one of Telberg's later photomontages, made after an interlude of nearly ten years during which he pursued nonobjective cement sculpture and avant-garde multimedia productions with his wife, Lelia Katayen. The erotic figurative theme, the multiple imagery, and the rich textural qualities of this work carry forward the signature of his early style. The essential difference is one of further complexity; there are more people, more scenes, and more variations in surface quality. The components of *Greeting* reveal how Telberg blends images from different places and times within one work: the figures in the lower right are models who posed for him at the time he made this photomontage; the bus scene was taken earlier in Amsterdam; and the dancer to the left (his wife) was also taken at an earlier time. Together the images imply a narrative, but what it might be remains untold. Here, as in other works, Telberg is interested in taking fragments of reality and creating fantasy so as to stimulate reflection on existence. As he said in 1954, "I try to invent a completely unreal world, new, free and truthful, so that the real world can be seen in perspective and in comparison."[4]

In this work the central activity is flanked by two opposing forces: a masked nude on one side, suggesting violence and oppression, and a dancer in movement on the other, alluding to creativity and life-giving energy. The dominant motif is the woman gesturing into the viewer's space. While the figure below her is clearly smiling, this woman's expression is ambiguous. Is she gesturing forward in happy anticipation, or in fear? The juxtaposition of these two figures sets a mood of tension and turmoil in motion. As in most of Telberg's photomontages, there is an undercurrent here of human tragedy. He has, in fact, said of this work that there is a "feeling of laughter among the tears."[5] A committed pacifist, Telberg is deeply concerned with the darker side of the human condition, with what man is capable of inflicting on himself. "I try to capture the mental images," he has said, "the emotional reactions, the feelings such as unhappiness, depression and injustice that war creates. This is due, in part, to my being a refugee during the Russian Revolution and my realization of the atrocities and horrors that war creates."[6]

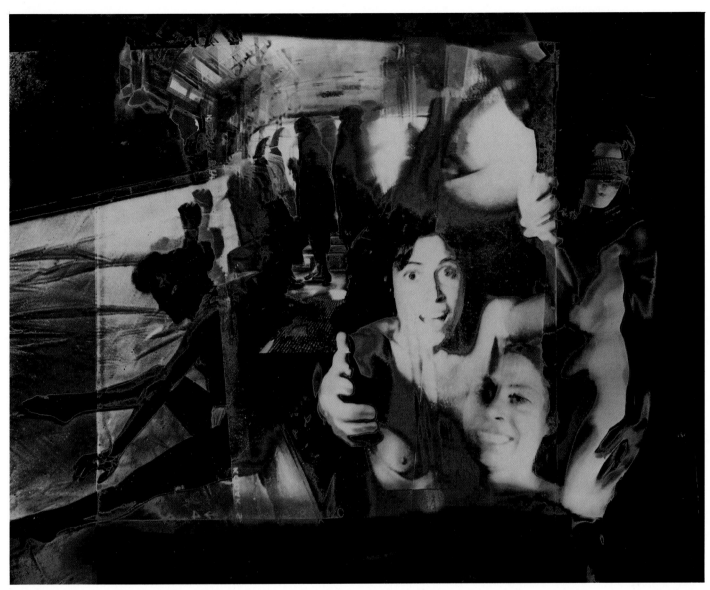

Plate 40

Joel-Peter Witkin

American, born 1939

The Prince Imperial

1981
gelatin silver print with
toner A. P. #3
14 15/16 x 15"
(38.0 x 38.1 cm)
Gift of
Dr. and Mrs. William R. Fielder
84.117

Is Joel-Peter Witkin a wild, wicked man surveying the world for subjects to shock us, or is he a dreamer searching the darkness for revelations of man's true nature? Witkin's pictures do not, as commonly speculated, spring from a disordered psyche, but from a wanton disregard for convention. In spirit he is closer to the painters Francis Bacon and Max Beckmann than to most photographers. In romantic microcosms, and sometimes in heroic terms, he affirms Hell's existence, touching on the fears we nurture in solitude. His absurd and often obscene scenarios recall such films as *The Cabinet of Dr. Caligari* and *The Story of O* in their unexpected combinations of people, animals, and cadavers, all making concrete the imaginary realm of the mind's inner thoughts and fantasies. A burned-out fun house or eerie imagination chamber seem to be the settings for his pictures in which strange, invented tales involving odd or grotesque actors are told. The Fellini-esque characters who populate his pictures are more often than not prone to oppressive behavior—such as domination or submission—for sexual pleasure.

While private fantasies are primarily interesting to the person who has them, Witkin transcends this limitation by creating dream pictures with the power to captivate the imagination of others. He has an ability to locate a raw nerve in our psyches, which explains why we react so strongly to his work. We tend to squirm when we view his images, forgetting that their extremism is staged. On the one hand, his pictures give us access to our forbidden fantasies and thereby relieve repressed emotion. On the other, they evoke the haunting vulnerability of all mankind to the fears that torment the soul.

The Prince Imperial of 1981 is one of Witkin's most extraordinary photographs. As is common in his photography, this is a restaging of an earlier work of art. In this case, Witkin has completely subverted the mid-nineteenth-century photograph by Mayer frères and Pierson of the Prince Imperial with his father, Napoleon III. This informal studio portrait of the young prince on horseback has been transformed by Witkin into a disturbing *tableau vivant* consisting of bizarre and enigmatic figures and props. He has reversed the position of the horse so that it stands with its head in the opposite direction and has replaced Napoleon III with an armless male nude who is masked and bound at the genitals. The most remarkable change is the substitution of an obese, nude figure for the prince. Like some perversion of a *belle-époque* prostitute, this transvestite, with his penis tied to his waist, wears a brassiere, black stockings, and high-heeled pumps. His stocky build and masked visage are frightening suggestions of a torturer or executioner. The evocation of violent physical abuse is heightened by the cord tied around the neck of the standing figure and connected to the lifeless fish on the floor. The image is made even more poignant by the presence of death in the classic form of a skeleton. We realize that in this horrifying synthesis of eroticism, sadism, and death we are privy to a bizarre sexual ritual.

This type of visionary fiction making by Witkin is part of a growing interest in voyeuristic, erotic imagery in which problematic situations teem with private obsessions. In reaction to a computer-oriented society intent upon organizing and predicting the events of its world, there is a fascination with photography that deals in a most graphic form with mysticism and occultism. Witkin is a prime provocateur in this new direction.

Figure 57 Mayer Frères and Pierson. *Le Prince Impérial et Napoléon III* (The Prince Imperial and Napoleon III), ca. 1858. Albumen print from a collodion negative.

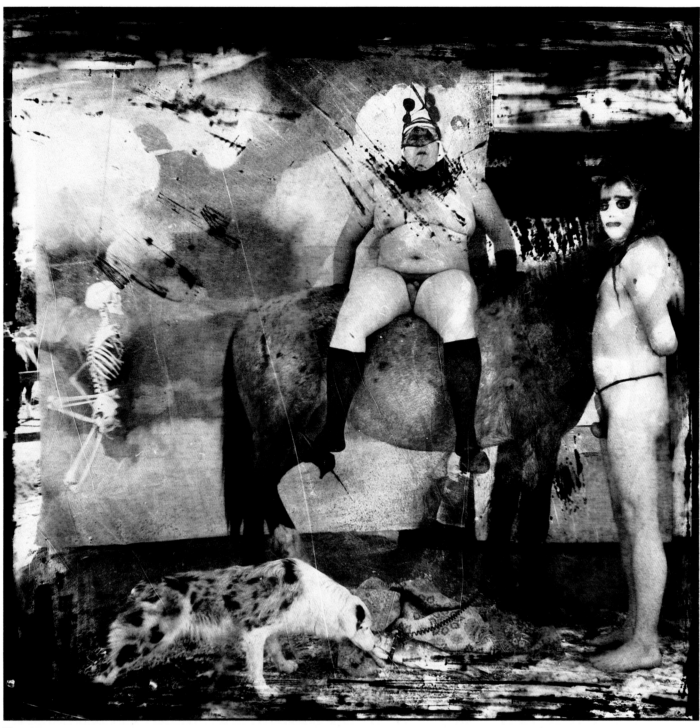

Plate 41

Expressionism

August Sander

German, 1876–1964

Studienrat

(Assistant Schoolmaster; High-school Master, Cologne)

1928
gelatin silver print
7 7/8 x 5 7/8"
(20.0 x 15.0 cm)
Clinton Walker Fund Purchase
84.63

[1] Quoted in John von Hartz, *August Sander*, Aperture History of Photography Series (Millerton, N.Y.: Aperture, 1977), p. 7.

[2] An important example of nineteenth-century travel photography is John Thomson's *Illustrations of China and Its People*, 4 vols. (London: Sampson Low, Marston, Low, and Searle, 1873–74).

[3] Noteworthy contemporaries of Sander who sought to document a given people include Emil Otto Hoppé, who turned his camera on women workers; Erna Lendvai-Dircksen, who, like Sander, used the camera to record the face of the German people, a body of work published as *Das deutsche Volksgesicht* in 1930; and Helmar Lerski, who created socio-psychological portraits according to occupation, a series of photographs published in Germany in 1931 as *Köpfe des Alltags* (Ordinary Faces).

[4] Quoted in Douglas Davis, "Sander's Faces of a Nation," *Newsweek*, vol. 95, no. 12 (March 24, 1980), p. 63.

[5] This work has been published with the English title *High-school Master* and dated as of 1932. However, the work is inscribed "1928."

[6] "Man of the Twentieth Century" is composed of seven core groups: Farmers, Workers, Women, Occupations, Artists, Urban Life, and Handicaps and Death. Each group is divided into subcategories, which total forty-five in all. "Teachers" is a subcategory of "Occupations," which is the largest core group. See Ulrich Keller, in *August Sander, Menschen des 20. Jahrhunderts: Portraitphotographien, 1892–1952*, ed. Gunther Sander (Munich: Schirmer-Mosel, 1980).

In 1910 August Sander set aside the make-believe environment of the portrait studio with its richly painted backdrops, gaudy furniture, and artificial flowers and ventured out into his native Siegerland and adjoining Westerwald near Cologne, beginning what became his lifelong project—"Man of the Twentieth Century." His vision was no less than to create a comprehensive document of the German people by means of photographs. Like an anthropologist, he sought to classify his nation's highly stratified society according to social class, profession, vocation, or the sheer circumstances of fate. Beginning with farmers—"These people, whose way of life I had known from my youth [who] appealed to me because of their closeness to nature"[1]—he went on to photograph small-town people, urban dwellers, workers, the bourgeoisie, aristocrats, students, professionals, politicians, revolutionaries, industrialists, artists, the disabled, and the aged. By the early 1950s, this massive undertaking had produced some five or six hundred photographs.

From its inception, photography was recognized for its power of description, and photographers traveled the world over to record faraway and often unexplored places and unknown peoples.[2] While an enthusiasm for the camera's truthfulness aligns Sander with his predecessors, what distinguishes him is his decision to document his German contemporaries rather than the exotic, and his insistence on democratically representing all levels of society rather than only one segment of it. Although still a young nation in 1910, Germany was swiftly developing a national identity, and, in one sense, Sander's "Man of the Twentieth Century" is a response to the idea of "Germanness," to discovering the shared characteristics of a people nourished by a common soil.[3]

Central to Sander's portrayal of the German people was the concept of physiognomy, which holds that personality and moral character are reflected in the human countenance. "We know that people are formed by the light and air," Sander once said, "by their inherited traits, and their actions. We can tell from appearance the work someone does or does not do; we can read in his face whether he is happy or troubled."[4] While sensitive to individual character, Sander was also fascinated by group consciousness and how it is revealed by demeanor, attire, and surroundings.

Authoritative, stern, with lips pursed, the subject of Sander's *Studienrat* of 1928[5] reveals the weight of tradition that continued to dictate social attitudes about education despite the more liberal climate of post–World War I Weimar Germany.[6] Fastidiously groomed and clothed and commandingly posed behind a desk that serves as a barrier between himself and his students, the teacher solemnly conveys a sense of Calvinistic discipline. However stiff and overbearing, he—along with several of the other teachers Sander photographed and identified by occupation only and not by individual name—illustrates how, as a type, a school teacher stands as an exemplary figure embodying the time-honored values of society.

If in this portrait and the several hundred others that comprise "Man of the Twentieth Century" Sander tells us something about the German people of an earlier era, he also tells us something about modern man. Throughout his pictures, a sober reality predominates; there is little variation in the intense reserve and privateness of his subjects. Each individual photographed by Sander, whether singly or in groups, exudes a feeling of utter self-reliance, but also of aloneness. And it is this atmosphere of alienation that makes Sander's pictures so tellingly modern. Perhaps only in America, in the work of such post–World War II photographers as Diane Arbus and Richard Avedon, has the sense of existential isolation that permeates Sander's portraits been so poignantly expressed.

Plate 42

Umbo
(Otto Umbehr)

German, 1902–1980

Porträt Rut Landshoff (Der Hut)
(Portrait of Rut Landshoff [The Hat])

1927
gelatin silver print
5 x 6 15/16"
(12.7 x 17.7 cm)
Purchase
81.48

Germany of the 1920s was the scene of a renaissance in the arts. By 1923 the social, political, and economic turmoil of World War I and its aftermath began to subside, making for a calmer and more prosperous climate in which the arts could flourish with the same vigor as they had prior to 1914.[1] In each of the major cities of the Weimar Republic—Berlin, Hannover, Munich, Cologne, Dresden, and Stuttgart—important innovations in the visual arts, architecture, film, theater, dance, opera, and ballet took place. Considered the most sophisticated and modern of all these municipalities, Berlin was the symbolic center of Weimar culture. It was there that Umbo (Otto Umbehr) became, by the end of the decade, one of the foremost pioneers of photojournalism, capturing on film this exciting and creative milieu. Once an actor himself and a production and camera assistant in the film industry, Umbo's special interest was in Berlin's world of entertainment—the painted faces of the men and women of the theater, motion pictures, dance, the cabaret, and the circus.

Umbo initially moved to Berlin in 1923, shortly after completing his studies in painting and design at the Bauhaus in Weimar. He held a variety of jobs, but of special importance was his work with Walter Ruttmann on his documentary film *Berlin, Die Sinfonie einer Grossstadt (Berlin, Symphony of a Great City)*, completed in 1927. This experience along with the encouragement of Paul Citroën, whom Umbo first met at the Bauhaus, eventually led to Umbo's own work in photography.

The actress Rut Landshoff, as seen in this portrait of 1927, was Umbo's first model.[2] The success of pictures such as this resulted in numerous commissioned portraits of celebrities in film and theater and ultimately in the opening of a portrait studio, which Umbo operated until 1928. This image of Rut Landshoff—a starkly rendered, tightly framed depiction that makes use of dramatic contrasts of highlights and shadows—is typical of Umbo's portraiture. The economy of means and the emphasis on design, which nearly reduce the areas of light and dark to abstract lines and shapes, reveal the impact of Umbo's Bauhaus training. What is most striking is the tension Umbo creates by crowding the isolated face against the left edge. Illustrating the influence of film on Umbo's still photography, the image is a fragment, a moment seen at a glance, like a close-up from a motion picture. Landshoff's parted lips and the eye in the deep shadow of the hat's brim evoke a disconcerting air of mystery.

Like Umbo's later photojournalistic work, this photograph captures the feeling of uneasiness in German society at the time. For beneath the glittering façade of optimism and prosperity there lurked the anxieties of a people swept up in a complex, and eventually deadly, confrontation between freedom and dictatorship.

Figure 58 Umbo. *Rut Maske (Die Larve)* (Rut Masked [The Mask]), 1927/1980. Gelatin silver print.

[1] John Willett, *The Weimar Years: A Culture Cut Short* (New York: Abbeville Press, 1984), p. 41.
[2] For other pictures of Rut Landshoff, see *Umbo: Photographien 1925–1933*, exhibition catalogue (Hanover: Spectrum Photogalerie in Kunstmuseum Hannover, 1979), nos. 3, 4, 6, 9, and 19.

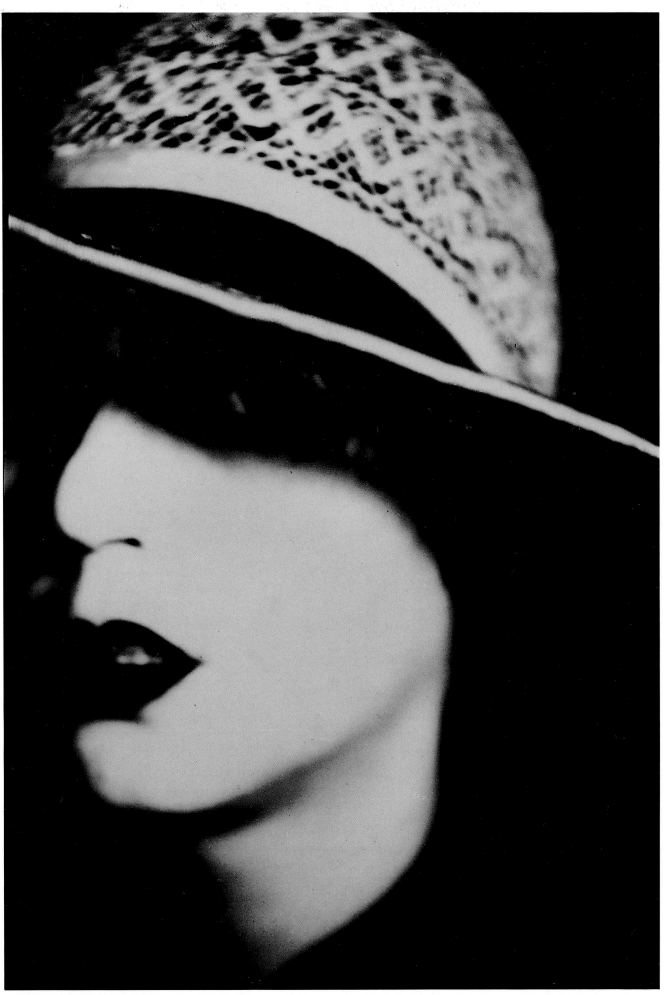

Plate 43

Tato
(Guglielmo Sansoni)

Italian, 1896–1974

Ritratto meccanico di Remo Chiti
(Mechanical Portrait of Remo Chiti)

1930
gelatin silver print
9 3/8 x 7"
(23.8 x 17.8 cm)
Byron Meyer Fund Purchase
83.19

[1] F. T. Marinetti, "The Founding and Manifesto of Futurism 1909"; reprinted in *Futurist Manifestos*, ed. Umbro Apollonio, The Documents of 20th-Century Art (New York: Viking Press, 1973), pp. 19–24.

[2] Anton Giulio Bragaglia, "Futurist Photodynamism 1911"; reprinted in *Futurist Manifestos*, op. cit., pp. 38–45. The manifesto was first mentioned in an advertisement in *Lacerba* (Florence), July 1, 1913.

[3] F. T. Marinetti and Tato, "Manifesto," 1930; reprinted in Giovanni Lista, *Futurismo e fotografia* (Milan: Multhipla Edizioni, 1979), pp. 317–18.

[4] Umberto Boccioni, Carlo Carrà, Luigi Russolo, Giacomo Balla, Gino Severini, "Manifesto of the Futurist Painters," 1910; quoted in Marianne W. Martin, *Futurist Art and Theory 1909–1915* (New York: Oxford University Press, 1968; reprint New York: Hacker Art Books, 1978), p. 52.

[5] Ibid., p. 50.

On February 20, 1909, *Le Figaro* in Paris published poet Filippo Tommaso Marinetti's first manifesto on Futurism, thus marking the birth of the movement.[1] In this aggressive and radical statement, Marinetti rejected a civilization burdened by its past and acclaimed instead the modern industrial age and a new beauty: "the beauty of speed." Initially a literary movement, Futurism soon found expression in the visual arts. Despite Marinetti's revolutionary posture, Futurist investigations by such artists as Giacomo Balla, Umberto Boccioni, Carlo Carrà, Luigi Russolo, and Gino Severini occurred primarily within the traditional hierarchy of artistic mediums—painting, sculpture, and architecture.

Although the influence of photography was felt by some of the key Futurist painters, none of them personally explored the medium. This fell to Anton Bragaglia, son of a Milan film-company manager, who found in the camera the ultimate Futurist tool—a modern machine capable of readily and effectively capturing the sensation of speed. Inspired by the Futurist painters with whom he associated, Bragaglia began to investigate issues of dynamism and simultaneity as they related to photography. Culminating in the manifesto "Futurist Photodynamism 1911,"[2] Bragaglia's investigations were endorsed by Marinetti, but not by the other Futurists, es-

Figure 59 Tato. Untitled (Portrait of Filippo Tommaso Marinetti), 1930. Gelatin silver print.

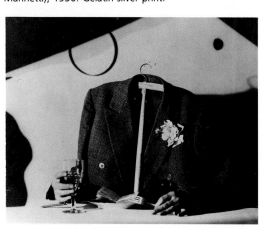

Figure 60 Tato. *Il Perfetto borghese (The Perfect Bourgeois)*, 1930. Gelatin silver print.

pecially Umberto Boccioni, who refused to view photography as an art. Ultimately, Boccioni denounced Bragaglia's Futurist photography, which, with the onset of World War I, effectively halted further research into Photodynamism.

In the 1920s, however, the legacy of Futurist photography was carried forward by one of the major figures of the postwar Italian avant-garde, the painter, photographer, and designer Tato (Guglielmo Sansoni). As an international movement, Futurism diminished in importance after the defeat of Germany in 1918, but in Mussolini's Italy it maintained a lively artistic direction, primarily under the impetus of Marinetti, who continued to work for the artistic, social, and political revolutions for which he had first proselytized years earlier. After returning from the war, Tato became interested in Futurism and aligned himself with Marinetti. Together they organized the Futurist Salon of the National Photographic Competition in Rome in 1930 and wrote the accompanying manifesto of Futurist photography.[3]

Tato experimented with a variety of approaches, including an inventive form of still life, but one of his most successful genres was the portrait, as seen in his *Ritratto meccanico di Remo Chiti* of 1930. One of several portraits of the Italian literati with whom Tato was closely associated, this work features the mechanism of a chronometer superimposed over a close-up view of Chiti's face. The Futurist concern with time and the dematerialization of the object in space are seen here both literally and symbolically. Through the technique of superimposing different negatives, Tato has actually dissolved matter in part and blended it into a new synthesis, recalling an earlier statement by the Futurist painters, "Our bodies penetrate the benches on which we sit and the benches penetrate our bodies, just as the passing tram penetrates the houses which in their turn hurl themselves upon the tram and merge with it."[4] The fusion of the watch gear and Chiti's face is also a metaphor for the Futurist concept of time, which was seen not as divided into discrete, autonomous units but rather as a dynamic continuum. "For us the gesture will no longer be an *arrested moment* of the universal dynamism: it will clearly be the *dynamic sensation* itself made eternal," the Futurist painters had declared in 1910.[5] In *Ritratto meccanico di Remo Chiti* the issues of time and the interpenetration of objects coalesce to capture the feeling of the new kinetic machine world that was so enthusiastically embraced by the Futurist aesthetic and Mussolini's Fascist regime.

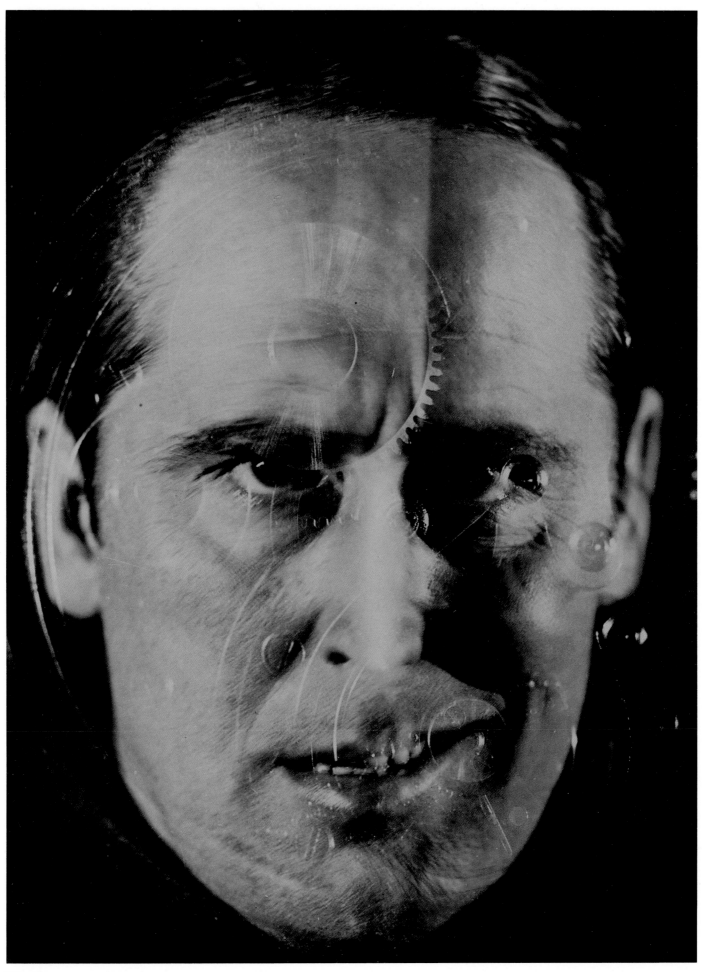

Plate 44

Helen Levitt

American, born 1918

Untitled

ca. 1942
gelatin silver print
9 3/4 x 7 3/4"
(24.8 x 19.7 cm)
Gift of Marcia Weisman
84.55

An interest in people, particularly children—laughing, playing, crying, together or alone—has been the constant chord in Helen Levitt's photography. Not all the world, but the poor, working-class, and ethnic neighborhoods of New York have been the stage for human drama in her work.[1] First, during the late 1930s and 1940s, with black-and-white still photography, then in the 1950s with motion-picture film, and later, in the early 1960s and again in the 1970s, with color transparency materials, Levitt has found a lyrical beauty in the daily rhythm of street life.

Levitt first became seriously interested in photography after seeing an exhibition of Henri Cartier-Bresson's work (plate 24) at the Julien Levy Gallery in New York. Inspired by Cartier-Bresson's "decisive moment" style, Levitt began in the late 1930s to work with the small 35-mm Leica camera which could be used quickly and concealed easily, making it appropriate for capturing, unobserved, life's spontaneous, expressive moments. Like Cartier-Bresson, Levitt came to believe that "the artist's task is not to alter the world as the eye sees it into a world of aesthetic reality but to perceive the aesthetic reality within the actual world, and to make an undisturbed and faithful record of the instant in which this movement of creativeness achieves its most expressive crystallization."[2]

While people and their lives in the street are the primary subjects of Levitt's photographs, not all of her pictures show individuals engaged in activity. Some, like this early work of circa 1942, capture those moments in which the human presence is indicated by only a mark. The "hieroglyphs of innocence"[3] have fascinated Levitt, and this work is one of several that depict children's graffiti drawings on the city's sidewalks and walls. Here, Levitt fully expresses the wonder in the naïve vision of children, its intuitiveness, spontaneity, and utter freedom from conventional modeling and correct optical proportion. She evokes the child's fantasy world—the play-acting with handkerchiefs over mouths which become masks, garbage-can covers that serve as shields, cardboard boxes that turn into forts.

This graffiti drawing was captured with the same tenderness—a tenderness without sentimentality—that Levitt exhibits in her photographs of children playing games in the city's streets, sidewalks, and doorways. In isolating this simple, crudely wrought yet enchanting image, Levitt understood that the urge to mark is an urge to assert one's humanism.

[1] In 1941 Levitt spent five months in Mexico, primarily Mexico City and its suburbs, but the majority of her work has been done in her native city.

[2] James Agee, in "A Way of Seeing," photographs by Helen Levitt, text by James Agee, *Horizon*, vol. 7, no. 3 (Summer 1965), p. 49; published as *A Way of Seeing*, photographs of New York by Helen Levitt, with an essay by James Agee (New York: Viking Press, 1965).

[3] Ibid.

Plate 45

Roy DeCarava

American, born 1919

**Man Coming up
Subway Stairs,
New York**

1952
gelatin silver print
12 7/8 x 8 9/16"
(32.7 x 21.8 cm)
The Helen Crocker Russell
and William H. and Ethel W.
Crocker Family Funds Purchase
80.28

In America, black photographers have rarely been represented in major exhibitions, nor discussed by leading critics, nor included in the standard histories. The work of Gordon Parks, it is true, has received some acclaim, and the photographs of Roland Freeman have had occasional visibility and have been collected by a few museums. Among black American photographers, New Yorker Roy DeCarava has most consistently had his work before the public. First seen in depth in the landmark book *The Sweet Flypaper of Life*,[1] his photographs express the daily struggles of Afro-Americans in the densely packed black neighborhoods of New York City, particularly Harlem where DeCarava was born and raised.

DeCarava's photograph *Man Coming up Subway Stairs, New York* of 1952, of an elderly black man with gritted teeth and drooping shoulders, graphically portrays the profound weariness of a people battling to compete in a world dominated by whites. Emerging from a darkened subway entrance, this grimacing black man summarizes the effects of social injustice. The image is emotionally powerful not only because of the telling moment it has captured, but also because of its strong composition, which features a diagonal counterpoint, and the dramatic chiaroscuro lighting that gives the figure a sense of three-dimensionality. The feelings expressed in this work, which can be seen as a testimonial, originated in DeCarava's heart, but the form that conveys them derived from his early training as a painter.

Figure 61 Roy DeCarava. *Woman Resting, Subway Entrance, New York,* 1952. Gelatin silver print.

[1] Roy DeCarava and Langston Hughes, *The Sweet Flypaper of Life* (New York: Simon and Schuster, 1955; reprint New York: Hill and Wang, 1967). German and Chinese editions were published in 1956 and 1958.

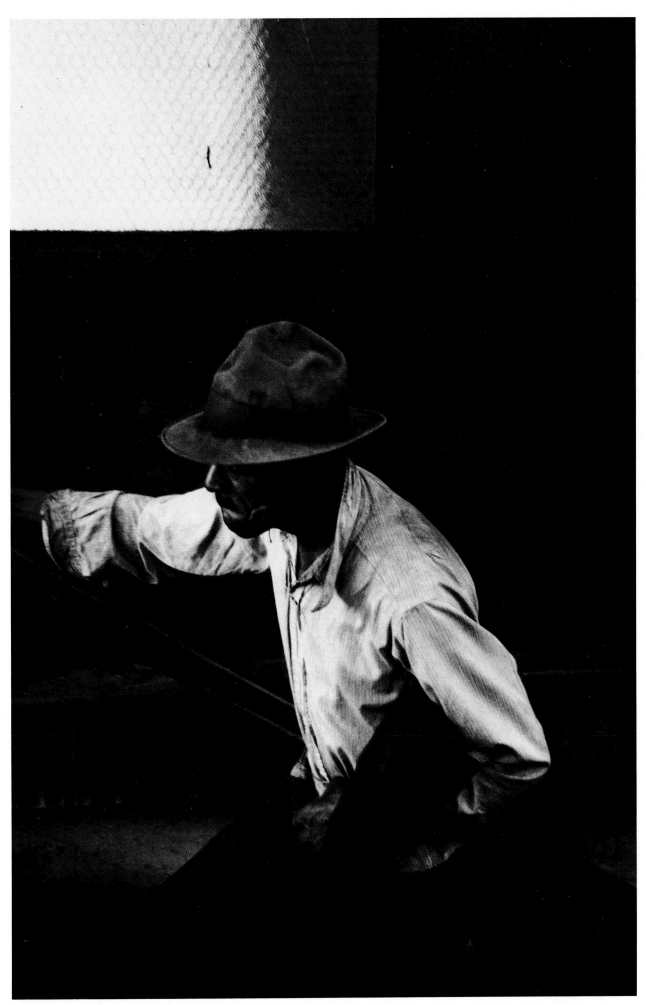

Plate 46

Robert Frank

American, born Switzerland, 1924

City Fathers, Hoboken

1955/ca. 1979
from the series *The Americans*
gelatin silver print
9 3/4 x 13"
(24.8 x 33.0 cm)
Byron Meyer Fund Purchase
81.61

[1] William Hogan, "Photo Coverage of the Ugly American," *San Francisco Chronicle*, January 27, 1960, p. 25.

[2] *Les Américains*, photographs by Robert Frank, text edited by Alain Bosquet (Paris: Robert Delpire Éditeur, 1958).

[3] *The Americans*, photographs by Robert Frank, introduction by Jack Kerouac (New York: Grove Press, 1959; rev. and enl. ed. New York: An Aperture Book, Grossman Publishers, 1969).

[4] Philip Brookman, who with Anne Tucker organized the Robert Frank retrospective that opened in February 1986 at the Museum of Fine Arts, Houston, and Stuart Alexander, formerly of the Center for Creative Photography in Tucson, Arizona, who has compiled a comprehensive bibliography on Robert Frank (to be co-published by the museum and the center), kindly provided a complete list of the reviews of the first American edition of *The Americans*.

[5] Gilbert Millstein, review in *New York Times Book Review*, January 17, 1960, p. 7.

[6] Unsigned review in *New Yorker*, vol. 36, no. 13 (May 14, 1960), p. 204.

[7] Michel Lambeth, review in *Canadian Forum*, vol. 40, no. 8 (August 1960), p. 120.

[8] Dorothy Nyren, review in *Library Journal*, vol. 85, no. 6 (March 15, 1960), p. 1104.

[9] Naomi Rosenblum, *A World History of Photography* (New York: Abbeville Press, 1984), p. 481.

[10] Robert Frank, "A Statement . . . ," *U.S. Camera 1958*, ed. Tom Maloney (New York: U.S. Camera Publishing, 1957), p. 115.

[11] Philip Brookman, in telephone conversation with Diana du Pont, February 21, 1985.

[12] Jack Kerouac, in *The Americans*, op. cit. (1969), p. ii.

"When the artist studies America and finds no hope, I think the artist is wrong," William Hogan declared in his review of Robert Frank's book *The Americans*.[1] This unequivocal statement summarizes how Frank's controversial book—the culmination of a two-year sojourn across the United States supported by a Guggenheim grant—painfully challenged the way some Americans viewed the country at midcentury. The disturbing effect of the book is underscored by the fact that Frank, a Swiss émigré, initially was unsuccessful in having the book issued in this country. Consequently, it first appeared in France, where it was published by a friend.[2] The precedent of the French edition combined with Frank's close friendship with the Beat poets, by then well known, may ultimately have provided the necessary inroads for its publication in America a year later.[3]

When *The Americans* appeared in this country the most vituperative response among the small group of critics who acknowledged it came chiefly from the photography community, while literary and intellectual circles recognized Frank's unique vision.[4] The liberal and sophisticated reviewers of the *New York Times Book Review*, the *New Yorker*, the *Canadian Forum*, and the *Library Journal* contained such comments as: "a valuable book";[5] "the special quality of American life is here exposed with brutal sensitivity";[6] "an incentive to photographers . . . to say something special";[7] "for any library that can afford it."[8] The more conservative photography editors and reviewers of such magazines as *Popular Photography*, *Modern Photography*, and even *Aperture*, on the other hand, attacked Frank for his "narrow," "ugly," and "wart-covered" view of America. The explanation for this bitter reaction can be found, in part, in the nature of photography in America at midcentury.

Postwar photography in this country was dominated by photojournalism, then in its heyday. In response to the "popular yearning in the West for 'one world,'"[9] photographers for *Life*, *Look*, and the many other picture magazines of the time were sent across the globe to capture different cultures on film. Photography was seen as a universal language capable of promoting understanding among people, a belief epitomized in Edward Steichen's enormously successful theme exhibition *The Family of Man* of 1955. Optimistic, compassionate, and harmonious, this celebration of humanity became, in essence, the model for expressive pictures of people. It is not surprising, then, that photographers embedded in the humanistic social documentary tradition would be affronted by Frank's detached and bitterly ironic pictures.

Truly a twentieth-century Honoré Daumier, Frank unsparingly called attention to the feeling of malaise and alienation in the country. With the keen eye of a foreigner, he revealed what was "invisible"[10] to most natives swept away by the economic prosperity, domestic peace, and political conformism of the Eisenhower era. Much of what Frank disclosed about America resulted from his probing of public events—parades, rodeos, movie premieres, motoramas, parties, and funerals. Taken during a parade,[11] *City Fathers, Hoboken* is featured as the second picture in *The Americans*. Here, Frank does not depict marching soldiers, musicians, or baton twirlers, but rather people on the sidelines. As viewers, we watch them watch the parade. The "city fathers" are not dignified representatives of government; they are plain, jowly, stalwart politicians preposterously dressed in top hats and tuxedos with carnations in their lapels. Key is the figure to the far right whose comical expression at once suggests the hollowness of this American ritual and calls into question those at the helm of democracy. As Jack Kerouac wrote of this picture in his introduction to *The Americans*, "Hoboken in the winter, platform full of politicians all ordinary looking till suddenly at the far end to the right you see one of them pursing his lips in prayer politico (yawning probably) not a soul cares."[12]

Figure 62 Robert Frank. Detail of a contact sheet from the series *The Americans*, 1955–56.

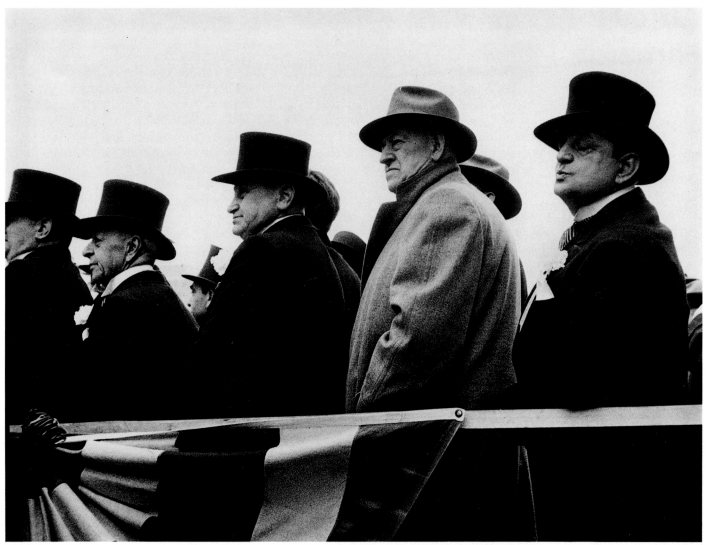

Plate 47

Alfred Ehrhardt

German, 1901 – 1984

Düne, Kurische Nehrung, Ostdeutschland

(Dune, Kurische Nehrung, Eastern Germany)

1936
gelatin silver print
19 1/2 x 12 15/16"
(49.6 x 32.9 cm)
Clinton Walker Fund Purchase
83.3

The German photographer Alfred Ehrhardt was long a student of the vast stretches of sand created by the outgoing tide in the North Sea and Baltic regions. In his photographs, beginning in the mid-1930s, he sought to link tidal cycles and their effect on the pattern and form of sand flats with all of nature's processes. Though grand and romantic, his photographs of beaches are decidedly modern in their attempt to reveal the underlying structure of the world. They convey the same mysterious sense of infinity as that evoked by pictures from outer space, in which the vast curvature of the earth serves as a reminder of man's place in the cosmos.

In one of Ehrhardt's most daring photographs, *Düne, Kurische Nehrung, Ostdeutschland* of 1936, the edge of the earth is dramatically tilted at a forty-five-degree angle, a pictorial device widely used after the mid-twenties by avant-garde artists working in Germany, but here given a fresh interpretation. Ehrhardt's radical perspective creates a feeling of cosmic space, implying that nature's mysteries are scaleless. His intent was to suggest that in the arrangement of grains of sand the answer to some of life's riddles could, perhaps, be found.

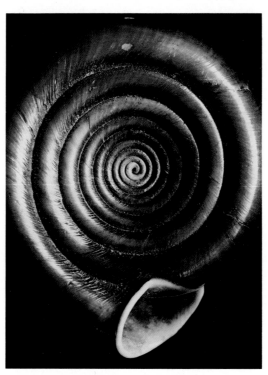

Figure 63 Alfred Ehrhardt. *Polygratia polygrata (Brasilien)*, ca. 1937. Gelatin silver print.

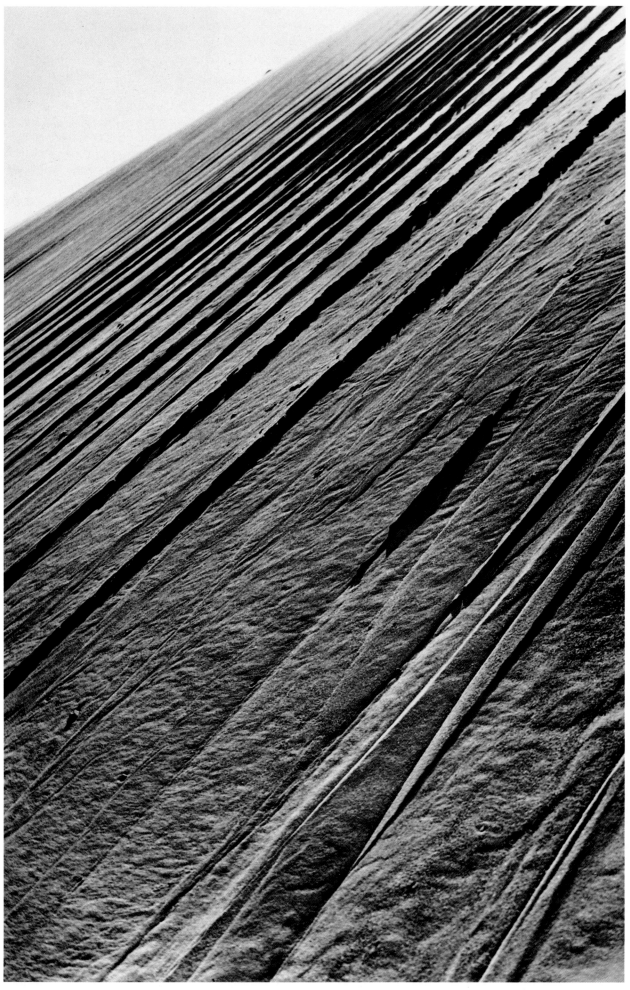

Plate 48

Paul Caponigro

American, born 1932

Bloomfield, N.Y.

1957
gelatin silver print
7 5/8 x 9 5/8"
(19.4 x 24.5 cm)
Gift of Brett Weston
84.297

Paul Caponigro has said that his intent as a photographer is to capture "the elusive image of nature's subtle realms."[1] For him, this aim involves a sense of mysticism and the relationship of nature and man to God. His photographs use a language of light and shadow that communicates through the sheer lushness of tone which, in time, penetrates our protective crust, touching our inner being. Much of Caponigro's work concerns aspects of his personal history, and because he is also a serious pianist, his pictures can be discussed in terms of musical analogies. In the tradition of Alfred Stieglitz and Minor White (plate 50), Caponigro's photographs are "equivalents" for emotional states, from elation to despair; each image blends both up-beat melodies and accents that ring with brooding chords.

Caponigro first saw the cut tree stump pictured in *Bloomfield, N.Y.*, of 1957, as might a child who was looking for adventure. This early print, so telling in its abstraction, at first reminded him of an entrance to a cave and a meeting with a mysterious figure. Later he came to realize that there were personal implications of pain and death in the jagged splinters of the felled tree. When he made this photograph, the "death" of his family was taking place; brothers, a sister, and parents separated.[2] In *Bloomfield, N.Y.*, Caponigro initially reacted to the lure of the unknown suggested by the broken and sawed tree stump, but ultimately its hidden meaning asserted itself from the depths of his unconscious.

[1] Paul Caponigro, *Landscape* (New York: McGraw-Hill, 1975), opposite pl. 32.
[2] Letter to Van Deren Coke, March 15, 1984.

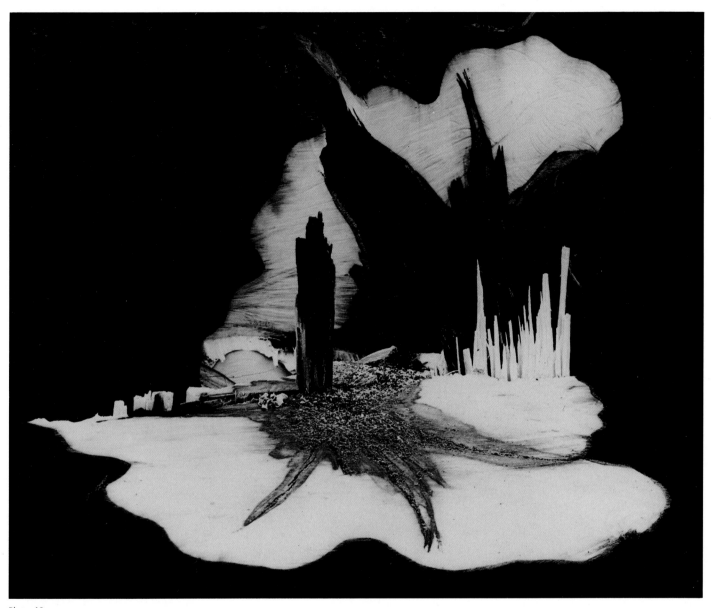

Plate 49

Minor White

American, 1908–1976

Untitled

1958
gelatin silver print
(from an infrared negative)
7 7/16 x 9 1/2"
(18.9 x 24.2 cm)
Purchase
83.37

In twentieth-century photography, the idea of the photograph as metaphor was first explored in depth by Alfred Stieglitz. Strongly influenced by Vasily Kandinsky's paintings and writings, especially his pivotal 1911 essay *On the Spiritual in Art*, Stieglitz sought to express in his many cloud pictures of the 1920s an inner reality through the literal subject before his camera. Called "equivalents" by Stieglitz, these small, often incandescent, images gave expression to his philosophy of life and his innermost feelings—his hopes, fears, wants, and despairs.

In the tradition of Stieglitz, Minor White fully embraced the idea of the "equivalent." He was a poet before he was a photographer, so the language of metaphor was natural to him. Thus, it became the very basis of his photographic oeuvre and an important vehicle for the expression of his intensely personal and spiritual beliefs. The depth and range of White's spirituality are revealed in his conversion to Catholicism in the late 1940s and his study of Zen Buddhism, mysticism, and Gestalt psychology beginning in the 1950s. Most important to White were the philosophical teachings of George Ivanovich Gurdjieff (d. 1949), who proposed energizing the intellectual, emotional, and instinctual centers of being. From a synthesis of these myriad influences, White evolved a passionate approach to photography as a means of both self-exploration and spiritual quest.

In such infrared photographs as this untitled image[1] of trees, railroad tracks, and commercial and public buildings taken in the old Great Lakes port of Oswego, New York, in 1958, White captured an otherworldliness in the mysterious emanations of light. In its broad viewpoint, architectural subject, and use of infrared film, this work is related to a 1955 series of infrared photographs featuring the "magnificent barns"[2] located near Naples and Dansville in upstate New York. Of this group of photographs, which ultimately comprised *Sequence 10*, or *Rural Chapels* as the series has also been called, White wrote: "During the previous year I experimented with infrared film to give contrast to the landscape, which after the west coast landscape seemed much too bland. . . . *Sequence 10* was the fruit of that experimentation."[3] In this picture, the darkened sky and luminous foliage—the result of infrared film's special response to heat absorbed by the atmosphere and reflected by green foliage—do, indeed, lend the composition a new dynamism. The trees are particularly brilliant, for the infrared film also sensed their internal rhythm, that is, their invisible, but heat-producing biological activity. The vaporish, shimmering trees together with the enigmatic railroad tracks that lead to a blackened tunnel, suggesting both a physical and spiritual journey to the unknown, create a strange, ethereal dreamscape. White has essentially transformed something recognizable into something magical. This transformation of the commonplace into the extraordinary is at the heart of much of White's photography.

[1] White also made a conventional negative on panchromatic film of the same subject; letter from Peter Bunnell to Van Deren Coke, April 14, 1984.

[2] Letter from Minor White to Katherine Baker, September 3, 1957; San Francisco Museum of Modern Art Exhibition Files, *Photographs by Dorothy Norman and Minor White*, October 8–27, 1957.

[3] Minor White, *Mirrors, Messages, Manifestations* (New York: Aperture, 1969), p. 229.

Figure 64 Minor White. *Toolshed in Cemetery,* 1955. Gelatin silver print (from an infrared negative).

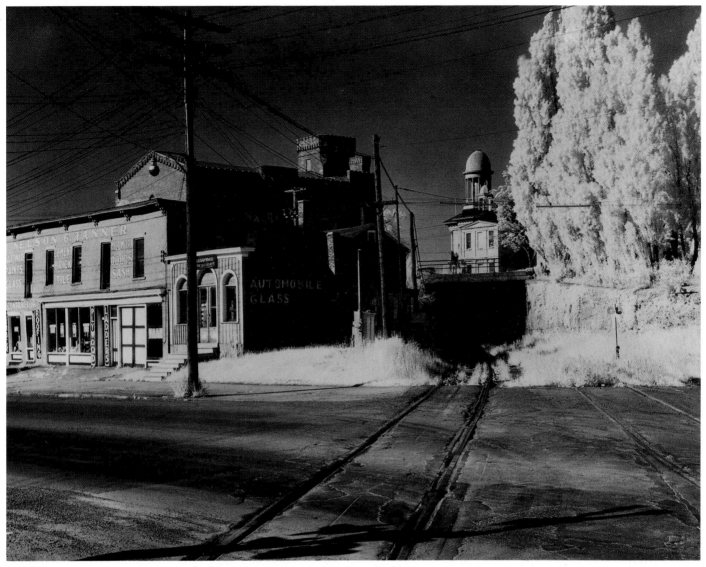

Plate 50

Larry Clark

American, born 1943

Untitled

1971
from the portfolio *Tulsa*,
1980 61/100
gelatin silver print
7 15/16 x 12 1/16"
(20.2 x 30.7 cm)
Gift of Gary Roubos
82.502.16

Larry Clark's legendary book *Tulsa* of 1971[1] —a disturbing document of the 1960s drug culture in Middle America—established Clark as a photographer with a great eye for capturing in a moment the dreamlike feeling of altered states. Clark himself was an intimate part of this drug culture when he made these visceral images of society's misfits. The physical and mental pain evoked by his scenes of young men and women in the thrall of drugs pierces to the heart. Clark's laconic words reveal the source of power in this work: "I was born in Tulsa, Oklahoma in 1943. When I was 16 I started shooting amphetamines. I shot with my friends everyday for three years and then left town but I've gone back through the years. Once the needle goes in it never comes out."[2]

The mindless destruction of flesh and spirit is most poignantly seen in this untitled picture by Clark of a young pregnant woman inserting a needle full of drugs into her vein. For Clark the picture's composition is ancillary to its content. The emphasis is on a tautness of expression that approaches the breaking point, so turgid and jarring is this image. We shy away from it, because it elicits a feeling of collective guilt for the way society has failed this person who is in a swirling decline.

To some, venturesome artists are seen as outlaws. This perception certainly fits Clark, for he has lived beyond the canons of polite society. Thus, the edge of his sword is sharp when piercing the sensibilities of philistines. Steeped in the ethos of young people overwhelmed by the power of drugs and sex, the *Tulsa* series is not far removed from the demonic black paintings of Francisco de Goya or the opium-induced poetry of Arthur Rimbaud.

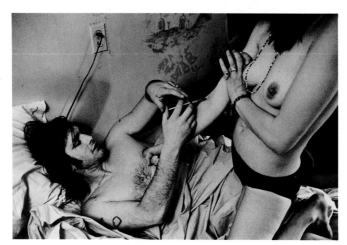

Figure 65 Larry Clark. Untitled, between 1963 and 1971/1980. Gelatin silver print.

[1] *Tulsa* was published first as a book (New York: Lustrum Press, 1971) and later as a portfolio (New York: Lustrum Press, 1974) comprising ten photographs. A second portfolio (RFG Publishing, 1980) mirrors the original book in that all of its fifty images are identical in the selection and sequencing. In 1983 the book was republished by Larry Clark.

[2] Quoted in Guy Trebay, "Larry Clark, Hot Flash?: The Photographer from 'Tulsa' Resurfaces," *Village Voice*, vol. 25, no. 42 (October 15–21, 1980), p. 1.

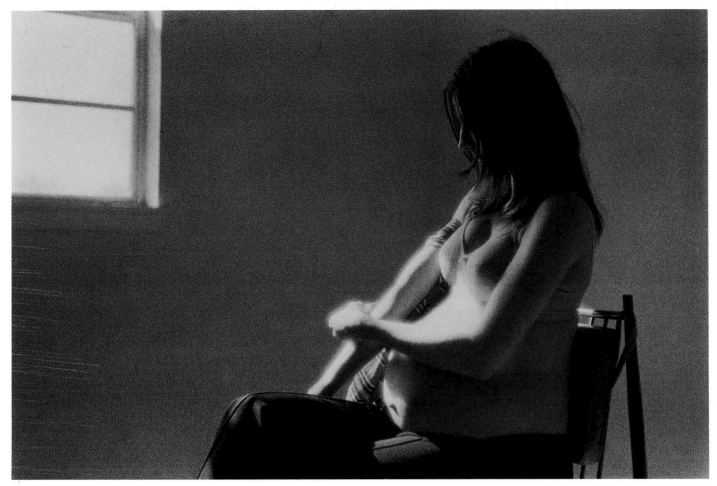

Plate 51

Arnulf Rainer

Austrian, born 1929

Bündel im Gesicht
(Bundle in Face)

1974
gelatin silver print
with ink and oil crayon
20 1/16 x 23 13/16"
(51.0 x 60.5 cm)
Anonymous gift
83.209

[1] Rainer made his first photographic, overpainted self-portrait in 1955; see reproductions in *Arnulf Rainer: Facefarces, Bodyposes 1968–1975*, exhibition catalogue (Paris: Galerie Stadler, 1975), unpaginated. However, he did not begin to make broad use of the medium until the late 1960s. By the mid-1960s many artists, including the Viennese Action group, were using photography either as an integral element in their work or as documentation of their art, a factor that may account for Rainer's renewed interest in photography at this time; see Hans Gercke, "Fotografie in der gegenwärtigen Kunst," *Das Kunstwerk*, vol. 28, no. 1 (January 1975), pp. 3–33, and Peter Weibel and Valie Export, eds., *Wien: Bildkompendium wiener Aktionismus und Film* (Frankfurt: Kohlkunstverlag, 1970). Special thanks is owed Kristine Stiles, a historian specializing in Performance Art, whose knowledge of the subject has been invaluable.

[2] Arnulf Rainer, in *Arnulf Rainer: Facefarces*, op. cit.

[3] Ibid.

[4] Arnulf Rainer, "Face Farces: Grimaces, Facial Forms, Over-drawings, Painted Photographs." Statement dated Vienna, Summer 1971; page 26 detached from an unidentified publication sent by Rainer's atelier in response to the Museum's artist's questionnaire.

[5] *Arnulf Rainer: Overpainted Rainers*, op. cit.

[6] Arnulf Rainer, in *Arnulf Rainer: Facefarces*, op. cit.

One of the most expressive artists working today is the Austrian Arnulf Rainer. This intensity of expression is clearly seen in Rainer's work utilizing photography, a medium to which this accomplished painter and graphic artist turned in the late 1960s.

Rainer's *Facefarces* and *Bodyposes*, in which he photographed his face and nude body and then savagely marked over the photographic prints, possess an emotionalism, a preoccupation with self, and a passionate reliance on an explosive agitated line in the tradition of Viennese Expressionism, especially as characterized by the anguished work of Egon Schiele. Rainer's first extensive use of photography began in 1968.[1] At the time, he had been making drawings of imaginary faces, of "faces, hidden and deformed, grimacing maliciously,"[2] but ultimately felt that they lacked the concentrated intensity he sought. "It was only on the day when, finding myself in front of a mirror, I was able to achieve such a state of excitation that by a veritable 'monologue of mimes' the dialogue was re-established. I repeated this experience often and was able, especially after I had had a few, to tell myself all sorts of things by means of my face."[3] For Rainer, the logical extension of this experience was to fix the mirror image through photography; thus, during 1968 and 1969 he photographed himself grimacing before a camera in a passport photo booth in a Vienna train station. Grimacing, the act of distorting the countenance to express a range of feeling, fascinated Rainer as a primordial form of communication, as a kind of preverbal language. Influenced by the rise of Body Art in the late 1960s and 1970s, especially as practiced in the circle of Viennese Action artists Günter Brus, Hermann Nitsch, Otto Muehl, and Rudolf Schwarzkogler around whose periphery he orbited, Rainer soon moved beyond the

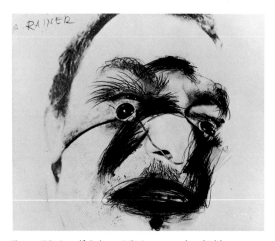

Figure 66 Arnulf Rainer. *Mit Augenstarker* (With Eyestrain), 1971. Gelatin silver print with pencil and oil crayon.

face to include his entire body, in the belief that body language, like physiognomy, can reveal inner character, that the process of performing before the camera can summon "dormant, or psychopathic, reserves of energy."[4]

From the hundreds of photographs he took of himself grimacing and posturing, Rainer would select as final works only those with the greatest "intensity of facial transformation and nervous tension."[5] Early on, however, he found that these images, no matter how contorted in pose, lacked the incisiveness he was seeking, that in and of itself the photograph did not fully document psychic reality. He discovered that this was more closely approximated by both altering and accenting the photographic image by means of the hand-drawn mark. "It was only when I began to re-work, in drawing, the photographs of my physiognomic 'farces,'" Rainer has written, "that I made an astonishing discovery: all sorts of new personages suddenly appeared to me who, all being ME, were not capable of manifesting themselves solely by the movement of my muscles."[6]

Violent, explosive, even grotesque, *Bündel im Gesicht* of 1974, a work from the *Facefarces* series, reveals the skillful way in which Rainer creates an emotionally charged image from an inventive hybrid of photography and drawing. With aggressive marks of the hand, Rainer brutally accentuates his twisted, grimacing self-image captured by the camera. His tightly shut eyes and furrowed eyebrows along with his hair and stubby beard are in effect mimicked by the forceful, gestural drawing. While the marks are inherently harsh, there is something even more disturbing in the way they violate the realistic image of the artist. This intense action is one of self-effacement in which Rainer seems beset with either a persecution complex or a desire for immolation that leads him to take on the role of Christ and through personal flagellation exorcise the sins of man.

Just as Rainer creates a feeling of tension between what is photographic and what is hand-drawn, so does he construct a dialectic between violence and humor. In *Bündel im Gesicht*, the grotesque is tempered by the amusing "disguise" Rainer dons. The way in which the plastic eyes mimic the real eyes, together with the way in which the marks imitate the photographic information, is a strategy of parody. While this work and all the works comprising the *Facefarces* and *Bodyposes* represent a process of self-discovery and self-transformation, they also exemplify a balance between the tragic and the comic, and in this way serve as a metaphor for the human condition.

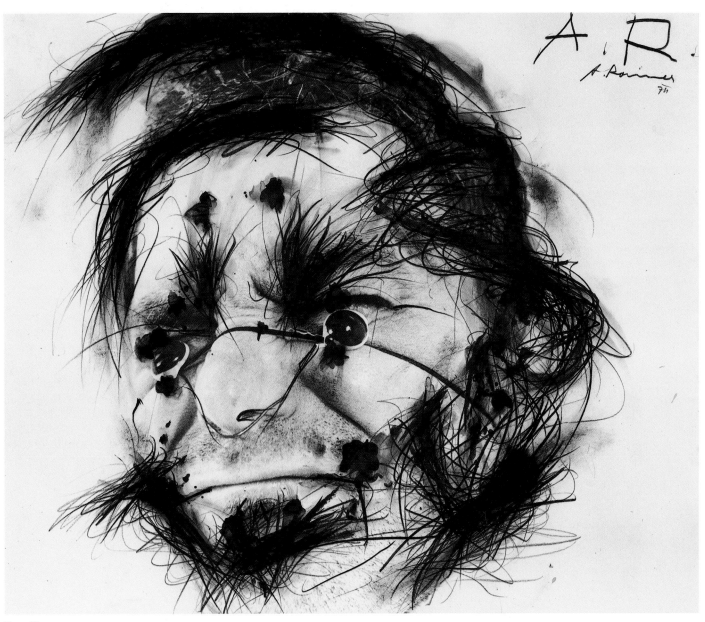

Plate 52

Judith Golden

American, born 1934

Live It as a Blonde

1975
from the series *Chameleon*
gelatin silver print with pastel,
graphite, bump chenille,
and thread in plastic
14 7/8 x 11 13/16"
(37.8 x 30.0 cm)
Anonymous gift
83.329

One of the aims of Surrealism was to release the instinctive self and free suppressed desires. This has been the goal of Judith Golden in her many self-portraits, in which she assumes the appearances and personas of others. Behind her highly manipulated black-and-white and color photographs are dreams of a self-revealing nature. These pictures are not only the result of rationality, but of improvisation as well; they touch that fanciful realm where ego and art, idea and image foil one another.

Golden draws on her subconscious to retrieve childhood fantasies and dreams of primitive powers that are instinctual in nature. A painter-printmaker turned photographer, she gives full rein to her fascination with the application of brightly colored paint and collage elements—sequins, scraps of fabric, or jewelry—to the photographic surface. These unusual additions lend her prints a sense of physicality and symbolize her freedom from conventional photographic limitations. Through her sophisticated hybrid of painting and photography, Golden questions what is real and what is illusion. Of her earliest work in this vein, the *Chameleon* series, she has commented, "I was putting real objects on photographs and sewing them in plastic, adding the element of realness to the photographic illusion. I like to play little games with it. In one of the 'Chameleon'

works, one of them called 'Snow', has little white crystal glitter in it so that you can shake it like those old paperweights and put snow all over the face. On some of them I would have a real fake rose on top of a photographic fake rose that was underneath. I was interested in the fact that when you first looked at it, you couldn't really tell whether the photograph was real or the collage thing was real."[1]

It is through the application of unorthodox materials to the print surface that Golden changes the color and style of her make-up and takes on another identity. In *Live It as a Blonde* of 1975, a work from the *Chameleon* series, Golden's coloring of her likeness with oil pastels and chalk was inspired by a Clairol hair advertisement that implied that if one changed the color of one's hair, life would be happier and more exciting. Golden was responding to the stereotypes created by advertisers and their effects on women's attitudes about themselves and their roles in society. The work cleverly also makes reference to the way advertisers package ideas by the way the photograph is sandwiched between two sheets of vinyl, like factory-sealed items hanging on supermarket display racks.

[1] Dinah Portner, "Dialog with Judith Golden," *Los Angeles Center for Photographic Studies Newsletter*, vol. 4, no. 10 (October 1978), n.p.

Plate 53

Aleksandras Macijauskas

Lithuanian, born 1938

Untitled

1977
from the series
In the Veterinary Clinic
gelatin silver print
11 1/8 x 14"
(28.3 x 35.6 cm)
Gift of the artist
80.273

While the photographs of Aleksandras Macijauskas tell us much about life today in rural Lithuania, they also poignantly convey the range of human expression from petulance to pleasure. His photographs of simple country living, something now largely alien to many parts of the industrialized Western world, fascinate us, for there is in them a directness about the cycles of life—about the way people interact with each other and with the animals and environment that help to sustain them.

Since the beginning of his photographic career in the early 1960s, Macijauskas has had an affinity for those everyday occurrences that, when isolated, epitomize commonly felt emotions. This unique sensitivity is most movingly seen in his 1977—78 series *In the Veterinary Clinic*. Taken in a rural veterinary hospital, these images depict at times gruesome and disturbing scenes of ailing animals being strapped to wooden operating tables, undergoing injections, anesthesia, and surgery, or having stillbirths. In this untitled work from the series, a cow is seen securely bound to an operating table, while attending veterinarians, dressed in their professional white coats and caps, seem to exert a men-

acing control over the now entirely helpless creature. Indeed, at first glance there is a haunting suggestion of torture, which is only redressed by the title of the series.

In this and every image in the group, Macijauskas creates a sense of stark immediacy by using a high-speed, grainy film and a wide-angle lens that brings us within close range of the subject in the near foreground; we are not observers standing at a distance, but are personally involved at the very center of action. We are confronted by this miserable creature whose gaping mouth and wide-open eyes are the embodiment of raw fear. The power of this photograph lies in its ability to intensify our identification with this basic, primitive emotion. The animal's vulnerability is unsettling, for it stirs hidden fears within us, those frightful moments in our nightmares or experiences when we were helpless and in pain.

Plate 54

Harry Bowers

American, born 1938

Untitled (HB-28-80)

1979/1980
Ektacolor print 1/10
50 x 39 3/4"
(127.0 x 101.0 cm)
Gift of Byron Meyer
82.489

In America during the 1970s feminism enjoyed a high profile that brought about fundamental and unsettling social change. The media—television, newspapers, magazines, and films—created an instant and universal awareness of the movement, which made for swift and far-reaching appraisals of traditional values. Feminism's challenge of stereotypical male and female roles led to an exchange of participation in areas previously reserved for one or the other sex: women ventured forth into new vocations and men began to take greater responsibility in the home. This radical transformation of the highly sex-specific role of delineations of the 1950s and early 1960s provoked much discussion of gender identity. What was really feminine and masculine was actively debated in both the social-science journals and the popular press. "Sexual Identity and Sex Roles," "How to Reduce Sex-role Stereotyping," "Sex Role Differences: Why? . . . and Their Future Importance" are representative titles of the articles on the subject published during the period. If changing perceptions of sexuality captured the attention of social scientists and writers during the 1970s and early 1980s, it also intrigued artists.

For photographer Harry Bowers this concern was an important issue in his 1979–80 series of large-scale Ektacolor prints of which Untitled (HB-28-80) is one. Related to his earlier series *Skirts I've Known* in that it is a tableau specifically fabricated for the camera, this work features a large black-and-white photograph of the artist, shirtless and dressed in cut-off dungarees and socks, crouching in a fetal position on a chair. Collaged over the representation of his body is a white paper mannequin whose silhouette echoes—in reverse—that of the artist. There is the suggestion that he is carrying a child, in this case himself.[1]

Bowers challenges traditional gender stereotyping by implying that the wish to bear a child is not exclusively a female prerogative. In this challenge there seems to be the positive acknowledgment that people are a complex blending of personality characteristics rather than just one-dimensionally feminine or masculine. "There are these certain kinds

of sexual attitudes that are being more clearly defined," Bowers has said. "All I'm suggesting is that we are naturally androgynous. The differences [between the sexes] aren't as great as people would like to make them out to be, and when they try to make differences it might be more for political reasons than anything else."[2] Bowers's recognition that such an idea is received as an affront to old values is seen in the way he shamefully covers his head as if to conceal it and the way in which it is bathed in brilliant red, like the scarlet letter symbolic of sin in Nathaniel Hawthorne's novel.

The aesthetic considerations of this large-scale, pristinely rendered and luxuriously colored work are as provocative as Bowers's subject. Fascinated with the perceptual dilemma between reality and the illusion of reality as captured by the camera, he created an elaborate tableau using a pane of glass as a matrix around which to organize the collage elements. Bowers's figure, a cut-out from a large black-and-white photograph, has been placed behind the glass plane against a field of green fabric, while the remaining surround—in perfect register with the figure—and the paper mannequin have been placed in front of the glass so as to give a slight impression of depth. This sense of three-dimensionality is subtly reinforced by the shadows cast by pieces of tape and the way in which the cut edges of the surround are turned back as if to unveil the figure underneath. To produce the final work of art, Bowers recorded this fabricated setup with the camera's exacting eye. He "maximizes the inherent realism of photography"[3] through his use of color and life-size scale, thereby creating a trompe-l'oeil effect. The convincing illusion of this work defies the camera's single eye, which typically flattens space. As Bowers has said, "I think it [the trompe l'oeil] had to do with just denying all photographic rules, signs and identifications that said 'This is a photograph.'"[4]

[1] Another possible interpretation is that this mannequin symbolizes an alter-ego, a second, unconscious self from which the artist retreats as if it were a burden in these troubling times.

[2] Harry Bowers, interview with David Fahey, *G. Ray Hawkins Gallery PhotoBulletin*, vol. 3, no. 6 (September 1980) n. p.

[3] Hal Fischer, "Harry Bowers," exhibition review, *Artforum*, vol. 17, no. 1 (September 1978), p. 87.

[4] Harry Bowers, interview with David Fahey, op. cit.

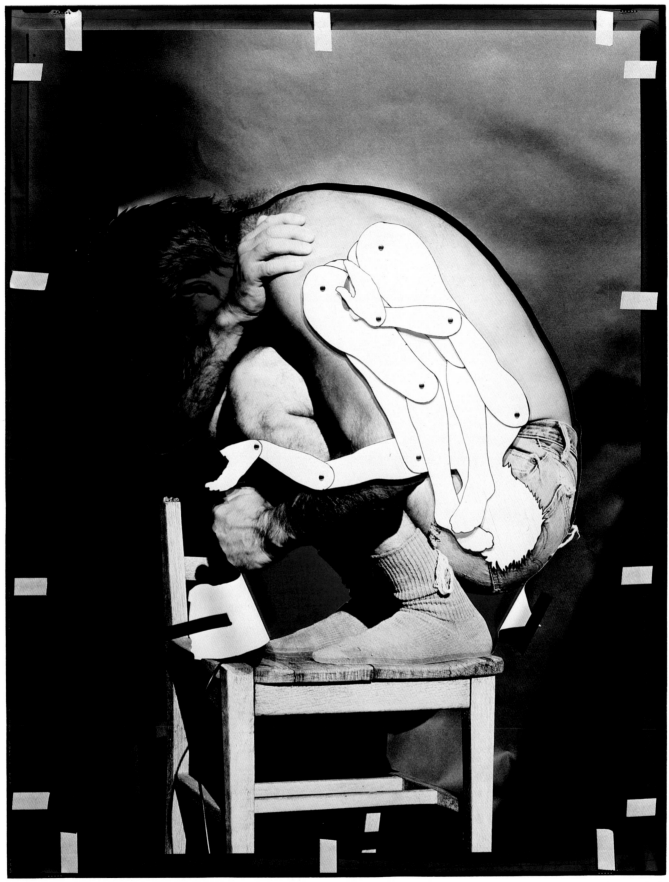

Plate 55

Anne Noggle

American, born 1922

Mary

1981
gelatin silver print
15 15/16 x 11 5/16"
(40.5 x 28.8 cm)
Clinton Walker Fund Purchase
83.72

Anne Noggle is acutely sensitive to our deep-seated fears about aging and its effect on our physical as well as spiritual being. "I photograph the tragedy of fallen flesh," she has said.[1] Middle-aged and elderly women—often herself, family, or friends—are the primary subjects of this photographer who first began to work with the camera in her early forties. In her penetrating portraits, America's image of women as eternally youthful is subverted by a near-brutal honesty about what it means to be human. Deeply etched wrinkles and sagging flesh tell a poignant story; they are indications of a life's history, the visual evidence of how time has shaped personal character.

Noggle's women are a new kind of heroine in this unsettled world. They are survivors, whose faces reveal the strain and effort, but they remain bright-eyed and willful. *Mary* of 1981, a portrait of the artist's older sister, for example, is a modern vision of the American Western woman. While the pain and anguish of life have left their imprint, Mary stands proud and determined against the mountains and sky of the Southwest, her jaw stoically fixed. Relying on the camera's power of description in this straightforward black-and-white photograph, Noggle captures her squinting in the face of the bright sun, which harshly illuminates every nuance of this face sculpted by time. With characteristic wit, Mary's inner strength is underscored by her "macho" Dallas Cowboys T-shirt and her gardening claw. Like the other high-spirited and often eccentric women in Noggle's photographs, Mary is not defeated by life's bouts with grief, sorrow, and love, but rather emboldened by them. "I hope that all of my images have or hold in some sense the heroics of confronting life," Noggle has said. "I hope I speak more of immortality, of humanness and that our limited spans on this planet are notable. I'm trying to humanize the middle-aged and older, to find a new perspective that does more than simply deny older persons and let them be a viable part of society."[2]

Yet, for all her tenacity there is deep down a painful awareness of mortality, and it is this tension between freedom and fate, toughness and vulnerability that makes for the complexity of Noggle's images. The challenge, it seems, becomes one of confronting not only the difficulties of life, but ultimately of death as well with courage and dignity.

[1] Quoted in Jan Zita Grover, "Anne Noggle's Problematic Portraits," *Afterimage*, vol. 8, no. 4 (November 1980), p. 5.

[2] Quoted in Janice Zita Grover, "Anne Noggle's Saga of the Fallen Flesh," in *Silver Lining: Photographs by Anne Noggle* (Albuquerque: University of New Mexico Press, 1983), p. 27.

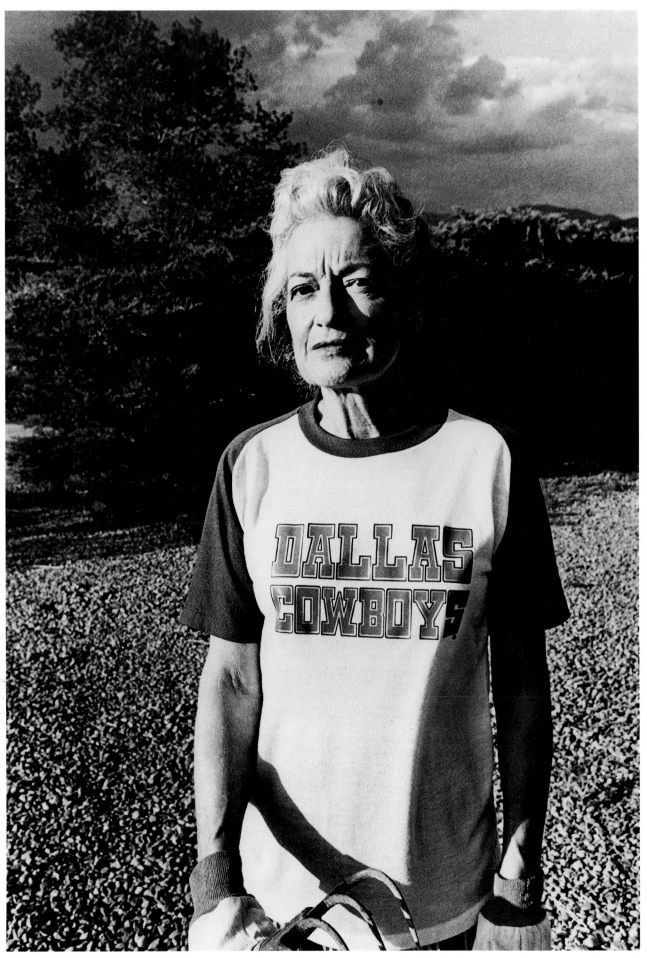

Plate 56

Sandra Semchuk

Canadian, born 1948

Series #10

1982/1983
5 Cibachrome prints
overall 7 7/8 x 48 1/2"
(20.0 x 123.2 cm)
Purchase
83.34 A–E

Plate 57

[1] "Whether expressing itself in words, paint, collage, sculpture, or the photographic image," wrote Joyce Tenneson Cohen in 1978 in her introduction to *In/Sights: Self-Portraits by Women*, "the autobiographical statement has emerged as a major concern of contemporary women artists. Perhaps it is simply the times, for the past decade has witnessed an unprecedented study of 'self', while the women's movement with its emphasis on finding and establishing a personal identity has encouraged and legitimized this form of expression." Cited in Brian D. Taylor, "Recent Autobiographical Trends in Photography" (M.F.A. diss., University of New Mexico, 1979), pp. 29–30.

[2] Joan Solomon, "In/Sights." Review of *In/Sights*, comp. by Joyce Tenneson Cohen, *Ten.8* [London], no. 4 (Spring 1980), p. 4.

[3] "Although the images . . . deal with a woman's awareness (I include my daughter in that), my work is not limited to woman. In fact, in the devolution/evolution of family, my relationships with key men have been fundamental. The new work, the collaborations, has progressively involved Stephen [Cummings] in the actual creation of the work as an exploration of the creative dynamics of the male/female relationship"; letter to Diana du Pont, June 4, 1985.

In the hands of Sandra Semchuk, the camera—historically considered a master recorder of objective reality—is turned toward the subjective, toward the elusive realm of her own psyche. Semchuk's concern with the autobiographical has been a consistent thread throughout her work, which constitutes part of a trend in photography of the 1970s—especially among women—toward a diaristic, self-conscious art.[1] Unlike other women photographers, such as Jacqueline Livingston and Judith Golden (plate 53), for example, who are interested in how society has shaped female roles, Semchuk makes no overt political statement.[2] Rather, her work represents an endless search for self-awareness, a highly personal, poetic journey to her hidden and authentic inner being.[3]

It was in Saskatchewan, Canada, in 1975 that Semchuk began photographing herself—either alone or with family and close friends—over an extended period of time, monitoring "nuances of change in the physical and psychological being."[4] Engaging in their direct confrontation with the viewer, these black-and-white images made consistent use of a tripod and set formats, such as head-and-shoulder poses. "Like a poet choosing a conventional form such as the haiku, I set formal limitations," wrote Semchuk, "so that I had boundaries within which to expand my vision."[5] Seeking change, in 1982 Semchuk came to New Mexico, where the radically different physical and social en-

vironment, combined with an earlier introduction to the discipline of Chinese brushwork, led to a marked divergence in the style of her work, while the content remained essentially autobiographical in its exploration of the "mysteries of relationships."[6]

During her period of graduate study at the University of New Mexico, Semchuk moved

Figure 67 Sandra Semchuk. *Self-Portrait at Grieg Lake, August, 1979*, 1979. Gelatin silver print.

144

away from the confrontational, descriptive self-portrait toward the more generalized, co-operative self-portrait wherein her daughter plays an increasingly important role. Her approach to autobiography used the camera no longer to ''witness'' the self, but to ''parallel'' it:[7] parallel in the sense of both living within the moment instead of merely observing it, and looking at someone who is close to you as a separate and independent person, but still deeply connected to you and part of your life's history. With this change in approach came a new reliance on the emotional impact of color and a more integrated, rhythmic sequencing of images.

Made in New Mexico in 1982, *Series #10* depicts Semchuk's daughter, Rowenna, performing a kind of spontaneous ritual in nature with glimpses of Semchuk herself, a foot here and a hand there. With the camera, Semchuk—who once said, ''It seems as though I grew up with water, mud, and snow halfway up my knees''[8]—enters into a dance with, or in essence parallels, her daughter as she moves through, explores, and develops within a black, seemingly primordial body of water, that timeless symbol

of metamorphosis. Discarding the rigid constraints that guided the making of her earlier self-portraits, Semchuk photographs intuitively, as if the camera were attached to the top of her head. She seems to run and swim and occasionally dive into deep water, recording glimpses all about her as she passes through space. A loping dance rhythm, with brief periods of repose, characterizes the lyrical imagery of this sequence, which presents no full frontal views, only oblique fragments. Sometimes sharply focused and seen at close range, sometimes blurry and seen at a distance, Semchuk's spontaneous, fluid imagery has evolved from her work with Chinese calligraphy. To her the camera is the equivalent of the Chinese brush, and she sees herself as ''taking it through a kind of stroke'' which is ''always working with tension and always changing and moving against itself to create a sense of life.''[9]

The sense of endless flux that Semchuk achieves is a metaphor at once for her daughter's physical and psychic development as well as her own evolving levels of self-awareness. ''I find environs of shapes,'' Semchuk has written, ''for rites of passage from one state of consciousness to another; a constant breaking of the shells of my own consciousness; a creation of shells in order to destroy them and to create anew.''[10]

[4] Sandra Ann Semchuk, ''Toward Real Change: My Photographic Work Done in Saskatchewan from 1972–1982 and in New Mexico from 1982–1983'' (Master of Arts in Studio Art thesis, University of New Mexico, 1983), p. v.

[5] Ibid., p. 7.

[6] Ibid., p. 8.

[7] Ibid., p. v.

[8] Ibid., p. 2.

[9] Telephone conversation with Diana du Pont, March 18, 1985.

[10] Semchuk, op. cit., p. 16.

Les Krims

American, born 1942

**A Marxist View;
Bark Art; Art Bark
(for ART PARK);
Irving's Pens;
A Chinese
Entertainment;
and Brooklyn:
Another View**

1983/1984
Ektacolor print A.P. VII/X
28 1/4 x 35 3/4"
(71.8 x 90.8 cm)
Gift of the artist
84.103

[1] "Interview with Leslie Krims," *Aura*, vol. 1, no. 1 (February 1976), pp. 6 and 42.
[2] This work is a study for *A Marxist View; Madam Curious; Bark Art; Art Bark (for ART PARK); a Chinese Entertainment; Irving's Pens; Something to Look at Spotting Upside Down; Hollis's Hersheys; and 4 Lovely Women Posing. . .*, 1984, Ektacolor print, in an edition of 15.
[3] Krims claims that his main interest in this work was in addressing "fashionable ideological views," especially those of the contemporary art world. To him, the most central aspect of the work is its attack on the "prevailing fashionable Marxism" in art (interview with Diana du Pont, June 1985). This reaction stems specifically from the intense criticism he has received from the Marxist Feminists—as he identifies them—associated with the Society for Photographic Education; see, for example, in the society's quarterly magazine D. A. Clarke, "The Evidence of Pain," *Exposure*, vol. 19, no. 3 (1981), pp. 16–18, a highly condemnatory discussion of a Krims work.

Like the comedian Lenny Bruce before him, the photographer Les Krims has been accused of scabrous humor that shocks and entertains by the crudest, most vulgar methods. Many have found his satirical work—from pictures of his Jewish mother making chicken soup in nothing but her underpants, to those of young women feigning sexual assault and death by murder—violently offensive. Touching upon society's conventions, insecurities, prejudices, and hypocrisies, Krims's difficult subject matter has the power to invoke extreme reactions.

Dedicated to the *tableau vivant*, Krims presents his serious humor in wildly imaginary contexts. His business is fiction making, creating a kind of surreal theater of the absurd in which he emphasizes quixotic juxtapositions of eccentric and kitschy props. For Krims—who in the mid- to late 1960s was a leader of the directorial mode in photography—fabricating scenes to be photographed is the essence of his artistic practice. He thinks of himself as a conceptualist and of his work as an objectification of "mind-imaged ideas." "Photography," he has said, "is a tool employed to objectify certain kinds of image-ideas, and that is its ultimate form."[1]

Based on objects attached to a wall in Krims's house over about a ten-month period, *A Marxist View; Bark Art; Art Bark (for ART PARK); Irving's Pens; A Chinese Entertainment; and Brooklyn: Another View*[2] is a recent work in which the mélange of ideas, objects, and symbols is at, perhaps, its most complex level—integrating personal, social, and art-related concerns. Inspired by the graphic presentation of fireworks in sales catalogues, Krims decorated the entire wall with fireworks and other Americana, creating a modern rococo kitsch. The fireworks, to which "A Chinese Entertainment" refers in the enigmatic title, allude to the Fourth of July, to America's founding and its ideals. One is prompted to ponder this allusion further by the question written over the central window which asks, "What's the American Dream?," until one reads the reply, "Five Million Blacks Swimming Back to Africa with a Jew under Each Arm." In using this bigoted riddle, an adaptation from the book *Tasteless Jokes*, Krims bares a national hypocrisy. He further emphasizes feelings of racism and anti-Semitism by writing the word "Blacks" in black and "Jew" in yellow, the color of the star of David Jews were forced to wear in Nazi Germany.[3] As in his book *Making Chicken Soup* and, in a more strident way, in his series *Idiosyncratic Pictures*, Krims once again makes reference to his Jewish heritage.

The question of racism and anti-Semitism, however, is only one facet of this rich and varied piece. As in all of Krims's work, the complex symbolism—much of which is entirely peculiar to his unique vision—cannot be reduced to a single programmatic reading. Mysterious, for example, is the inclusion of Paul Diamond, his wife, and their baby, Brooklyn, who is held upside down (thus the reference "Brooklyn: Another View" in the title). The suspended baby and the ax lying on the rough-hewn chair vaguely allude to sacrifice. Ambiguous too is Krims himself, who is pictured sitting with a puppet in one hand and a red tray with seed and stuffed birds in the other. In this world of excessive pop consumerism, Krims has also included some traditional symbols cum kitsch—honeycomb-paper apples and rubber snakes, which relate to the paper brides and grooms and, in turn, hark back to Adam and Eve. Whether comprehensible as a unified concept or not, this work offers sheer delight in its plethora of marvelous, eccentric paraphernalia exquisitely rendered by the 8 x 10" view camera. At the very least, this strange, inexplicable image comments on the madness of our contemporary world and its prejudices.

Plate 58

Pluralism

Robert Cumming

American, born 1943

Spray-Snow Christmas

1969
gelatin silver print
7 11/16 x 9 3/4"
(19.6 x 24.8 cm)
Gift of Foto Forum
84.11

[1] Quoted in "Robert Cumming: Objects and Their Photographs," interview with Russell Keziere, *Vanguard* [The Vancouver Art Gallery] (December 1978–January 1979), p. 10.

[2] Quoted in "Through Western Eyes: Seven Artists Talk about Living and Working in Southern California," interviews by Leo Rubinfien, *Art in America*, vol. 66, no. 5 (September–October 1978), p. 80.

[3] Ibid.

[4] For a discussion of Cumming and narrative art, see *American Narrative/Story Art: 1967–1977*, ed. Paul Schimmel, exhibition catalogue (Houston, Tex.: Contemporary Arts Museum, 1978), p. 80.

[5] An interest in linguistics and the idea of transforming abstract signs into physical objects were further pursued in a 1970 work entitled *Sentence Structures*. "In an empty lot Cumming erected rows of wooden poles and crossbars to which he attached words made up of foot-high cutout wooden letters; the words, which formed sentences, were arranged on the supporting poles according to a popular graphic method of . . . diagramming the 'sentence structure'"; see Charles Hagen, "Robert Cumming's Subject Object," *Artforum*, vol. 21, no. 10 (Summer 1983), p. 37.

Artificiality and illusionism have been important themes at the center of Robert Cumming's photographic work. Indeed, his best-known photographs of the 1970s—witty, staged images seemingly intended to fool the eye—were inspired by America's greatest mass producer of illusion: Hollywood. A native New Englander educated in the Midwest, Cumming moved to the Los Angeles area in 1970. "When I came to California I was fascinated by the movie lore," Cumming has said. "I collected stills of the sets, strange documents of these little worlds that you were allowed to look at without the main focal point of the fiction."[1] These still photographs, which often included the labyrinthine scaffolding and the manifold lights, pulleys, and machines behind movie sets, revealed to Cumming the paradoxical obsession with which the film industry pursued illusion. "A lot of them," Cumming has remarked of these images, "are just pictures of completely vacant sets—photographs taken by the studios for their records—and they're really bizarre. They depict very common scenes—the kitchen, or the inside of a church—but instead of using a real church, the studio has fabricated the illusion of a church; it's jerry-built, and might only be two-dimensional. It doesn't have an outside, or if it has an outside it doesn't have an inside, and environments switch back and forth from inside to outdoors. For instance, you'd have an entire landscape constructed on a soundstage—a funny contradiction in environments."[2]

Yet, living in Los Angeles "was simply fuel for the fire,"[3] for a concern with setting a stage to be photographed was an interest Cumming had begun to explore in Milwaukee just prior to moving to California. It was here that his penchant for both sculpture and photography merged to form an innovative hybrid, as seen in such works as *Spray-Snow Christmas* of 1969, an early piece in which conceptual and social issues are united by Cumming's special sense of humor. In a darkened room illuminated by a lone floodlight, Cumming features the word "Christ-mas" as if it were a protagonist in an absurd drama.[4] He gives the impression of makeshift staging by creating a backdrop out of a piece of creased and torn cardboard propped up by a chair, and by including a stack of wood and other paraphernalia off to the side. In a blur of motion, he shows himself spraying the constructed letters with artificial snow.

Cumming's use of word as subject evolves from Conceptual Art's concern with language. Having made and assembled each of the letters to form, in essence, a piece of sculpture, Cumming plays with the idea of the word as both object and signifier. Three tiers of meaning are implied: the denotative, which refers to the birth of Christ; the connotative, which embraces the ritual surrounding Christmas; and the physical, which accounts for the actual construction.[5] By making the mechanics of the staging apparent, Cumming also addresses Conceptual Art's concern with process, with the idea of the artist as fabricator.

More importantly, Cumming speaks to the culture as fabricator. *Spray-Snow Christmas* is a parody of those kitschy Nativity scenes set up on people's lawns or in town squares during the Christmas season. The humorous way in which he attempts to make the letters stand upright by pulling them with a string mechanism alludes to the way modern, materialist society manufactures the ritual of Christmas. This, combined with the artificial spray snow and the casual, impromptu staging, suggests a trivializing of one of Western culture's most fundamental ceremonies. Whether in a direct, straightforward way, as in this early work, or in a more circuitous fashion, as in his illusionistic visual conundrums of the 1970s, Cumming's intent has always been to reveal the artifice: not to deceive, but to subvert fakery and illusionism.

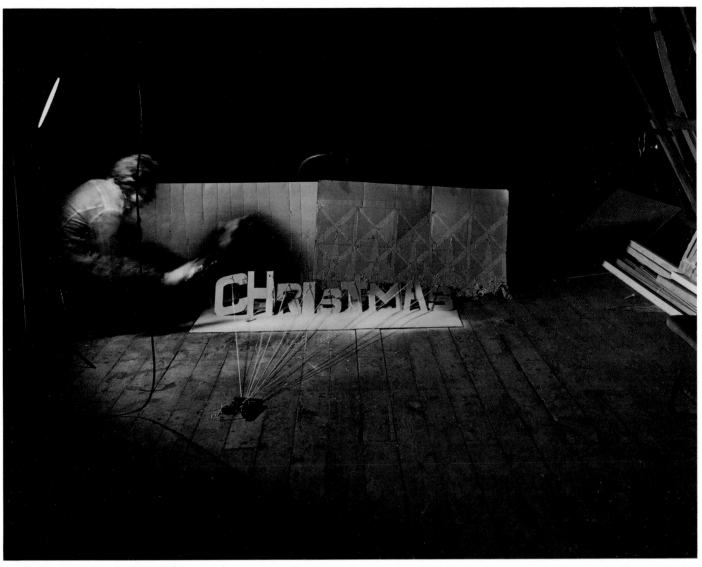

Plate 59

John Pfahl

American, born 1939

Australian Pines, Fort De Soto, Florida

1977
from the portfolio
Altered Landscapes, 1981 7/24
dye-transfer print
7 11/16 x 10 1/8"
(19.6 x 25.7 cm)
Purchased through a gift of
Julian and Jean Aberbach
81.140.7

Landscape is John Pfahl's domain. The most consistent subject of his photographs, it is the realm in which he addresses a complex of issues ranging from visual perception and contemporary aesthetics to man's relationship to nature.

Pfahl's first extensive work with the landscape began in 1975. While he had always felt a special affinity for the majestic beauty of nature, he did not embrace it as a subject until the mid-1970s, believing that traditional landscape photography as typified by Ansel Adams and the Sierra Club was an overpopularized genre capable of little innovation. By 1974, however, he at last discovered a fresh and inventive way to deal with his "deeper responses to the landscape."[1] In May of that year he collaborated with "new music" artist and composer David Gibson on the making of photographic music scores, for which his contribution involved applying colored tapes to trees in the forests south of Buffalo, New York. The notion of interacting with the landscape was key for Pfahl; it gave him the freedom to photograph beauty in the landscape, not as an end in itself but as a nexus for more conceptual concerns. "I was finally able to use the landscape and all those traditions of the 'picturesque' as a substrate for more intellectual overlays."[2]

Pfahl thus embarked upon his now well-known *Altered Landscapes* series in which, with frequent wit and humor, he photographed fabricated geometric forms—derived from mapmaking and diagramming systems and made of such materials as string, tape, and foil—within splendorous landscapes that at times spoof Ansel Adams or Eliot Porter and their nineteenth-century predecessors Timothy O'Sullivan, Carleton Watkins, and William Henry Jackson. A beautiful, white sandy beach, aquamarine ocean, and brilliant blue sky beyond a grove of trees is, for example, the subject of *Australian Pines, Fort De Soto, Florida*, a work of 1977 from the *Altered Landscapes* series. A conceptual game player using optical illusion, Pfahl at first entices us to read this "picturesque"[3] scene, enhanced by the richly hued color, as

if it were a picture window with conventional perspective. It is soon apparent, however, that rounds of aluminum foil have been meticulously attached—rather than hand-drawn on the print surface—to the tree trunks so as to echo the existing horizontals in the landscape and negate the initial sensation of depth. "When I'm looking at one of my photographs I can look at it two ways," Pfahl has remarked. "If I ignore my added configuration I can see a good deal of depth, but when I concentrate on the configuration it immediately flattens out. I like the snapping back-and-forth that happens."[4]

Pfahl's imaginative manipulations extend modernism's concern with the nature of seeing, causing us to question our perceptions and our assumptions about the illusionism of photography. Like many of his contemporaries working in the medium, he questions the acceptance of photography as a picture window onto the world. He employs the fabricated elements to interrupt our seamless view so as to remind us that we are not looking at reality but at a photograph of reality, thereby creating a dialectic much like that in René Magritte's famous painting *This Is Not a Pipe*. *Australian Pines, Fort De Soto, Florida* comments upon the fact that the camera is a man-made system for representing reality just as one-point perspective was for the Renaissance. The work challenges Western man's unthinking acceptance of such picture-making systems as mirrors of reality at the same time that it alludes to how fragile man's perceptions are, how easily his conditioned responses can be overturned by the clever addition of tape, foil, or lace. In its own right, and as part of the *Altered Landscapes* series, *Australian Pines, Fort De Soto, Florida* turns photography on its head, causing us not only to re-evaluate the way we see, but also to understand the systems that shape the process of making art.

[1] Stuart Rome, "John Pfahl Interview," *Northlight* [School of Art, Arizona State University, Tempe, Ariz.], vol. 14 (1983), p. 37.
[2] Ibid.
[3] See Pfahl's statement on the "picturesque" in Anthony Bannon, "John Pfahl's Picturesque Paradoxes," *Afterimage*, vol. 6, no. 7 (February 1979), p. 12.
[4] Unpublished interview with Van Deren Coke, 1978, p. 4.

Plate 60

Rick Dingus

American, born 1951

Untitled

1977–79
gelatin silver print
with silver pencil
14 1/8 x 14 1/2"
(35.9 x 36.9 cm) irregular
The Helen Crocker Russell
and William H. and
Ethel W. Crocker
Family Funds Purchase
80.179

The glints from Rick Dingus's silvery marks catch the eye immediately, for they convey the energy of a dynamic sketch. Set against the reality of photographic imagery, his marks affect the viewer instinctively. They are vital, personal, expressive manifestations of the hand which counter the precise, detached, mechanical recordings of the camera. In the mid- to late 1970s, Dingus, like many photographers of his generation, became skeptical about conventional black-and-white photography as a viable means for self-expression. These artists came to see the act of marking as an effective way to inject an element of human participation into photographic imagery so as to evoke more directly the primal roots of art. For them, to make marks on their photographs was a means of returning to the idea that art is a form of incantation.

It was in New Mexico in 1976 that Dingus first began to draw on his photographs. Interested in the landscape, and most particularly in the natural processes of the earth, he selected unassuming hillsides, simple mounds of dirt, or depressions in the ground, as subjects for his photo-drawings. In contrast to the dramatic vistas of the Southwest, these narrowly framed, unspectacular sites offered new perspectives with which to express a fascination with both geologic time and change, and the notion of mark making. An embankment with dirt mounds and a pathway at its base was the object of the camera's eye in this untitled photo-drawing of 1977–79. In marking this photograph, Dingus enhanced or obscured areas of the image so as to convey an expressive energy.

The evanescent, silvery marks create a magical surface dynamism as they constantly shift in the way they reflect light, at one moment appearing as highlights and at another as shadows, depending on the viewer's vantage point. In their exuberance and energy, these markings imply the invisible forces shaping the earth.

While subtle correspondences emerge between the delicate middle-gray tones and uniform textures in the photograph and those of the hand-drawn mark, Dingus's juxtaposition of the additive process of hand-created imagery with the subtractive process of camera-created pictures heightens our awareness of the fundamental differences between these two modes of image making. For Dingus, the essential "dialectic" is between "the spontaneous gestural impressions" of the drawing and "the precise analytical clarity and stillness of the scene captured by the camera."[1] Just as significant is the parallelism Dingus establishes between his markings *on* the photograph and the man-made marks *in* the photograph, including the evocation of middens where Indians have left their "marks" in the Southwest.

Dingus's pictures and those by other "markers" challenge the uncompromising bias of those photographers who see great virtue in the purity of process. In this there is a philosophical implication: that a dominance of high technology can become an enemy of humanity.

[1] Rick Dingus, letter to Van Deren Coke, December 15, 1982.

Plate 61

Thomas F. Barrow

American, born 1938

Self-Reflexive

1978
gelatin silver print with
Polariod SX-70 prints,
lacquers, epoxy enamels,
and staples
16 x 19 7/8"
(40.7 x 50.5 cm)
Purchase
79.254

Thomas Barrow is among those contemporary photographers who use a painter's strategy to free us from simple responses to the camera image. Initially trained in painting and graphic design before studying photography with Aaron Siskind (plate 36) at the Institute of Design in Chicago, Barrow creates pictures that have a strong design quality. Intellectual and cerebral, these works reveal a serious interest in the nature of photography and represent an important trend among photographers over the last decade to examine the medium.

The significance of Barrow's work does not hit the viewer between the eyes at first encounter. Rather, his complicated, hand-worked pictures accrue meaning through the slow process of assimilation. Our imagination is invited to partake in a peeling-back process, for his works are composed of such varied materials as paint, lacquers, photograms, Polaroid prints, stencils, and staples. A multiplicity of citations and literary allusions are used that presume a high level of sophistication and open-mindedness. Book titles, diagrams from technical publications, and snapshots are all presented as "evidence" which, when tied together, shape the meaning of the image.

In each of Barrow's prints, the art of their making is as paramount as the ideas expressed. In spray-painted pictures, such as *Self-Reflexive* of 1978, he harks back to his early interest in custom-painted automobiles as art objects, particularly to the brightly colored "low rider" cars of Spanish-Americans who frequent the streets of Albuquerque, New Mexico, where he lives. By using various colored lacquers and monitoring the quantity applied to create semitransparent layers, Barrow controls the amount of photographic information conveyed. The color serves to integrate the autobiographic imagery—the Polaroid SX-70 prints of snapshot negatives—with the rest of the picture. The stenciled lettering adds additional meaning and texture to the overall surface. Due to the painterly treatment, there is no confusing this mixed-media work with conventional photography.

Self-Reflexive extends the perimeters of the medium. The title refers not only to the artist's personal history, but to the process of photography as well; the picture questions itself.

Plate 62

Michel Szulc Krzyza- nowski

Dutch, born 1949

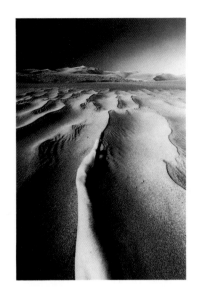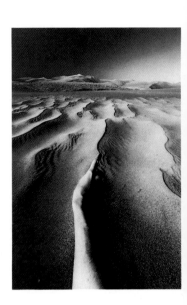

Plate 63

The Great Sand Dunes, November 14, 1979

1979
6 gelatin silver prints
overall 5 3/4 x 31 1/4"
(14.6 x 79.4 cm)
Purchase
81.145 A−F

[1] See Beaumont Newhall, "The Instant Vision of Henri Cartier-Bresson," *Camera*, vol. 34, no. 10 (October 1955), pp. 485−89.

[2] The phrase was used as the title of a book on Cartier-Bresson's work; see *The Decisive Moment: Photography by Henri Cartier-Bresson* (New York: Simon and Schuster, 1952).

[3] For a brief overview of the history of sequential photography from the nineteenth century to the present, see Anne Wilkes Tucker, Introduction, *Target III: In Sequence, Photographic Sequences from the Target Collection of American Photography*, exhibition catalogue (Houston: Museum of Fine Arts, 1982), pp. 5−9.

[4] Michel Szulc Krzyzanowski, Interview, in *Michel Szulc Krzyzanowski*, exhibition catalogue (Amsterdam: Stedelijk Museum, 1979), unpaginated.

With the introduction of miniature cameras—the Leica and the Ermanox, for example—during the 1920s, such photographers as André Kertész (plate 23) and Henri Cartier-Bresson (plate 24) became masters of "instant vision," capturing in a fraction of a second the uneventful ordinariness of life in its most telling visual and psychological expression.[1] Often referred to as the "decisive moment,"[2] this approach to photography, which emphasized the sanctity of the single image as shaped by the conventions of painting, was a dominant trend through the 1960s. During the 1970s, however, the influence of film, of the serial and grid forms of Minimal and Pop Art, and Conceptual Art's emphasis on linguistics led to a resurgence of interest in sequential imagery.[3] For many contemporary artists and photographers, the isolated image was no longer of interest; the essential issue became the individual photograph in an extended body of work in which its interrelationship with other images was crucial to the creation of formal and iconographical significance.

Michel Szulc Krzyzanowski, who turned to photography in 1970 after studying painting, became one of the leading European photographers in the development of the sequential format. Guided by a deep interest in the observation of reality and its registration on film, Krzyzanowski's exploration of this structured form led to what he believes is "a much broader conception of photography." In an interview in 1979 he noted, "Through making these sequences I want to go right back to the basis of the process of looking and realizing. My sequences are the outcome of my search in that direction. But this way of registration also satisfies my curiosity about the way things are interconnected."[4] The deserted islands of the Netherlands, the unpeopled deserts of America, and the lonely beaches of Mexico were the sanctuaries where Krzyzanowski retreated to a life of isolation for weeks at a time in order to create his sequences. Free to pursue his art in the absence of modern everyday pressures, he

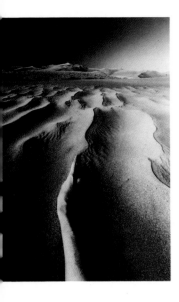 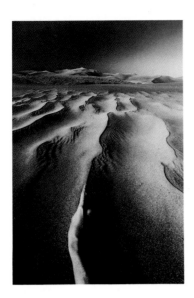 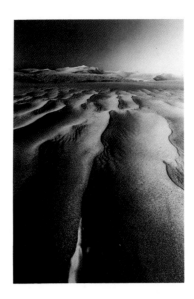

absorbed the warmth of the sun's rays and quietly watched how the everchanging winds and waves altered the shape of the land.

Composed of six separate images, *The Great Sand Dunes, November 14, 1979* demonstrates Krzyzanowski's transformation of vast natural spaces into magical playgrounds, in the process of which his active imagination freely draws upon multiple aspects of contemporary art—Performance Art, Body Art, Conceptual Art, and Earthworks. In this sequence, Krzyzanowski performs for the camera; he is the sole participant, progressively moving his hand and arm along the crest of a sand dune. Through his ritualistic gesturing, he addresses the issue of marking in the landscape.[5] Yet he deliberately courts ambiguity, for it is unclear whether the dark line of the crest is being drawn by his extended finger, or whether it already exists but is simply obscured by Krzyzanowski's arm and hand in the initial frame and slowly revealed in each succeeding frame as he changes his position. While a photographic sequence need not deal with a quantifiable measurement of movement in time (see plate 65), this quality is key to this work.[6] Krzyzanowski's use of the sequence to create a sensa-

tion of subtle change within a continuum reveals his powerful identification with the rhythms of nature—the cycles of the tides, the movement of the sun and moon, and the change of seasons.

The intense sympathy with the landscape in Krzyzanowski's work places it within the long tradition of Northern European Romanticism.[7] Unlike his predecessors in painting, Caspar David Friedrich, Franz Marc, Vasily Kandinsky, or Piet Mondrian, Krzyzanowski does not seek to evoke a sense of the sacred in the natural world; nevertheless, his work insists on a communion with nature. Krzyzanowski's sequences evolve out of meditation to provoke meditation, not on man's transcendence through nature, but rather on his harmony within nature.

[5] This series is related to another sequence made at the same time and also titled *The Great Sand Dunes, November 14, 1979*. In this latter work, Krzyzanowski clearly records the marks he has made in the earth, which from frame to frame act as a continuation of the sand dune's crest; see *Michel Szulc Krzyzanowski: Sequences*, introduction by David Travis (Haarlem: Joh. Enschedé, 1984), unpaginated.

[6] For a discussion of the concept of time in Krzyzanowski's sequences, see David Travis, "Krzyzanowski the Timekeeper," ibid.

[7] For a discussion of connections between modern painting and the Northern Romantic tradition, see Robert Rosenblum, *Modern Painting and the Northern Romantic Tradition: Friedrich to Rothko* (New York: Harper & Row, 1975)

Bernhard Johannes Blume

German, born 1937

Magischer Determinismus
(Magical Determinism)

1976
11 gelatin silver prints
including text
overall 6' 4" x 9'
(1.9 x 2.7 m)
Gift of Foto Forum
86.7 A–K

Bernhard Johannes Blume grew up with photography—his mother was a photo-processing assistant—but did not begin using the medium himself until the early 1960s. During this time, Blume also became involved with Performance Art and collaborated with such avant-garde artists as Joseph Beuys and John Cage. Eventually, Blume's experience with photography and Performance Art fused and emerged as a type of photographic theater in which the artist, family members—especially his mother—and common household objects serve as protagonists. Influenced by the Fluxus movement, which is concerned with reflecting the aesthetic in the trivial, Blume's humble beginnings in a lower-middle-class home are often the source for the familiar contexts he deliberately undermines. The predictable petit bourgeois home and its way of life is sabotaged as people, furniture, vases, and jugs are set spinning in an atmosphere of chaos and hysteria.

A large-scale work composed of eleven gelatin silver prints including text, *Magischer Determinismus* presents the artist and an everyday pitcher adrift in space. It is an amorphous, weightless, blurry world that is perpetually shifting, creating disturbing, exaggerated distortions of form. To achieve this effect, Blume relies on the cool eye of the camera lens. He extends human vision by exploiting the camera's special abilities to foreshorten, to shift objects out of focus, to arrest motion. For Blume, the savage forms and loaded brush of his Neo-Expressionist contemporaries do not match the power of the photographic image. It is only photography, he believes, which he views as the most direct, immediate, and pervasive medium of the times, that is able forcefully to communicate the uneasy instability in this world.[1]

The outlandish character of Blume's performance, the kind of self-parody in *Magischer Determinismus,* stems from a number of sources relating to the artist's personality and background, which includes a degree in philosophy. One is Blume's double life as an artist and a school teacher, which keeps him in contact with youthful clownishness. Another is his fertile imagination and swift eye for objects he can transform into major players in his photographic theater. There is also Blume's disposition, which is by nature both

dour and whimsical; he responds to the turbulence of the modern era with a true pessimist's outlook. His actions range between humor and the grotesque; they are often absurd, or grimly funny, for they reflect the fears that impel him.[2] One must consider Blume's eccentric behavior before the camera as a kind of catharsis. He seems driven by inner tensions, and the production of his art provides a release from the negativism that has evolved from his living in what he believes is an unjust society. His method of work, Blume has said, "has an effect of distancing and liberation for the private performer who seeks to take the place of the figures of authority. It was above all a means of survival, of avoiding sinking under the weight of the circumstances."[3]

Recent art in Germany has often reflected the deep frustrations of a people divided into two Germanies and the great fear that the super powers might use the severed country as an atomic battleground. Out of these circumstances, a highly expressionistic, jagged, tense, and oftentimes savage style of painting—named Neo-Expressionism—has evolved that focuses on subjects with political implications and uses the human figure as a prime symbolic device. This movement, however, represents only one facet of the contemporary art scene in Germany. For many German artists, the hand-drawn or hand-painted mark, even when infused with a visceral rawness, does not possess the same power as the photographic image. In these anxiety-ridden times, numerous German artists—among them Bernhard Blume—have turned to the medium of photography to express a collective angst.

[1] At the same time that Blume acknowledges the psychological impact of the photograph, he is concerned with some of the effects of its widespread use in contemporary society. His concerns address the fact that photographs can serve as evidence of culture and, thus, as a vehicle for promoting tradition rather than change. He also believes that the photograph has become a substitute for experience, in effect, devaluing reality. For Blume's discussion of these ideas, see his essay "On Photography," in *Behind the Eyes: Eight German Artists*, exhibition catalogue (San Francisco Museum of Modern Art, 1986), pp. 125–27.

[2] This notion of balancing the tragic and the comic suggests an interesting comparison between Blume's sequences and the photographic work of the Austrian artist, Arnulf Rainer (plate 52).

[3] Quoted in "On Photography," op. cit., p. 30.

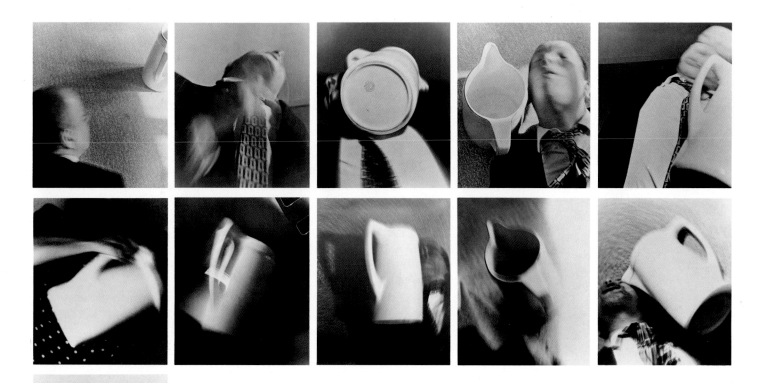

MAGISCHER DETERMINISMUS

Magischer Determinismus ist die Bezeichnung
für den Umstand
gelegentlich selbst eine Kanne zu sein.
Allerdings ist das Bewußtsein in diesem Augenblicke
auf das bloße Sein der Kanne reduziert.
Ich wäre also eine Kanne
ohne mich als Kanne zu erkennen
und verbliebe darüberhinaus in dem Wahne
im Unterschiede zu der Kanne
weiterhin ich selbst zu sein.
Dem ist aber nicht so!

Bernhard Johannes Blume 1976

Plate 64

Robbert Flick

American, born Netherlands 1939

Manhattan Beach, Looking West from Vista

1980
from the series *Sequential Views*
gelatin silver print
20 x 23 13/16"
(50.8 x 60.5 cm)
Fund of the 80's Purchase
85.12

[1] Lewis Baltz, *Landscape: Theory* (New York: Lustrum Press, 1980), p. 23.

[2] William Jenkins, *New Topographics: Photographs of a Man-altered Landscape. Robert Adams, Lewis Baltz, Bernd and Hilla Becher, Joe Deal, Frank Gohlke, Nicholas Nixon, John Schott, Stephen Shore, Henry Wessel, Jr.*, exhibition catalogue (Rochester: International Museum of Photography at George Eastman House, 1975).

[3] Telephone interview with Diana du Pont, October 11, 1985.

[4] Quoted in Chris Keledjian, "Form and Feeling," *Artweek*, vol. 13, no. 11 (March 20, 1982), p. 11.

"I want my work to be neutral and free from aesthetic or ideological posturing," Lewis Baltz (plate 19) has declared.[1] In this one statement he cogently summarized a significant attitude in American landscape photography of the 1970s and early 1980s. Termed "New Topographics" by William Jenkins,[2] this approach rejected the emotionalism of the Sublime for an art based on neutrality and preconceived strategy. Its practitioners ceased to find convincing the majestic vision of the natural landscape that had guided photography from the early dramatic vistas of Timothy O'Sullivan and Carleton Watkins of the 1860s and 1870s to the expressive details of nature by Paul Caponigro (plate 49) and Brett Weston of the 1960s.

It was this stance of neutrality combined with ideas from Conceptual Photography that redirected Robbert Flick's picture making practice in 1979. No longer interested in the emotional, subjective response to a given place—or the "empathic mode," as he terms it[3]—that guided his earlier *Midwest Diary* series (1971–76), Flick turned to a systematic method of working. Like many photographers of the 1970s and early 1980s, he adopted a serial format, specifically the grid. By means of the grid—composed of distinct, equally weighted units—Flick was able to explore the idea of photography as a visual language and, equally important, to present an expanded awareness of the landscape. As Flick has stated, "The extended confrontation with the image allows me to pick up the rhythms of the land, to repeat them, to underscore them and to move through the structures of my perceptions."[4] By presenting a multitude of individual viewpoints collectively, Flick questioned the sanctity of the single image, and his challenging experiments initiated a visually and intellectually rich body of work entitled *Sequential Views*.

For *Manhattan Beach, Looking West from Vista*, an early work from the *Sequential Views* series, Flick walked through a Southern California beach community, scanning the locale with his camera. Beginning on Vista Avenue, which courses a ridge paralleling the ocean, Flick photographed the view directly west from the center of every intersecting street. This strategy was repeated along parallel consecutive streets leading down to the sea. Although Flick established

an objective working method, he subtly subverted it by the inclusion of human incident—bicyclists, joggers, surfers, turning cars. This presentation of visual impressions blending the predictable and the unpredictable creates a sense of place with all its varying tonalities, textures, and spatial densities. By emphasizing the repetition in the urban landscape of signposts, roadsigns, sidewalk crossings, and boxlike residences, Flick sets forth complicated, layered rhythms that slowly emerge upon close viewing. Yet the most dominant accent is the play between open and closed space. In this dynamic, Flick captures the essential experience of moving through a landscape that is anchored by the presence of the sea. As the viewer's eye roams through the space of this image, guided by the horizontal and vertical scanning, it is blocked at one moment by buildings lining a city block, while the next it is free to gaze at the nearby ocean. Since Flick's individual views are all of the same weight, and thus avoid a central focus, they produce the sensation of peripheral vision. The sequenced images are not about the flow of time, but are a mosaic of fixed moments that together create a sense of suspended time.

In using rectangular and grid forms, the familiar vocabulary by which our society organizes itself and its information, Flick repeats the systems that govern our lives. His images also remind us of the nature of our thought patterns. By sequencing related images of the same locale in which repetition is a key factor, Flick forces us to examine the strategy, to ferret out the similarities and differences among the multiple views. In making a central theme of this work the intellectual act of comparing one thing with another, Flick implies that seeing is an active process and that art is an open-ended form of investigation.

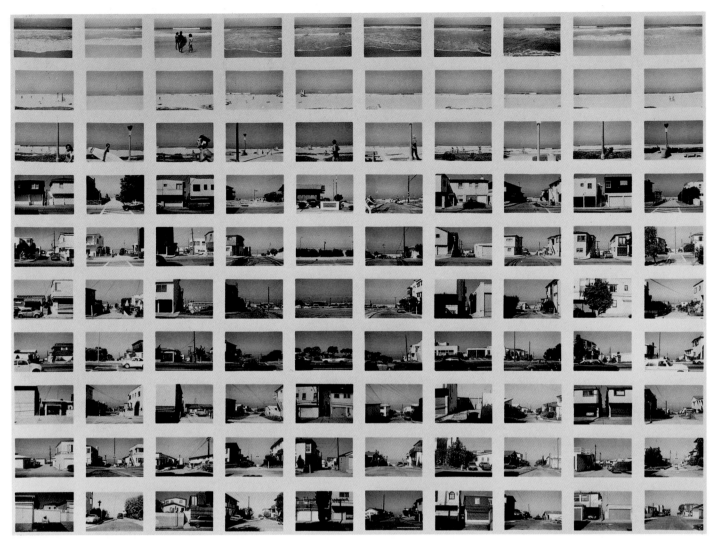

Plate 65

Greg MacGregor

American, born 1941

Backyard Sales Demonstration, Hayward, California

1983
7 gelatin silver prints
overall 10 x 63 1/16"
(25.4 x 160.2 cm)
Gift of Marcia Weisman
84.56 A–G

[1] Greg MacGregor, in taped interview with Diana du Pont, November 13, 1985.

[2] Ibid.

[3] Greg MacGregor, "Explosions," unpublished statement by the artist, ca. 1980–81, Artists Archives, San Francisco Museum of Modern Art.

[4] MacGregor's notion of using violence and destruction as a form of creation was influenced by Destructive Art of the 1960s, an international movement that included such artists as Jean Tinguely, Jean Toche, Alberto Burri, John Latham, and Gustav Metzger. MacGregor was particularly influenced by Yves Klein. Also important is MacGregor's scientific background, which includes working for the Lawrence Livermore National Laboratory, a weapons research center.

[5] Four of the seven images comprising *Backyard Sales Demonstration, Hayward, California* are the last photographs in an as-yet-unpublished book by MacGregor entitled *Explosions: A Handbook for Blasters*. Divided into four sections ranging from practical applications to social reform, it is a satire on the "do-it-yourself mania" of the 1970s and all the concomitant self-help books that have been churned out. "I thought I would comment on this phenomenon by adding one more book to the pile, an absurd book," MacGregor has said.

[6] Quoted in Richard Colvin, "His Art Is Blasting Its Way into American Culture," *Daily Review* (Hayward, California), June 12, 1983.

[7] Ibid.

Humor in twentieth-century creative photography has been rare. Too earnest in their endeavors, pictorialist and modernist photographers alike have generally left the making of witty and humorous images to the fields of advertising and popular entertainment, or to amateur photography. When photographers have embraced humor it has usually been in the area of photojournalism. Certain images by Henri Cartier-Bresson (plate 24) and Robert Doisneau in the 1940s and 1950s and those by Elliott Erwitt and Burk Uzzle of the 1960s and 1970s, for example, seize in a moment the naturally comic in life. Humorous in a different vein, the work of social documentarians Geoff Winningham and Bill Owens of the early 1970s gently satirizes contemporary American culture.

In recent years, one of the most intriguing developments in photography, particularly in the United States, has been the emergence of humor in work by Conceptual artists who have turned to the medium to document their ideas, and by trained photographers who have been influenced by Conceptual Art. From Eleanor Antin's amusing postcard series of marching boots or Robert Cumming's clever, staged images seemingly intended to fool the eye (see plate 59) to William Wegman's comical portrayals of his dog, Man Ray, there is a newfound emphasis on wit, irony, satire, or just plain whimsy.

One of photography's important new humorists is the American Greg MacGregor. A physicist turned photographer, MacGregor was trained "to make beautiful, aesthetic photographs,"[1] but by the mid-1970s, under the influence of Conceptual and Performance Art, especially Arte Povera, he began to redefine his approach. "I wasn't a documentarian," MacGregor has remarked, "but Arte Povera, since it deals with events and documenting events, initiated a big switch for me, it gave me permission to document something ugly."[2] MacGregor, who defines himself as a "context shifter," had been making photographs that centered around "redefining relationships, usually between objects and the space they occupy" in order to "tamper with . . . traditional assumptions and expectations." Under the influence of Arte Povera he became interested in redefining the "context for an event instead of an object."[3] Thus, MacGregor became an "outlaw" photographer, creating a series of wonderful tongue-in-cheek explosions that he documented with his camera.[4] Images of a pet dog blowing up his doghouse, a home gardener exploding holes in his backyard in order to plant tree seedlings, or a hobbyist seeking an effortless method for digging clams by blasting the seashore are wonderfully humorous in the way they introduce explosives into the familiar, workaday world.

Backyard Sales Demonstration, Hayward, California of 1983, a sequence of seven images based on a 1982 performance entitled *Artist Survival Tactics for the 80's*, provides step-by-step instruction on how the average American can blow himself up. Forced to take drastic measures by Reaganomics and his eighth rejection by the National Endowment for the Arts, MacGregor turned to business for survival, to the selling of his Home Improvement Blasting Kit, which retailed for $19.95. Here, dressed in a business suit, horn-rimmed glasses, and hat, MacGregor disappears behind a twenty-foot explosion, only to reappear miraculously intact, wearing a T-shirt advertising his product.[5]

Not mere whimsy, MacGregor's situations reveal a sophisticated sense of humor that, like the best of its kind, operates on multiple levels. In one sense, *Backyard Sales Demonstration, Hayward, California* is a comment on the unprecedented materialism that obsesses America. "Everything I see going on," MacGregor has remarked, "indicates we're more concerned with . . . dollars and a new commercialism."[6] Since the majority of his photography students at California State University at Hayward are business majors, MacGregor noted, "It seemed appropriate to me that I too should become a business man."[7] More poignant is the suggestion that MacGregor's anarchic explosion is a metaphor for the violence in contemporary life, the senseless political assassinations, terrorist bombings, and sociopathic killings that are now commonly reported in the mass media. Ultimately, in a world made anxious by the threat of nuclear holocaust, MacGregor's mock self-destructions allude to the self-destructive course of a highly technological society.

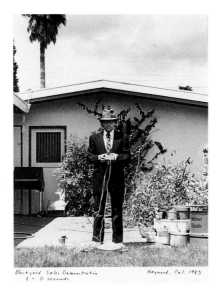

Backyard Sales Demonstration
t = 0 seconds
Hayward, Cal. 1983

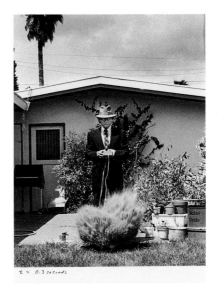

t = 0.3 seconds

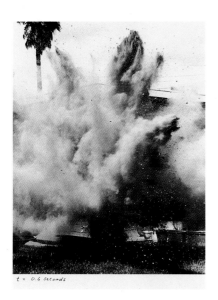

t = 0.6 seconds

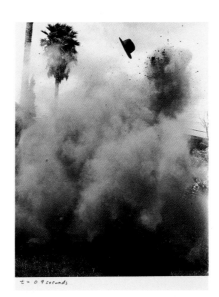

t = 0.9 seconds

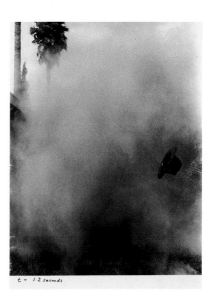

t = 1.2 seconds

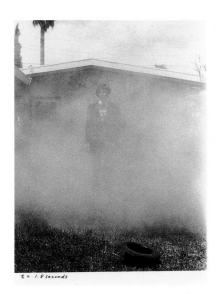

t = 1.8 seconds

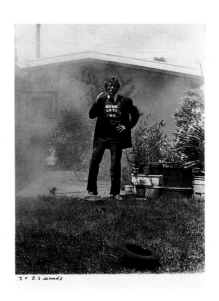

t = 2.3 seconds

Plate 66

Biographies of the Artists
Compiled by John Bloom and Diana C. du Pont

Gertrud Arndt

*Born Ratibor, Silesia
(Racibórz, Poland), 1903*

Self-Portrait, ca. 1929

Although born in what was then the Prussian province of Silesia, Gertrud Arndt was raised in Vienna and then Erfurt, Germany, where she studied architecture (1920–23). Guided by the advice of a local photography dealer and influenced by reproductions in books, Arndt began her first experiments with photography in 1920. In 1923 she studied at the Bauhaus in Weimar with Paul Klee, Vasily Kandinsky, László Moholy-Nagy, and Oskar Schlemmer. The following year she was accepted into the weaving class of Bauhaus master Georg Muche. In 1927 she received the equivalent of a Bachelor of Fine Arts degree in weaving and married the Bauhaus architect Alfred Arndt.

Between 1927 and 1929 Arndt photographed for her husband's architectural firm at the same time that she began a series of photographic self-portraits. In 1929 she moved to Dessau, where her husband had been ap-

pointed to head the interior-design workshop at the Bauhaus. There she continued her series of self-portraits, which evidence an interest in how framing, lighting, costuming, and makeup can alter the way a face appears. In line with the "new vision" photography espoused by the Bauhaus, Arndt also photographed daily events from unusual perspectives so as to transform the commonplace into strong visual statements. She also directed her attention to still life, creating photographs that emphasize design and repetition, as did many Bauhaus photographers.

With the rise of Nazi Germany and the closing of the Bauhaus in 1933, Arndt moved to Probstzella, Germany. Eventually, she moved to Darmstadt, where she currently lives.

Ellen Rosenberg Auerbach

*Born Karlsruhe,
Germany, 1906*

Portrait, ca. 1979

Interested in art, following her graduation from gymnasium, Ellen Rosenberg Auerbach studied sculpture, first at the Kunstakademie in Karlsruhe (1924–27), then at the Kunstschule in Stuttgart (1928). It was at the Kunstschule that Auerbach was given her first camera, as a reward for her work in sculpture. Practical considerations of how to earn a living soon led her to give up sculpture for a career in photography. She moved to Berlin in 1928 and became a private student of photographer Walter Peterhans, through whom she met Grete Stern, who had come to the city a year earlier. The two studied with Peterhans until 1930, when he moved permanently to Dessau where he was teaching at the Bauhaus.

The sale of the contents of Peterhans's Berlin studio to Grete Stern in 1930 launched Studio Ringl & Pit, one of the most innovative photographic establishments in Europe between the wars. Named after the two childhood nicknames of Stern and Auerbach, respectively, the studio concentrated on portraiture, still life, advertising photography, and magazine illustration. While Stern and Auerbach emphasized pristinely rendered form and texture in the spirit of "new vision" photography, they developed a distinctive style, especially in their advertising, by means of the subtle introduction of critical humor and Surrealist motifs. Their work was published in such

widely distributed periodicals as *Gebrauchsgraphik* (Commercial Art) and *Cahiers d'art*, as well as in smaller magazines, such as *Neue Frauenkleidung und Frauenkultur* (New Women's Clothing and Women's Culture).

With Hitler's takeover of Germany in 1933, Studio Ringl & Pit closed and Auerbach emigrated to Palestine, where she photographed for W.I.Z.O. (Women's International Zionist Organization) and produced a short film about Tel Aviv. In 1936 she moved to London to work with Stern, who had emigrated there in 1933. Unable to obtain a working permit, however, she came to the United States in 1937. During the 1940s she photographed the print collection of Lessing Rosenwald in Philadelphia and experimented with infrared and ultraviolet fluorescence photography, and with the carbro-color process. In 1945 she moved to New York City, where, in addition to making photographs for record albums, she specialized in making films and still photographs of children. In 1955–56 she traveled through Mexico with Eliot Porter to document in color photographs the interiors of Mexican churches. From 1965 to 1986, she worked in New York as an educational therapist for children with learning difficulties.

Auerbach lives in New York City.

Lewis Baltz

*Born Newport Beach,
California, 1945*

Portrait, 1972

Lewis Baltz recognized at the age of fifteen that he wanted to be a photographer. Beginning in 1967, he attended the San Francisco Art Institute, from which he was granted a Bachelor of Fine Arts degree in 1969, and then completed graduate studies in photography at the Claremont Graduate School, receiving a Master of Fine Arts degree in 1971. From 1970 to 1972 he taught art at Pomona College at Claremont, California, and in 1972 taught photography at the California Institute of the Arts in Valencia. During this time he produced the portfolio entitled *The Tract Houses*, the first of several extended series that combine his sense of formal order and awareness of photography as a documentary tool with the complexities of man's relationship to his environment.

From 1970 to 1973 Baltz produced the portfolio *The Public Places*, a study of commercial areas in California and the West. In 1973–74 he worked on the portfolio and book *The New Industrial Parks near Irvine, California*, an extended study of developers' transformations of the barren landscape by massive real-estate developments. *Maryland*, completed in 1976 as a Bicentennial Project, is a study of the residential suburban areas of

Washington, D.C.—Wheaton, Silver Spring, Bethesda, Chevy Chase, Towson, and College Park.

In 1977 Baltz received a Guggenheim Fellowship to photograph in northern Nevada; the resulting images of the landscape, existing architecture, and new construction were published as a portfolio and book in 1978. Other projects since then include *Park City* (1978–80), views of the development of a Utah town as a ski resort; *San Quentin Point* (1981–83), a study of industrial detritus; and *Continuous Fire/Polar Circle* (1985–86), a suite of seven photographs made on Svolvaer Island, Norway. Baltz is currently working on another series based in the San Francisco Bay region, a survey of a site that is being developed into the Candlestick State Recreation area.

Baltz has taught extensively both in this country and abroad. He has published criticism and has been the curator of exhibitions of photography. He lives and works in Sausalito, California.

Thomas F. Barrow

Born Kansas City,
Missouri, 1938

Portrait, 1984

Thomas Barrow had an early interest in race-car driving, but, motivated by a paperback book on art he found in a drug store, he attended Kansas City Art Institute, Missouri, from which he received a Bachelor of Fine Arts degree in graphic design in 1963. In 1964 he studied film history and aesthetics with Jack Ellis at Northwestern University, Evanston, Illinois; from 1965 to 1967 he studied photography with Aaron Siskind at the Institute of Design at Illinois Institute of Technology, Chicago, where he received a Master of Science degree in photography in 1967. In 1965 he had joined the staff at the George Eastman House (now the International Museum of Photography at George Eastman House), where he remained until 1972, first as Assistant Curator of Exhibitions, then as Associate Curator of the Research Center (1965–71), and finally (1971–72) as Assistant Director and editor of *Image*, the museum's journal of photography and motion pictures.

During his studies at the Institute of Design, Barrow embarked on his first major group of photographs, a documentary study of the automobile in American culture. In 1965 he began his "print-through" images, photograms made from magazine pages. In 1968 he began making images by using the Verifax copy machine, produced by Eastman Kodak, which continued his interest in the overlapping and juxtaposition of media imagery. In that same year he began the series *Pink Stuff* and *Pink Dualities*, photographs printed in pairs which explore the nature of photographic vision.

Cancellations, a series begun in 1973, are topographic urban landscape photographs made from negatives that have had an *X* scratched into the emulsion, then printed and toned brown. They are a commentary on the standard printer's method of cancelling plates after completing an edition and on the picture-window assumptions about photography. In 1977–78 he worked on *Libraries*, photographs taken in various libraries, which are straightforward documents of book arrangements on shelves. His concern with alternative directions in photography has continued with the *Spray Photograms,* images oversprayed with car lacquers (begun 1978), and *Caulked Pieces*, torn landscape images reassembled with staples and silicon caulking (begun 1979); and most recently in his sculptural pieces (begun 1982).

In 1973 Barrow was appointed Associate Director of the University Art Museum at the University of New Mexico in Albuquerque; in 1976 he became a full-time professor in the Department of Art, where he is a major influence on younger photographers.

Barrow continues to live and work in Albuquerque.

Hans Bellmer

Born Katowice, Silesia
(Poland), 1902
Died Paris, 1975

Self-Portrait, ca. 1950

At the insistence of his father, Hans Bellmer pursued the study of engineering at the Technische Hochschule in Berlin from 1923 to 1924. Most important for him there was his instruction in drawing and perspective with the Neue Sachlichkeit painter George Grosz. After leaving the school in 1924, Bellmer worked as a typographer, illustrator, and designer of book covers.

Influenced by Lotte Pritzel, a well-known Berlin dollmaker, and Max Reinhardt's production of Jacques Levy Offenbach's opera *The Tales of Hoffmann*, which features an automated doll, Bellmer designed and constructed his first puppet doll in 1933–34. Primarily self-taught in photography, he used this doll as a model for a series of photographs that he published as *Die Puppe* in 1934 (French edition, *La Poupée*, 1936). Through these photographs, Bellmer made graphic the themes of sexual obsession, perversion, and violence. A selection of these images was later published in *Minotaure* (Winter 1935), which led to Bellmer's immediate embrace by the Surrealists who saw the "doll" as the perfect Freudian fetish object. In 1935 Bellmer made another "doll," this time with ball joints, which offered greater flexibility in terms of body position and interchangeability of parts. This Surrealist object was the focus of a series of photographs that were first published with a suite of poems by Paul Eluard in the magazine *Messages* (1939), then as a book (*Les Jeux de la poupée*, 1949). In 1937 Bellmer created his third major doll-object, "The Machine Gun in a State of Grace," which also served as a photographic model.

With the rise of Nazism, Bellmer moved in 1938 to Paris, where he became closely associated with the Surrealist circle. In 1940 he was interned in a prison camp near Aix-en-Provence. After his release, he settled in the south of France for the duration of the war. In the late forties he returned to Paris where he continued to photograph while he supported himself as a designer. In 1953 Bellmer met the writer Unica Zürn, who subsequently lived with him and became his model for a series of sado-masochistic photographs in which she is depicted nude and bound. In 1970 Zürn committed suicide and shortly thereafter Bellmer suffered a partial stroke.

Bernhard Johannes Blume

Born Dortmund,
Germany, 1937

Portrait, 1984

Having a mother who worked at home as a photo-processing assistant, Bernhard Johannes Blume was already familiar with the sight and smell of photography as a young child. However, he did not pursue the medium himself until the early 1960s. Apprenticed to a poster and display artist, he was subsequently employed in a department store and at a variety of other jobs in which he used his graphics skills. Eventually, he decided to attend art school and from 1960 to 1965 studied at the Staatlichen Kunstakademie in Düsseldorf with J. Fassbender, G. Hoehme, K. O. Goetz, and Joseph Beuys. This was followed in 1967 by studies of philosophy and pedagogy at the University of Cologne, where he remained until 1971.

During his student years Blume was influenced by Happenings and the Fluxus movement, and was a collaborator in performance pieces with both Joseph Beuys and John Cage. It was during this time that he began to use photography. Inspired by the strange light and dark spots he discovered on his earliest developed negatives, he sought to create a kind of photo-mysticism, images in which he himself appears with mysterious fields of brightly illuminated spectra. Since 1970 he has been writing poetical-theoretical texts and producing drawings to express his own, as well as society's, internal and external states of mind. Of equal importance has been his work with photo sequences, which he has freely combined with text and drawings.

In the late 1970s Blume became involved with photo-actions, using the Polaroid SX-70 instant color process. Eventually, his experience with photography and Performance Art fused to form a type of photographic theater in which the artist, family members—especially his mother—and common household objects serve as protagonists. Autobiographical in nature, these social-psychological images—termed "psychoprovincialism" by the artist—aim to transform the mundane and the everyday into a fusion of hysteria and ecstasy. The tragicomic interplay between man and object reveals an enduring interest in philosophical inquiry that marks all of Blume's work. In addition to his art work and his prolific writing, Blume is also known for his theatrical public lectures.

While pursuing his own work, Blume also teaches art and philosophy at a gymnasium in Cologne.

Erwin Blumenfeld

Born Berlin, 1897
Died Rome, 1969

Self-Portrait, 1943

Erwin Blumenfeld's interest in photography began in childhood, but the death of his father when he was sixteen forced him to work in Berlin's garment industry. He served as an ambulance driver in the German army from 1916 to 1918, after which he went to Amsterdam, where he opened a leather shop in 1922. From then until 1935 he worked as an amateur photographer while operating his shop. Photographer, painter, and poet, he worked extensively in collage, influenced by his Dadaist friends. As the Depression reduced his business he asked customers to pose for his camera and used his shop to display his works.

Blumenfeld kept in contact with the creative world outside Amsterdam through reading the magazines *Variétés* (Brussels), *Der Querschnitt* (Berlin), and *Minotaure* (Paris). Beginning in the early thirties, his portraits and studies of female nudes demonstrated the experimental techniques that marked contemporary avant-garde photography in France and Germany, such as multiple exposure, solarization, selective bleaching, negative-positive combinations, and reticulation of the emulsion. His photographs were first reproduced in the 1935 photo-

graphic annual *Photographie*, published by Arts et Métiers Graphiques.

In 1936, after his Amsterdam business went bankrupt, Blumenfeld moved to Paris, where he began a career as a professional photographer, doing portraiture as well as advertising and fashion photography. In 1937 he shot his first fashion cover, for *Votre Beauté*, and had work published in *Verve*. In 1938 he became a staff photographer for French *Vogue*, for which he produced Surrealist-inspired fashion images, in which he used superimposition and imaginative backdrops, froze wet negatives, and draped his figures in wet silk.

In 1939 in New York he signed a contract with *Harper's Bazaar*. Returning to France in 1940, he was imprisoned and sent to a concentration camp, from which he escaped. He found his way back to the United States in 1941, where he shared a studio in New York with Martin Munkacsi. In 1943 he opened his own studio and became widely known for his fashion and commercial photography. During his career, his work appeared in many important magazines, among them *Vogue, Harper's Bazaar, Look,* and *Popular Photography*.

Pierre Boucher

Born Paris, 1908

Self-Portrait, 1980

Pierre Boucher received his art education at the commercially oriented Ecole des Arts Appliqués, which he attended from 1922 to 1925. In 1928, after working as an advertising designer for the department store Au Printemps, he entered the French air force, where he worked in the photographic division. After completing his military service, he returned to Paris. In 1931 he began to contribute to *Photographie*, the photographic annual published by Arts et Métiers Graphiques, and continued to do so throughout the thirties. Shortly after his return to Paris, Boucher met the Surrealist photographer Maurice Tabard and the graphic artist A. M. Cassandre, both of whom were able to apply the ideas of Surrealism and the avant-garde to commercial ends. In the early thirties Boucher became a founding member of Agence Alliance-Photo, a photo agency.

In 1934 Boucher began working in the advertising photography studio of René Zuber, where he specialized in typography and layout. At this time he became increasingly absorbed with photomontage techniques for both commercial and experimental purposes. From 1934 to 1939 he documented his travels through Spain, Morocco, Tunisia, and Egypt. Interested in capturing movement, he photographed friends jumping in the air. He also embarked on a series of nudes, which was published in 1935 as *Le Nu en photographie*, a book sum-

marizing his experimental work with the nude figure. In 1935 Boucher began experimenting with manipulative photographic techniques such as solarization, bas-reliefs, photograms, sandwiched negatives, and optical distortions. In 1938 he illustrated *Truquages en photographie*, a book that describes these various techniques, which he began to use in the creation of his photomontages. In 1941 he completed his first photomontage mural, *L'Esprit et la matière* (over fifty-five feet long), in Lyons, France, based on a text by Luc Dietrich. In 1947 he designed and published *Méthode française de ski*, a detailed photographic study of skiing.

Following World War II Boucher became Director of Graphic Services for the European Recovery Program (Marshall Plan), a position he held from 1948 to 1952. His second photomontage mural, *Textile* (almost fifty feet long), commissioned by Tweedales and Smalley of Manchester, England, was completed in 1951. In 1968 he finished a color photomontage mural (some fifty-two feet long) on the subject of gasoline for the Northern Gas Board in Newcastle upon Tyne, England. His most recent work has been large color-enhanced prints of geometric designs.

Boucher lives and works in the town of Faremoutiers in the Seine-et-Marne region near Paris.

Harry Bowers

Born Los Angeles, 1938

Self-Portrait, 1982

Harry Bowers was educated as an engineering physicist and in 1964 received his Bachelor of Science degree from the University of California, Berkeley. In 1972, while earning a living as an engineer and electronics consultant, he enrolled in the graduate program in photography at the San Francisco Art Institute. He received his Master of Fine Arts degree in 1974 and by 1976 had abandoned his engineering career to devote himself entirely to photography.

Bowers is representative of a group of photographers who turned to fabricating images and using color film in the 1970s, but key to Bowers's work is his strong technical background. To achieve his desired effects, he often builds his own equipment, including his cameras, and processes his own Ektacolor and dye-transfer prints. His first major body of work, *Summer Icons* (1976), consists of a series of color photographs (dye-transfer prints) in which the mundane objects of summer are transformed into expressive symbols. In 1978 Bowers moved to an arresting 30" x 40" format in which life-size articles of clothing are arranged in an anthropomorphic manner to suggest the nature of and cultural attitudes toward male-female relationships. In his work of 1979–80 Bowers extended the lush, painterly quality of these fabri-

cated images to include cutout constructions, paper mannequins, and black-and-white portraits (with spray paint) of himself and his wife, Jane. A selection of these images comprises the portfolio *Harry Bowers: 10 Photographs*, published in 1984.

Away from his color-processing equipment while teaching at the University of Michigan, Ann Arbor, during 1982, Bowers began an extended series of large-scale, black-and-white prints. While they continue the issue of male-female sexuality in his work, they also express the Postmodernist concern with restating works of art from the past. Masterpieces from the history of art, such as Manet's *Le Déjeuner sur l'herbe*, are recast with Bowers himself and other models serving in place of the original subjects.

Continually interested in new technologies, Bowers has recently been exploring the possibilities of using computers to make photographic imagery. In addition to working with computer-digitized imagery that is printed by means of an electrostatic printer, he is investigating making negatives by generating graphics on an Apple Macintosh computer and then printing them on film rather than on conventional computer paper.

Bowers lives and works in Berkeley, California.

Francis Joseph Bruguière

Born San Francisco, 1879
Died London, 1945

Self-Portrait, ca. 1935

Francis Joseph Bruguière was born in San Francisco into a wealthy banking family. His early interests were centered around painting and music; however, during an extended visit to New York in 1905 he met Alfred Stieglitz and Frank Eugene, through whom he became interested in photography as an art form. Eugene introduced Bruguière to photographic techniques and aesthetics and influenced his early Pictorialist style. Four of Bruguière's images were included in the *International Exhibition of Pictorial Photography*, organized by Stieglitz at the Albright Art Gallery in Buffalo in 1910. After returning to San Francisco in 1906, Bruguière opened a studio and photographed the 1915 Panama-Pacific International Exposition.

By 1919, forced to earn a living, he had moved again, to open a studio in New York City. Within a year his portraits of theater personalities were published in *Vogue, Harper's Bazaar,* and *Vanity Fair*. As official photographer for the Theatre Guild from 1919 to 1927, he photographed performers and documented stage sets and models created by New York's most noted designers. As early as 1912 Bruguière had experimented with multiple exposures, but he carried the idea further during 1923–25 in a surrealistic still-photo sequence for *The Way*, an unrealized film about psychic states. Also in 1923 he began "light abstractions," photographs made of projected light forms, and cut-paper images, in which cut and formed paper served as light modulators. In 1927 he had his first major one-person show, at the Art Center in New York. In the historic *Film und Foto* exhibition sponsored by the Deutsche Werkbund and held in Stuttgart in 1929, his work was included with the most experimental and progressive photographers at the forefront of modern photography.

In London, where Bruguière had moved in 1928, he continued experiments with light and multiple exposure. With Oswell Blakeston, writer and film critic, he produced England's first abstract film, *Light Rhythms* (1930). At this time, he also experimented with solarization, bas-relief, *cliché-verre*, and camera movement to produce the effect of motion. In 1933 he met and collaborated with E. McKnight Kauffer, graphic designer and Art Director for Lund, Humphries, Ltd., an advertising agency that had clients who were interested in having advertisements that were as avant-garde as the most recent modern art. Together they did a series of Cubist-inspired posters. In 1937 he designed the entrance to the British Pavilion at the Paris Exposition.

Because of failing health, Bruguière stopped photographing in 1940. Retiring to the English countryside, he spent the last five years of his life painting, writing, and studying the mandala and the works of C. G. Jung.

Paul Caponigro

Born Boston, 1932

Portrait, 1976

Paul Caponigro developed an interest in photography and music as a junior high school student. After studying piano at the College of Music, Boston University, from 1950 to 1951, he worked at a commercial photographic studio. Drafted into the army in 1953, he was stationed in San Francisco where he served as a photographer. During this time he studied with Benjamin Chin, a former student of Ansel Adams and Minor White, at the California School of Fine Arts (now the San Francisco Art Institute). Discharged from the army in 1955, Caponigro returned to Boston as a freelance photographer; in 1956 he moved to San Francisco to continue his studies with Chin and Alfred Richter.

During 1957–58 Caponigro studied with Minor White at the Rochester Institute of Technology in Rochester, New York, and the following year assisted him with creative photography workshops in San Francisco and Portland, Oregon. His first major one-person exhibition, *In the Presence Of*, was held at the George Eastman House (now the International Museum of Photography at George Eastman House), Rochester, in 1958. *Portfolio*

One, published in 1961, consists of lyrical and tonally delicate studies of landscape and details of nature, whose precisely rendered imagery established his work as an extension of ideas and techniques explored by Alfred Stieglitz, Paul Strand, Ansel Adams, and Minor White.

In 1966 Caponigro received a Guggenheim Fellowship to photograph the ancient stone monuments and the landscape throughout the British Isles and in Brittany; a selection of these images was shown in 1968 at the Museum of Modern Art, New York. He spent the year 1976 photographing Shinto shrines and gardens in Japan, continuing his interest in nature and sacred places. In 1978 he published the portfolio entitled *Stonehenge*, consisting of graphic studies of form and light which captured the mystery as well as the spiritual power of the ruins.

Since 1973 Caponigro has lived and worked in Santa Fe, New Mexico.

Henri Cartier-Bresson

Born Chanteloupe, France, 1908

Portrait, 1946

Henri Cartier-Bresson began studying painting in 1922, first with Jean Cottenet and then with Jacques-Emile Blanche. In 1927–28 he pursued his studies with the Cubist painter André Lhote. In 1929 he attended Cambridge University, where he studied literature. It was in 1930–31, while recuperating from an illness, that he became seriously involved in photography. He soon began photographing for periodicals and newspapers and thus launched his career in photojournalism.

During the early 1930s Cartier-Bresson associated with such Surrealists as Man Ray and André Kertész, whose photography was an inspiration, as was that of Eugène Atget. His first photographic exhibitions were held at the Atheneo Club in Madrid and at the Julien Levy Gallery in New York City in 1932. The following year he began using a 35-mm Leica camera, through which he brought a new impulse to photojournalism. The title of his most influential book, *Images à la sauvette (The Decisive Moment)*, published in 1952, became the descriptive for the style he formulated with that instrument: split-second arrangements in which both animate and inanimate forms are captured at their most telling visual and psychological moment.

In 1935 Cartier-Bresson studied cinematography in New York City with Paul Strand; in 1936 he returned to France to work on films with Jean Renoir. In 1937, during the Spanish Civil War, he made a documentary film, *Victoire de la vie*, on the conditions in Spanish hospitals. Drafted into the French army at the outbreak of World War II, he was captured by the Nazis in 1940, but escaped from prison in 1943. That year he organized photographic units for the French Resistance to document the German Occupation of France and its liberation. In 1945 he produced *Le Retour*, a film about homecoming prisoners of war, for the U. S. Office of War Information. In 1946 he had a major one-person exhibition at the Museum of Modern Art, New York. The following year he, Robert Capa, George Rodger, and David Seymour founded Magnum Photos, a cooperative picture agency. During the next twenty years he traveled all over the world as a freelance photographer, documenting important political and cultural events with a revelatory understanding of the relationship between people and their environment. He left Magnum in 1966 to spend time developing his painting and drawing, though he continues to photograph as personal notations.

Cartier-Bresson lives and works in Paris.

Larry Clark

Born Tulsa,
Oklahoma, 1943

Portrait, 1984

From 1958 to 1961 Larry Clark worked in his family's commercial photography studio, during which time he and his mother traveled as door-to-door photographers making children's portraits. During 1961–62 he studied photography at the Layton School of Art in Milwaukee, Wisconsin. His adolescent experience with ampheta-mines and other hard drugs brought him into contact with the Tulsa drug culture, which he began to photo-graph on his vacations from school. In 1964 Clark lived and worked in New York City as a freelance photogra-pher until he was drafted into the army and sent to Vietnam. Following his military service he resumed his career as a freelance photographer in New York, but eventually returned to Tulsa to continue photographing the implicit and explicit violence that was part of the sexuality and drug use of his peers in that city. This proj-ect, completed and published in 1971 as a book entitled

Tulsa, has since become a paradigm of the integration of a photographer's life experience with the subjects he has photographed. In 1973 he was awarded a National Endowment for the Arts Photographer's Fellowship.

Convicted and sentenced to prison for shooting a man in 1976, he was paroled after nineteen months on con-dition that he leave Oklahoma. From there he returned to New York City in 1978 and began photographing the adolescent hustlers who work Forty-second Street off Times Square, for which he received a New York State Creative Arts Public Service Photographers' Grant in 1980. *Teenage Lust,* published in 1982, draws from work done between 1963 and 1980 and summarizes his portrayal of the sexual practices of youth culture. It has, as its subtextual theme, Clark's autobiography.

Currently working on a book to be entitled *Children of Alcoholics*, Clark lives and works in New York City.

Konrad Cramer

Born Würzburg, Germany, 1888
Died Woodstock, New York, 1963

Portrait, 1948

From 1906 to 1909 Konrad Cramer studied painting at the Karlsruhe Academy of Fine Arts. Following his stud-ies he served in the German army, after which he estab-lished a studio in Karlsruhe. He made frequent trips to Munich, where his acquaintance with the work of Vasily Kandinsky, Franz Marc, and other members of the Blaue Reiter group radically changed his approach to art. In 1911 he married the American artist Florence Ballin and emigrated to the United States, settling in Woodstock, New York.

Through his association with Alfred Stieglitz and his circle and the artists' colony in Woodstock, Cramer spread the revolutionary ideas of abstraction that he had learned in Europe. In his own canvases he fully devel-oped the possibilities of pure color and form, creating some of the first abstract paintings in America. In the aftermath of World War I, however, Cramer, like many other American artists, returned to painting recognizable subject matter, particularly landscapes and still lifes.

By the mid-1930s, encouraged by his friend Alfred Stieglitz, Cramer shifted his creative efforts to photogra-phy. With the same open-minded spirit that invigorated his painting of the 1910s, he avidly investigated a variety of experimental techniques, including solarization, nega-tive prints, composite images, and photograms. In 1937 he started the Woodstock School of Miniature Photogra-phy ("miniature" referring to 35-mm cameras, as op-posed to the large-format cameras then widely in use); during the late 1930s and early 1940s he taught one of the first college-level courses in photography in the world, at Bard College in Annandale-on-Hudson, New York. During the 1940s and 1950s he wrote technical articles on photography and created still lifes and ab-stract constructions specifically to be photographed. He sporadically returned to drawing or painting, but worked most diligently at his experimental photography.

Robert Cumming

Born Worcester,
Massachusetts, 1943

Self-Portrait, 1976

Robert Cumming grew up in Boston where he received a Bachelor of Fine Arts degree in painting from the Mas-sachusetts College of Art in 1965. He continued his art studies in the graduate program at the University of Illi-nois, Urbana-Champaign, where he received a Master of Fine Arts degree in painting in 1967. While Cumming was in the painting program, he began working with sculpture and photography and, in fact, did more three-dimensional work during these student years than any-thing else. Interested in photosilkscreening, he studied photography with Art Sinsabaugh in order to understand the basic techniques of the photographic medium.

After graduating from the University of Illinois, Cum-ming taught at the University of Wisconsin in Milwaukee (1967–70). It was there that he began photographing more seriously, even though sculpture continued to be his primary interest. His exploratory photographs and his photographic documentation of his sculpture eventually began to meld, as he turned to using the camera in a more conceptual way. Increasingly his sculptures became props for his photographs.

By 1970 Cumming was interested in making a radical change. He moved to California, where he began teach-ing at California State College, Fullerton, which was the first of several teaching positions he held in the Los An-geles area during the 1970s. Beginning in 1971, with *Picture Fictions*, he issued a series of privately published books that summarized his conceptual use of photogra-

phy by creating visual conundrums accompanied by cap-tions and other verbal material that challenged the veracity of the photograph. The books that followed are *A Training in the Arts* (1973); *A Discourse on Domestic Disorder* (1975); and *Interruptions in Landscape and Logic* (1977). In 1977 he published the portfolio *Studio Still Lifes*, made on location at Hollywood studios. De-picting elaborate Hollywood sets that had been con-structed to create grand illusions on film, these images are a witty counterpoint to Cumming's earlier works in which his small-scale prop-building was used to fabricate illusion.

In 1978 Cumming returned to the East Coast, where he settled in West Suffield, Connecticut, and began to teach at the Hartford Art School. His book, *Equilibrium and the Rotary Disc*, published in 1980, consists of drawn illustrations accompanied by a fictional narrative about a failing industrial firm in the Northeast. In 1980 he began working on a series of large-scale charcoal drawings that have evolved into acrylic drawings/paint-ings on paper. In 1984 Cumming was one of the ten artist-photographers chosen to document the Olympic Games in Los Angeles.

Currently involved in photographing new scientific technology at Massachusetts Institute of Technology in Cambridge, Massachusetts, Cumming lives in West Suf-field.

Imogen Cunningham

Born Portland, Oregon, 1883
Died San Francisco, 1976

Portrait, 1945

Imogen Cunningham was raised in Seattle, Washington, where she made her first photographs in 1901. While attending the University of Washington in Seattle, she studied chemistry and took botany classes, for which she made lantern slides. From 1907 to 1909 she worked in Seattle at the studio of Edward S. Curtis, the photographer of American Indian life, from whom she learned the process of platinum printing. In 1909 she received a scholarship to study the chemistry of photography at the Technische Hochschule in Dresden, Germany, where she developed an inexpensive imitation platinum paper based on the use of lead salts. During her return trip to the United States in 1910, she met Alvin Langdon Coburn in London; in New York she met Alfred Stieglitz and Gertrude Käsebier, whose work she found particularly inspiring.

Cunningham opened her own studio in Seattle in the fall of 1910. In 1912 she had her first one-person show, at the Brooklyn Institute of Arts and Sciences, New York, in which she exhibited soft-focus Pictorialist studies of figures in the landscape. In 1915 she married the artist Roi Partridge; in 1917 they moved to San Francisco, where she opened a portrait studio.

In the 1920s Cunningham began making sharply focused, close-up studies of plant forms and unconventional views of industrial structures and modern architecture. Concerned with light, form, and abstract pattern, these photographs established her as one of the pioneers of modernist photography on the West Coast. Edward Weston selected ten of these works for the historic *Film und Foto* exhibition held in Stuttgart, Germany, in 1929. Cunningham was a founding member of Group f.64 and participated in its important showing at the M. H. de Young Memorial Museum in San Francisco in 1932. It was there, in the same year, that she was given a one-person exhibition. Her work was also included in the landmark exhibition *Photography 1839–1937* held at the Museum of Modern Art, New York, in 1937.

In addition to plant forms, Cunningham also did portraiture. Having published her pictures of the dancer Martha Graham in *Vanity Fair* in 1932, Cunningham continued to work for the magazine in both New York and Hollywood until 1934. Throughout her long and productive career, portraiture continued to be an important subject. During the fifties she photographed the poets of the Beat Generation and in the sixties, the flower children of San Francisco's Haight Ashbury district. At the age of ninety-two Cunningham began her last major portrait project, a book of images primarily of people over ninety years old. Unfinished at the time of her death, the book, entitled *After Ninety*, was published posthumously in 1977 to coincide with an exhibition of these photographs at the Focus Gallery in San Francisco.

Roy DeCarava

Born New York City, 1919

Portrait, 1971

From 1934 to 1938 Roy DeCarava attended Textile High School in New York where he majored in art. After graduation he began working in the poster division on the WPA project and studied painting at night at the Cooper Union Institute (1938–40). From 1940 to 1942 he studied painting as well as printmaking at the Harlem Art Center and continued, from 1944 to 1945, at the George Washington Carver Art School in Harlem. There he met the painter Charles White, who encouraged him to focus on human concerns and social conditions in his work. At first, in the mid-forties, DeCarava used photography to create resource material for his paintings. However, he became increasingly interested in photography for its own sake, and by 1947 it had become his principal medium.

DeCarava's first photographic project was an emotionally powerful study of the people of Harlem, which he continued when he became the first black Guggenheim Fellow in 1952. His studies of everyday life in Harlem were published in 1955 in the book entitled *The Sweet Flypaper of Life*, which he did in collaboration with the writer Langston Hughes. In 1950 the Forty-fourth Street Gallery in New York City held his first one-person exhibition. His interest in promoting exhibitions of photography prompted DeCarava to found and direct (1954–56) A Photographer's Gallery in New York, one of the first post–World War II galleries to show photography as a fine art. In the late 1950s he photographed the jazz culture of Harlem with the idea of producing jazz equivalents with photographic techniques, such as extended exposures and camera movement.

Throughout the 1960s DeCarava continued to document life among blacks, but with greater interest in spatial ambiguity and the effects of selective depth of field. Interested in teaching, in 1963 he founded and, until 1966, directed the Kamoinge Workshop to teach young black photographers; since 1975 he has taught photography at Hunter College of the City University of New York. In 1985 DeCarava received an honorary Doctor of Fine Arts degree from the Rhode Island School of Design; in 1986 he received an honorary Doctor of Arts degree from the Maryland Institute, College of Art, for his contributions to photography.

DeCarava lives and works in Brooklyn, New York.

Rick Dingus

Born Appleton City, Missouri, 1951

Portrait, 1984

Rick Dingus attended the University of California, Santa Barbara, where he majored in painting and also produced mixed-media site and process pieces. He also made a series of stereographic color slides of objects that he illuminated by drawing around them with colored penlights while the camera shutter was open. The drawing, or light-writing, ranged from imitation of the forms to broad gestures.

In 1976 Dingus moved to Albuquerque to pursue graduate studies in photography at the University of New Mexico, where he studied with Van Deren Coke, Thomas Barrow, Betty Hahn, and Anne Noggle. He received a Master of Arts degree in 1977 and a Master of Fine Arts degree in 1981. It was in New Mexico that Dingus began making photo-drawings, created by first producing black-and-white stereographic prints on which he then drew with ink and applied drafting tape. He also began making monoptical pictures of unassuming landscape sites, which he then selectively marked with a silver pencil. Dingus has since been closely identified with the recent trend in photography to mark imagery.

During 1978–79 Dingus worked as a photographer for the Rephotographic Survey Project, a program launched in 1976 by Mark Klett, Ellen Manchester, and JoAnn Verburg to research and rephotograph locations originally recorded during nineteenth-century geological surveys of the United States by such expeditionary photographers as Timothy H. O'Sullivan, Andrew Joseph Russell, and William Henry Jackson. In 1982 Dingus helped organize "Marks and Measures," a photographic survey of Indian petroglyph and pictograph sites in North America. Dingus's interest in photography, the landscape, geology, and archaeology coalesced in his book *The Photographic Artifacts of Timothy H. O'Sullivan*, published in 1982. He is presently photographing vernacular and mythical events and places throughout the Southwest.

Dingus lives in Lubbock, Texas, where he teaches at Texas Tech University.

František Drtikol

Born Příbram, Bohemia (Czechoslovakia), 1883

Died Prague, 1961

Self-Portrait, 1930

František Drtikol began his photographic career in 1898 as an apprentice in a local studio in his hometown. From 1901 to 1903 he studied portraiture at the Lehr- und Versuchsanstalt für Photographie (Teaching and Research Institute for Photography) in Munich, where he was exposed to the then-current ideas of Symbolism and Jugendstil (German Art Nouveau).

After his service in the Austro-Hungarian army from 1904 to 1907, Drtikol worked as an assistant in various photographic studios in Karlsruhe, Chur, Turnov, and Prague. In 1910 he opened a portrait studio in Prague where he photographed artists, writers, celebrities, and many others in the soft-focus Pictorialist style. In 1911 Drtikol entered a partnership with Augustin Škarda, editor of the magazine *Fotografický obzor* (Photographic Horizon) and member of the Czech Photo Club of Amateur Photographers, and together they launched the firm Drtikol and Company, which lasted until 1921. In 1911 they published *Z pražských dvoru a dvorečku* (From Prague's Courtyards and Backyards), a portfolio comprising primarily Pictorialist views of the city of Prague.

In the late teens Drtikol abandoned Pictorialism for a modernist approach emphasizing new concepts of form, space, and light. This shift in direction is seen in his concentrated study of the female nude throughout the

twenties, which became the work for which he is best known. In these staged images, Drtikol used Symbolist themes along with expressionistic lighting techniques, such as harsh spotlights, to create distinct cast shadows. By the mid-1920s, he began working with Art Deco concepts, combining the human body with geometric shapes. His book of photographs *Les Nus de Drtikol* was published in Paris in 1929. In the early 1930s Drtikol began using hand-cut painted plywood figures in place of the human figure in his photographic tableaux, a shift that marked his move toward a greater reliance upon symbolism.

In 1935, at the height of his celebrity, Drtikol retired from the world of photography to the suburbs of Prague, where he devoted himself for the remainder of his life to painting and to the study of occult philosophy and Orientalism. Another book of his nudes, *Žena ve Světle* (Women in Light), was published in Prague in 1940. In 1942 he donated his archive of over two thousand prints, negatives, and personal documents to the Museum of Decorative Arts in Prague; in 1948 he was made a member of the Union of Czechoslovak Artists.

Alfred Ehrhardt

Born Triptis, Thuringia, Germany, 1901

Died Cuxhaven, Germany, 1984

Portrait, 1983

Alfred Ehrhardt's earliest art training dates to 1921 when he began to study music, painting, and printmaking in Hamburg. He subsequently attended the Bauhaus (1927–28), taking classes with Oskar Schlemmer, Josef Albers, and Vasily Kandinsky, with whom he maintained close relationships into the late thirties. Following his studies at the Bauhaus, Ehrhardt was a freelance artist in Hamburg until 1931 when he became an instructor at the Hamburger Landeskunstschule (Hamburg State Art School). Dismissed in 1933 because of his progressive views on art, he accepted a teaching post at the university in Asco, Denmark, where he remained until 1935.

In 1935 Ehrhardt, who had made his first photographs in the early 1920s, returned to Germany, to Cuxhaven, and began an extended photographic study of the natural landscape, especially the tidal flats along the coastline of northern Germany and at Kurische Nehrung along the coast of the Baltic Sea. Infused with spiritual and philosophical nuances, Ehrhardt's pictures were a radical departure from conventional landscape photography; unusual, disorienting perspectives and broad, simplified

forms resulted in striking compositions whose rhythms and patterns spoke of an ordered universe.

At the same time that Ehrhardt pursued landscape photography, he explored micro- and macro-photography, prompted by his fascination with the structure of natural forms. Much of this work was later published in book form: *Die Melodie des Lebens—Mikroskopische Welt* (The Melody of Life—The Microscopic World, 1939); *Kristalle* (Crystals, 1939); and *Muscheln und Schnecken* (Shells and Snails, 1941). Beginning in 1937 Ehrhardt also explored these themes through documentary film, which became his primary medium after 1945. In addition to landscape and natural forms Ehrhardt photographed animals and architecture. *Lämmer, Kücken, Kälbchen* (Lambs, Geese, Calves) was published in 1940 and *Das Tier der Wildnis* (Wild Animals) in 1949. His architectural views appeared in *Ewiges Flandern* (Eternal Flanders, 1943) and *Frankfurt am Main: Portrait einer Stadt, Vergangenheit und Gegenwart* (Frankfurt am Main: Portrait of a City, Past and Present, 1958).

Hans Finsler

Born Zurich, 1891

Died Zurich, 1972

Portrait, 1969

Hans Finsler studied architecture from 1909 to 1914 at the Technische Hochschule in Munich, where he became interested in modern art under the influence of art historian Fritz Burger. During World War I, because of his citizenship in a neutral country, he was permitted to remain in Germany, where he studied art history with the noted formalist art historian and theoretician Heinrich Wölfflin.

In 1922 he was appointed librarian and professor of art history at the Kunstgewerbeschule, Burg Giebichenstein, in Halle. There he began making photographs documenting the students' projects; in 1927 he started a photography course. Though he was primarily self-taught, Finsler was aware of the development of "new vision" photography and thus taught his students to emphasize sharp detail and bold, geometric design. He became a master of product, or "object," photography, which was characterized by pristinely rendered compositions of primarily man-made objects whose clean, spare geometry he raised to a heightened level of intensity.

With his technique and vision, Finsler brought a new impulse to the developing fields of commercial illustration and advertising design. Recognized as fresh and innovative, his photographs were included in the 1929 *Film und Foto* exhibition held in Stuttgart.

In 1932 Finsler returned to Zurich to start the photography program at the Kunstgewerbeschule, the first training center for professional photographers in Switzerland. Teaching there until his retirement in 1958, Finsler personally instructed or had a connection with some of the best post–World War II Swiss photographers—Robert Frank, Werner Bischof, René Burri, and Emil Schulthess. Near the end of his life, Finsler, both philosopher and photographic theorist, published a small volume, *Mein Weg zur Fotografie: 30 Aufnahmen aus den zwanziger Jahren/My Way to Photography: 30 Photographs Taken in the Twenties* (1971), which stated and illustrated his approach to photographing objects.

Robbert Flick

*Born Amersfoort,
Netherlands, 1939*

Portrait, 1984

From 1947 to 1952 Robbert Flick lived in the Dutch West Indies, where he began photographing the landscape at about the age of nine. He returned to the Netherlands for his primary education and then moved to western Canada (1958), where he worked as a logger during the early sixties. Influenced by the published work of Edward Weston, Ansel Adams, and Robert Frank, Flick began to explore photography seriously. He studied art at the University of British Columbia, Vancouver, where he received his Bachelor of Arts degree in 1967. The following year he began studying photography with Robert Heinecken at the University of California, Los Angeles, where he received a Master of Arts degree in 1970 and a Master of Fine Arts degree in 1971. During his stay in Los Angeles he produced the *L. A. Diary* series, which consists of prints (manipulated by solarization and toning) each made from a negative exposed six or seven times in camera. As a group, these images represent a kaleidoscopic vision of Los Angeles.

In 1971 Flick moved to Illinois to teach at the University of Illinois, Urbana-Champaign, where he remained until 1976. During this time he produced two extensive bodies of work: *Midwest Diary*, which included studies and meditations on the midwestern landscape and the horizon line; and *Wall Series*, in which he rephotographed configurations of *Midwest Diary* images positioned on his studio wall.

Flick returned to the Los Angeles area in 1976 to teach at the University of Southern California. At this time he worked on the *L. A. Doubles* series, which pairs images that comment on perception of spatial location. In 1977 and 1978 he produced the *Arena Series*, a study of the light, space, and structure of a parking garage over an extended period of time. From 1978 to 1980 he made color photographs for the Bicentennial Los Angeles documentary project. Also during this time he began structuring images into composite grids, *Sequential Views*, which were studies of location achieved through the subtle variation of camera positions.

Flick lives and works in Inglewood, California.

Robert Frank

Born Zurich, 1924

Portrait, 1976

Robert Frank apprenticed with photographers Hermann Eidenbenz in Basel (1940–41) and Michael Wolgensinger in Zurich (beginning in 1942). Following military service in 1944, he took his first professional job as a still photographer for Gloria Films in Zurich. In 1947, after a brief stay in Paris, he emigrated to the United States and settled in New York, where he was hired to make fashion photographs by Alexey Brodovitch, art editor at *Harper's Bazaar*. At the same time he began doing freelance reportage and advertising photography for other popular magazines, among them *Fortune, Look, Life,* and *McCalls*. In addition to his commercial work in the United States, Frank traveled on assignment to Europe and South America. He produced compassionate studies of Welsh miners, ironic studies of London businessmen, and intimate documents of Peruvian and Bolivian Indian life.

In 1955 Frank became the first European-born photographer to receive a Guggenheim Fellowship, an award that allowed him to travel and photograph extensively throughout the United States during 1955–56. He selected and sequenced eighty-three of these images for the book *The Americans*, a profoundly perceptive and critical document of American life published first in France in 1958, then in the United States in 1959 with an introduction by Jack Kerouac. In 1958 Frank began making films in collaboration with artists and writers of the Beat Generation. His first film, *Pull My Daisy*, co-produced and filmed by the painter Alfred Leslie and narrated by Kerouac, was completed in 1959. Other films include *The Sin of Jesus* (1961), *Me and My Brother* (1968), *Cocksucker Blues* (1972), and *Keep Busy*, with Rudi Wurlitzer (1975).

In 1969 Frank moved to Nova Scotia, Canada, where in 1972 he completed *The Lines of My Hand*, a book summarizing his work in photography and film. His work from the later 1970s is highly autobiographical and introspective, often using the landscape or ocean view as a backdrop for still lifes that include earlier images suspended along a wire.

Frank lives and works in Mabou, Nova Scotia.

Lee Friedlander

*Born Aberdeen,
Washington, 1934*

Self-Portrait, 1969

Lee Friedlander began taking pictures in 1948, at the age of fourteen. He went on to study photography with Edward Kaminski at the Art Center School in Los Angeles (1953). He then moved in 1956 to New York City, where he launched a career as a freelance photographer, working for magazines and record companies. His first major body of work was a series of portraits of New Orleans jazz musicians done in the late 1950s.

During the 1960s Friedlander turned to what has been called the "social landscape," to people, their environs and artifacts. Influenced by Walker Evans and Robert Frank, he adopted the tradition of the snapshot in photography not only to reflect on American culture with a sense of humor and irony, but also to question the nature of photographic perception. At the same time Friedlander began an extensive series of self-portraits in which his shadow or his reflection was frequently used to mark his presence in the photograph. In the 1970s he made a series of photographs for the Bicentennial project *The Nation's Capital in Photographs, 1976* and a series on public monuments called *The American Monument*, which was published as a book (1976).

After Friedlander's move from New York City to a Rockland County suburb in 1959, motifs from nature played a greater role in his work, as seen in his *Trees and Flowers* series of 1972–78. *Shiloh*, an extensive series of landscapes of the military park in Tennessee, was produced in 1977. In 1979 he was commissioned by the Akron Art Center to photograph the urban and industrial landscape of Ohio and Pennsylvania, a project later published as the book *Factory Valleys* (1982).

Friedlander lives and works in Rockland County, New York.

Jaromír Funke

*Born Skuteč, Bohemia
(Czechoslovakia), 1896
Died Prague, 1945*

Portrait, 1940

Although initially a student of medicine and then law, Funke ultimately chose a career in photography. By 1923 he was publishing in Czech photographic journals and gaining recognition as a leader of the photographic avant-garde in Czechoslovakia. In 1924 Funke and Josef Sudek were among the founders of the Czech Photographic Society.

Though his early photographs were influenced by Pictorialism, Funke's photographs of the 1920s paralleled the development of "new vision" photography in Germany. From 1923 to 1925 he made sharply focused studies of simple subjects, such as crystal spheres, wire coils, and bottles. Influenced by the Constructivist photography done at the Bauhaus in Germany, Funke's work of the late 1920s consisted of carefully arranged still-life compositions emphasizing abstraction and the play of light and shadow. While his work of the late 1920s reflects the influence of Constructivism, Funke's work of the 1930s is indebted to Surrealism. Produced between 1930 and 1934, *Čas trvá* (Time Persists) is one of several cycles (a term he used to denote the development of an idea through a series) that reveal the impact of Eugène Atget, whose work inspired such Surrealist photographers as Man Ray.

A teacher as well as a photographer, Funke taught photography at the Bratislava School of Applied Arts from 1931 to 1934, while he himself studied art history and aesthetics at the University of Bratislava. At the same time that he forged the avant-garde in photography, he used the camera as a tool for social documentation. During his tenure at Bratislava, he was a member of the leftist group Sociofoto, which recorded the housing conditions of the poor. In 1935 he moved to Prague to become professor at the State School of Graphic Arts, where he remained until 1944.

In 1935 Funke published *Fotografie vidí povrch* (Photography Sees the Surface), a book that emphasizes abstract still-life compositions in which simple objects are photographed close up and at unusual angles to lend a concentrated focus on the thing itself. From 1939 to 1941, in collaboration with Josef Ehm, he edited the magazine *Fotografický obzor* (Photographic Horizon), in which he published "From the Photogram to Emotion," an insightful essay about photography and abstraction. One of Funke's last works, entitled *Můj Kolín* (My Kolín), is a formal study of the town of Kolín in which he uses the dynamic of the diagonal as its central visual theme.

Judith Golden

Born Chicago, 1934

Self-Portrait, ca. 1978

At the age of seventeen Judith Golden won an American Legion Scholarship to study art, which she carried out at Indiana University. Following her courses there, she worked as a commercial artist in Chicago. In 1967 she resumed her education at the School of the Art Institute of Chicago, where she received a Bachelor of Fine Arts degree in 1973. Her work at this time centered around printmaking, which incorporated photographic elements. From Chicago, Golden moved to California, where she enrolled in the graduate program in art at the University of California, Davis. While pursuing her degree she produced the *Chameleon* series, photographic self-portraits amplified with hand coloring, drawing, and three-dimensional collage elements. Found materials, such as feathers and hair, added a humorous and fantastic element to her work, which commented on alternate identities and the influence of the media on women's roles in contemporary culture.

After receiving her Master of Fine Arts degree in 1975, Golden moved to Los Angeles to teach at the University of California, where she remained until 1979. She began several series of images in 1975 which, as an extension of the *Chameleon* series, are hand-altered with

pencil and oil and are a political commentary on the relationship between the mass media and self-image. In addition to the *Magazine* series, Golden produced the *Magazine Makeovers* series, in which she photographed torn pages from magazines held in front of her face, and the *People Magazine* series, in which she appears through cutout portions of the covers of that magazine. In 1977 she began the *Ode to Hollywood* series, in which she substituted her own image on promotional movie posters.

Between 1980 and 1981 Golden made her *Portraits of Women* series, Cibachrome prints amplified with color dye to produce psychologically intense portraits. The series *Relationships*, begun in 1982, consists of staged group portraits that comment on the relationships between men and women. Her most recent series, *Persona* and *Cycles*, are color portraits for which she has painted her sitters before photographing them and then altered, in many cases, the subsequent transparencies and the final prints.

Golden lives in Tucson, where she teaches at the University of Arizona.

Philippe Halsman

*Born Riga, Latvia, 1906
Died New York City, 1979*

Portrait, ca. 1959

Philippe Halsman was already an avid amateur photographer by the age of fifteen. Although he studied electrical engineering at the Technische Hochschule in Dresden from 1924 to 1928, Halsman finally decided to extend his interest in photography from the personal to the professional. In 1931 he established a studio in Paris, which he developed into a successful enterprise doing freelance portrait and fashion photography for such magazines as *Vu, Voilà,* and Paris *Vogue.*

In 1940, under the auspices of Albert Einstein (whom he would later photograph for a cover of *Life* magazine), Halsman obtained an emergency exit visa which enabled him to flee Occupied France and go to New York City. There he signed on with Black Star picture agency. He shot his first cover for *Life* magazine in 1942 and over the next thirty years produced one hundred more. He also worked for *Look, Saturday Evening Post, Paris Match,* and *Stern.* For these magazines he made psycho-

logically astute and technically superb portraits of celebrated personalities of the time: statesmen, scientists, political leaders, cultural figures, and socialites; among them, in addition to Einstein, were Winston Churchill, Henri Matisse, and the Duke and Duchess of Windsor.

During his career Halsman published several photographic books, beginning in 1948 with *The Frenchman: A Photographic Interview with Fernandel.* In 1954 he produced *Dali's Mustache: A Photographic Interview with Salvador Dali,* and in 1959 he issued *Philippe Halsman's Jumpbook,* a collection of photographs of the famous, the wealthy, and the powerful jumping off the ground. In 1961 he published *Halsman on the Creation of Photographic Ideas* and subsequently became a dedicated teacher of master classes in portraiture at the Famous Photographers' School in Connecticut.

Georges Hugnet

Born Paris, 1906
Died Saint-Martin,
Ile de Ré, 1974

Portrait, 1934

Although born in Paris, Georges Hugnet spent his early childhood in Argentina. He returned to Paris with his family in 1913, at the age of seven. When he was fourteen, he was introduced to the poet and painter Max Jacob, through whom he would meet Max Ernst, Jean Cocteau, Marcel Duchamp, and Man Ray. Sometime around 1926, interested by these artists' concern with the subconscious, Hugnet experimented with Surrealist automatic drawing. In 1928 he published his first book of poems, *40 poésies de Stanislas Boutemer*, illustrated by Max Jacob. The following year Hugnet wrote the script for his first movie, *La Perle*, a humorous, Buster Keaton type of absurd film celebrating the fantastic, as did the films of Salvador Dali and Luis Buñuel.

In the early 1930s Hugnet began making Dada/Surrealist-influenced collages, a selection of which was published as *La Septième Face du dé* in 1936. Characterized by sexual themes, these collages consist of fragments of photographs, advertisements, and old engravings set with bits of newspaper text on a white background, creating a nonillusionistic space. The cover was designed by Marcel Duchamp. From 1934 to 1940 Hugnet operated

a bookbinding shop in which he crafted three-dimensional covers for books by the poets Paul Eluard and André Breton. In 1940 he opened a bookstore that became a center for underground publishing in Paris during the Occupation.

In 1947 Hugnet made collages organized with a more coherent, believable space and accompanied by text for *Huit jours à Trebaumec* (published in 1969), a Surrealist vacation diary satirizing Michelin travel guides. From 1948 to 1950 he produced *La Vie amoureuse des spumifères*, collages based on erotic postcards. During the 1950s he made a series of Surrealist objects for which he utilized found materials such as driftwood and stones. He returned to collage in 1961, but used more simplified forms than those of his earlier work.

In addition to making art, Hugnet also wrote about art; throughout his career, he produced a number of historical essays on Dada and Surrealism. In 1972, a little more than a year before his death, Guy Authier published *Pleins et déliés*, a selection of Hugnet's writings on art.

Gyorgy Kepes

Born Selyp,
Hungary, 1906

Portrait, 1977

From 1924 to 1928 Gyorgy Kepes studied painting at the Academy of Fine Arts in Budapest. While a student there he joined Munka, a politically active group of avant-garde artists and writers through whom he was exposed to Expressionism, Cubism, Constructivism, and Dada.

In search of "more advanced, dynamic," and, as he has said, "socially potent forms of visual communication," Kepes gave up painting for filmmaking in 1929. He then began corresponding with his fellow Hungarian László Moholy-Nagy, who invited Kepes to join him in Berlin, which Kepes did in 1930. There he experimented with still and motion-picture photography while supporting himself with exhibition, stage, and graphic-design work. His still pictures, like those of many other avant-garde photographers working in Germany during this period, made dramatic use of low- and high-camera positions to flatten and abstract space.

In 1936 Kepes joined Moholy-Nagy in London. In 1937 he came to Chicago to head the Light and Color Workshop at the New Bauhaus (re-formed as the Chicago School of Design in 1939, and renamed the Institute of Design in 1944) under Moholy-Nagy, with whom

he became a principal spokesman for Constructivism. Kepes's interest in the relationship among art, science, and technology is revealed in a series of abstract photograms of the late 1930s and 1940s which were influenced by the novel vision of nature's invisible structure as revealed by micro- and macrophotography.

In 1943 Kepes left the New Bauhaus; the following year he published his book *Language of Vision*, in which he expressed the essence of his approach to photography and teaching. In 1945 he was invited to teach visual design at the Massachusetts Institute of Technology where, in 1967, he founded the Center for Advanced Visual Studies. In 1951 painting again became his primary creative focus. He also worked with exhibition and graphic design and established a distinguished career in environmental design. In 1977 he retired from teaching to devote himself more fully to his own work. He began working with photography again, making abstract photograms and *cliché-verre* prints. In 1984 the Polaroid Foundation invited Kepes to use the 20" x 24" instant camera, which resulted in a series of carefully constructed still lifes.

Kepes lives and works in Cambridge, Massachusetts.

André Kertész

Born Budapest, 1894
Died New York City, 1985

Portrait, 1972/ca. 1975

André Kertész was trained in business at the Academy of Commerce and worked at the Budapest stock exchange from 1912 to 1914. In his spare time he devoted himself to learning photography, taking pictures of Budapest, its people, street life, and the surrounding landscape. As an officer in the Austro-Hungarian army during World War I, he continued to photograph, making pictures of his fellow soldiers and their activities. Severely wounded in 1915, Kertész returned to Budapest and continued working at the stock exchange until he emigrated to Paris in 1925.

In Paris Kertész became a freelance photographer, working for a variety of European magazines and newspapers, including the *Münchner Illustrierte Presse, Berliner Illustrirte Zeitung, Uhu, Vu*, and the London *Sunday Times*. Highly acclaimed for his innovative work by peers and critics, Kertész became a leader of modern reportage, influencing such younger photographers as Brassaï, Henri Cartier-Bresson, and Robert Capa. Kertész seized the fleeting moment with his camera with an innate sense of design and form poetically combined with a

compassionate feeling for everyday human experience. His photographs of artists, writers, and musicians are a collective portrait of the Parisian avant-garde of the 1920s and 1930s. Influenced by Surrealism while in Paris, Kertész also did an unusual series called *Distortions*, in which the female form is dramatically metamorphosed by means of a fun-house mirror.

In 1936 Kertész came to New York under a one-year contract with Keystone Studios. The worsening political climate in Europe preceding World War II convinced Kertész to remain in America, where he became a citizen in 1944. From 1937 to 1949 he was a freelance photographer for fashion magazines and journals of interior decoration; from 1949 to 1962 he worked under an exclusive contract with Condé Nast Publications. After 1962 Kertész devoted himself more fully to his personal work. Publications and exhibitions from the 1960s on have focused on his noncommercial photographs, as well as his professional assignments.

Edmund Kesting

Born Dresden, 1892

*Died Birkenweder,
near Berlin, 1970*

Self-Portrait, 1931

From 1911 to 1916 Edmund Kesting studied at the Akademie der Künste in Dresden. From 1916 to 1918 he served in the military, during which time he made some of his first paintings and collages. After returning from service, Kesting took master classes with painters Richard Müller and Otto Gussmann. About 1920 he turned from painting to photography, while continuing to work in collage. Kesting's photographic experiments with multiple exposure, partial solarization, multiple printing techniques, and photograms and his awareness of the new Cubist-Constructivist perceptions of space placed him at the center of the German avant-garde in the 1920s. In his extensive series of portraits taken close up, Kesting made dramatic use of multiple imagery through montage techniques and an inventive use of light and cast shadow. His nudes and landscapes exhibited the same sense of freedom in combining various approaches.

Kesting's one-person exhibition in Dresden in 1918 was followed by another in 1923 at the gallery Der Sturm in Berlin. The showing was accompanied by the publication of Kesting's work in *Der Sturm*, a magazine

of the literary and artistic avant-garde published by Herwarth Walden, director of the gallery, with whom Kesting had become friends in 1920. In 1926 he had exhibitions in New York and Moscow, and in the following year he participated in the *Grösse Berliner Kunstausstellung* (Great Berlin Art Exhibition).

In 1927, along with Lothar Schreyer, Kesting founded a private art school in Berlin. In 1933 the school was closed by the Nazis because of its association with "Degenerate Art," and Kesting's work was banned because of his association with the avant-garde.

After World War II, in 1946, Kesting and art historian Will Grohmann organized the *Erste deutsche Kunstausstellung* (First German Art Exhibition) in Dresden, which included examples of "Degenerate Art." In 1948 Kesting taught at the Kunst-Hochschule in Berlin-Weissensee; in 1953 he was appointed professor at the Hochschule für Film und Fernsehen in Potsdam-Babelsberg, East Germany, where he remained until 1967.

Les Krims

Born New York City, 1942

Portrait, 1984

Les (Leslie Robert) Krims painted and drew extensively as a child. He studied painting and printmaking at the Cooper Union School of Art in New York, where he received a Bachelor of Fine Arts degree in 1964, and subsequently studied and taught advanced printmaking at Pratt Institute in Brooklyn, from which he received a Master of Fine Arts degree in 1967. Dissatisfied with the limitations of printmaking, while still a graduate student he taught himself photography. From 1967 to 1969 he taught photography at the Rochester Institute of Technology; in 1969 he began to teach at the State University College at Buffalo, New York.

In 1970 Krims's first portfolio was published, *Eight Photographs/Leslie Krims*, a series of Kodalith images in which he pioneered the directorial mode to create poignant social commentary. In 1972 he published several portfolios, among them *The Little People of America 1971*, a tragi-comic documentary on dwarfs; *The Deerslayers*, an ironic study of hunters and their kill; *The Incredible Case of the Stack O' Wheats Murders*, staged murder scenes done in the style of police photographs; and *Making Chicken Soup*, a humorous recipe book illustrated with his semi-nude mother as cook. *Fictcryptokrimsographs*, a book published in 1975, presents

grotesque, heavily manipulated Polaroid SX-70 images of female nudes with household implements. *Academic Art 1975−76* is an extensive series of approximately ten subseries of images with such titles as *Silvered Silhouettes Academic Art*, *Academic Academic Art*, and *Large Cameras Academic Art*, each a tongue-in-cheek commentary on trends in contemporary art, photography, and architecture. The portfolio *Please!*, completed by 1978, consists of images of the photographer's mother dressed in a bikini, wearing a placard on her head reading "Please" and begging with a tin cup and pencils on the streets of Buffalo.

The portfolio *Idiosyncratic Pictures* produced in 1979−80 (published as a postcard set in 1982) is a series of black-and-white view-camera images of fabricated tableaux including highly patterned backgrounds, an extensive array of cultural artifacts, and male and female nude figures. His most recent images, done in color with an 8" x 10" view camera, are extensions of the ideas introduced in *Idiosyncratic Pictures*.

Krims teaches and works in Buffalo.

Michel Szulc Krzyzanowski

*Born Oosterhout,
Netherlands, 1949*

"Concerning your request for a portrait I kindly inform you that it is my policy not to profile myself as an artist personally, but only to show my sequences. That is the reason why I regretfully wish not to submit your request."

Statement, 1984

Michel Szulc Krzyzanowski studied painting at the art academies in Breda and 's-Hertogenbosch. In 1970 he became a freelance photographer, but rejected commercial use of the medium in 1971 when he began working with the sequential form as a conceptual expression of the relationship between photography, time, and space. His first sequence consisted of two images comparing distance relationships (near/far) rendered by the camera, though subsequent sequences have been more extensive and complex, using as many as eight images. Krzyzanowski stages his photographs in sparse landscapes, sometimes directing models or including parts of his own body or shadow.

Related but yet quite distinct from Krzyzanowski's sequential work in the landscape is the social documentary project he worked on in 1974, which includes comparative views of people of different social backgrounds at work and at home. In a similar vein is his extended

photo-reportage of the growth of a woman from child to adult, a series published as the book *Neem Nou Henny* (Let's Take Henny) in 1977.

In his pursuit of the relationship between nature and idea through conceptual structure in photographs, Krzyzanowski lived on the isolated Greek island of Andros for three months in 1977 in order to achieve an intensity of observation through the camera of the subtle changes of light, texture, and ambience in the environment. Many of the pieces made there as well as in America and Mexico are included in *Sequences*, a volume featuring Krzyzanowski's work with the sequential format from 1975 to 1983. In 1984 Krzyzanowski ceased his exploration of the sequential format, and in his most recent work he is investigating the creation of art out of pornography.

Krzyzanowski lives and works in Amsterdam.

Helen Levitt

Born New York City, 1918

Portrait, ca. 1952

In 1936, equipped with a 35-mm camera and inspired by Henri Cartier-Bresson's "decisive moment," Helen Levitt began to photograph the street life in Harlem and other areas of New York City. In 1941 she went to Mexico City, where she photographed the street life of that city and its suburban districts. Though she captured a wide range of the city life in both places, it is her photographs of children that are the best-known works from this time. Her first one-person exhibition, *Helen Levitt: Photographs of Children*, held at the Museum of Modern Art, New York, in 1943, revealed a body of work that demonstrated her uncanny ability to merge strong empathy for her subjects with a sense of moment and formal order.

Beginning in the late forties, Levitt collaborated with the writer James Agee (whom she had met at the studio of Walker Evans, whose photography also influenced her vision) and Janice Loeb on two films, *The Quiet One*

(1949, nominated for a Motion Picture Academy Award) and *In the Street* (1952), which translated the style of her street images into film. During the 1950s she worked primarily as a director and editor on various films and did little still photography.

Awarded Guggenheim Fellowships in 1959 and 1960 to investigate the techniques of color photography, Levitt applied a highly attuned feeling for color to her already developed sense of discerning order in street life. These color photographs were exhibited at the Museum of Modern Art in 1963. After a ten-year hiatus, she resumed photographing in the streets in 1971, producing the images shown at the Museum of Modern Art in 1974.

Levitt lives in New York City, where she works in both black-and-white and color photography.

Herbert List

Born Hamburg, 1903
Died Munich, 1975

Portrait, 1930

Herbert List attended the Johanneumschule from 1912 to 1920. From 1921 to 1923 he apprenticed at the Landfried Coffee Company in Heidelberg and then (1925–26) worked as a buyer in his father's import company. An expert in coffee tasting and fluent in four languages, he traveled (1926–28) on behalf of the company through the coffee-producing countries of Brazil, Guatemala, San Salvador, and Costa Rica, as well as the United States.

From 1928 to 1936 he was a partner in the family firm. During this period he participated in the upper-class bohemian social and cultural life of Hamburg within a group called Children of the Sun. He was particularly involved with the theater at this time, but began working with photography as well. While List was mainly self-taught, the photographer Andreas Feininger introduced him to the then recently developed twin-lens reflex camera and provided him with technical instruction. List's first photographs, dating from 1930, are of the city of Hamburg.

Forced to leave Germany because he was Jewish, List moved briefly to London, then to Paris, where he be-

came primarily a fashion photographer. Beginning in 1937 his photographs were published in such magazines as *Vogue, Life, Harper's Bazaar, The Studio*, and the photographic annuals published by Arts et Métiers Graphiques. In the Surrealist style of Horst P. Horst and Cecil Beaton, List's fashion photographs were tableau arrangements in which models appeared with mysterious props. In 1937 List traveled through Greece making photographs that demonstrated his concern with classical antiquity and the statuesque quality of the male figure.

Returning to Germany after World War II, List photographed the shattered city of Munich, focusing on fallen Neoclassical sculpture amid the massive debris. During the next twenty years he traveled extensively on assignment throughout Europe and the Caribbean photographing artists, celebrities, and travel subjects primarily for *Du* magazine. He ceased photographing in the early 1960s and devoted the remainder of his life to studying and collecting Italian old master drawings.

Dora Maar

Born Paris, France, 1907

Portrait, ca. 1936

Daughter of a French mother and a Yugoslavian father, Dora Maar (Dora Markovitch) spent many of her early years in Argentina, where her father worked as an architect. After her return to France, she studied painting in Paris at the Ecole d'Art Décoratif, the Académie de Passy, the Académie Julien, and, for a brief period, with the Cubist painter André Lhote. She also studied photography at the Ecole de Photographie de la Ville de Paris. Introduced to the Surrealist circle by Georges Bataille, she became friends with Michel Leiris, Man Ray, André Breton, and Paul Eluard. Around 1930, just at the time that she was beginning to work in photography, she met the photographer Brassaï, with whom, according to the latter, she shared a darkroom for a brief period. Like Brassaï, Maar worked as a professional photographer in the field of photoreportage. She also worked in advertising and fashion.

In her rare and provocative photographs made for herself, which date primarily from the 1930s, Maar adopted the Surrealist practice of infusing the real with the bizarre. Laden with a sense of absolute silence and suspended time, her photomontages, which are all rephotographed collages, reveal a penchant for placing enigmatic figures in desolate architectural settings. Her

unmanipulated photographs also depend on the sense of enigma. Her most well-known image, the *Portrait d'Ubu*, for example, is a straight photograph of a larval salamander called an axolotl, but through her choice of this unusual subject, which acts as a caricature of human form, and through her framing and dramatic lighting, Maar elicits feelings of mystery and the unknown.

In late 1935 or early 1936 Eluard introduced Maar to Pablo Picasso. She became Picasso's close companion for several years and principal model for the extended series of portraits he did from the late thirties through the war years. She also served as a model for *Guernica* (1937), of which she made documentary photographs at each stage of the work's evolution.

Maar's photographs were included in the *International Surrealist Exhibition* held in London in 1936, and she participated in the Surrealists' postcard project with her photomontage *29 rue d'Astorg*, published in 1937. She also collaborated with Man Ray in making the photographs for the book *Le Temps déborde* (Time Overflows, 1947) by "Didier Desroches" (Paul Eluard).

Maar eventually withdrew from artistic circles. She lives in Paris and the south of France.

Greg MacGregor

Born La Crosse, Wisconsin, 1941

Portrait, 1983

Greg MacGregor learned to draw as a child through a radio education program and studied music and science in high school. He majored in physics at Wisconsin State University, from which he received a Bachelor of Science degree in 1963. The following year he earned a Master of Science degree in physics from the South Dakota School of Mines and Technology. In 1965, while teaching physics at Wisconsin State University at Whitewater, he developed a serious interest in photography.

In 1966 he moved to California and until 1970 worked as a physicist at the Lawrence Livermore National Laboratory, where he researched cosmic-ray physics and X-ray astronomy. Beginning in 1970 he took classes in photography with Jerry N. Uelsmann at the University of California, Berkeley, Extension, in San Francisco, and with Jack Welpott and Don Worth at San Francisco State University, from which he received a Master of Arts degree in 1973. While still a graduate student, MacGregor became an assistant professor of arts and natural sciences at Lone Mountain College, San Francisco, where he taught courses in astronomy. He soon founded the photography program at the college, which he directed until 1978.

MacGregor produced the series *Oddities in the Western Landscape* from 1973 through 1976. In 1975 Studebaker Press published his series *Deus Ex Machina*, a book of photographs that explore the relationship between man and machine by combining, through multiple printing, images of real and toy cars, planes and helicopters, with figures posed in carefully chosen settings. From 1976 to 1982, he worked on the *Remains* series, hand-colored photographs of man's residue in the landscape. In 1981 he completed the *American Tractor Series*, color photographs that exaggerate the toylike quality of heavy farm and construction vehicles set in open western landscapes. He is currently working on two series: *Explosions: A Handbook for Blasters*, begun in the late seventies, in which he is documenting explosions he constructs and stages for the camera; and *The New Woman of the American West*, begun in 1982, airbrushed black-and-white photographs in which he returns glamour to the Western woman.

MacGregor has been teaching photography at California State University at Hayward since 1981 and lives in Oakland, California.

Aleksandras Macijauskas

Born Kaunas, Lithuania, 1938

Self-Portrait, 1977

From 1947 to 1962 Aleksandras Macijauskas attended the Kaunas secondary school. He took up photography in 1963, while working at a machine-tool plant. From 1967 to 1973 he worked as a photo-correspondent for the daily Kaunas newspaper, *Vakarines Naujienos* (Evening News). Two series completed while he was a photo-correspondent were *Neighbors' Portraits* and *Folk Handicraftsmen*. Since 1969 he has been a member of the Photographic Art Society of Lithuania and was elected executive secretary of its Kaunas chapter in 1973. In 1971 he joined the Lithuanian Journalists' Union.

Macijauskas had his first one-person show at the Čiurlionis Museum in Kaunas in 1968 and an exhibition in 1969 at the Union of Journalists in Moscow. In 1972 he exhibited at the USSR People's Ethnographic Museum in Leningrad and in 1974 at the Bibliothèque Nationale, Paris.

From 1976 to 1977 Macijauskas studied philosophy at the University of Marxism-Leninism in Kaunas. During

this time he produced the series *Lithuanian Markets*, a journalistic and psychological study of people and animals in the mercantile atmosphere of a country market. In 1977 he began an extended photographic study, *In the Veterinary Clinic*, consisting of humanistic images that depict the tragi-comic relationship between man and beast in a medical context, the tasks of veterinarians, and the plight of the animals. Among Macijauskas's most recent series is *Footprints on the Bank*, published in 1984, an essay on the relationship between man and nature. Images depicting the power or poetic beauty of nature marked by the presence of man speak of the delicate balance between the two in an industrialized society.

Macijauskas lives and works in Kaunas.

Man Ray

Born Philadelphia, 1890
Died Paris, 1976

Self-Portrait, ca. 1930

Man Ray's family moved from Philadelphia to New York in 1897. There Man Ray eventually became a commercial artist for a publisher of maps and atlases, for whom he did layouts, lettering, and typography. At night he studied at the National Academy of Design and later at the avant-garde Art School of the Francisco Ferrer Social Center. Through Alfred Stieglitz, whom he had met in 1910–11 at gallery "291," Man Ray was introduced to modern developments in art. His first one-person show of paintings and drawings was held at the Daniel Gallery in New York in 1915. That same year he helped found the Society of Independent Artists and met Marcel Duchamp, with whom he became lifelong friends. Along with Duchamp and Francis Picabia, Man Ray was a key member of the New York Dada group during and in the years immediately following World War I. In 1918 he began his series of *Aerograph* paintings, abstract paintings done with an airbrush. In 1921, together with Duchamp, he published the first, and only, issue of the magazine *New York Dada*.

Although Man Ray had made photographs to document his paintings as early as 1915, it was only in 1920 that he became a serious photographer. In 1921 he moved to Paris; in the following year he turned to photography as a profession when he began making fashion

photographs and portraits of the literati and artists of the Paris community. At the same time he was at the forefront of experimental photography in Europe, exploring solarized negatives and developing (1922) his first cameraless images, called *Rayographs*. These images contained the shadows of recognizable objects and reflected his concern with chance, ambiguity, and unconscious association. During his years in Paris, from 1921 to 1940, Man Ray participated in the first group show of Surrealist painters at the Galerie Pierre (1925) and made several films, *Le Retour à la raison* (1923) and *L'Etoile de mer* (1928). He had exhibitions at the Galerie Surréaliste in 1926 and 1928, and in 1932 he took part in the *Exposition Retrospective Dada, 1916–1932*, held at the Galerie d l'Institut, Paris. Also in 1932, the Julien Levy Gallery in New York held his first one-person exhibition in the United States that consisted entirely of photographs.

The Nazi invasion of France forced Man Ray to return to the United States in 1940. He settled in Hollywood in 1942 and worked there as a freelance photographer and painter until his return to Paris in 1951. Although he experimented with color photography around 1960, painting became his primary focus after his return to France.

Ralph Eugene Meatyard

Born Normal, Illinois, 1925

Died Lexington, Kentucky, 1972

Portrait, ca. 1959

After graduating from high school in 1943, Ralph Eugene Meatyard attended Williams College in Massachusetts for one year under the Navy V-12 program. Discharged from the Navy in 1946, he subsequently apprenticed as an optician in Chicago and received his license in 1949. He soon left his job as an optician to return to school at Illinois Wesleyan University in Bloomington, where he remained for only one semester. He then took a job as an optician in Lexington, Kentucky, where he first began to take photographs.

In 1954 Meatyard studied with art historian-photographer Van Deren Coke and joined the Lexington Camera Club and the Photographic Society of America. During the summer of 1956 he took courses with Henry Holmes Smith and Minor White at Indiana University at Bloomington. It was during these years, photographing on weekends, that he began to stage his subjects (frequently his own children and friends) with grotesque masks in ruined or abandoned buildings. Centered on surrealist literary and psychological themes, his idiosyncratic and poetic vision implied mysterious and often ominous forces in human experience.

In 1956 his work was included by Van Deren Coke in the exhibition *Creative Photography* at the University of Kentucky at Lexington; in 1957 he coexhibited with Coke at A Photographer's Gallery in New York. Meatyard's first one-person show was held in 1959 at Tulane University, New Orleans, and that same year a portfolio with an essay by Coke was featured in the winter edition of the photographic journal *Aperture*. From 1967 to 1970 he worked on a series of photographs to accompany Wendell Berry's *The Unforeseen Wilderness*, an essay on Kentucky's Red River Gorge, published in 1970. Diagnosed as having terminal cancer that year, Meatyard nevertheless continued to photograph. He began work on his last major project, *The Family Album of Lucybelle Crater*, in which he staged members of his family and friends with masks and props for a fictional family album, which was published posthumously in 1974.

László Moholy-Nagy

Born Bácsborsód, Hungary, 1895

Died Chicago, 1946

Portrait, 1945

László Moholy-Nagy studied law at the University of Budapest until he joined the Austro-Hungarian army during World War I. Wounded in 1915, he produced his first crayon drawings and watercolors during his convalescence. After leaving the army he returned to his law studies, which were near completion when he committed himself to art. In 1919, after the defeat of the Hungarian Soviet Republic, he moved to Vienna, where he joined the circle of other Hungarian refugees around the activist periodical *Ma*. In 1920 he moved to Berlin, where he became associated with the Dadaists Kurt Schwitters, Hanna Höch, and Raoul Hausmann. In 1922 he had his first exhibition of paintings, at the gallery Der Sturm. Also in that year he participated in the Congress of Constructivists and Dadaists in Weimar.

In collaboration with his wife Lucia, Moholy-Nagy began experiments with photography which included negative prints, photograms, photomontages, and photocollages. The photograms in particular demonstrate a concern with light, transparency, and abstract form that was equally essential to his paintings. In 1923 he joined the staff of the Bauhaus in Weimar, where he continued experiments with light and color in addition to working with typography and layout design. With Walter Gropius, in 1924–25, he edited and designed several volumes in the *Bauhausbücher* (Bauhaus Books) series, which included his own *Malerei Fotografie Film* (1925; published in translation as *Painting, Photography, Film*, 1969).

In 1928 Moholy-Nagy resigned from the Bauhaus and returned to Berlin, where he worked on exhibition and stage design and in film. The following year he published *Von Material zu Architektur* (published in translation as *The New Vision: From Material to Architecture*, 1930), which formalized his integrated vision and practice of all the arts. Also in 1929 he helped organize the Deutsche Werkbund exhibition *Film und Foto* held in Stuttgart. Including many of his own photographs, the exhibition summarized the "new vision" in photography, for which he was an active propagandist.

With the rise of Nazi Germany, Moholy-Nagy emigrated to Amsterdam in 1934, but settled in London in 1935. He came to Chicago in 1937, where he founded the New Bauhaus (re-formed as the Chicago School of Design in 1939, and renamed the Institute of Design in 1944). Moholy-Nagy's last book, *Vision in Motion* (1947), was published shortly after his death from leukemia.

Martin Munkacsi

Born Kolozsvár, Hungary (Cluj, Romania), 1896

Died New York City, 1963

Self-Portrait, 1935

At the age of sixteen Martin Munkacsi moved to Budapest to work as a writer-reporter in the newspaper business. In 1921 he began his photographic career as a self-trained sports photographer for the Budapest newspaper *Az Est*. By 1923 he was a recognized photojournalist known for pictures that dramatically captured movement.

In 1927 Munkacsi moved to Berlin to further his career. He received a three-year contract to work for Ullstein Press, which published his pictures in the *Berliner Illustrirte Zeitung* and other publications such as *Die Dame, Die Koralle*, and *Uhu*. From 1930 to 1933, while continuing his magazine work, he experimented with many of the innovative techniques of "new vision" photography, such as close-ups, oblique angles, and bold diagonal elements in order to emphasize formal composition. During this time he also developed the spontaneous, but highly controlled, snapshot style that became his trademark and revolutionized fashion photography in the 1930s.

While Munkacsi was on assignment in the United States in 1933, his pictures were seen by Carmel Snow, editor-in-chief at *Harper's Bazaar*, who recognized their potential and offered him an exclusive contract. The following year he settled in New York, where he worked for *Harper's Bazaar* until 1940. During this time he made innovative action photographs as fashion illustrations, thus ushering in a new era in that field. After a severe heart attack in 1943, he spent more time writing. *Fool's Apprentice*, a partially autobiographical novel, was published in 1945. From 1946 to 1963, though he was less active in fashion photography, he continued to accept assignments and also worked as a film cameraman and lighting designer.

Anne Noggle

Born Evanston,
Illinois, 1922

Self-Portrait, 1984

By the age of eighteen Anne Noggle had received her student pilot's license; at twenty-one she became a Women's Air Force Service Pilot, and during World War II she towed targets for aerial gunnery practice. After the war she taught flying; in 1947 she joined an air show, where she performed stunt flying, and also worked as a crop duster. In 1953 she returned to active duty in the Air Force. In 1957 she was transferred to Paris, where she became interested in art through off-duty visits to the Louvre and other European museums. Retired as a captain in 1959 because of disability, Noggle moved to the Southwest and entered the University of New Mexico in Albuquerque to study art history. She took her first photography course in 1965 and subsequently enrolled in the graduate photography program (Master of Arts, 1970) at that time directed by Van Deren Coke.

In the late 1960s, working with a 35-mm 140° Panon camera, she made portraits of middle-aged or elderly people in their environments. In 1969 she began to photograph at much closer range with a wide-angle lens, using as primary subjects her mother and her mother's friends. In 1975 (and again in 1978) she received a Na-

tional Endowment for the Arts Photographer's Fellowship and traveled across the United States to photograph older women. That year she produced the *Face Lift* series, a psychologically intensive self-examination of various stages of her own face-lift. This series marked a concern with self-portraiture that continues to the present. From 1976 to 1980 she returned to photographing friends and family while experimenting with combinations of long exposure, ambient light, and electronic flash. The *Silver Lining* images of 1978 are portraits of middle-aged and elderly couples.

In 1982 Noggle received a Guggenheim Fellowship to photograph people in Seattle and East Texas, out of which evolved the series *Seattle Faces* and *East Texas Faces*. While she continues to photograph middle-aged and older people, she also makes portraits from a video screen and stages—in order to photograph them—*tableaux vivants* that include herself or other people.

Noggle lives in Albuquerque, where she has been an Adjunct Professor of Art at the University of New Mexico since 1970.

Paul Outerbridge

Born New York City, 1896
Died Laguna Beach,
California, 1958

Self-Portrait, 1938

During his adolescence Paul Outerbridge experimented with stage design, theatrical lighting, and poster making. From 1915 to 1917 he studied anatomy, drawing, and aesthetics at the Art Students League in New York. Beginning in 1917 he served first in the British Royal Flying Corps (Canada) and then in the United States army, which provided him with his first photographic experience, documenting lumber-camp operations. In 1921 he studied photography at the Clarence H. White School of Photography in New York. His photographs at this time, small and carefully crafted, were design-oriented studies of simple still lifes. The publication of his photographs in *Vogue* in 1922 marked the beginning of his career as a freelance photographer, during which his work also appeared in *Harper's Bazaar* and *Vanity Fair*.

In 1925 Outerbridge moved to Paris, where he became a freelance photographer for Paris *Vogue*. He met Constantin Brancusi, Pablo Picasso, Francis Picabia, and Igor Stravinsky and became friends with such artists of the European avant-garde as Marcel Duchamp, Man Ray, George Hoyningen-Huene, and Berenice Abbott. In 1927, with the financial backing of Mason Siegal, a leading manufacturer of mannequins, he formed a highly publicized but short-lived photographic studio. His work at this time was an extension of his earlier New

York work, with still lifes composed of everyday objects such as milk bottles, lightbulbs, and dressing-table accessories. He also began an extensive and noted series of female nudes, sometimes partially costumed or posed with stage props. In 1928 he lived in Berlin, where he worked on motion pictures, then in London, where he worked as a set advisor to film director E. A. Dupont.

Outerbridge returned to New York City in 1929 and in 1930 set up a studio in Monsey, New York. There he perfected the three-color carbro technique, which he used during the 1930s for his photographs of nudes and commercial still lifes. Many of the latter appeared as covers for the magazine *House Beautiful*. In 1940 Random House published *Photographing in Color*, which Outerbridge designed as well as illustrated.

In 1943 Outerbridge moved to Hollywood, California, but unable to find work, he settled in Laguna Beach, where he opened a small portrait studio. Beginning in 1945 he traveled widely for Lois-Paul Originals, a women's fashion business he formed with his wife. From 1954 until his death, Outerbridge wrote "About Color," a column for *U. S. Camera*.

Roger Parry

Born Paris, 1905
Died Cognac, 1977

Self-Portrait, 1936

Roger Parry studied at the Ecole des Arts Décoratifs and the Ecole des Beaux-Arts, where he concentrated on painting. After his graduation from the Ecole des Beaux-Arts in 1925 he worked as a draftsman and window designer for the department store Au Printemps until 1928. That year he met Maurice Tabard, who introduced him to photography. Parry then assisted Tabard with advertising and illustration work. During 1929 Parry completed photographs to illustrate *Banalité*, a book of prose and poetry by Léon-Paul Fargue. One of the earliest photographically illustrated books in Surrealist literature, it was issued in 1930 by Librairie Gallimard (Nouvelle Revue Française), a publishing house with which Parry would be associated throughout his life. In making the images for the book, Parry, assisted by Fabian Loris, used such experimental techniques as photomontages, photograms, negative prints, and solariza-

tions. The subject matter was machines, scientific debris, and other fragments of technology imbued with a sense of the macabre.

In the early 1930s Tabard turned the directorship of his photographic studio in Paris, Deberny Peignot, over to Parry. From this time Parry's work appeared in such magazines as *Voilà, Vu, Les Semaines,* and in the annual *Photographie*. In 1931 he traveled to Africa, and in 1932 to Tahiti, to photograph. In 1932 his work was included in two exhibitions at the Julien Levy Gallery in New York City, a group show of Surrealist artists and another featuring modern European photographers.

During the forties Parry was a war photo-correspondent for Agence France Presse. He later became head of photography and art director for Gallimard, a position he held for the remainder of his career.

Robert Petschow

Born Kolberg, Germany, 1888
Died Haldensleben,
Germany, 1945

Portrait, n.d.

Following his graduation from gymnasium in 1907, Robert Petschow pursued the study of engineering in Danzig. During this period he became interested in the sport of ballooning. Fascinated by the dramatic vistas he observed as he floated high above the German terrain, he taught himself photography in order to record what he saw. Petschow's enthusiasm for ballooning soon induced him to relinquish his studies in engineering for a career in the German air batallion. In 1914 he was promoted to lieutenant and during World War I he served as a balloon observer in Poland, France, and Belgium.

Petschow's most active period as an aerial photographer began around 1920. Entirely self-financed, he launched extensive balloon expeditions across the German countryside during which he made thousands of aerial photographs, which he sold to aerial-photography agencies. During the 1920s he became an editor of *Die Luftfahrt*, an air-travel magazine, and a member of the Air Club and the Berlin Society for Air Travel. His aerial pictures appeared regularly in specialized journals devoted to air travel, as well as in widely distributed daily newspapers and weekly or monthly magazines.

Quite apart from their informational value, Petschow's pictures presented a radically new pictorial world that was embraced by "new vision" photographers and critics. The flattening of space caused by Petschow's elevated perspective and the camera's single eye transformed the familiar landscape into striking arrangements of abstract planes and patterns. The Deutsche Werkbund, which sponsored the historic exhibition *Film und Foto* in Stuttgart in 1929, selected fifteen of his photographs, and the book *Foto-Auge*, essentially a summary of the experimental photography in the exhibition, included two of his images. Eugen Diesel's *Das Land der Deutschen,* published in 1931, an important book for conveying the liberating possibilities of new and unusual camera perspectives, was illustrated with 481 photographs, predominantly by Petschow.

In 1930 Petschow became editor-in-chief of the daily newspaper *Der Westen,* where he remained until 1936, when he enlisted in the army as a captain of aerial weaponry. During World War II his extensive archive of some 30,000 negatives was lost.

John Pfahl

Born New York City, 1939

Portrait, 1984

One of John Pfahl's favorite childhood activities was making illusionistic scenery for homemade puppet shows. Later, as an undergraduate, he studied advertising design and graphic communication at Syracuse University, where he received a Bachelor of Fine Arts degree in 1961. From 1961 to 1963 he served in the United States army, after which he worked for an advertising photographer in Manhattan. For a short time he lived in Los Angeles, where he assisted an architectural photographer. Dissatisfied with this job, he returned to Syracuse University in 1966 to enter the then-new graduate program in color photography. He received a Master of Arts in Communications in 1968.

In the fall of 1968 Pfahl began teaching photography at the Rochester Institute of Technology. From 1969 to 1973 he produced a series of sculptures in which photographic imagery was screen-printed with iridescent, transparent inks onto plastic sheets that were then vacuum formed. In 1974 Pfahl began photographing fabricated elements in the landscape as scores for "new music" in collaboration with composer David Gibson.

Finding the works more successful as strictly visual representations of optical illusions that play with perspectival space, Pfahl embarked upon an extensive series in which he used the camera to make "straight" photographs of tape, string, foil, or other materials that he introduced into the landscape. A selection of these images was published as a portfolio in 1980 and as a book in 1981. Pfahl's series *Picture Windows*, of 1978–81, explored the notion of windows as frames for views, a commentary on the fixed frame of camera vision. During 1981–84 he produced *Power Places*, a series of photographs portraying nuclear power plants and other massive producers of energy in picturesque American landscapes.

In 1983 Pfahl left his teaching position at the Rochester Institute of Technology in order to devote all his time to photography. He now lives in Buffalo, New York, where his current project is devoted to photographing the Niagara River.

Arnulf Rainer

Born Baden
bei Vienna, 1929

Portrait, 1984

Arnulf Rainer knew by the age of fourteen that he wanted to be an artist. In 1947, after seeing a British Arts Council exhibit that included work by Francis Bacon and Henry Moore, he made his first spontaneous figure drawings and portraits. While studying architecture with little enthusiasm at the technical college at Villach from 1947 to 1949, he continued to paint and draw at night.

In 1950 Rainer was a founding member of the surrealist Hundsgruppe along with painters Ernst Fuchs, Anton Lehmden, Arik Brauer, Wolfgang Hollegha, and Josef Mikl. However, he soon broke with the fantastic style of that group and developed a new interest in micromorphologies and form destruction, in which a Gestalt approach to abstraction and gestural marks became more important than content. The idea of decomposition was central to the *Übermalungen* (Overpaintings), an extended body of work executed between 1954 and 1965 in which Rainer obliterated previously painted canvases.

Beginning in 1953 Rainer became concerned with mysticism and the concept of piety, which inform his *Crucifixion* series (exhibited in 1956). From 1953 to 1959 he lived in seclusion in Gainfarn (Lower Austria), during

which time he continued the *Übermalungen* series and produced the geometric *Proportion Studies*, collages with colored paper and plastic objects. From 1964 to 1968 he experimented with drawings and paintings generated while under the influence of hallucinogenic drugs.

In 1968 Rainer began the series *Facefarces*, photographs of himself grimacing before the camera. One year later he began overpainting these photographs with calligraphic marks that amplified or altered the appearance of the figure. Work with overpainted photographs extended to *Bodyposes*, images that include his entire body posed in imitation of the body gestures of insane and catatonic persons. In the early 1970s he began making videotapes in collaboration with conceptual and performance artist Dieter Roth. Among his most recent work, completed in 1982, is the series *Hiroshima*, which features drawings on photographs of the destroyed city.

Rainer works in painting, photography, and video in Vienna, Vornbach near Passau, and Bavaria.

181

Alexander Rodchenko

Born Saint Petersburg, 1891
Died Moscow, 1956

Portrait, 1921

After studies in drawing and painting at the Kazan Art School from 1910 to 1914, and later at the Stroganov Institute in Moscow, Alexander Rodchenko's life and art centered around the social and aesthetic renewal heralded by Constructivism. In Moscow in early 1916, Rodchenko met Vladimir Tatlin, who invited him to exhibit with Kasimir Malevitch, Liubov Popova, Lev Bruni, and himself, among others, in an exhibition that became known as *The Store*. Beginning in 1918 Rodchenko worked in various capacities at IZO NKP (Visual Arts Department of the People's Commissariat for Enlightenment) organized by the avant-garde; from 1920 to 1930 he was professor at Vkhutemas/Vkhutein (Higher State Art-Technical Studios/Institute), Moscow.

Rodchenko's early paintings were Suprematist and Constructivist studies of shape, form, and color. From 1918 to 1921 he also worked on three-dimensional constructions in which he emphasized similar concerns: open form, planar shapes, and the play of light and shadow. In 1920 he became a member of Inkhuk (Institute of Artistic Culture), whose purpose it was to integrate art into everyday life. Throughout the 1920s he worked cooperatively with Vladimir Mayakovski on the development of book and advertising design, including illustrations for Mayakovski's *Pro eto: Ei i mne (About*

That: To Her and Me) of 1923. In 1922 he collaborated with filmmaker Dziga Vertov, who became an important influence on his photographic vision. From 1923 to 1928 he was associated with the Constructivist magazines *Lef* and *Novyi Lef*, which published his articles and photographs.

In the early 1920s Rodchenko began making photographs to use as design elements in photomontages. Aware of avant-garde developments in photography at the Bauhaus in Germany, he experimented broadly with the medium to produce double exposures, close-ups, negative prints, and bird's- and worm's-eye points of view with the camera. Best known for his photoreportage, in which he used "new vision" perspectives, his work was published in almost every Moscow periodical by 1927–28. In 1930 he joined the October group which followed the ideas of *Lef* and Constructivism, but was expelled a year later for his use of "formalism."

In 1931–32 Rodchenko turned to producing photographically illustrated books, for which his most frequent subject matter was sports, the circus, and festival celebrations. In the mid-1930s he returned to studio painting. During his last years, Rodchenko was active as an editor, graphic artist, and organizer of photography exhibitions.

Franz Roh

Born Apolda,
Thuringia, Germany, 1890
Died Munich, 1965

Portrait, ca. 1926/1980

After attending school in Weimar, Franz Roh studied literature and art history at the universities of Leipzig, Berlin, Basel, and Munich; in 1918 he completed his doctoral thesis on seventeenth-century Dutch painting. He then became an assistant to the renowned art historian Heinrich Wölfflin; in 1919 he began to write art criticism for *Cicerone* and *Das Kunstblatt*. In 1925 Roh published his first book, *Nachexpressionismus—Magischer Realismus: Probleme der neuesten Europäischen Malerei* (After Expressionism—Magic Realism: Problems in Recent European Painting).

Encouraged by the energies of his friend László Moholy-Nagy, Roh began working with photography in 1927. While limited to a period of only a few years, 1927–33, Roh's experiments are marked by the innovative spirit that characterizes "new vision" photography. Committed to transforming the conventional photograph into something dynamic, Roh tried his hand at myriad techniques and approaches: photograms; negative prints; bird's-eye views that emphasize form, light, shadow, and abstract patterning; extreme angle shots that convey a sense of speed and energy; and sand-

wiched negatives, in which the nude female figure was frequently superimposed over natural landscapes or urban settings. With graphic designer Jan Tschichold, Roh coedited *Foto-Auge*, a book that commemorated the historic *Film und Foto* exhibition held in Stuttgart in 1929. With an essay by Roh and seventy-six reproductions, the book was a comprehensive summary of the experimental photography of the time.

In 1933 Roh was arrested by the Nazis and held prisoner for three months. During the Third Reich he did not publish, and he ceased photography. He returned, instead, to the making of paper collages from old wood engravings as he had done during the 1920s.

After World War II Roh became a teacher of art history and resumed his writing, editing, and art criticism. In 1951 he was appointed the first president of the German section of AICA (International Association of Art Critics), and in 1954 he founded the Gesellschaft der Freunde junger Kunst (Society of the Friends of Modern Art).

Theodore Roszak

Born Posen, Prussia
(Poznan, Poland), 1907
Died New York City, 1981

Self-Portrait, ca. 1931

Theodore Roszak's family emigrated to Chicago, Illinois, in 1909. In 1922, while still in high school, Roszak enrolled in evening courses at the school of the Art Institute of Chicago, where he became a full-time student after his graduation. In 1926 he moved to New York City to study at the National Academy of Design and to work privately with the painter George Luks. He also attended classes in logic and philosophy at Columbia University. From 1927 to 1929 he was back in Chicago, pursuing graduate studies at the Art Institute. His painting at this time was influenced by the old masters and early-twentieth-century American Realist painters such as Luks and George Bellows.

In 1929 he received a Raymond Fellowship to travel in Europe for two years, which he spent primarily in Czechoslovakia, where he set up a studio in Prague for nine months. During his two-year stay he became acquainted with the concepts of Constructivism, which were reinforced by László Moholy-Nagy's book *The New Vision*, which Roszak purchased while in Europe.

Roszak returned to New York in 1931, to settle permanently. Though his paintings of this time reflect the concerns of Cubism and Surrealism, he eventually be-

came one of the first Americans to utilize Constructivist aesthetics. He experimented as early as 1932 with wall reliefs and freestanding constructions, and between 1936 and 1945 these forms became his primary concern; in them he produced finely crafted, geometrized works in metal, wood, and plastic. From 1937 to 1941 he explored geometry and light by making hundreds of photograms, a technique he used as a teaching tool from 1938 to 1940 at the experimental workshop at the Design Laboratory in New York City, which followed the principles of the Bauhaus and of Moholy-Nagy.

During World War II Roszak taught aircraft mechanics and built airplanes at the Brewster Aircraft Corporation in New Jersey. By the late 1940s he was making welded metal sculptures in which he rejected geometry for a more organic, expressionistic form which reflected his earlier concern with Surrealism and his interest in the then-emerging Abstract Expressionism. A teacher as well as an artist, Roszak taught at Sarah Lawrence College, Bronxville, New York, from 1940 to 1956, and at Columbia University, New York, from 1970 to 1972.

Lucas Samaras

*Born Kastoria,
Greece, 1936*

Portrait, 1978

Lucas Samaras's family emigrated to the United States in 1948, settling in West New York, New Jersey. At Rutgers University in New Brunswick from 1955 to 1959, Samaras participated in the earliest Happenings, staged by Allan Kaprow. In 1959 at the Reuben Gallery in New York, he acted in the historic Happenings staged by Pop artists Claes Oldenburg and Robert Whitman.

By 1963 Samaras was incorporating photographic self-portraits in most of his box sculptures, which ranged from the beautifully decorated to the grotesque and implicitly violent. In 1964 he moved to New York City and began his extensive series of sculptures called *Transformations*, in which he altered or decorated everyday objects, such as chairs and dinnerware. In 1969 he wrote, directed, and acted in the film *Self*. That same year he purchased a Polaroid camera and began his *Autopolaroids*, an extensive series of self-portraits that culminated in 1971 in the publication of *Samaras Album: Autobiog-*

raphy, Autointerview, Autopolaroids. In his *Photo-Transformations* series, begun in 1973, he was among the first to experiment with altering Polaroid SX-70 images by pressing into them while the emulsion was still soft, thereby producing distorted effects due to the mixing of dyes. *Lucas Samaras: Photo-Transformations* was published in 1975.

Along with significant work in other media, such as the large-scale fabric pieces called *Reconstructions* (begun in 1976), Samaras continued photographic portrait work, including a series titled *Sittings 8x10* (1978–80), in which he utilized large-format Polaroid materials, and another, begun in 1983, entitled *Panoramas*, in which he cut and reassembled Polaroid portraits and still lifes to create horizontally extended life-size images.

Samaras lives and works in New York City.

August Sander

*Born Herdorf, Germany, 1876
Died Cologne, 1964*

Portrait, ca. 1960

August Sander grew up in a coal-mining family but became interested in photography at the age of sixteen when he began making portraits with a 13 x 18-cm camera he received as a present. While fulfilling his military service in Trier between 1896 and 1898 he assisted at the Jung photographic studio in his free time, taking pictures of soldiers. After his discharge he became an itinerant photographer, working in Magdeburg, Berlin, Halle, Leipzig, and Dresden, where (1901–2) he studied portrait painting at the Academy of Painting. In 1902 he and a partner opened a studio in Linz, Austria, of which he became the sole proprietor in 1904. An exhibitor in numerous expositions, in 1904 he received the Gold Medal and Cross of Honor at the International Exhibition at the Palais des Beaux-Arts in Paris.

In 1910 Sander moved to Cologne and set up a studio in a suburb. While making industrial and architectural photographs to earn his living, he began photographing the peasants in his native Siegerland and adjoining Westerwald, near Cologne. From this he began to evolve his life masterwork, the project "Man of the Twentieth Century," which was to be a complete catalogue of types of German people. During World War I he served in the army, but continued to photograph. At the war's end he returned to his studio, where he made architectural, advertising, and industrial photographs, as well as commer-

cial portraits. Through his involvement in the artists' group Kölner Progressive, Sander was aware of developments in modern art, such as the Neue Sachlichkeit movement, which led him to a further clarification of his "Man of the Twentieth Century" series.

Throughout the 1920s he portrayed people of every stratum of society in pictures that were direct, unretouched, and printed on glossy paper to bring out maximum detail. In 1929 the book *Antlitz der Zeit* (Face of Our Time) was published in Munich, the first volume in a projected multivolume set of Sander's "Man of the Twentieth Century" series. In 1934, with the increasing power of Hitler, the Nazis confiscated the book and destroyed the plates. This prompted Sander to turn his attention to landscape and nature studies, which remained an ongoing interest.

In 1944 Sander's apartment, studio, and many negatives were destroyed during the bombing of Cologne. He relocated at Kuchhausen, where he photographed people and the landscape and worked on special projects, such as the series *Cologne as It Was*, a collection of architectural photographs made before World War II.

Sander suffered a stroke in 1963 and died the following year.

Sandra Semchuk

*Born Meadow Lake,
Saskatchewan, 1948*

Portrait, 1984

Sandra Semchuk began painting western cowboy cartoons on store windows along the main street of her hometown at the age of seven. She attended the University of Saskatchewan in Saskatoon, from which she received a Bachelor of Fine Arts degree in studio art in 1970. While working as a film editor for educational film projects in 1971, Semchuk helped found the cooperative Photographer's Gallery in Saskatoon.

In 1972, influenced by Dorothea Lange's photographs, Semchuk turned from painting and reliefs to photography with an extensive documentary of the people of Meadow Lake. The year 1975 marked the beginning of her work with self-portraiture and autobiography. In an extensive series of black-and-white photographs completed in 1981, she recorded herself, her family, and close friends in a straightforward manner, either tightly

framed against neutral backgrounds or in panoramic landscapes.

In 1982–83 Semchuk studied at the University of New Mexico, Albuquerque (Master of Arts, 1983), where she began working in color. At this point her work changed from recording observations of self to creating visual analogues to the experience of self. The sequences present the viewer with the world as a stream of consciousness visualized from the photographer's point of view. During 1984–85 she worked collaboratively with writer Stephen Cummings on cooperative self-portrait sequences that are concerned with time and motion through performance.

Semchuk lives and works in London, Ontario.

Aaron Siskind

Born New York City, 1903

Portrait, ca. 1956

In 1926 Aaron Siskind received a Bachelor of Social Science degree from the City College of New York, where his primary interests were literature and music. He went on to teach English in the New York City public schools until his resignation in 1949. Siskind first used a camera in 1930, but it was not until 1932 that he learned to process and print. Shortly afterward he became active in the Film and Photo League of New York, an association interested in photography as a tool for social documentation. During the 1930s Siskind produced documentary projects, among them *Tabernacle City, Bucks County, Harlem Document*, and *The Most Crowded Block in the World*.

Eventually Siskind abandoned social documentary concerns for an increasingly abstract and personal style, an aesthetic that brought him into close contact with the emergence of Abstract Expressionism. He became friends with the Abstract Expressionist painter Franz Kline and others in his circle, and he had his first major showing of photographs (1947) at New York's Egan Gallery, an important center in promoting the work of the Abstract Expressionists.

In the early 1950s Siskind began the series *Pleasures and Terrors of Levitation*, photographs of youths caught in mid-dive against a white sky. In Rome and Mexico during the 1960s he continued to explore the subject matter that has come to characterize his work: isolated objects, peeling paint, decaying signs, and weathered stone photographed not for their prosaic content, but for their symbolic and formal values.

Siskind has been an influential teacher. He first taught photography at Trenton Junior College, New Jersey, from 1949 to 1950, then, during the summer of 1951, at Black Mountain College, North Carolina, where he worked with Harry Callahan. At Callahan's invitation, Siskind then went to teach at the Institute of Design in Chicago in the fall of 1951. After two decades Siskind left the Institute and again joined Callahan, this time on the faculty of the Rhode Island School of Design, Providence, where he taught until his retirement in 1976.

Siskind lives and works in Providence.

Frederick Sommer

*Born Angri,
Italy, 1905*

Portrait, 1980

Frederick Sommer's family moved from Italy to São Paolo, Brazil, in 1913, then three years later to Rio de Janeiro. The son of a landscape architect and horticulturalist, Sommer expressed an enthusiasm for design applied to the natural environment. After completing several private landscape commissions in 1923, he traveled to the United States where he became the assistant to Edward Gordon Davis, head of the Department of Landscape Architecture at Cornell University, in Ithaca, New York. While working for Davis, Sommer attended Cornell, from which he received a Master of Arts degree in landscape architecture in 1927. He eventually returned to Brazil, where he and his father became partners in a landscape architecture firm. In 1930, having contracted tuberculosis, Sommer left Brazil for Arosa, Switzerland, for a period of convalescence. Although he had taken photographs for architectural study, it was here that he became seriously interested in photography.

In 1934 Sommer spent six months in Los Angeles; in 1935 he moved to Prescott, Arizona. Later that same year he traveled to New York, where he met Alfred Stieglitz at his American Place gallery. The following year Sommer met Edward Weston in Los Angeles and as a result became interested in the 8″ x 10″ view camera. In 1939 he began taking large-format, finely detailed "ho-

rizon-less" pictures of the Arizona landscape, as well as grotesque still lifes of chicken entrails. Both sets of images were of interest to such Surrealist artists as Yves Tanguy and Max Ernst, with whom Sommer formed a mutually influential friendship in 1941.

In 1946 Sommer had his first one-person show of photographs, at the Santa Barbara Museum of Art. A 1952 exhibition, *Diogenes with a Camera* at the Museum of Modern Art, New York, included photographs that explored literary and mystical themes through subject matter assembled from found objects and antique printed material. In the mid-fifties he began an extended exploration of cameraless photography by printing handmade negatives created by painting on cellophane or allowing smoke to accumulate on cellophane or glass. In 1962 Sommer made his first cut-paper images, photographs of cut paper that had been strategically lit to emphasize a broad range of tone, linear pattern, and volume. In 1972 he published, in collaboration with Stephen Aldrich, *The Poetic Logic of Art and Aesthetics*. In 1974 Sommer was the recipient of a Guggenheim Fellowship.

Sommer lives and works in Prescott, Arizona.

Ralph Steiner

*Born Cleveland, 1899
Died Hanover,
New Hampshire, 1986*

Portrait, 1981

Ralph Steiner decided to become a photographer while studying chemical engineering at Dartmouth College, Hanover, New Hampshire, from which he graduated in 1921. In 1921–22 he attended the Clarence H. White School of Photography in New York City, where he was a classmate of Paul Outerbridge. While working at a photogravure plant in 1922–23, he began a career as a freelance photographer doing magazine and advertising work. After meeting Paul Strand in 1926 or 1927, Steiner was encouraged to perfect his technique and thus spent a summer at Yaddo, the artists' and writers' colony in Saratoga Springs, New York. He devoted himself there to improving his craftsmanship and to exploring the use of a more sharply focused lens. While at Yaddo he became interested in making experimental films. Often cited as the second earliest American art film (after *Mannahatta* by Paul Strand and Charles Sheeler), Steiner's work H_2O, an abstract study of patterns of light and shadow on water, was awarded first prize for film by *Photoplay* in 1929.

During the 1930s Steiner worked extensively as a producer and director on the films *Surf and Seaweed, Mechanical Principles* (both 1931), and *Pie in the Sky* (1934) and as cameraman, along with Paul Strand, on Pare

Lorentz's *The Plow that Broke the Plains* (1935). In collaboration with Willard Van Dyke, one of the founding members of Group f.64, and composer Aaron Copeland, Steiner produced *The City*, which was shown at the 1939 New York World's Fair. In the late 1930s he worked in advertising and public relations and was a picture editor of the newspaper *PM*. His interest in film led him in the 1940s to Hollywood, where he worked first at MGM, then at RKO studios. On his return to New York he received photographic assignments from Walker Evans for *Fortune* magazine.

By the 1960s Steiner was able to devote more of his energies to his personal work. In rural Vermont, where he moved in 1963, and on Monhegan Island, Maine, where he had a summer home, Steiner began making small, square-format photographs of rocks, clouds, and trees in the straight tradition of Paul Strand. In 1967 he began making a series of films under the general title *The Joy of Seeing*, which includes *Motion on a Quiet Island, A Look at Laundry*, and *Light*.

Steiner's autobiography, *A Point of View*, was published in 1978.

Grete Stern

Born Elberfeld (Wuppertal), Germany, 1904

Portrait, 1980

From 1924 to 1927 Grete Stern studied graphic arts at the Kunstgewerbeschule in Stuttgart. Deeply impressed by the work of the American photographers Edward Weston and Paul Outerbridge, which she saw exhibited during a visit to Berlin in 1927, Stern decided to study photography. From 1927 to 1930 she studied with the photographer Walter Peterhans, both as a private student in Berlin and as a pupil at the Bauhaus in Dessau, where Peterhans had been appointed a professor in 1929. It was through Peterhans that Stern met Ellen Rosenberg Auerbach, who had come to study privately with the photographer in 1928.

Upon the sale of Peterhans's Berlin studio to Stern in 1930, she and Auerbach launched Studio Ringl & Pit, one of the most innovative photographic establishments in Germany during the Weimar Republic. Named after the two childhood nicknames of Stern and Auerbach, respectively, the studio concentrated on portraiture, still life, advertising photography, and magazine illustration. Drawn toward straightforward portraits, such as those of old master painters Albrecht Dürer or Hans Holbein, as well as the contemporary work of Edward Weston, Stern used the sharpness of the camera lens to create images in the style of "new vision" photography, which in their severity revealed subtle personality characteristics of the sitter. In their advertising photography, Stern and Auerbach developed a distinctive style; while employing modernist elements of "new vision" photography, such as pristinely rendered forms and textures, they often subtly introduced critical humor and Surrealist motifs. Their work was published in widely distributed periodicals, such as *Gebrauchsgraphik* (Commercial Art) and *Cahiers d'Art*, as well as in smaller magazines, such as *Neue Frauenkleidung und Frauenkultur* (New Women's Clothing and Women's Culture).

With Hitler's takeover of Germany in 1933, Studio Ringl & Pit closed and Stern emigrated to London, where she worked as a freelance photographer. She made portraits and advertising photographs until 1936, when she moved to Buenos Aires after having married Horacio Coppola, also a photographer who had been a private student of Peterhans. For fifteen years she worked as a photographer for the Museo Nacional de Bellas Artes and also as a freelance photographer for builders, architects, artists, and art galleries. Her other photography done in Argentina includes extensive photographic documentation of the Indians of Gran Chaco as well as her ongoing work in portraiture.

Stern lives and works in Buenos Aires.

Paul Strand

Born New York City, 1890
Died Orgeval, France, 1976

Portrait, 1917

While a student at the Ethical Culture High School in New York (1904–9), Paul Strand studied photography with Lewis Hine. Through Hine he met Alfred Stieglitz at his gallery "291." Strand eventually decided to become a photographer, and through Stieglitz and his gallery he became aware of the current developments in modern art. Experimenting with the principles of Cubism, by the mid-teens he produced a number of semiabstract photographs—close-ups of pottery bowls, chair backs, and patterns of shadows on a front porch. These images formed part of a folio of work that Strand exhibited in his first one-person show at gallery "291" in 1916, which Stieglitz published in *Camera Work* in October of that year. In June 1917 Stieglitz devoted the entire final issue of *Camera Work* to Strand's photographs.

From 1918 to 1919 Strand served as an X-ray technician with the U.S. Army Medical Corps. Following his discharge in 1919, he traveled to Nova Scotia where he made his first landscapes and semiabstract, close-up studies of rock formations. In 1920 he completed in collaboration with Charles Sheeler the film *Mannahatta*, an avant-garde experiment with filmic abstraction that mixed the energy and movement of New York City with fragments of Walt Whitman's poetry. Beginning in 1922, he continued his interest in film as a freelance cinematographer.

Interest in Mexico's sociopolitical reforms led Strand to that country in 1932. Working as a cinematographer for the Mexican government's Department of Fine Arts, he produced the film *Redes* (released in the United States as *The Wave*) in 1934–35. He returned to the United States in 1935 and became cameraman along with Ralph Steiner and Leo Hurwitz on Pare Lorentz's documentary film *The Plow that Broke the Plains*, made for the United States government in 1936.

In 1946–47 Strand collaborated with Nancy Newhall in providing photographs to accompany her text in the book *Time in New England* (published 1950). In 1950, disenchanted with the political climate in the United States, Strand moved to Orgeval, France.

In the 1950s and 1960s he traveled throughout France, Italy, Egypt, and Ghana, making photographs to be reproduced in books, such as *La France de profil* with text by Claude Roy (1952); *Un Paese* with text by Cesare Zavattini (1955); and *Tir a' Mhurain, Outer Hebrides* with text by Basil Davidson (1962)

Studio Ringl & Pit

See Ellen Rosenberg Auerbach *and* Grete Stern

Tato

Born Bologna, 1896
Died Rome, 1974

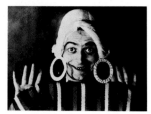

Self-Portrait, 1923

Prior to joining the army and leaving for the front in 1915, Tato (Guglielmo Sansoni) had attended the military academy in Parma. Self-taught as an artist, his first published works (1917) were drawings of the war. In 1919 he was sent to Novaro, where he completed his military service and made his first contacts with Futurism. Upon his discharge and return to Bologna he became increasingly involved with the second-generation Futurist artists who emerged in Fascist Italy following World War I. It was at this time that he adopted his pseudonym.

While initially a painter, Tato became a photographer, expanding upon the Futurist photography that Anton Giulio Bragaglia had initiated earlier and termed "photodynamism" in his manifesto "Futurist Photodynamism 1911." By 1930 Tato had become the leading exemplar and theorist of Futurist photography. In addition to organizing and participating in exhibitions of Futurist photography, he wrote the text "La Fotografia nell' avvenire" (The Photography of the Future) published in the December 1930 issue of *Oggi e domani*; with F. T. Marinetti, with whom he had been friends since the early 1920s, he wrote "Manifesto della Fotografia Futurista," written in April 1930 and published in the January 1931 issue of *Il Futurismo*.

In his photography, which dates primarily from the late twenties and thirties, Tato pursued many of the approaches that defined the experimental photography made in France and Germany during the same period: multiple exposures, photocollage, photomontage, and photoplastics. Sympathetic to Bragaglia's use of photography to render more than mere likeness, Tato sought the psychological, the emotional, and the symbolic in his many multiple-image portraits. Symbolic image-making was also at the heart of his "camuffamento di oggetti" (disguising of objects), a still-life genre he pioneered, in which arrangements of found objects as well as those fashioned by the artist were used to create surreal and absurd visual metaphors, ranging from magical allusion to critical social commentary.

Like the other Futurist artists of the period who followed Marinetti's lead in directing art toward the support of Fascism, Tato made politically oriented photocollages for *La Stirpe* (Race), a nationalistic review of art and politics. Also nationalistic were Tato's photoplastics, in which photography was incorporated with collage, paint, and plastic elements fabricated from wood, metal, and linoleum forming large bas-relief panels. Photographic as well as sculpted images of airplanes juxtaposed with aerial views of Italy made reference to the strength and modernity of Mussolini's Fascist regime.

Val Telberg

Born Moscow, 1910

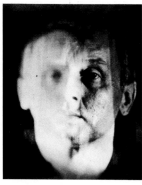

Self-Portrait, ca. 1947

From 1919 to 1927 the family of Val Telberg (Vladimir Telberg-von-Teleheim) lived in China, Japan, and Korea, where Telberg attended British, French, Japanese, and American schools. In 1928 he received a scholarship to attend Wittenberg College in Springfield, Ohio, where he received the equivalent of a Bachelor of Science degree in chemistry in 1932. He returned to China to work in a variety of business ventures, such as book publishing, editing a bilingual magazine, announcing for a radio station in three languages, and selling pharmaceuticals. After the invasion of China by Japan in 1938, he returned to the United States to live in New York.

Disappointed at not being able to enlist in the U. S. army due to physical reasons, he moved in 1941 to a secluded farm in New Jersey, where he spent an entire year painting. In 1942 he began taking painting classes at the Art Students League in New York, where he was exposed to Surrealism and experimental filmmaking. In order to paint during the day, Telberg held a variety of odd jobs, among them the rapid developing and printing of pictures of nightclub patrons. In 1944 he went to Florida, where he continued to work in nightclubs, and then to Lincoln Park, in Fall River, Massachusetts, where he operated a "mugging" concession, where people were photographed with painted cutout props in the likeness of celebrities.

After this experience Telberg returned to New York where he immersed himself in photography. He bought his first enlarger in 1945 and began to compose sandwiched negatives on a light table before printing them. In 1949 he moved to Europe where, in 1951, he experimented with 16-mm film montage at Oxford University and illustrated Anais Nin's *House of Incest*. In 1952 he returned to New York.

Telberg's work with scroll-like, large-scale, multiple-image photographs began in 1966. Two years later he moved to Sag Harbor, Long Island, where, for nearly a decade, he pursued non-objective cement sculpture and avant-garde multimedia productions with his wife, the dancer Lelia Katayen.

Telberg lives and works in Sag Harbor.

Raoul Ubac

Born Malmédy, Belgium, 1910
Died Dieudonne (Oise), France, 1985

Portrait, 1964

Interested in art, particularly drawing, since his youth, Raoul Ubac was eager to visit Paris. In 1928 he finally made his first trip there, where he met the painter Otto Freundlich and the poet Jean Gacon, who introduced him to artist groups in Montparnasse. Ubac returned to his hometown, where his reading of André Breton's first Surrealist Manifesto was, in his words, "a revelation and a calling." He subsequently found his way back to France, where he became closely associated with the Surrealists.

Ubac's early paintings, based on dream imagery, were influenced by the work of Giorgio de Chirico, Salvador Dali, and his countryman René Magritte. Through his association with Man Ray, Ubac made his first photographs in 1933, during a trip to Hvar, an island in the Adriatic Sea, where he depicted groups of stones whose forms resembled the figural references in his drawings.

From the mid-thirties to the early forties Ubac conducted photographic experiments with solarization, *brûlage* (a technique that involves melting the photographic emulsion), and photographic bas-relief made from coupling positive and/or negative transparencies, by which his works gained a sense of dimension. In 1934, under the pen name of Raoul Michelet, Ubac published a small book of poems and photographs with Camille Bryen entitled *Actuation poétique*. In the late thirties many of Ubac's images were published in the Surrealist magazine *Minotaure*. In 1940, with the German invasion of France, Ubac took refuge in Carcassonne in the south of France, where he participated in the Main à Plume group and continued to work with writers and poets. Six of his photographs illustrated Jean Lescure's book *L'Exercise de la pureté* published in Paris in 1942.

Distanced from Surrealism, which had dissipated during the war, Ubac abandoned photography by the mid-forties to return to drawing and painting in gouache and oils. He began carving in relief in slate in 1946 and by 1947 developed an abstract style in painting characterized by the *tachisme* of the School of Paris. In his painting of more recent years, Ubac concentrated on two major themes—landscape and the human figure.

Jerry N. Uelsmann

Born Detroit, 1934

Portrait, 1982

Encouraged by his father, Jerry N. Uelsmann became interested in photography in high school at the age of fourteen. He pursued his study of photography at the Rochester Institute of Technology, where he was influenced by Ralph Hattersley and Minor White. After receiving his Bachelor of Fine Arts degree in 1957, he attended graduate school at Indiana University at Bloomington, first in the Audio-Visual Communications Department, then in the Art Department. There Uelsmann studied with Henry Holmes Smith, whom he considers a primary influence on the development of his work. He received his Master of Fine Arts degree in 1960 and became, at the behest of Van Deren Coke, an instructor in the Department of Art, University of Florida, Gainesville. Appointed Professor of Art at this institution in 1969 and Graduate Research Professor in 1974, he continues to teach there.

By 1963 multiple printing—the technique of combining several negatives to make one print—was an integral part of Uelsmann's work, though he had produced multiple imagery as early as 1959. His photographs of the 1960s drew upon Surrealist sources with figures printed in illogical, sometimes negative or solarized landscapes and architecture, and objects juxtaposed to emphasize their symbolic content. In 1967 he received a Guggenheim Fellowship to further his exploration of multiple printing techniques.

Since 1967 Uelsmann has lectured and demonstrated his technique throughout the United States and Europe. During the early 1970s he experimented with color in his printing techniques and continued exploring dreamlike subconscious imagery that is spatially ambiguous and distorted in scale. In the later 1970s and early 1980s he focused more on the illusion of projective geometry superimposed on or in juxtaposition with images of nature.

Uelsmann lives and works in Gainesville.

Umbo

Born Düsseldorf, 1902
Died Hannover, 1980

Self-Portrait, ca. 1930/1980

After graduating from secondary school, Umbo (Otto Umbehr) worked as a coal miner, a potter, and an actor with a traveling theater group. He then enrolled at the Bauhaus, where from 1921 to 1923 he studied under Paul Klee, Vasily Kandinsky, Johannes Itten, Oskar Schlemmer, and Walter Gropius. In 1923 he moved to Berlin and worked as a house painter, a clown, and a designer of film posters, and also as a camera assistant to Walter Ruttmann on the documentary film *Berlin, Die Sinfonie einer Grossstadt* (Berlin, Symphony of a Great City), completed in 1927.

In 1926, with the help of Paul Citroën, a former colleague at the Bauhaus and *photomonteur*, Umbo opened a portrait studio, which became the basis for his pioneering work in photojournalism, a burgeoning field in Germany during the late 1920s and early 1930s. In 1928 Umbo met Simon Guttmann who that year founded Dephot (Deutsche Photodienst), the first cooperative photojournalist agency. Felix H. Man supervised the photojournalists, while Umbo was put in charge of the studio, in addition to being responsible for photoreportage and writing about theater, film, and dance. His photographs, consistent with avant-garde innovations in form and composition, appeared in such magazines as the *Berliner Illustrirte Zeitung, the Münchner Illustrierte Presse, Die Dame,* and *Die Koralle*. From the late 1920s on, his studio work included experiments with photomontage, multiple exposure, and X-ray film. In 1929 his photographs were included in the *Film und Foto* exhibition in Stuttgart.

With the Nazi takeover of the press in 1933, Dephot came to an end. However, Umbo continued to work in Berlin as a freelance photographer, receiving assignments to photograph in North Africa in 1941 and in Italy in 1942. From 1943 to 1945 he served in the German army, during which time his studio and all his prints and negatives were destroyed. After the war he moved to Hannover, where he continued his career as a freelance photographer.

Umbo also taught photography, first at a government vocational school for the handicapped in Bad Pyrmont from 1957 to 1964, then at an arts-and-crafts school in Hildesheim from 1965 to 1974.

Edward Weston

Born Highland Park, Illinois, 1886
Died Carmel, California, 1958

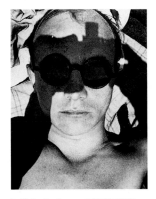

Portrait, ca. 1920s

At the age of twenty Edward Weston left Chicago for California, where he worked as a door-to-door portrait photographer. Two years later he returned to Chicago and attended (1908–11) the Illinois College of Photography in Effingham. He then settled in California, where he opened a portrait studio in Tropico (now Glendale). There, throughout the teens, he produced work for which he enjoyed both commercial and artistic success in his use of Oriental design motifs and soft-focus effects in the Pictorialist mode.

By 1920, however, he began experimenting with a hard-edged style involving dramatic natural lighting, formal clarity of picture organization, and a concern with abstract patterns. Weston's experiments led to his sharply focused, finely detailed industrial photographs of the Armco Steel Plant made during a visit to Middletown, Ohio, in 1922, a body of imagery that marked an important turning point in his career. From Ohio, Weston traveled to New York, where he met Alfred Stieglitz, Paul Strand, and Charles Sheeler, whose pure, unmanipulated "straight" photographs reassured Weston's confidence in his new direction.

From 1923 to 1926 Weston lived in Mexico, where he became an integral part of the Mexican Renaissance artists' community. There he abandoned the pictorialist aesthetic altogether and consolidated his earlier sharp-focus experiments into his mature style. His work from this period consisted primarily of close-up studies of everyday objects, natural forms, and unposed portraits in direct sunlight.

Returning to Los Angeles late in 1926, Weston continued to explore abstract form through extreme close-up views of shells, vegetables, and nudes. After briefly operating a studio in San Francisco with his son Brett in 1928, he settled in 1929 in Carmel, California, where he again opened a portrait studio with Brett and began photographing at Point Lobos. The extent to which Weston was then identified with modern straight photography is evident from the fact that his work was selected for the *Film und Foto* exhibition in Stuttgart in 1929.

In 1932 Weston collaborated in the formation of Group f.64, which confirmed his aesthetic of lenticular clarity. In 1937 he was awarded the first Guggenheim Fellowship in photography, by means of which he photographed in the western and southwestern United States, a project that culminated in 1940 in the book *California and the West*, with text by Charis Wilson. That same year he traveled across the United States to make photographs for a special edition of Walt Whitman's *Leaves of Grass*, which was published in 1942.

Due to the onset of Parkinson's disease, Weston made his last photographs, which were of Point Lobos, in 1948.

Minor White

Born Minneapolis, 1908
Died Boston, 1976

Portrait, 1975

Minor White became interested in photography while still a youngster. Following graduation from the University of Minnesota in 1933, with a major in botany and a minor in English, he went to Portland, Oregon, where he worked as a hotel clerk and was active in the Oregon Camera Club. In 1939 he was employed by the Works Project Administration, for which he photographed the Portland waterfront. In 1940–41 he taught photography at La Grande Art Center in eastern Oregon and photographed in the Grande Ronde–Wallowa Mountain area.

From 1942 to 1945 White served in the U. S. Army Intelligence Corps. After his discharge he went to New York, where he met Beaumont Newhall, Director of the Department of Photography at the Museum of Modern Art, and studied art history with Meyer Schapiro at Columbia University (1945–46). In 1946 he met Alfred Stieglitz, an important influence on his ideas about photography. Later that year White was appointed to the faculty at the California School of Fine Arts (now the San Francisco Art Institute), whose photography program was then headed by Ansel Adams.

In 1947 White produced *Second Sequence/Amputa-tions*, his first sequence of images in which photographs were ordered for metaphoric rather than narrative content, a highly personal approach that remained central to White's work throughout his career. He helped found *Aperture* magazine in 1952 and as editor until 1975 made important contributions to photographic literature. From 1953 to 1957 he was curator of exhibitions at the George Eastman House (now the International Museum of Photography at George Eastman House), Rochester, New York. There he was also responsible for editing *Image*, the museum's publication. In 1955 he began teaching at the Rochester Institute of Technology. It was during these years (1956–57) that he developed a deep interest in Oriental and Sufic philosophy, which informed his photography and teaching methods.

In 1965 White was appointed Visiting Professor at the Massachusetts Institute of Technology, Cambridge, where he organized such exhibitions as *Light⁷* (1968), *Octave of Prayer* (1972), and *Celebrations* (1974). He was given a tenured professorship in 1969, from which he resigned in 1974.

Joel-Peter Witkin

Born Brooklyn, 1939

Portrait, 1984

Joel-Peter Witkin began photographing while still in his teens. His first pictures were of the performers in the Coney Island Freak Show. In the late 1950s he began staging and photographing his own bizarre events—inspired by his study of art history—based on works by Rembrandt and Felicien Rops to Max Beckmann and Balthus. Beginning in 1961 Witkin worked full time as a color printer while taking evening classes at the Cooper Union School of Art, where he majored in sculpture. He was then drafted into the army, where he served as a photographer in the United States and Europe, documenting, among other things, deaths resulting from military maneuvers or suicide.

In his sculptural work Witkin had explored religious iconography, but on his discharge from the military he possessed an even greater ambition: to investigate through photography not only himself, but also his vision of God, a desire that was expressed in his series *Contemporary Images of Christ* of the early 1970s. Also produced at this time was his *Images of Woman* series, a disturbing body of work in which he investigated his fantasies of sexual perversion and voyeurism.

After receiving his Bachelor of Arts degree from the Cooper Union School of Art in 1974, Witkin enrolled in the graduate program in photography at the University of New Mexico, Albuquerque. While a student there (1975–76), he continued to orchestrate scenes to be photographed, but now he was less interested in representing personal fantasy than in recording in real time the authentic reactions of his models to stressful situations he established. By the early 1980s Witkin had evolved an emotionally charged and highly controversial body of imagery in which scratching the negative was one element in a complex printing process involving layers of dampened tissue paper and selective toning and bleaching. Raising the goal of self-understanding to the level of spiritual quest, Witkin pursued the darkest reaches of his psyche, exploring through deliberately fabricated tableaux the taboo themes of sexual fetishism, transvestism, androgyny, sadomasochism, homosexuality, pain, suffering, and death.

In his most current project, Witkin is combining his experience with both photography and sculpture to create a twelve- to fourteen-foot crucifix at the points of which will be placed photographic imagery in lead.

Witkin works in San Francisco, New York, and Albuquerque, where he maintains his permanent residence.

Documentation of Portraits
Accompanying Biographies of the Artists

Unless otherwise noted, photographs have been provided by the artists or their representatives

Gertrud Arndt Self-Portrait, ca. 1929. Courtesy Rudolf Kicken Galerie, Cologne.

Ellen Rosenberg Auerbach Portrait by Barbara Klemm, ca. 1979.

Lewis Baltz Portrait by Joan Murray, 1972. San Francisco Museum of Modern Art. Gift of Joan Murray in honor of John Humphrey (80.479).

Thomas F. Barrow Portrait by Laurie A. Barrow, 1984.

Hans Bellmer Self-Portrait (detail), ca. 1950. From *Hans Bellmer Photographien*. Introduction by Alain Sayag. Munich: Schirmer/Mosel, 1984.

Bernhard Johannes Blume Portrait (detail), photographer unknown, 1984.

Erwin Blumenfeld Self-Portrait, 1943. From Erwin Blumenfeld. *Jadis et Daguerre*. Paris: Éditions Robert Laffont, 1975.

Pierre Boucher Self-Portrait, 1980.

Harry Bowers Self-Portrait (detail of *Margaret*), 1982.

Francis Joseph Bruguière Self-Portrait, ca. 1935. Collection James and Roxanne Enyeart, Tucson, Arizona.

Paul Caponigro Portrait by Dayne Bonta, 1976.

Henri Cartier-Bresson Portrait by Dorothy Norman, 1946. San Francisco Museum of Modern Art. Clinton Walker Fund Purchase (83.12).

Larry Clark Portrait by Amy Clark, 1984.

Konrad Cramer Portrait by Florence Ballin Cramer, 1948. Courtesy Photofind Gallery, Woodstock, New York.

Robert Cumming Self-Portrait (detail of *Monument Fingernails, Washington, D.C.*), 1976.

Imogen Cunningham Portrait by Alma Lavenson, 1945. San Francisco Museum of Modern Art. The Henry Swift Collection, Gift of Florence Alston Swift (63.19.125).

Roy DeCarava Portrait by Sherry DeCarava, 1971.

Rick Dingus Portrait by Ashton G. Thornhill, 1984.

František Drtikol Self-Portrait, 1930. From *František Drtikol*. Introduction by Kateřina Klaricová. Prague: Mezinárodni Fotografie, 1981.

Alfred Ehrhardt Portrait by Karsten Fricke, 1983. Courtesy Galerie Wilde, Zülpich-Mülheim, West Germany.

Hans Finsler Portrait, photographer unknown, 1969. Courtesy Fondation pour la Photographie Suisse, Zurich.

Robbert Flick Portrait by Susan Rankaitis, 1984.

Robert Frank Portrait by Arnold Crane, 1976. San Francisco Museum of Modern Art. Gift of Emidio L. Gaspar (83.286).

Lee Friedlander Self-Portrait, 1969. San Francisco Museum of Modern Art. Purchase (83.27).

Jaromír Funke Portrait, photographer unknown, 1940. From *Jaromír Funke: Fotografie*. Prague: Odeon, 1970.

Judith Golden Self-Portrait, ca. 1978.

Philippe Halsman Portrait, photographer unknown, ca. 1959. San Francisco Museum of Modern Art. Archives.

Georges Hugnet Portrait (detail of *L'Échiquier surréaliste* [*Surrealist Chessboard*]) by Man Ray, 1934.

Gyorgy Kepes Portrait by Bela Kalman, 1977.

André Kertész Portrait by Jerry Burchard, 1972/ca. 1975. San Francisco Museum of Modern Art. Gift of Rio Rocket Valledor (82.493).

Edmund Kesting Self-Portrait, 1931. Collection Audrey and Sydney Irmas, Los Angeles.

Les Krims Portrait by Patricia O'Brien, 1984.

Michel Szulc Krzyzanowski Statement to San Francisco Museum of Modern Art, July 17, 1984.

Helen Levitt Portrait by Emma Ling, ca. 1952.

Herbert List Portrait by Andreas Feininger, 1930. Courtesy PPS Galerie, Hamburg, Germany.

Dora Maar Portrait by Man Ray, ca. 1936. Courtesy Juliet Man Ray, Paris.

Greg MacGregor Portrait by Procopio Calado, 1983.

Aleksandras Macijauskas Self-Portrait, 1977. San Francisco Museum of Modern Art. Gift of the artist (80.317).

Man Ray Self-Portrait, ca. 1930. San Francisco Museum of Modern Art. Extended Anonymous Loan.

Ralph Eugene Meatyard Portrait by Cranston Ritchie, ca. 1959. Courtesy Christopher Meatyard, Lexington, Kentucky.

László Moholy-Nagy Portrait by Vories Fisher, 1945. Courtesy Hattula Moholy-Nagy, Ann Arbor, Michigan.

Martin Munkacsi Self-Portrait, 1935. Courtesy Joan Munkacsi, Woodstock, New York.

Anne Noggle Self-Portrait, 1984.

Paul Outerbridge Self-Portrait, 1938. Courtesy G. Ray Hawkins Gallery, Los Angeles.

Roger Parry Self-Portrait, 1936. Courtesy Zabriskie Gallery, New York.

Robert Petschow Portrait, photographer unknown, n.d. From Karl Steinorth. *Photographen der 20er Jahre*. Munich: Laterna Magica, 1970.

John Pfahl Portrait by Tom Feldvebel, 1984.

Arnulf Rainer Portrait by Rolf Hoffmann, 1984.

Alexander Rodchenko Portrait by M. A. Kaufman, 1921. From *Alexander Rodtschenko: Fotografien 1920–1938*. Edited by Evelyn Weiss. Cologne: Wienand Verlag, 1978.

Franz Roh Portrait by Lucia Moholy, ca. 1926/1980. San Francisco Museum of Modern Art. Gift of Lucia Moholy (82.311).

Theodore Roszak Self-Portrait, ca. 1931. Collection Sara Jane Roszak, New York. Courtesy Zabriskie Gallery, New York.

Lucas Samaras Portrait by Philip Tsiaras, 1978. Courtesy Pace Gallery, New York.

August Sander Portrait by Gunther Sander, ca. 1960. San Francisco Museum of Modern Art. Gift of Gerd and Christine Sander (84.1435).

Sandra Semchuk Portrait by Stephen Cummings, 1984.

Aaron Siskind Portrait by Arthur Siegel, ca. 1956. San Francisco Museum of Modern Art. Anonymous gift (81.132).

Frederick Sommer Portrait by Bill Jay, 1980. Courtesy Bill Jay, Tempe, Arizona.

Ralph Steiner Portrait by Eleanor Briggs, 1981. Courtesy Eleanor Briggs, Hancock, New Hampshire.

Grete Stern Portrait by Alicia Segal, 1980.

Paul Strand Portrait by Alfred Stieglitz, 1917. Courtesy the Paul Strand Archive and Library, Aperture Foundation, Millerton, New York.

Studio Ringl & Pit. *See* Ellen Rosenberg Auerbach *and* Grete Stern.

Tato (Guglielmo Sansoni) Self-Portrait, 1923. From Giovanni Lista. *Futurismo e Fotografia*. Milan: Multhipla Edizioni, 1979.

Val Telberg Self-Portrait, ca. 1947. San Francisco Museum of Modern Art. Gift of the artist (83.128).

Raoul Ubac Portrait by C. Gaspari, 1964. Courtesy Galerie Adrien Maeght, Paris.

Jerry N. Uelsmann Portrait by Diane Farris, 1982.

Umbo (Otto Umbehr) Self-Portrait, ca. 1930, from *Umbo Portfolio*, 1980, 34/50. San Francisco Museum of Modern Art. Purchase (83.36.5).

Edward Weston Portrait by Johan Hagemeyer, ca. 1920s. San Francisco Museum of Modern Art. Foto Forum Purchase, Gift of Anne MacDonald Walker (84.1749).

Minor White Portrait (detail) by Judy Dater, 1975. Courtesy Judy Dater, San Anselmo, California.

Joel-Peter Witkin Portrait by Cynthia Witkin, 1984.

Documentation of Text Illustrations

Figure 1 Charles Sheeler. *Bucks County House, Interior Detail*, 1917. Gelatin silver print, 8 1/4 x 5 7/8" (21.0 x 15.0 cm). The Metropolitan Museum of Art, New York. The Alfred Stieglitz Collection (33.43.343).

Figure 2 Morton Schamberg. Untitled, 1917. Gelatin silver print, 9 3/8 x 7 1/2" (23.8 x 19.1 cm). Collection John Waddell, New York.

Figure 3 Alfred Stieglitz. *Old and New New York*, 1910. Photogravure, 13 1/8 x 10 1/8" (33.4 x 25.7 cm). San Francisco Museum of Modern Art. Alfred Stieglitz Collection, Gift of Georgia O'Keeffe (52.1853).

Figure 4 Paul B. Haviland. *Passing Steamer*, ca. 1912. Photogravure from *Camera Work*, no. 39 (July 1912), 6 7/8 x 7" (17.5 x 17.8 cm). San Francisco Museum of Modern Art. Alfred Stieglitz Collection, Gift of Georgia O'Keeffe (78.222).

Figure 5 Christian Schad. Untitled, 1918. Printing-out paper (Schadograph), 6 5/8 x 4 15/16" (16.8 x 12.5 cm). The Museum of Modern Art, New York. Purchase (287.37).

Figure 6 Alvin Langdon Coburn. *Vortograph #8*, 1917/1950s. Gelatin silver print (Vortograph), 11 3/8 x 8 7/8" (28.9 x 22.5 cm). San Francisco Museum of Modern Art. Purchased through a gift of Dwight V. Strong (85.419).

Figure 7 Paul Strand. *Man, Five Points Square, New York*, 1916. Platinum print, 10 x 12" (25.4 x 30.5 cm). Jedermann Collection, N.A.

Figure 8 Francis Picabia. *The Saint of Saints*, 1915. From *291*, nos. 5–6 (July–August 1915), 17 3/16 x 11 5/16" (45.3 x 30.4 cm). San Francisco Museum of Modern Art.

Figure 9 Man Ray. *L'Inquiétude* (Disquiet), 1920. Gelatin silver print, 3 11/16 x 4 11/16" (9.4 x 11.9 cm). Collection Robert Shapazian, Fresno, California.

Figure 10 Man Ray. *La Femme*, 1920. Gelatin silver print. From *Man Ray: Photographs*. Introduction by Jean-Hubert Martin. New York: Thames and Hudson, 1982.

Figure 11 Pages from *Die Koralle*, vol. 5, no. 6 (September 1929), pp. 250–51. Photographs by E. O. Hoppé (left) and unidentified photographer(s) (right). Photo courtesy New York Public Library.

Figure 12 Pages from *Die Koralle*, vol. 5, no. 6 (September 1929), pp. 252–53. Photographs by unidentified photographer (left) and Martin Munkacsi (right). Photo courtesy New York Public Library.

Figure 13 Salvador Dali. *Remorse (Sphinx Embedded in the Sand)*, 1931. Oil on canvas, 7 1/2 x 10 1/2" (19.1 x 26.6 cm). Kresge Art Museum, Michigan State University, East Lansing. Gift of John F. Wolfram (61.8).

Figure 14 Angus McBean. *Bea Lillie*, ca. 1937. Gelatin silver print, 14 1/2 x 11 11/16" (36.9 x 29.7 cm). San Francisco Museum of Modern Art, Anonymous gift (83.207).

Figure 15 Pages from *Minotaure*, no. 6 (1935), pp. 30–31. Photographs by Hans Bellmer. Photo courtesy Doe Library, University of California, Berkeley.

Figure 16 Pages from *Minotaure*, no. 7 (1935), pp. 30–31. Photographs by Brassaï (Gyula Halász). Photo courtesy Doe Library, University of California, Berkeley.

Figure 17 Bruce Nauman. *Self-Portrait as a Fountain*, 1966–67. Type-C print (edition of eight), 19 3/4 x 23 3/4" (50.2 x 60.4 cm). Photo courtesy Leo Castelli, Inc., New York.

Figure 18 Richard Long. *A Circle in Alaska.* Bering Strait Driftwood on the Arctic Circle, 1977. Gelatin silver print, 48 1/4 x 37 7/16" (122.5 x 87.5 cm). Photo courtesy Anthony d'Offay Gallery, London.

Figure 19 Paul Strand. *Abstraction, Porch Shadows, Twin Lakes, Connecticut*, 1916, from *On My Doorstep: A Portfolio of Eleven Photographs, 1914–1973*, 1976, 19/50. Gelatin silver print, 13 1/8 x 9 1/16" (33.3 x 23.0 cm). San Francisco Museum of Modern Art. Purchase (77.7.2).

Figure 20 Paul Strand. *Shadows, Twin Lakes, Connecticut*, 1916. Platinum print, 13 x 9 7/8" (33.0 x 25.1 cm). Collection Thomas Walther, New York.

Figure 21 Paul Strand. *Still Life, Pear and Bowls, Twin Lakes, Connecticut*, 1916. Platinum print, 10 1/4 x 11 3/8" (26.1 x 28.9 cm). Collection Gilman Paper Company, New York.

Figure 22 Paul Strand. *Bottle, Book and Orange, Twin Lakes, Connecticut*, 1916. Platinum-palladium print, 10 1/4 x 11 3/8" (26.1 x 28.9 cm). Collection George H. Dalsheimer, Baltimore.

Figure 23 Paul Outerbridge. *Marmon Crankshaft*, 1923. Platinum print. From *Paul Outerbridge: A Singular Aesthetic*. Edited by Elaine Dines. Laguna Beach Museum of Art, 1981.

Figure 24 Edward Weston. *Mexican Toys*, 1925. Platinum print, 7 3/8 x 8 5/8" (18.8 x 21.9 cm). San Francisco Museum of Modern Art. Byron Meyer Fund Purchase (81.106).

Figure 25 Imogen Cunningham. *Aloe*, 1925/1984. Gelatin silver print (printed by Rondal Partridge), 10 15/16 x 8 5/8" (27.8 x 21.9 cm). San Francisco Museum of Modern Art. Purchase (86.83).

Figure 26 Robert Petschow. *Balloon with Shadows*, 1926. Gelatin silver print, 6 9/16 x 4 7/16" (16.7 x 11.3 cm). From Van Deren Coke. *Avant-Garde Photography in Germany, 1919–1933*. New York: Pantheon Books, 1982.

Figure 27 Jaromir Funke. Untitled, ca. 1927. Gelatin silver print, 9 1/16 x 11 5/8" (22.9 x 29.5 cm). San Francisco Museum of Modern Art. Mrs. Ferdinand C. Smith Fund Purchase (79.105).

Figure 28 František Drtikol. *Studie*, 1929. Gelatin silver print, 4 x 3 1/4" (10.2 x 8.3 cm). Collection Dr. and Mrs. R. Joseph Monsen, Seattle.

Figure 29 Franz Roh. Untitled, ca. 1927–28. Gelatin silver print (negative image). From *Retrospektive Fotografie: Franz Roh*. Introduction by Juliane Roh. Düsseldorf: Edition Marzona, 1981.

Figure 30 Edmund Kesting. *Kennwort: Kulturerbe* (Code Word: Cultural Heritage), 1933. Gelatin silver print, 5 1/16 x 8 15/16" (12.9 x 22.7 cm). San Francisco Museum of Modern Art. Fund of the 80's Purchase (85.227).

Figure 31 Alexander Rodchenko. *Lefortovo—studentské městečko* (Lefortovo—Student Village), 1930. Gelatin silver print. From *Revue fotografie 77* (Prague), vol. 21, no. 1 (1977).

Figure 32 Gertrud Arndt. Untitled, 1930. Gelatin silver print, 8 7/8 x 6 1/8" (22.6 x 15.6 cm). San Francisco Museum of Modern Art. Fund of the 80's Purchase (85.109).

Figure 33 László Moholy-Nagy. Untitled (Portrait of Oskar Schlemmer), 1926. Gelatin silver print. From Andreas Haus. *Moholy-Nagy: Photographs and Photograms*. New York: Pantheon Books, 1980.

Figure 34 László Moholy-Nagy. *The Schlemmer Children*, 1926. Gelatin silver print. From Andreas Haus. *Moholy-Nagy: Photographs and Photograms.* New York: Pantheon Books, 1980.

Figure 35 László Moholy-Nagy. *Ascona*, 1926. Gelatin silver print. From Andreas Haus. *Moholy-Nagy: Photographs and Photograms.* New York: Pantheon Books, 1980.

Figure 36 Roger Parry. Untitled, 1929, from the deluxe edition book *Banalité* (Paris: Nouvelle Revue Française, 1930). Gelatin silver print with toner. San Francisco Museum of Modern Art. Gift of Robert Shapazian (82.539).

Figure 37 André Kertész. Pages from *Vu* magazine, no. 129 (September 3, 1930), pp. 866–67, 872. Photo courtesy Estate of André Kertész.

Figure 38 André Kertész. Back cover of *Vu* magazine, no. 129 (September 3, 1930). Photo courtesy Estate of André Kertész.

Figure 39 Georg Muche. Untitled, ca. 1925. Gelatin silver print. From László Moholy-Nagy. *Painting, Photography, Film*. London: Lund Humphries, 1969.

Figure 40 Studio Ringl & Pit (Grete Stern and Ellen Rosenberg Auerbach). *Komol*, ca. 1931. Gelatin silver print, 14 3/16 x 9 1/8 (36.1 x 23.2 cm). From Van Deren Coke. *Avant-Garde Photography in Germany, 1919–1933.* New York: Pantheon Books, 1982.

Figure 41 Hans Bellmer. *Maschinengewehr im Zustand der Gnade (Machine Gun in a State of Grace)*, 1937. Gelatin silver print with gouache, 25 9/16 x 25 13/16" (65.0 x 65.5 cm). From *Hans Bellmer Photographien*. Introduction by Alain Sayag. Munich: Schirmer/Mosel, 1984.

Figure 42 Pablo Picasso. Detail of *Guernica*, 1937. Oil on canvas, 11' 5 1/2" x 25' 5 3/4" (349.3 x 776.6 cm). Museo del Prado, Madrid.

Figure 43 Mother carrying her dead son, from Sergei Eisenstein's film *Battleship Potemkin*, 1925.

Figure 44 Erwin Blumenfeld. Untitled, ca. 1940. Gelatin silver print (solarized), 13 1/8 x 10 3/16" (33.2 x 25.9 cm). San Francisco Museum of Modern Art. Mrs. Ferdinand C. Smith Fund Purchase (79.92).

Figures 45–47 Pierre Boucher. Photographs used to create the photomontage *Ondine*, 1938. Gelatin silver prints. 45: 3 1/2 x 3 1/16″ (8.9 x 7.8 cm); 46: 3 1/2 x 3 1/8″ (8.9 x 8.0 cm); 47: 3 1/2 x 3 1/16″ (8.9 x 7.8 cm). San Francisco Museum of Modern Art. Archives.

Figure 48 Frederick Sommer. *Chicken Entrails 1st Series #3*, 1938. Gelatin silver print, 9 5/8 x 7 5/8″ (24.5 x 19.4 cm). San Francisco Museum of Modern Art. Gift of Brett Weston (83.412).

Figure 49 Raoul Ubac. Untitled, 1938–39, from the series *Le Combat des Penthésilées (Battle of the Amazons)*. Gelatin silver print (bas-relief), 6 5/8 x 9″ (16.9 x 22.8 cm). Collection Roger Therond, Paris.

Figure 50 Raoul Ubac. *Le Mur sans fin* (The Infinite Wall), 1938–39. Gelatin silver print (bas-relief). From *Minotaure*, nos. 12–13 (May 1939).

Figure 51 Konrad Cramer. Untitled, ca. 1938. Gelatin silver print (solarized), 4 13/16 x 3 7/8″ (12.3 x 9.9 cm). International Museum of Photography at George Eastman House, Rochester, New York (74:073:103).

Figure 52 Philippe Halsman. *Dali Atomicus*, 1948, from the portfolio *Halsman/Dali*, 1981, 35/250. Gelatin silver print, 9 1/8 x 12 15/16″ (23.2 x 32.9 cm). San Francisco Museum of Modern Art. Gift of Marjorie Neikrug (84.1653.1).

Figure 53 Aaron Siskind. Untitled, 1961, from the series *Pleasures and Terrors of Levitation*. Gelatin silver print, 4 5/8 x 4 5/8″ (11.8 x 11.8 cm). San Francisco Museum of Modern Art. Gift of Virginia Hassel Ballinger in memory of Paul Hassel (73.56.10).

Figure 54 Aaron Siskind. Untitled (#37), 1953, from the series *Pleasures and Terrors of Levitation*. Gelatin silver print, 5 3/4 x 4 1/2″ (14.6 x 11.5 cm). San Francisco Museum of Modern Art. Gift of Virginia Hassel Ballinger in memory of Paul Hassel (73.56.11).

Figure 55 Jerry N. Uelsmann. *Free but Securely Held*, 1965. Gelatin silver print. From *Jerry N. Uelsmann*. Introduction by Peter C. Bunnell. New York: Aperture, 1971.

Figure 56 Lucas Samaras. *Photo-Transformation 11/22/73*, 1973. Polaroid SX-70 print, 3 x 3″ (7.6 x 7.6 cm). San Francisco Museum of Modern Art. William L. Gerstle Collection, William L. Gerstle Fund Purchase (80.404).

Figure 57 Mayer Frères and Pierson. *Le Prince Impérial et Napoléon III* (The Prince Imperial and Napoleon III), ca. 1858. Albumen print from a collodion negative. From "Le Second Empire vous regarde," *Le Point*, vols. 53–54 (January 1958).

Figure 58 Umbo (Otto Umbehr). *Rut Maske (Die Larve)* (Rut Masked [The Mask]), 1927, from *Umbo Portfolio*, 1980, 34/50. Gelatin silver print, 7 1/16″ x 5 1/16″ (18.0 x 12.9 cm). San Francisco Museum of Modern Art. Purchase (83.36.3).

Figure 59 Tato (Guglielmo Sansoni). Untitled (Portrait of Filippo Tommaso Marinetti), 1930. Gelatin silver print. From Geno Pampaloni and Mario Verdone. *I Futuristi Italiani*. Florence: Le Lettere, 1977.

Figure 60 Tato (Guglielmo Sansoni). *Il Perfetto borghese (The Perfect Bourgeois)*, 1930. Gelatin silver print, 10 13/16 x 13 1/2″ (25.9 x 34.3 cm). San Francisco Museum of Modern Art. Gift of Foto Forum (86.44).

Figure 61 Roy DeCarava. *Woman Resting, Subway Entrance, New York*, 1952. Gelatin silver print, 13 1/8 x 9 1/8″ (33.3 x 23.1 cm). San Francisco Museum of Modern Art. The Helen Crocker Russell and William H. and Ethel W. Crocker Family Funds Purchase (80.27).

Figure 62 Robert Frank. Detail of a contact sheet from the series *The Americans*, 1955–56. From Robert Frank. *The Lines of My Hand.* New York: Lustrum Press, 1972.

Figure 63 Alfred Ehrhardt. *Polygratia polygrata (Brasilien)*, ca. 1937. Gelatin silver print, 9 1/4 x 6 15/16″ (23.5 x 17.7 cm). San Francisco Museum of Modern Art. Purchase (81.43).

Figure 64 Minor White. *Toolshed in Cemetery*, 1955. Gelatin silver print (from an infrared negative). From Minor White. *Mirrors, Messages, Manifestations.* New York: Aperture, 1969.

Figure 65 Larry Clark. Untitled, between 1963 and 1971, from the portfolio *Tulsa*, 1980, 61/100. Gelatin silver print, 8 x 12 1/8″ (20.3 x 30.8 cm). San Francisco Museum of Modern Art. Gift of Gary Roubos (82.502.15).

Figure 66 Arnulf Rainer. *Mit Augenstarker* (With Eyestrain), 1971. Gelatin silver print with pencil and oil crayon, 20 x 23 3/4″ (50.8 x 60.4 cm). From *Drawings by Lesak and Rainer*. Minneapolis: Walker Art Center, 1980.

Figure 67 Sandra Semchuk. *Self-Portrait at Grieg Lake, August, 1979*, 1979. Gelatin silver print, 13 x 19 1/4″ (33.0 x 48.9 cm) overall. Collection Saskatchewan Arts Board, Canada.

Index

Page numbers in *italics* refer to illustrations